Canon® EOS 60D

FOR

DUMMIES®

Canon® EOS 60D
FOR
DUMMIES®

by Julie Adair King and Robert Correll

WILEY

John Wiley & Sons, Inc.

Canon® EOS 60D For Dummies®

Published by
John Wiley & Sons, Inc.
111 River Street
Hoboken, NJ 07030-5774

www.wiley.com

WILEY

About the Authors

Julie Adair King is the author of many books about digital photography and imaging, including the best-selling *Digital Photography For Dummies*. Her most recent titles include a series of *For Dummies* guides to popular digital SLR cameras, including the *Canon Rebel T1i/500D, XSi/450D, XS/1000D,* and *XTi/400D.* Other works include *Digital Photography Before & After Makeovers, Digital Photo Projects For Dummies, Julie King's Everyday Photoshop For Photographers, Julie King's Everyday Photoshop Elements,* and *Shoot Like a Pro!: Digital Photography Techniques.* When not writing, King teaches digital photography at such locations as the Palm Beach Photographic Centre. A graduate of Purdue University, she resides in Indianapolis, Indiana.

Robert Correll is an author, a photographer, and a musician with a lifetime of film and digital photography experience. He is a photo editing, photo management, raw processing, HDR application, and graphics software expert. His latest titles include *Digital SLR Photography All-in-One For Dummies, High Dynamic Range Digital Photography For Dummies, High Dynamic Range Photography Photo Workshop,* and *Photo Retouching and Restoration Using Corel PaintShop Photo Pro,* 2nd edition. He's done a bunch of other stuff, too. When not writing, Robert enjoys his family life, playing the guitar, producing and recording music, and consulting. Robert graduated from the United States Air Force Academy.

Authors' Acknowledgments

This book was a team effort from start to finish. Everyone contributed their time, skill, and professional acumen to try to produce the best possible product for you.

We would like to thank everyone on the *For Dummies* team for all their hard work, expertise, and dedication to this project, including Steve Hayes (Executive Editor), Nicole Sholly (Project Editor), Teresa Artman (Senior Copy Editor), David Hall (Technical Reviewer), and many others who contributed to this project.

Special thanks go to Roger Cicala of LensRentals.com for his timely support and professional service.

Finally, we thank our families and friends for supporting and encouraging us during all the hard work and sleepless nights.

Publisher's Acknowledgments

We're proud of this book; please send us your comments at http://dummies.custhelp.com. For other comments, please contact our Customer Care Department within the U.S. at 877-762-2974, outside the U.S. at 317-572-3993, or fax 317-572-4002.

Some of the people who helped bring this book to market include the following:

Acquisitions and Editorial

Project Editor: Nicole Sholly

Executive Editor: Steve Hayes

Senior Copy Editor: Teresa Artman

Technical Editor: David Hall

Editorial Manager: Kevin Kirschner

Editorial Assistant: Amanda Graham

Sr. Editorial Assistant: Cherie Case

Cartoons: Rich Tennant
(www.the5thwave.com)

Composition Services

Project Coordinator: Patrick Redmond

Layout and Graphics: Thomas Borah, Samantha K. Cherolis, Timothy C. Detrick, Joyce Haughey

Proofreaders: Melissa Cossell, Linda Seifert

Indexer: Potomac Indexing, LLC

Publishing and Editorial for Technology Dummies

Richard Swadley, Vice President and Executive Group Publisher

Andy Cummings, Vice President and Publisher

Mary Bednarek, Executive Acquisitions Director

Mary C. Corder, Editorial Director

Publishing for Consumer Dummies

Kathleen Nebenhaus, Vice President and Executive Publisher

Composition Services

Debbie Stailey, Director of Composition Services

Contents at a Glance

Table of Contents

Introduction

*T*he Canon EOS 60D is a ground-breaking digital SLR camera that offers the best of two worlds, bridging the gap between the entry-level Canon EOS Rebel line and the much more expensive, professional-level Canon models like the EOS 7D and beyond. The 60D is designed to sit in a sweet spot of price and performance: accessible to beginners and yet powerful enough for more advanced photographers.

This camera offers the range of advanced controls and features that experienced photographers demand (impressive high ISO performance, great top-end shutter speed, a top LCD screen, plenty of flash options, higher sync-speed, flexibility, customizability, and more) plus an assortment of tools designed to help beginners be successful (a cool articulated LCD monitor, great Quick Control screen, Live View, easy-to-use shooting modes, and more). Adding to the fun, this camera also continues the Canon commitment to cameras that can record high-definition digital movies.

The 60D is so feature packed, in fact, that sorting out everything can be a challenge, especially if you're new to digital photography or SLR photography, or both. For starters, you may not even be sure what SLR stands for (single lens reflex; now you know!), what that means, or how it affects your picture taking, let alone have a clue about all the other techie terms you encounter in your camera manual: resolution, aperture, white balance, format. If you're so overwhelmed by all the controls on your camera that you haven't yet ventured beyond fully automatic picture-taking mode, this is the book for you.

In *Canon EOS 60D For Dummies,* you can discover not only what each bell and whistle on your camera does but also when, where, why, and how to best use each bell and whistle. Unlike many photography books, this one doesn't require any previous knowledge of photography or digital imaging to make sense of concepts, either. In classic *For Dummies* style, everything is explained in easy-to-understand language, with lots of illustrations to help clear up any confusion.

In short, what you have in your hands is the paperback version of an in-depth photography workshop tailored specifically to your Canon picture-taking powerhouse. Whether your interests lie in taking family photos, exploring nature and travel photography, or snapping product shots for your business, you'll get the information you need to capture the images you envision.

Mirror, mirror: Understanding the SLR part of your dSLR

One defining characteristic of any SLR (single lens reflex) camera, whether digital or film, is the mirror that is located in the camera body, just behind the lens and in front of the film or image sensor. The purpose of the mirror is to bounce light coming through the lens up to the viewfinder so you can frame, focus, and meter the same scene the camera sees. When you press the shutter button all the way, the mirror flips up (the technical term for a flipping mirror is a *reflex* mirror) so that the light goes directly onto the image sensor, rather than being diverted to the viewfinder. In Live View shooting and Movie modes, the mirror flips up and out of the way so light can hit the image sensor and be routed to the LCD monitor. That's one reason the viewfinder gets turned off and normal auto-focus routines don't work — the mirror isn't in the right position to reflect light up to the view-finder and AF sensors.

A Quick Look at What's Ahead

This book is organized into four parts, each devoted to a different aspect of using your camera. Although chapters flow in a sequence designed to take you from absolute beginner to experienced user, we also tried to make each chapter as self-standing as possible so that you can explore the topics that interest you in any order you please.

The following sections offer brief previews of each part. If you're eager to find details on a specific topic, the index shows you exactly where to look.

Part 1: Fast Track to Super Snaps

Part I contains four chapters that help you get up and running with your EOS 60D:

- Chapter 1, "Getting the Lay of the Land," offers a tour of the external controls on your camera, shows you how to navigate camera menus to access internal options, and walks you through initial camera setup and customization steps.

- Chapter 2, "Choosing Basic Picture Settings," introduces you to the Basic shooting modes on the Mode dial; different drive modes; basic flash photography; and picture quality settings, such as the resolution (pixel count), file format, file size, and picture quality.

- Chapter 3, "Taking Great Pictures, Automatically," shows you how to get the best results when using the camera's fully automatic exposure modes, including Portrait, Sports, and Landscape. The camera also fea-

tures the Creative Auto mode, which makes it easy for you to take a little more artistic control over your photos.

✔ Chapter 4, "Exploring Live View Shooting and Movie Making," explains how to review your pictures on the camera monitor, delete unwanted images, and protect your favorites from accidental erasure. In addition, this chapter introduces you to Live View shooting, in which you can use your monitor as a viewfinder. We also explain your camera's movie-recording features.

Part II: Working with Picture Files

This part of the book discusses the often-confusing aspect of reviewing the photos while still on the camera, and then moving them from camera to computer and beyond.

✔ Chapter 5, "Picture Playback," explores the Playback function of your 60D. You'll see how to view photos in Playback mode; quickly jump back and forth between photos; rotate them; zoom in on them; change how much information is displayed; and delete, protect, and rate them.

✔ Chapter 6, "Downloading, Printing, and Sharing Your Photos," guides you through transferring pictures from your camera memory card to your computer's hard drive or other storage device. Just as important, this chapter explains software options for managing, editing, printing, and sharing your collection.

Part III: Taking Creative Control

Chapters in this part help you unleash the full creative power of your camera by moving into semiautomatic or manual photography modes.

✔ Chapter 7, "Getting Creative with Exposure and Lighting," covers the all-important topic of exposure, starting with an explanation of three critical exposure controls: aperture, shutter speed, and ISO. This chapter also discusses your camera's advanced exposure modes (P, Tv, Av, M, B, and C), explains exposure options (such as metering mode and exposure compensation), and offers tips for using the built-in flash.

✔ Chapter 8, "Manipulating Focus and Color," provides help with controlling those aspects of your pictures. Look here for information about your camera's automatic and manual focusing features as well as for details about color controls, such as white balance and the Picture Style options.

✔ Chapter 9, "Putting It All Together," summarizes all the techniques explained in earlier chapters, providing a quick-reference guide to the camera settings and shooting strategies that produce the best results for specific types of pictures: portraits, action shots, landscape scenes, close-ups, and more.

Part IV: The Part of Tens

In famous *For Dummies* tradition, the book concludes with top-ten lists containing additional bits of information and advice.

- Chapter 10, "Ten Creative (and Practical) Features," expands your knowledge of your 60D beyond the basics and covers fun stuff, such as applying creative filters to your photos, creating a custom menu, registering your own exposure mode, locking up the mirror, adding copyright information, and more.

- Chapter 11, "Ten More Ways to Customize Your Camera," covers interesting bonus factoids that show you how to customize the camera to work how you want it to. You'll discover how to change what the Set button does, turn off those red autofocus points, change your focus screen, and create custom picture styles. Sounds like fun!

Icons and Other Stuff to Note

If this isn't your first *For Dummies* book, you may be familiar with the large, round icons that decorate its margins. If not, here's your very own icon-decoder ring:

- We apply this icon either to introduce information that's especially worth storing in your brain's long-term memory or to remind you of a fact that may have been displaced from that memory by another pressing fact.

- When you see this icon, look alive. It indicates a potential danger zone that can result in much wailing and teeth-gnashing if ignored.

- Lots of information in this book is of a technical nature; digital photography is a technical animal, after all. When we present a detail that's useful mainly for impressing your geeky friends, we mark it with this icon.

- A Tip icon flags information that saves you time, effort, money, or another valuable resource, including your sanity.

Additionally, we need to point out a few other details that will help you use this book:

- **Camera buttons and icons:** Replicas of some of your camera's buttons and onscreen graphics also appear in the margins of some paragraphs and in some tables. These images are handy reminders of the appearance of the button or option being discussed.

- **Software menu commands:** In sections that cover software, a series of words connected by an arrow indicates commands you choose a program menu. For example, if a step tells you, "Choose File⇨Print," click the File menu to unfurl it and then click the Print command on the menu.

- **Camera firmware:** *Firmware* is the internal software that controls many of your camera's operations. This book was written using version 1.0.6 of the firmware, which was current at the time of publication.

 Occasionally, Canon releases firmware updates, and you should check its Web site (www.canon.com) periodically to find out whether any updates are available. (Chapter 1 tells you how to determine which firmware version your camera is running.) Firmware updates typically don't carry major feature changes; they're mostly used to solve technical glitches in existing features. An exception to this rule is in the new world of high-definition video; some recent Canon firmware updates have included neat and useful video (and sound) recording improvements. If you download an update, be sure to read the accompanying description of what it accomplishes so that you can adapt this book's instructions as necessary.

About the Software Shown in This Book

Providing specific instructions for performing photo organizing and editing tasks requires that we feature specific software. In sections that cover file downloading, organizing, printing, and e-mail sharing, we showcase the Canon EOS Utility along with Canon Digital Photo Professional (for editing those Raw files), Canon ZoomBrowser EX (for Windows users) and ImageBrowser (for Mac users). These programs are part of the free software suite that ships with your camera.

Rest assured, though, that the tools used in these programs work similarly in other programs, so you should be able to easily adapt the steps to whatever software you use. (Of course, we recommend that you read your software manual for details.)

eCheat Sheet

As a little added bonus, you can find an electronic version of the famous *For Dummies* Cheat Sheet at

```
www.dummies.com/cheatsheet/canoneos60d
```

The Cheat Sheet contains a quick-reference guide to all the buttons, dials, switches, and exposure modes on your 60D. Log on, print it out, and tuck it in your camera bag for times when you can't carry this book with you.

Practice, Be Patient, and Have Fun!

To wrap up this preamble, we want to stress that if you initially think that digital photography is too confusing or too technical for you, you're in very good company. *Everyone* finds this stuff a little mind-boggling at first. Take it slowly, experimenting with just one or two new camera settings or techniques at first. Then, every time you go on a photo outing, make it a point to add one or two more shooting skills to your repertoire. Playfulness with your camera is encouraged!

We know that it's hard to believe when you're just starting out, but it truly isn't long before everything starts to come together. With some time, patience, and practice, you'll soon wield your camera like a pro, dialing in the necessary settings to capture your creative vision almost instinctively.

Without further ado, we invite you to grab your camera and a cup of whatever it is you prefer to sip while you read and then start exploring the rest of this book. Your EOS 60D is the perfect partner for your photographic journey, and we thank you for allowing us, in this book, to serve as your tour guides.

Part I
Fast Track to Super Snaps

*M*aking sense of all the controls on your EOS 60D isn't a task you can complete in an afternoon — or, heck, in a week or maybe even a month. But that doesn't mean you can't take great-looking pictures today. By using your camera's point-and-shoot automatic modes, you can capture terrific images with very little effort. All you do is compose the scene, and the camera takes care of almost everything else.

This part shows you how to take best advantage of your camera's automatic features and also addresses some basic setup steps, such as adjusting the viewfinder to your eyesight and getting familiar with the camera menus, buttons, and dials. In addition, chapters in this part explain how to obtain the best picture quality whether you shoot in an automatic mode or a manual mode, and how to use your camera's Live View and movie-making features.

Getting the Lay of the Land

For many people, getting your first *serious* camera means moving from a point and shoot (and some point and shoots are very capable) to an SLR (single lens reflex). As with any growth spurt, the excitement of the move is often tempered with a bit of anxiety. Sure, you'll be able to do lots of new things with your dSLR (digital SLR), but along with that newfound capability comes a barrage of new buttons, knobs, LCD menus, and mechanical knickknacks. Heck, this may be the first time you've even changed lenses on a camera: a big step in itself. Sure, you have the camera manual by your side, but it can be written in a cold or complicated way, making the learn-to-use-your-new-camera experience even more challenging.

If the 60D is your first SLR *and* your first digital camera, you're getting something of a double-whammy in the New Stuff department. Fear not, though, because your new camera isn't nearly as complicated as your first inspection may suggest. With some practice and the help of this chapter (which introduces you to each external control), you'll find yourself nestling in comfortably with your new camera, making your photography more exciting and natural than ever.

This chapter also guides you through the process of mounting and using an SLR lens, working with digital memory cards, and navigating your camera's internal menus. Finally, the end of the chapter walks you through options that enable you to customize many aspects of your camera's basic operation.

Before you start exploring this chapter, be sure that you fully charge your camera battery and then install it into the battery chamber on the bottom of the camera. You've probably already done this, but if not and you need help, the front part of the camera manual provides details.

Working with the Movable Monitor

The EOS 60D is the first Canon digital SLR that sports an *articulated monitor:* You can adjust the position of the LCD monitor on the back of the camera (see Figure 1-1), moving it around to find the best position for you. The monitor, which is mounted on a sturdy hinge, can move in and out and even swivel. To protect it (or if you decide you don't need it), you can even turn the monitor over so the screen faces into the camera body.

The important thing to remember is to treat the LCD monitor with respect. You don't have to baby it, but don't force it, either. If it resists or feels like it won't turn how you want, stop what you're doing or you may break it. It's easy to forget which way it's supposed to twist; when that happens, rely on the feeling of resistance to tell you to turn it the other way.

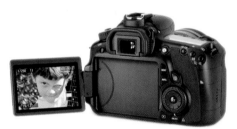

Figure 1-1: That's one nice articulated monitor.

These steps show you how to manipulate your LCD monitor:

1. **Flip out the monitor, as shown in the left image of Figure 1-2.**

 Put a finger in the indentation on the back of the camera and leverage the monitor out of its housing.

2. **Position the monitor, as shown in the right image of Figure 1-2.**

 You can pull it out all the way so the monitor extends to the side of the camera, and even rotate it toward or away from you. If you're holding the camera low, position the monitor so it faces up (and vice versa).

 If you position the monitor so it points away from you, you can turn the camera around and take your own portrait.

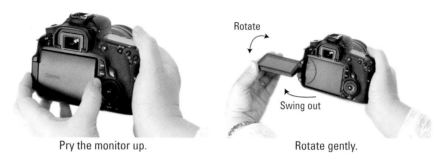

Pry the monitor up. Rotate gently.

Figure 1-2: Extract and position the movable LCD monitor.

3. **To use the monitor so it acts like a more conventional LCD, flip it out of the camera, rotate it away from you (the face will rotate upward and then away), and flip it back into the camera. See Figure 1-3.**

4. **Position the monitor for storage by extending it from the camera, rotating the screen so it faces you, and then flipping the monitor back into the camera.**

 The back of the monitor should face you. This is the most secure and protected position.

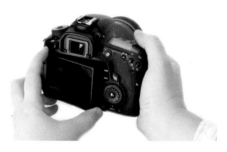

 Keep these points in mind as you manipulate your LCD monitor, and you will keep it in tip-top shape:

Figure 1-3: Position the monitor traditionally.

- ✔ **Easy does it.** Don't force the monitor when flipping or rotating.

- ✔ **Protect the monitor.** Face the monitor inward when not using the camera. This protects the LCD from scratches and bumps. This is a great tip even when you pack your camera in a camera bag because even padded bags can be dropped, crushed, or banged.

- ✔ **Watch the crunch factor.** When positioning the monitor back into the camera (whether face in or face out), take care that nothing gets in the way. Use a lens brush or blower to clean the monitor housing on the camera back so there's nothing in the way that could damage the monitor.

✔ **Protect your fingers.** Like other obstructions, fingers can get caught between the monitor and the camera body. Fingers can get hurt, so make sure they're out of the way when snapping the monitor back into the camera.

✔ **Be aware.** You can easily lose track of what you're doing when you have a nice LCD monitor to look at. Conversely, most of us don't walk or otherwise move around when we look through the viewfinder. When using the monitor, watch where you're going.

✔ **Read the manual.** Pages 12 and 13 of the camera manual list several safety tips for your camera and monitor, which we recommend reviewing. Take special care to protect your camera from water, heat, bumps, drops, magnetic fields, moisture, and corrosive chemicals.

✔ **Clean smart.** Wipe off your LCD monitor regularly. We recommend cleaning it after every use and as required when you are using it:

- *Don't let smudges or fingerprints accumulate.* Wipe them away every chance you get.

- *Use only approved cleaning techniques and materials, such as a damp microfiber cloth.* For routine touch-ups, a back and forth motion works well to clean the monitor. For tougher smudges, use a gentle circular motion.

 Do not use paper products like paper towels because they can contain wood fibers that can scratch the surface of the LCD.

- *Use a solution such as diluted isopropyl alcohol to clean the monitor.* LCDs don't like products with ammonia.

- *Take your monitor to a Canon dealer or service center for a professional cleaning if it becomes greasy or really dirty.*

Getting Comfortable with Your Lens

One of the biggest differences between a point-and-shoot camera and an SLR camera is the lens. With an SLR, you can swap out lenses to suit different photographic needs: going from an extreme close-up lens to a super-long telephoto, for example. Additionally, an SLR lens has a movable focusing ring that allows you to focus manually instead of relying on the camera's auto-focus mechanism. Even this basic difference extends your picture-making opportunities in big ways.

Of course, those added capabilities mean that you need a little background information to take full advantage of your lens. To that end, the next three sections explain the process of attaching, removing, and using this critical part of your camera.

Attaching a lens

Your camera can accept two categories of Canon lenses: those with an EF-S design and those with a plain-old EF design.

The EF stands for *electro focus;* the S, for *short back focus.* And *that* simply means the rear element of the lens is closer to the sensor than with an EF lens. And no, you don't need to remember what the abbreviation stands for. Just make sure that if you buy a Canon lens other than the one sold with the camera, it carries either the EF or EF-S specification. (The letters are part of the lens name; for example, the kit lens name is EF-S 18–135mm IS, and IS stands for image stabilization, a feature we explain later in this chapter.)

If you want to buy a non-Canon lens, check the lens manufacturer's Web site to find out which lenses work with the EOS 60D. Remember to buy the version of the lens with the Canon mount because most lens manufacturers make several versions of the same lens, each designed to fit on a different camera. For example, if you were looking to buy a Sigma 10–20mm F4–5.6 EX DC HSM, make sure you're getting the Canon mount and not something for Nikon, Sony, or another camera.

Whatever lens you choose, follow these steps to attach it to the camera body:

1. **Remove the cap that covers the lens mount on the front of the camera. (Twist counterclockwise, just like you're removing a bottle cap.)**

 This step assumes the camera doesn't already have a lens mounted. If it does, you have to remove the existing lens first. Those instructions are next.

2. **Remove the cap that covers the back of the lens (counterclockwise again).**

 Put this (and any other) cap in a safe, dust-free place, like a pocket in your camera bag.

3. **Locate the proper lens mounting index on the camera body.**

 A *mounting index* is simply a marker that tells you where to align the lens with the camera body when connecting the two. Your camera has two of these markers — one red and one white — as shown in Figure 1-4.

 Which marker you use to align your lens depends on the lens type:

 - *Canon EF-S lens:* The white square is the mounting index. The 18–135mm kit lens that ships with the 60D is an EF-S lens.

 - *Canon EF lens:* The red dot is the mounting index.

 If you buy a non-Canon lens, check the lens manual for help with this step.

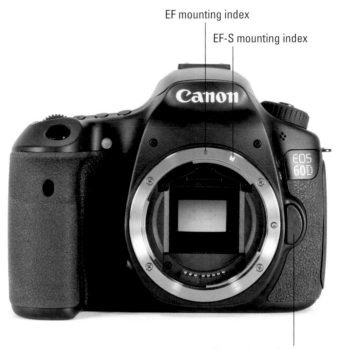

EF mounting index

EF-S mounting index

Canon

EOS 60D

Lens-release button

Figure 1-4: Which index marker you should use depends on the lens type.

4. **Align the mounting index on the lens with the correct one on the camera body.**

The lens also has a mounting index. Figure 1-5 shows the one that appears on the so-called *kit lens*: the EF-S 18–135mm IS zoom lens that Canon sells as a unit with the EOS 60D. If you buy a different lens, the index marker may be red or some other color, so again, check the lens instruction manual.

5. **Keeping the mounting indexes aligned, position the lens on the camera's lens mount.**

When you do so, grip the lens by its rearmost collar, as shown in Figure 1-5.

Don't touch the back of the lens with your finger, or you risk leaving a smudge. You may not realize it when taking pictures, but when you get back to your computer, the photos might be blurry and ruined. You should also resist the urge to stick your finger in the camera when the

lens is off. You could scratch or smudge the mirror and possibly damage other parts of the camera interior with your finger.

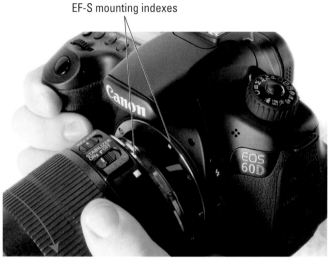

EF-S mounting indexes

Turn to attach

Figure 1-5: Place the lens in the lens mount with the mounting indexes aligned.

6. **Turn the lens in a clockwise direction until the lens clicks into place.**

 In other words, turn the lens toward the lens-release button (see Figure 1-4), as indicated by the red arrow in Figure 1-5.

Always attach (or switch) lenses in a clean environment to reduce the risk of getting dust, dirt, and other contaminants inside the camera or lens. Changing lenses on the beach on a windy day, for example, isn't a good idea. For added safety, point the camera body slightly down when performing this maneuver, as shown in the figure. Doing so helps prevent any flotsam in the air from being drawn into the camera by gravity.

Removing a lens

To detach a lens from the camera body, take these steps:

1. **Make sure the lens cap is on the front of the lens and have the rear lens cap (and possibly the camera body cap) handy.**

2. **Locate the lens-release button on the front of the camera, labeled in Figure 1-4.**

3. **Grip the rear collar of the lens.**

 In other words, hold onto the stationary part of the lens that's closest to the camera body.

4. **Press the lens-release button while turning the lens away from the lens-release button (counterclockwise).**

 You can feel the lens release from the mount at this point. Lift the lens off the mount to remove it.

5. **Place the rear protective cap onto the back of the lens.**

 If you aren't putting another lens on the camera, cover the lens mount with the protective cap that came with your camera, too. These steps help keep your lens and camera interior dust-free.

Using an IS (Image Stabilizer) lens

The 18–135mm lens sold with the EOS 60D camera offers *image stabilization.* On Canon lenses, this feature is indicated by the initials *IS* in the lens name.

Image stabilization attempts to compensate for small amounts of camera shake common when photographers handhold their cameras and use a slow shutter speed, a lens with a long focal length, or both. Camera shake is a problem because it can result in blurry images, even when your focus is dead-on. Although image stabilization can't work miracles, it does enable most people to capture sharper handheld shots in many situations that they otherwise couldn't.

However, when you use a tripod, image stabilization can have detrimental effects because the system may try to adjust for movement that isn't actually occurring. Although this problem shouldn't be an issue with most Canon IS lenses, if you do see blurry images while using a tripod, try setting the Image Stabilizer switch (shown in Figure 1-6) to Off. You also can save battery power by turning off image stabilization when you use a tripod.

If using a non-Canon lens, the IS feature may go by another name: anti-shake, vibration compensation, and so on. In some cases, the manufacturers may recommend that you leave the system turned on or select a special setting when you use a tripod, so be sure to check the lens manual for information.

Whatever type of lens you use, IS isn't meant to eliminate the blur that can occur when your subject moves during the exposure. That problem is related to shutter speed, a topic you can explore in Chapter 7. Chapter 8 offers more tips for blur-free shots and explains focal length and its effect on your pictures.

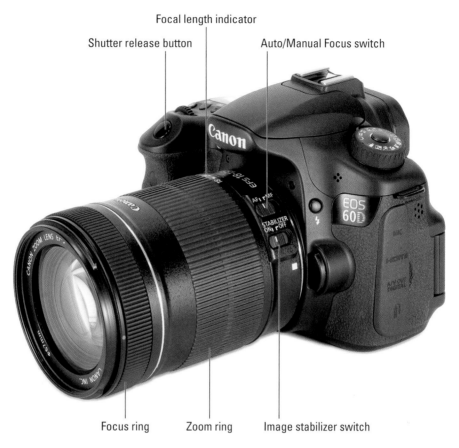

Focal length indicator

Shutter release button

Auto/Manual Focus switch

Focus ring Zoom ring Image stabilizer switch

Figure 1-6: The MF and IS controls are generally close together on the lens (which makes them easy to operate).

Manually focusing

Like any modern camera, the EOS 60D offers autofocusing capabilities. In fact, the EOS 60D offers an excellent autofocusing system, which you can find out how to exploit to its best advantage in Chapter 8. When shooting some subjects, however, using autofocus can be slow or impossible, which is why your camera also offers manual focusing.

Make the shift from auto to manual focus as follows:

1. **Locate the AF/MF switch on the side of the lens.**

 This switch sets the focus operation to either auto (AF) or manual (MF). Figure 1-6 shows you the switch as it appears on the EOS 60D kit lens. The switch should be in a similar location on other Canon lenses. If you use a lens from another manufacturer, check the lens instruction manual.

2. **Set the switch to the MF position, as shown in Figure 1-6.**

 Set the camera to manual focus before trying to focus manually because that keeps the autofocus machinery from trying to autofocus when you press the shutter halfway.

3. **Look through the viewfinder and twist the focusing ring until your subject comes into focus.**

 On the kit lens, the focusing ring is at the far end of the lens barrel, as indicated in Figure 1-6. In this case, it's far smaller than the zoom ring. Back in the days of manual focus cameras, this arrangement was reversed because manual focusing was of primary importance. If you use another lens, the focusing ring may be located elsewhere, so check your lens manual.

Half-press the shutter release while focusing, and you'll hear a beep and see your focus area(s) illuminate when sharp focus is achieved. (You can read more about this in Chapter 8.)

If you have trouble focusing, you may be too close to your subject; every lens has a minimum focusing distance. (For the kit lens, the minimum close-focus range is about 18 inches; for other lenses, check the specifications in the lens manual.) You also may need to adjust the viewfinder to accommodate your eyesight; read more about this later in this chapter.

 Some lenses enable you to use autofocusing to set the initial focusing point and then fine-tune focus manually. Check your lens manual for information on how to use this option, if available. (This option isn't offered on the kit lens.)

Zooming in and out

If you're using a zoom lens, it sports a movable zoom barrel (sometimes referred to as a *zoom ring*). On the kit lens, the barrel is just behind the focusing ring and is much larger, as shown in Figure 1-6, but again, the relative positioning of the two components depends on your lens. With the kit lens, you rotate the lens barrel to zoom. A few zoom lenses use a push-pull motion to zoom instead.

The numbers around the edge of the zoom barrel, by the way, represent *focal lengths.* Chapter 8 explains focal lengths in detail. In the meantime, just note that when the lens is mounted on the camera, the number that's aligned with the white focal-length indicator (always on top of the lens when mounted to the camera), labeled in Figure 1-6, represents the current focal length.

Some lenses, such as the Canon EF-S 18–200mm f/3.5–5.6 IS, have a feature that locks the zoom ring in place and keeps the lens from moving around. You can lock it only at the widest angle, which in this case is 18mm. The reason is so you can carry or pack the camera with the lens at its shortest length and not have to worry about the lens accidentally extending. To lock the lens, set the focal length to 18mm and slide the locking lever toward Lock. To release the lock, slide it in the opposite direction.

Working with Memory Cards

Traditional cameras record images on film, but digital cameras store pictures on *memory cards.* Your EOS 60D uses a specific type of memory card: an SD (Secure Digital) card, shown in Figures 1-7 and 1-8. You can also use high-capacity SD cards (which carry the SDHC label) and the newest SDXC cards that promise up to — ready for this? — 2TB (terabytes) of storage. (The *high-capacity* part just means that you can store more files on these cards than on regular SD cards.)

You have to purchase memory cards separately unless you're buying the camera as part of a bundle. Bundles are put together by vendors (not Canon) and include things like an inexpensive tripod, camera bag, one or more memory cards, and other gear. If you want a specific size, make, or model of card, you are better off buying them individually.

For movie recording, Canon recommends that you purchase a high-capacity card that carries an SD speed class rating of 6 or higher. This number refers to how quickly data can be written to and read from the card. A higher-speed card helps ensure the smoothest movie recording and playback.

Whatever the speed or capacity, safeguarding your memory cards — and the images on them — requires a few precautions:

✔ **Inserting a card:** Turn the camera off and then put the card in the card slot with the label facing the back of the camera, as shown in Figure 1-7. Push the card into the slot until it clicks into place.

✔ **Formatting a card:** The first time you use a new memory card, take a few seconds to format it by choosing the Format option on Setup Menu 1. This step ensures that the card is properly prepared to record your pictures. See the upcoming section, "Setup Menu 1," for details.

Memory card access light Card slot cover (open)

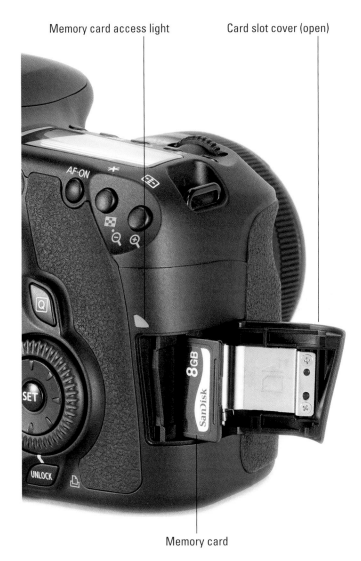

Memory card

Figure 1-7: Insert the card with the label facing you as you hold the camera.

✏ **Removing a card:** First, check the status of the memory card access light, labeled in Figure 1-7. After making sure that the light is off, indicating that the camera has finished recording your most recent photo, turn off the camera. Open the memory card door, as shown in Figure 1-7. Press in the memory card slightly until you hear a little click and then let go. The card pops halfway out of the slot, enabling you to grab it and remove it.

✏ **Handling cards:** Don't touch the gold contacts on the back of the card! (See the left card in Figure 1-8.) When cards aren't in use, store them in the protective cases they came in or in a memory card wallet. Keep cards away from extreme heat and cold as well.

✏ **Locking cards:** The tiny switch on the left side of the card, labeled *lock switch* in Figure 1-8, enables you to lock your card, which prevents any data from being erased or recorded to the card. Press the switch toward the bottom of the card to lock the card contents; press it toward the top of the card to unlock the data. You *don't* want to lock the card when shooting because the camera can't write your images to a locked card.

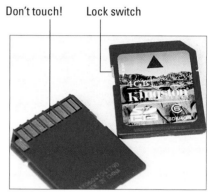

Don't touch! Lock switch

Figure 1-8: Avoid touching the gold contacts on the card.

Exploring External Camera Features

Scattered across your camera's exterior are a number of buttons, dials, and switches that you use to change picture-taking settings, review and edit your photos, and perform various other operations.

Later chapters discuss all your camera's functions in detail and provide the exact steps to follow to access those functions. The next three sections provide a basic road map to the external controls plus a quick introduction to each.

Topside controls

Your virtual tour begins on the top-left side of the camera as if you were holding it, as shown in Figure 1-9.

The items of note here are

✔ **Power switch:** Okay, you probably already figured this one out, but just move the switch to On to fire up the camera and then back to Off to shut it down.

By default, the camera automatically shuts itself off after 30 seconds of inactivity to save battery power. To wake up the camera, press the shutter button halfway or press the Menu, Info, or Playback button. You can adjust the auto shutdown timing via Setup Menu 1, covered later in this chapter.

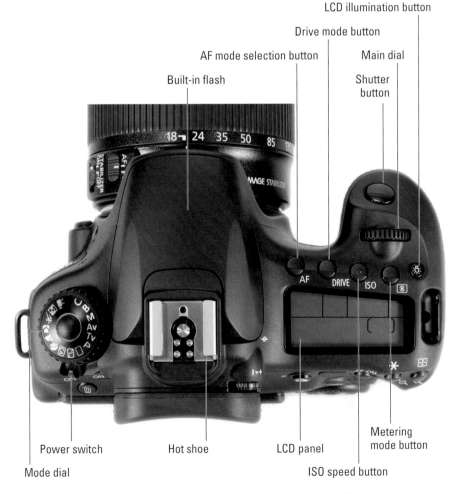

Figure 1-9: The tiny pictures on the Mode dial represent special automatic shooting modes.

✔ **Mode dial:** Rotate this dial to select an *exposure mode,* which determines whether the camera operates in fully automatic, semi-automatic, or manual exposure mode when you take still pictures. To shoot a movie, set the dial to Movie mode.

Canon categorizes the various modes into zones:

- *Image Zone:* The camera offers five Image Zone settings designed to make it easy to automatically capture specific types of scenes: Portrait mode for people photos, Sports mode for action shots, and so on. (Chapter 3 explains all five.)

- *Basic Zone:* The Basic Zone category includes the five Image Zone settings plus Full Auto, Flash Off, and Creative Auto modes, also covered in Chapter 3.

- *Creative Zone:* The Creative Zone category includes the advanced exposure modes, (P, Tv, Av, M, B, and C), which we introduce in Chapter 7. Movie mode is outside the zoning limits, as it stands on its own, with no zone moniker.

✔ **Built-in flash:** This hood houses the built-in flash, also called the *pop-up flash.* When stowed, the flash is tidily protected. Figure 1-10 shows the flash extended. *Note:* You can't use the hot shoe (see next point) with the flash up. The flash also doubles as an autofocus assist beam when the camera has trouble autofocusing in low light conditions.

✔ **Hot shoe:** The *hot shoe* is a metal bracket on which you can affix an external flash (or other hot shoe accessory) securely on top of your camera. (It's called a hot shoe because it's wired to communicate back and forth from the camera using electrical signals.)

Built-in flash

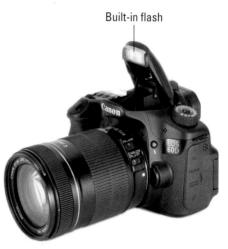

Figure 1-10: The built-in flash extends above the camera when popped up.

Don't go poking around the hot shoe. The flash-sync contacts (the little round metal posts) need to be clean and free of debris to work properly.

The next four buttons are used predominately with the top LCD panel. They provide a tactile way to change their corresponding settings as opposed to using the Quick Control screen and back LCD monitor. Only the first three buttons are active when using Live View (viewing the scene on the back of the camera instead of through the viewfinder), and just the first two work when in Movie mode. For more information on Live View and Movie modes, please turn to Chapter 4.

- **AF mode selection button:** This handy button is an alternate way to select AF mode via the top LCD panel. See Chapter 8 for more information on AF modes.

- **Drive mode button:** This button switches between the various available drive modes, such as single or high-speed continuous. See Chapter 2 for more information.

- **ISO speed button:** This button provides one way to access the camera's ISO speed setting, which determines how sensitive the camera is to light. Chapter 7 details this critical exposure setting.

- **Metering mode button:** Finally, this button gives you a quick way to select from among the camera's different metering modes. See Chapter 7 for more information on metering.

Now, back to our regularly scheduled programming. These controls and displays complete the top of the camera:

- **Main dial:** Just behind the shutter button is a prominent black dial that has the official name *Main dial.* You use this dial when selecting many camera settings (specifics are provided throughout the book). In fact, this dial plays such an important role that you'd think it might have a more auspicious name, like The Really Useful Dial, but Main dial it is.

- **Shutter release button:** You probably already understand the function of this button, too, but see Chapter 3 to discover the proper shutter-button-pressing technique. You'd be surprised how many people mess up their pictures because they press that button incorrectly.

- **LCD panel illumination button:** This tiny little button illuminates the top LCD panel with an amber backlight, making it easy to see in low light conditions. It's much handier than it sounds.

Back-of-the-body controls

Traveling over the top of the camera to its back, you encounter a smorgasbord of buttons — 11, in fact, not including the knob you use to adjust the viewfinder to your eyesight, as discussed later in this chapter, and a few other dials. Figure 1-11 gives you a look at the layout of the backside controls.

Don't let the abundance of buttons intimidate you. Having all those external controls actually makes operating your camera easier. On cameras that have only a few buttons, you have to dig through menus to access the camera features, which is a pain. On the 60D, you can access almost every critical shooting setting on your camera via external buttons, which is much more convenient.

Quick Control button

Info button AF-ON button

Live View/Movie button AE Lock/FE lock/ Index/Reduce button

Erase button Menu button

Dioptric adjustment knob AF Point Selection/ Magnify button

Set button

Playback button Multicontroller

Unlock/Direct Print button

Figure 1-11: Having lots of external buttons makes accessing the camera's functions easier.

Throughout this book, pictures of some of these buttons appear in the margins to help you locate the button being discussed. So even though we provide the official control names in the following list, don't worry about getting all those straight right now. The list is just to get you acquainted with the *possibility* of what you can accomplish with all these features.

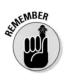

Do note, however, that many of the buttons have multiple names because they serve multiple purposes depending on whether you're taking pictures, reviewing images, recording a movie, or performing some other function. In this book, we refer to these buttons by the first label you see in the following list to simplify things. For example, we refer to the AF Point Selection/Magnify button as the AF Point Selection button. Again, though, the margin icons help you know exactly which button is being described.

And here's another tip: If the label or icon for a button is blue, it indicates a function related to viewing, printing, or downloading images. Labels that indicate a shooting-related function are white, and the sole red label indicates a button purpose related to Live View and movie shooting.

With that preamble out of the way, it's time to explore the camera back, starting at the top-right corner and working westward (well, assuming that your lens is pointing north, anyway):

✔ **Erase button:** Sporting a trash can icon (the universal symbol for delete), use this button to erase pictures from your memory card. Chapter 4 has specifics. In Live View and Movie mode, also covered in Chapter 4, this button is involved in the focusing process.

✔ **Dioptric adjustment knob:** Use this knob to tune the viewfinder to correct for vision problems, if necessary. See the upcoming section, "Adjusting the Viewfinder Focus" for more information.

✔ **Live View/Movie button:** You press this button to shift the camera into Live View mode and, when shooting movies, to start and stop recording. (For the latter, you must first set the Mode dial to Movie mode.) Chapter 4 offers the pertinent details.

✔ **AF-ON button:** Just like pressing the shutter button halfway, pressing this button initiates autofocus. If you don't want to accidentally take a photo when autofocusing (especially when you want to lock focus), use this instead of the shutter button. See Chapter 8 for more information on focus.

✔ **AE Lock/FE Lock/Index/Reduce button:** As you can guess from the official name of this button, it serves many purposes. The first two are related to still-image capture functions: You use the button to lock in the autoexposure (AE) settings and to lock flash exposure (FE). Chapter 8 details both issues. When using Live View and Movie modes, this button serves only as an exposure lock (unless you've customized the button's function, which we discuss in Chapter 11).

This button also serves two image-viewing functions: It switches the display to Index mode, enabling you to see multiple image thumbnails at once, and it reduces the magnification of images when displayed one at a time. Chapter 5 explains Playback, and Chapter 4 covers Live View and Movie modes.

✔ **AF Point Selection/Magnify button:** When you use certain advanced shooting modes, you press this button to specify which of the nine auto-focus points you want the camera to use when establishing focus. Chapter 8 tells you more. In Playback, Live View, and Movie mode, you use this button to magnify the image display (thus the plus sign in the button's magnifying glass icon). See Chapters 4 and 5 for help with that function.

✔ **Menu button:** Press this button to access the camera menus. We discuss navigating menus later in this chapter.

✔ **Info button:** The Shooting Settings display, also covered later in this chapter, appears automatically on the monitor when you turn on the camera. The screen shuts off after a period of inactivity, after which you can bring it back to life by either pressing the Info button or pressing the shutter button halfway and then releasing it.

But that's just the start of the Info button's tricks. If the camera menus are displayed, pressing the button takes you to the Camera Settings display, explained in the upcoming section, "Viewing and Adjusting Camera Settings." In Playback, Live View, and Movie modes, pressing this button changes the picture-display style, as outlined in Chapters 4 and 5.

✔ **Quick Control, or Q, button:** You press this button to enter Quick Control mode. The Quick Control screen varies according to which exposure mode is in use.

✔ **Quick Control dial:** The Quick Control dial surrounds the Set button and the multicontroller (explained in the next bullet). The Quick Control dial offers a handy way to quickly scroll through options and settings. It's a time-saver.

✔ **Set button and multicontroller:** Figure 1-11 points out the Set button and surrounding circular controller, known as the multicontroller. These buttons team up to perform several functions, including choosing options from the camera menus. You use the multicontroller to navigate through menus and then press the Set button to select a specific menu setting. You can find out more about ordering from menus later in this chapter.

You can customize the function of the Set button; Chapter 11 explains how. While you're working with this book, though, stick with the default setup. Otherwise, the instructions we give won't work.

✔ **Unlock/Direct Print button:** This button has two purposes. The first is to unlock the Quick Control dial after you've locked it in the menu system. As the Direct Print button, it's used to print directly from the camera to a compatible printer. For more information on PictBridge, see Chapter 6.

✔ **Playback button:** Press this button to switch the camera into picture-review mode. Chapter 5 details playback features.

Front odds and ends

On the front-left side of the camera body are a few more things of note, labeled in Figure 1-12.

- ✒ **Flash button:** Press this button to bring the camera's built-in flash out of hiding (refer to Figure 1-10) when you use the Creative Zone modes (P, Tv, Av, M, B, or C). See Chapters 2 and 3 for help with using flash in the other exposure modes, and flip to Chapters 7 and 9 for more tips on flash photography.

- ✒ **Lens-release button:** Press this button to disengage the lens from the lens mount so that you can remove it from the camera. See the first part of this chapter for details on mounting and removing lenses.

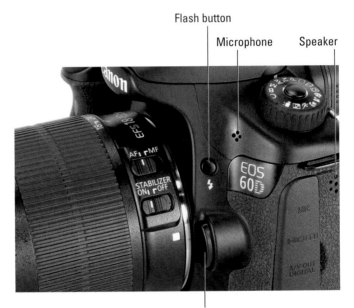

Figure 1-12: Press the Flash button to bring the built-in flash out of hiding.

- ✒ **Microphone/speaker:** Behind these holes (noted in Figure 1-12) is the mono microphone that picks up sound when you're in Movie mode. We labeled the speaker in this figure as well, which plays audio from recorded movies when you're viewing them from the camera.

A couple of sensors and a button are on the right side of the camera, as shown in Figure 1-13:

✐ **Remote control sensor:** Most of the time, you'll unintentionally cover this sensor with your right hand as you grip the camera. When using the Remote Controller RC-6 (or RC-1 or RC-5) wireless remote (these accessories must be bought separately), the sensor detects the signal and controls the camera.

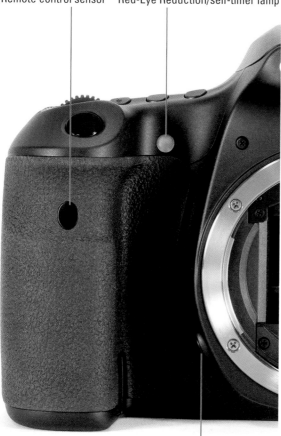

Remote control sensor Red-Eye Reduction/self-timer lamp

Depth-of-field preview button

Figure 1-13: The front right has two sensors and one button.

✔ **Depth-of-field preview button:** When you press this button (hidden near the bottom of the lens), the image in the viewfinder offers an approximation of the depth of field that will result from your selected aperture setting, or f-stop. *Depth of field* refers to how much of the scene will be in sharp focus. Chapter 8 provides details on depth of field, which is an important aspect of your picture composition. Chapter 7 explains aperture and other exposure settings.

✔ **Red-Eye Reduction/self-timer lamp:** When you set your flash to Red-Eye Reduction mode, this little lamp emits a brief burst of light prior to the real flash: the idea being that your subjects' pupils will constrict in response to the light, thus lessening the chances of red-eye. If you use the camera's self-timer feature, the lamp blinks to provide you with a visual countdown to the moment at which the picture will be recorded. See Chapter 2 for more details about Red-Eye Reduction flash mode and the self-timer function.

Adjusting the Viewfinder Focus

Perched on the top-right edge of the viewfinder is a tiny black knob, labeled in Figure 1-14. Officially known as a *dioptric adjustment control,* use this knob to adjust the magnification of the viewfinder to accommodate your eyesight.

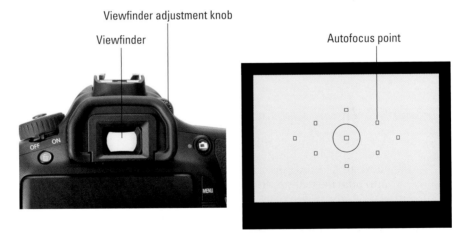

Viewfinder adjustment knob

Viewfinder

Autofocus point

Figure 1-14: Roll the little wheel (knob) to set the viewfinder focus for your eyesight.

Adjusting the viewfinder to your eyesight is critical: If you don't, scenes that appear out of focus through the viewfinder may actually be sharply focused through the lens, and vice versa.

Follow these steps to adjust your viewfinder:

1. **Look through the viewfinder and concentrate on the focusing screen shown on the right side of Figure 1-14.**

 Make sure the lens cap is off.

 The *focusing screen* is the collective name assigned to the group of nine autofocus points that appears in the viewfinder: the little rectangles. One of the little guys is labeled in Figure 1-14. (The circle that surrounds the center autofocus point is related to exposure metering, a subject you can explore in Chapter 7.)

2. **Rotate the dioptric adjustment knob until the autofocus points appear to be in focus.**

 Don't worry about focusing the actual picture now; just pay attention to the sharpness of the autofocus points.

If your eyesight is such that you can't get the autofocus points to appear sharp by using the dioptric adjustment knob, you can buy an additional eyepiece adapter. This accessory, which you affix to the eyepiece, enables further adjustment of the viewfinder display. Prices range from about $15–$30, depending on the magnification you need. Look for an E-series dioptric adjustment lens adapter.

Keep in mind, too, that with the 60D, you can opt to use the LCD monitor instead of the viewfinder to frame and preview your shots. This feature is called *Live View* shooting, which is covered in Chapter 4.

Unfortunately, you can't adjust the focus of the Live View image.

Ordering from Camera Menus

You access many of your camera's features via internal menus, which, conveniently enough, appear on the monitor when you press the Menu button, located atop the upper-left corner of the camera back. Features are grouped into nine menus, described briefly in Table 1-1.

In case you didn't notice, the icons that represent the menus are color coded. Shooting Menus 1 through 4 have red icons, as do the Movie menus; Playback Menus 1 and 2 have a blue symbol; Setup Menus 1, 2, and 3 sport yellow icons; Custom Functions has an orange symbol; and the My Menu icon is green. (Chapter 10 explains the My Menu feature, through which you can create your own, custom menu.)

Table 1-1		Canon EOS 60D Menus
Symbol	**Open This Menu**	**To Access These Functions**
	Shooting Menu 1	Picture Quality settings, Image Review, Red-Eye Reduction flash mode, Flash mode, and a few other basic settings.
	Shooting Menu 2	Advanced photography options: Exposure Compensation, Picture Style, White Balance, and Color Space. Appears only in P, Tv, Av, M, B, and C modes. This menu is dynamic. When a Basic Zone is chosen, the advanced options disappear and are replaced with a few Live View features.
	Shooting Menu 3	Advanced photography options: Dust Delete Data and Auto ISO. Appears only in P, Tv, Av, M, B, and C modes. Doesn't appear when you select a Basic Zone mode.
	Shooting Menu 4	Live View shooting options: Live View, Live View AF mode, grid display, aspect ratio, and so forth. This menu is dynamic. When in a Basic Zone mode, some options appear in Shooting Menu 2.
	Playback Menu 1	Rotate, protect, resize, and erase pictures. functions related to processing and printing directly from the camera.
	Playback Menu 2	Additional playback features: highlight alert, histogram display, rating, image jump, slide shows, and HDMI control.
	Setup Menu 1	Memory card formatting plus basic customization options, such as the file-numbering system and auto shutdown timing.
	Setup Menu 2	More customization options: LCD brightness, date/time, language, and sensor cleaning. Some options available only in Creative Zone modes.
	Setup Menu 3	Battery info, Info button options, user settings, copyright embedding, firmware info, and options for resetting camera functions to factory defaults (very useful if you mess up settings and want to get back to factory specs).
	Custom Functions Menu	Exposure, Image, Autofocus/Drive, and Operations/Others. Also has an option to clear all Custom Functions. This menu appears only when in a Creative Zone mode.

Symbol	Open This Menu	To Access These Functions
☆	My Menu	User-customized menu setup; also available only in Creative Zone modes.
🎬	Movie Menu 1	Movie exposure. Auto Focus mode, choosing AF during movie recording, function of Shutter/AE lock button during movie recording, ISO speed increments, and highlight tone priority when shooting movies. Appears only when Mode dial is set to Movie mode, and replaces Shooting Menus 1–4.
🎬	Movie Menu 2	Movie resolution, sound recording, silent shooting, metering timer, and grid display. Like Movie Menu 1, menu appears only when the Mode dial is set to Movie mode, and replaces Shooting Menus 1–4.
🎬	Movie Menu 3	Exposure compensation when shooting movies, Auto Lighting Optimizer, Picture Style, and White Balance. Menu available only when in Movie mode.

After you press the Menu button, a screen similar to the one shown on the left in Figure 1-15 appears. Along the top of the screen, you see the icons shown in Table 1-1, each representing a menu. (Remember: Which icons appear depends on the setting of the Mode dial.)

The highlighted icon marks the active menu; options on that menu appear automatically on the main part of the screen. In Figure 1-15, Shooting Menu 1 is active, for example.

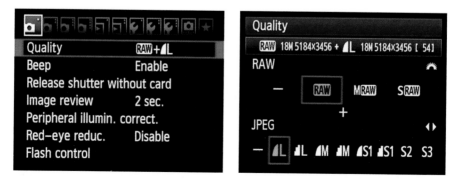

Figure 1-15: Use the multicontroller to navigate menus; press Set to access available settings.

The menu system is dynamic. Many menus don't appear when you shoot in a Basic Zone mode. Others appear only when you're in Movie Mode. Others appear but have different options.

We explain all the important menu options elsewhere in the book; for now, just familiarize yourself with the process of navigating menus and selecting options. After pressing the Menu button to display the menus, use these techniques:

- **To select a different menu:** Press right or left on the multicontroller or rotate the Main dial to cycle through the available menus.

- **To select and adjust a function on the current menu:** Press up or down on the multicontroller or quickly scroll with the Quick Control dial to highlight the feature you want to adjust. On the left side of Figure 1-15, the Quality option is highlighted, for example. Next, press the Set button. Settings available for the selected item then appear either right next to the menu item or on a separate screen, as shown on the right side of the figure. Either way, use the multicontroller to highlight your preferred setting and then press Set again to lock in your choice.

Using the Quick Control Screen

The Quick Control screen is a sort of one-stop shopping locale that displays your camera's shooting settings and enables you to modify them with a minimum of button presses and dial movements. Although it might look complicated, the Quick Control screen shows you what's practically necessary at the time.

And sometimes that's the bare minimum, as shown in the left image of Figure 1-16. In this case, the camera is set to a shooting mode in the Basic Zone. You have a lot less control over the camera in these modes, so the Quick Control screens shows less information.

On the other hand, when you're operating in a Creative Zone mode (right image of Figure 1-16), you see much more.

The real power of the Quick Control screen is that it makes it easy for you to quickly control the camera. The next sections summarize how. The rest of the book goes into more detail for each exposure mode.

Don't confuse the Quick Control screen with the Shooting Settings screen. They are almost identical. The key difference is that you can change settings in Quick Control mode. The Shooting Settings screen is just for looking.

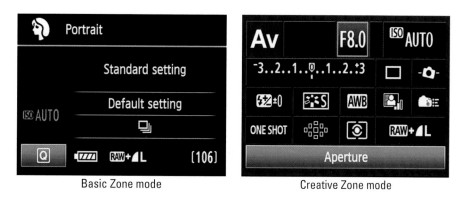
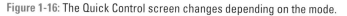

Basic Zone mode Creative Zone mode

Figure 1-16: The Quick Control screen changes depending on the mode.

Using the Quick Control dial

The Quick Control dial (labeled in Figure 1-11) is a great way to make fast selections, whether you're working with the Quick Control Settings screen or the camera's menu system. It's a versatile tool, and we encourage you to use it whenever possible. Here are some of the things it does:

- **Basic Zone modes:** The Quick Control dial does nothing without first pressing Q (lower left; left side of Figure 1-16) and then using the multicontroller to select an option. At that point, you can scroll through the available settings with the Quick Control dial.

- **Creative Zone modes:** When in a Creative Zone mode and the Shooting Settings screen is shown, the Quick Control dial automatically changes exposure compensation in P, Tv, and Av modes. In M mode, using the Quick Control dial changes the f-stop.

 Otherwise, the Quick Control dial makes setting changes when you press Q a second time to enter edit mode. Then, use the multicontroller to select a setting (for example, ISO), and use the Quick Control dial to scroll through options.

- **Playback:** When playing back photos, the Quick Control dial moves one photo forward or reverse, depending on the direction you turn the dial.

- **Menus:** When in the menu system, the Quick Control dial scrolls up and down individual menu items. The multicontroller (or Main dial) moves you from tab to tab.

When in doubt, remember that the Quick Control dial is a fast way to scroll through options or photos.

Locking and unlocking the Quick Control dial

It can be frustrating when you're working in a Creative Zone mode, and you accidentally nudge the Quick Control dial and make a change to a random shutter speed or aperture. That's the bad news. The good news is that you can lock the dial in place when you're in a Creative Zone mode. To lock the Quick Control dial, follow these simple steps:

1. **Set the Mode Dial to a Creative Zone mode.**

 This won't work in any modes in the Basic Zone.

2. **Press Menu and navigate to Setup Menu 2.**

3. **Scroll to Lock, as in the left image of Figure 1-17, and then press Set.**

4. **Choose Enable, as in the right image of Figure 1-17, and then press Set.**

5. **Press Menu to exit the menu.**

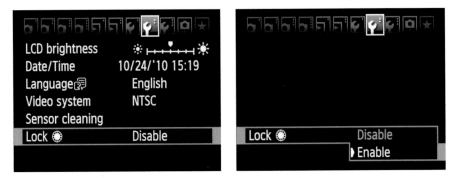

Figure 1-17: Enable Quick Control dial locking in Setup Menu 2.

Now when you're in a Creative Zone mode and you press Q to look at the Quick Control Settings screen, you can't change any settings with the Quick Control dial until you press Q a second time and enter edit mode.

Press Unlock (refer to Figure 1-11) to temporarily unlock the Quick Control dial and make changes. Depending on the mode you're in, rotating the dial (remember, this is before you press Q the second time) changes a different setting. In Av mode, it changes the exposure compensation.

Accessing Custom Functions from the Quick Control screen

From the Quick Control screen, you can change certain shooting settings without using the control buttons (ISO button, the Exposure Compensation button, and so on) or menus.

You can use this technique to adjust settings in any exposure mode, but the settings that are accessible depend on the mode you select. To try it out, set the Mode dial to Tv so that what you see on your screen looks like what you see in the upcoming figures. Then follow these steps:

1. **Display the Shooting Settings screen.**

 Either press the shutter button halfway and then release it, or press the Info button.

2. **Press the Quick Control button.**

 The screen shifts into Quick Control mode, and one of the options on the screen becomes highlighted. The option name also appears at the bottom of the screen, as shown on the left in Figure 1-18, which has the Flash Exposure Compensation setting selected.

3. **Press the multicontroller to move the highlight over the setting you want to adjust.**

 Again, the available options depend on the exposure mode, and Figure 1-18 shows options presented in the Tv (shutter-priority auto-exposure) mode.

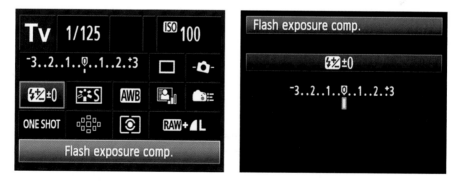

Figure 1-18: Press the Quick Control button to shift to Quick Control mode; the active option appears highlighted.

4. **Adjust the setting.**

In general, you can use either of these two techniques:

- Rotate the Main dial to scroll through the possible settings.

- Press the Set button to display a screen that contains all the possible settings. In some cases, the screen contains a brief explanation or note about the option, as shown on the right in Figure 1-18. You then can choose between rotating the Main dial or pressing the multicontroller to highlight the setting you want to use. Then press Set again to return to the Quick Control screen.

A few controls require a slightly different approach, but don't worry; we spell out all the needed steps throughout the book.

5. **To exit Quick Control mode, press the shutter button halfway and release it, or press the Quick Control button again.**

You return to the normal Shooting Settings display.

Monitoring Critical Camera Settings

Even in the most basic shooting modes, it's important to monitor your 60D settings so that you can take the photos you want to take. Part of your journey as a photographer, whether as a professional or amateur, is learning to understand, monitor, and control all the elements that make a modern digital SLR work. To do that, you keep track of what's happening in your camera by monitoring the critical camera settings, such as shooting mode, mode options, exposure settings, drive, metering, autofocus modes, and so forth.

The 60D has a plethora of tools for you to use to monitor these settings. You can use the tools you want and ignore the rest, or you can learn to use them all. This section takes you through the most important tools and features you use to see how the camera is set up to shoot.

The Info button: Choosing what the screen shows

Press Info to cycle through different displays (as shown in Figure 1-19) to show on the back LCD monitor. To change what you see there, follow these steps:

1. **Navigate to Setup Menu 3 and select the Info button display options.**

2. **Select the items you want to enable with a check and disable the items you want to suppress by clearing the check mark.**

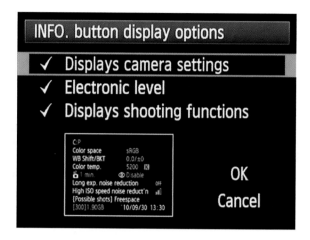

Figure 1-19: Customize the Info button.

Either way, scroll to the item in question and press Set to toggle the check on or off.

Your options are

- *Displays Camera Settings:* Shows camera settings, as discussed later in the chapter.

- *Electronic Level:* Displays the electronic level, which is a helpful tool when you want to make sure the camera is level with the earth. We talk more about the level in Chapter 10.

- *Displays Shooting Functions:* Shows you the current shooting functions. You can turn it off, and still access them by pressing Q and entering Quick Control mode.

3. Highlight OK and press Set to lock in your changes.

Decoding viewfinder data

When the camera is turned on, you can view critical exposure settings and a few other pieces of information in the viewfinder. Just put your eye to the viewfinder and press the shutter button halfway to activate the display. In Live View mode, you use the LCD monitor as viewfinder; the viewfinder is disabled (ditto for Movie mode), so you don't want to be in these modes if you want to get information from the viewfinder. (See Chapter 4 for details about Live View and Movie modes.)

The viewfinder data changes depending on what action you're undertaking and what exposure mode you're using. For example, if you set the Mode dial to P (for programmed autoexposure), you see the basic set of data shown in Figure 1-20: shutter speed, f-stop (aperture setting), exposure compensation setting, and ISO setting. Additional data displays when you enable certain features, such as Flash Exposure Compensation.

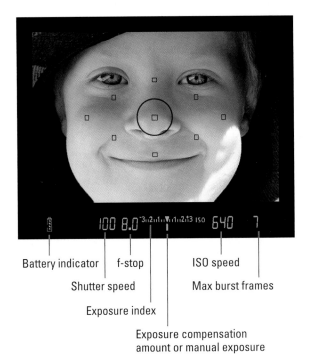

Battery indicator | f-stop | ISO speed

Shutter speed | Max burst frames

Exposure index

Exposure compensation amount or manual exposure

Figure 1-20: Viewing camera information at the bottom of the viewfinder.

Again, we detail each viewfinder readout as we explain your camera options throughout the book. But we want to point out now one often-confused value you may see: The value at the far right end of the viewfinder (7, in Figure 1-20) shows you the number of *maximum burst frames.* This number relates to shooting in the Continuous capture mode, where the camera fires off multiple shots in rapid succession as long as you hold down the shutter button. (Chapter 2 has details on this mode.) Note that although the highest number that the viewfinder can display is 7, the actual number of maximum burst frames may be higher. At any rate, you don't really need to pay attention to the number until it starts dropping toward 0, which indicates that the camera's *memory buffer* (its temporary internal data-storage tank) is filling up. If that happens, just give the camera a moment to catch up with your shutter-button finger.

While you're looking through the viewfinder, you can adjust some shooting settings by using the Main dial. For example, if you're working in Av mode, rotating the Main dial changes the f-stop.

Using the Shooting Settings display

As shown in Figure 1-21, the Shooting Settings display contains the most important critical photography settings: aperture, shutter speed, ISO, and the like. Note that the display is relevant only to regular still-photography shooting, though. When you switch to Live View mode or Movie mode, you can choose to see some settings superimposed over your image in the monitor, but the process of adjusting settings and customizing the display is different. (See Chapter 4 for details.)

The types of data shown in the Shooting Settings display depend on the exposure mode you select. The figure shows data that's included when you work in one of the advanced modes, such as Tv (shutter-priority autoexposure). In the fully automatic modes as well as in Creative Auto mode, you see far fewer settings because you can control fewer settings in those modes. Figure 1-21 labels two key points of data that are helpful in any mode:

✔ **Shots remaining:** This number indicates how many more pictures can fit on your memory card at the current settings. For more information on how size and quality affect the number of photos you can fit onto a memory card, please turn to Chapter 2.

✔ **Battery status:** A "full" battery icon like the one in the figure shows that the battery is fully charged. If the icon appears empty, you better have your spare battery handy if you want to keep shooting.

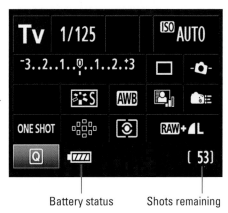

Battery status Shots remaining

Figure 1-21: Monitoring current picture settings.

You can use the Shooting Settings display to both view and adjust certain picture-taking settings. Here's what you need to know:

✔ **Turning on the Shooting Settings display:** The display won't always appear when you turn on the camera and the LCD monitor is visible. It depends what the display was on when you turned off the camera. If you left the Shooting Settings display on, it should reappear. If not, press the Info button until the Shooting Settings display appears (assuming you have it enabled, as discussed earlier). Or, if menus are on the screen, you can press Info or the shutter-button halfway to go back to the Shooting Settings display.

> ✔ **Adjusting settings:** While the Shooting Settings display is active, you can change some shooting settings by rotating the Main dial, the Quick Control dial, or by using the dial in combination with one of the camera buttons.
>
> For example, in the shutter-priority autoexposure mode (Tv, on the Mode dial), rotating the Main dial changes the shutter speed.

Checking the Camera Settings display

In addition to the Shooting Settings display, you can view a collection of additional settings data via the Camera Settings display, as shown in Figure 1-22. This screen is purely an informational tool, however; you can't actually adjust any of the reported settings from this screen.

To display the Camera Settings screen, first display the camera menus by pressing the Menu button. Then press the Info button.

Figure 1-22 shows the settings that you can monitor when shooting in the Creative Zone modes. Again, that's P, Tv, Av, M, B, and C. Here are the details you can glean from the display, with settings listed in the order they appear onscreen.

C:P	
Color space	sRGB
WB Shift/BKT	0,0/±0
Color temp.	5200 🄺
🔋 1 min.	👁 Disable
Long exp. noise reduction	OFF
High ISO speed noise reduct'n	▮▮▯
[Possible shots] Freespace	
[54]1.98GB	10/04/'10 23:20

Figure 1-22: Press the Info button when the menus are active to view this screen.

> ✔ **Camera User Setting mode:** The C: at the top of the screen doesn't refer to computer drive. It's what mode your Camera User Setting mode is based on. The default is P, which is short for Program AE. Both modes are covered in Chapter 7.
>
> ✔ **Color Space:** Tells you whether the camera is capturing images in the sRGB or Adobe RGB color space, an advanced option that you can investigate in Chapter 8.
>
> ✔ **White Balance Shift/Bracketing:** Add this to the list of advanced color options covered in Chapter 8.
>
> ✔ **Color Temp:** Shows you the current manual color temperature, whether or not you have it selected as a white balance option. Chapter 8 has more information on the topic.
>
> ✔ **Auto Power Off and Red-Eye Reduction flash mode:** These two functions share a line onscreen. Notes the time you selected to power-off and whether Red-Eye Reduction flash is enabled.

✔ **Long exposure and High ISO speed noise reduction:** Tell you whether you have noise reduction enabled for these two conditions.

✔ **Possible Shots/Freespace:** Indicates how much storage space remains on your camera memory card. How many pictures you can fit into that space depends on the Quality setting you select. Chapter 2 explains this issue.

✔ **Date/Time:** The section "Setup Menu 2" also explains how to adjust the date and time.

In the Basic Zone modes, much of the information is grayed out, indicating that you can't change it. Of course, with the exception of the Freespace value, you also can simply go to the menu that contains the option in question to check its status. The Camera Settings display just gives you a quick way to monitor some of the critical functions without having to hunt through menus.

Checking out the top LCD panel

Another way for you to keep track of shooting information on your 60D is through the LCD panel on the top side of the camera, as shown in Figure 1-23. This panel provides a lot of information although it's presented differently than the viewfinder or LCD monitor.

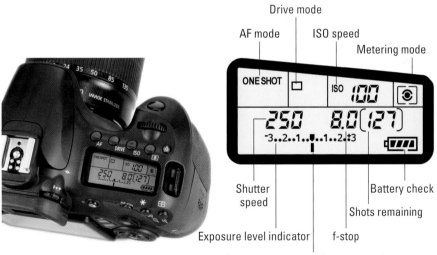

Figure 1-23: The top LCD panel is another useful situational awareness tool.

As you can see from the figure, the panel is divided into five areas. Depending on how you have the camera set up, you'll see currently selected options or settings displayed in the various sections of the panel. For example, in the top-left corner devoted to the AF mode, you'll see One Shot, AI Focus, AI Servo, or M Focus, depending on what AF mode you're in. (See Chapter 8 for more information on setting AF modes.)

The top display line corresponds to the four buttons described in the earlier section, "Topside controls." Use the four buttons in front of the LCD panel (AF, Drive, ISO, and Metering; refer to Figure 1-9) to quickly make important focus, drive, exposure, and metering decisions while looking at the panel.

The bottom area of the LCD panel is devoted to displaying other information, with a heavy emphasis on the camera's current exposure settings, such as the shutter speed and f-stop.

Reviewing Basic Setup Options

One of the many advantages of investing in the Canon EOS 60D is that you can customize its performance to suit the way *you* like to shoot. Later chapters explain options related to actual picture taking, such as those that affect flash behavior and autofocusing. The rest of this chapter details options related to initial camera setup, explaining how to accomplish such things as setting the date and time, setting up the camera's file-numbering system, and adjusting monitor brightness.

Setup Menu 1

At the risk of being conventional, start your camera customization by opening Setup Menu 1, shown in Figure 1-24.

Here's a quick rundown of each menu item:

- **Auto Power Off:** To help save battery power, your camera automatically powers down after a certain period of inactivity. By default, the shutdown happens after 30 seconds, but you can change the shutdown delay to 1, 2, 4, 8, or 15 minutes. Or you can disable auto shutdown altogether by selecting the Off setting.

- **Auto Rotate:** If you enable this feature, your picture files include a piece of data that indicates whether the camera was oriented in the vertical or horizontal position when you shot the frame. Then, when you view the picture on the camera monitor or on your computer, the image is automatically rotated to the correct orientation.

To automatically rotate images both in the camera monitor and on your computer monitor, stick with the default setting. In the menu, this setting is represented by On followed by a camera icon and a monitor icon, as shown in Figure 1-24. If you want the rotation to occur just on your computer and not on the camera, select the second On setting, which is marked with the computer monitor symbol but not the camera symbol. To disable rotation for both devices, choose the Off setting.

Auto power off	1 min.
Auto rotate	On 🖰 🖵
Format	
File numbering	Continuous
Select folder	

Figure 1-24: Options on Setup Menu 1 deal mainly with basic camera behavior.

Note, though, that the camera may record the wrong orientation data for pictures that you take with the camera pointing directly up or down. Also, whether your computer can read the rotation data in the picture file depends on the software you use; the programs bundled with the camera can perform the auto rotation.

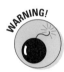

✔ **Format:** The first time you insert a new memory card, use this option to *format* the card, a maintenance function that wipes out any existing data on the card and prepares it for use by the camera.

If you used your card in another device, such as a digital music player, be sure to copy those files to your computer before you format the card. You lose *all* data on the card when you format it, not just picture files.

When you choose the Format option from the menu, you can opt to perform a normal card formatting process or a *low-level* formatting. The latter gives your memory card a deeper level of cleansing than ordinary formatting and thus takes longer to perform. Normally, a regular formatting will do.

✔ **File Numbering:** This option controls how the camera names your picture files.

- *Continuous:* This is the default; the camera numbers your files sequentially, from 0001 to 9999, and places all images in the same folder. The initial folder name is 100Canon; when you reach image 9999, the camera creates a new folder, named 101Canon, for your next 9,999 photos. This numbering sequence is retained even if you change memory cards, which helps to ensure that you don't wind up with multiple images that have the same filename.

- *Auto Reset:* If you switch to this option, the camera restarts file numbering at 0001 each time you put in a different memory card. This isn't a good idea, for the reason we just stated.

Whichever option you choose, beware of one gotcha: If you swap memory cards and the new card already contains images, the camera may pick up numbering from the last image on the new card, which throws a monkey wrench into things. To avoid this problem, format the new card before putting it into the camera. (See the earlier Format bullet point for details.)

- *Manual Reset:* Select this setting if you want the camera to begin a new numbering sequence, starting at 0001, for your next shot. The camera then returns to whichever mode you previously used (Continuous or Auto Reset).

✓ **Select Folder:** Press this to select a new folder on your memory card.

Setup Menu 2

Setup Menu 2, as shown in Figure 1-25, offers an additional batch of customization options:

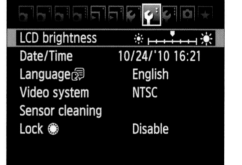

Figure 1-25: Setup Menu 2 offers more ways to customize basic operations.

✓ **LCD Brightness:** Make the camera monitor brighter or darker. After highlighting the option on the menu, as shown in Figure 1-25, press the Set button to display a screen similar to what you see in Figure 1-26. The camera displays a picture from your memory card; if the card is empty, you see a black box instead. Use the Quick Control dial or press right or left on the multicontroller to adjust the brightness setting. Press Set to finish the job and return to the menu.

What you see on the display may not be an accurate rendition of the actual exposure of your image. Crank up the monitor brightness, for example, and an underexposed photo may look just fine. Keeping the brightness at its default center position, as shown in Figure 1-26, is a good idea unless you're shooting in

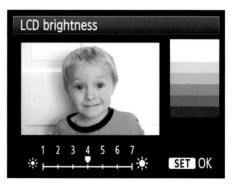

Figure 1-26: Adjust the brightness of the camera monitor.

very bright or dark conditions. As an alternative, you can gauge exposure by displaying a histogram tool, which we explain in Chapter 5, when reviewing your images.

✔ **Date/Time:** When you turn on your camera for the very first time, it automatically displays this option and asks you to set the date and time.

Keeping the date/time accurate is important because that information is recorded as part of the image file. In your photo browser, you can then see when you shot an image and, equally handy, search for images by the date they were taken. Chapter 5 shows you where to locate the date/time data when browsing your picture files.

✔ **Language:** Set the language of text displayed on the camera monitor. Screens in this book display the English language, but we find it entertaining on occasion to hand our camera to a friend after changing the language to, say, Swedish. We're real yokesters, yah?

If you change your language (intentionally or by accident) to something freaky, you'll appreciate the little speech bubble icon next to the Language setting for those times when you can't read the word for *Language.*

✔ **Video System:** This option is related to viewing your images and movies on a television, a topic we cover in Chapter 9. Select NTSC if you live in North America or other countries that adhere to the NTSC video standard; select PAL for playback in areas that follow that code of video conduct.

✔ **Sensor Cleaning:** Highlight this option and press the Set button to access some options related to the camera's internal sensor-cleaning mechanism. These work like so:

 • *Auto Cleaning:* By default, the camera's sensor-cleaning mechanism activates each time you turn the camera on and off. This process helps keep the image sensor — which is the part of the camera that captures the image — free of dust and other particles that can mar your photos. You can disable this option, but it's hard to imagine why you would choose to do so.

 • *Clean Now:* Select this option and press Set to initiate a cleaning cycle.

 • *Clean Manually:* In the advanced exposure modes (P, Tv, Av, M, B, and C), you can access this third option, which prepares the camera for manual cleaning of the sensor. We don't recommend this practice; sensors are delicate, and you're really better off taking the camera to a good service center for cleaning.

✔ **Lock:** As we mention earlier, this menu locks the Quick Control dial when in a Creative Zone mode.

Setup Menu 3

Setup Menu 3, shown in Figure 1-27, contains the following offerings (some of which are not available in all modes).

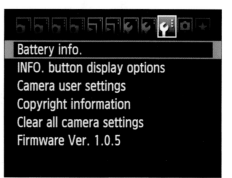

Figure 1-27: To display most options in Setup Menu 3, you must set the Mode dial to a Creative Zone mode.

- ✔ **Battery Info:** Press to see battery information. There's more here than you might think. You'll see what type of battery you have in the camera (or if you're connected to the power grid), how much power you have left (as a percentage), the number of photos you've taken on this battery, and the battery's recharge performance. Not bad!

- ✔ **Info Button Display Options:** As we mention earlier, control the screens you see after pressing Info.

- ✔ **Camera User Settings:** As we explain in Chapter 10, register and clear camera user settings.

- ✔ **Copyright Information:** Also explained in Chapter 10, embed copyright information in the image metadata.

- ✔ **Clear All Camera Settings:** Restore the default shooting settings.

- ✔ **Firmware Version:** This screen tells you the version number of the camera firmware (internal operating software). At the time of publication, the current firmware version was 1.0.5.

Keeping your camera firmware up to date is important, so visit the Canon Web site (www.canon.com) regularly to find out whether your camera sports the latest version. Follow the instructions given on the Web site to download and install updated firmware if needed.

More customization options

Shooting Menu 1 (covered briefly earlier in the chapter), shown in Figure 1-28, offers two more basic setup options:

- ✔ **Beep:** By default, your camera beeps after certain operations, such as after it sets focus when you use autofocusing. If you're doing top-secret surveillance and need the camera to hush up, set this option to Off.

✔ **Release Shutter without Card:**
Setting this option to Disable
prevents shutter-button release
when no memory card is in
the camera. If you turn on the
option, you can take a picture
and then review the results for
a few seconds in the camera
monitor. The image isn't stored
anywhere, however; it's only
temporary.

Quality	RAW+◢L
Beep	Enable
Release shutter without card	
Image review	2 sec.
Peripheral illumin. correct.	
Red–eye reduc.	Enable
Flash control	

Figure 1-28: You can silence the camera via
Shooting Menu 1.

If you're wondering about
the point of this option, it's
designed for use in camera
stores, enabling salespeople to
demonstrate cameras without having to keep a memory card in every
model. Unless that feature somehow suits your purposes, keep this
option set to Disable.

Adding a final level of customization choices, the My Menu feature does just
what its name implies: You can create a personalized menu that contains up
to six functions from the existing menus. Then, instead of hunting through all
the other menus to find settings that you use frequently, you can access the
settings quickly just by displaying My Menu. Chapter 10 shows you how to
take advantage of this terrific feature that eliminates burrowing down
through menus to find settings.

2

Choosing Basic Picture Settings

In This Chapter

▶ Spinning the Mode dial

▶ Changing the shutter-release mode

▶ Adding flash

▶ Understanding the Quality setting (resolution and file type)

*E*very camera manufacturer strives to provide a good out-of-box experience — that is, to ensure that your first encounter with the camera is a happy one. To that end, the camera's default (initial) settings are selected to make it as easy as possible for you to take a good picture the first time you press the shutter button.

On the 60D, the default settings ensure that the camera works about the same way as any automatic, point-and-shoot camera you may have used in the past: You frame the subject in the monitor, press the shutter button halfway to focus, and then press the button the rest of the way to take the shot.

Although you can get a good picture using the default settings in many cases, they're not designed to give you the optimal results in every shooting situation. Rather, they're established as a one-size-fits-all approach to using the camera. You may be able to use the defaults to take a decent portrait, for example, but will probably need to tweak a few settings to capture fast action. And adjusting a few options can also help you turn that decent portrait into a stunning one, too.

So that you can start fine-tuning camera settings to your subject, this chapter explains the most basic picture-taking options, such as the exposure mode, shutter-release mode (also called drive), and the picture quality. They're not the sexiest or most exciting options to explore (don't think we didn't notice you stifling a yawn), but they make a big difference in how easily you can capture the photo you have in mind. You also need to understand this core group of camera settings to take best advantage of all the advanced color, focus, and exposure controls covered in Part III of the book.

Choosing an Exposure Mode

The very first picture-taking setting to consider is the exposure mode, which you select via the Mode dial, labeled in Figure 2-1. Your choice determines how much control you have over two critical exposure settings — aperture and shutter speed — as well as many other options, including those related to color and flash photography. To change the mode, press down on the Mode dial lock-release button, also labeled in the figure, while turning the dial.

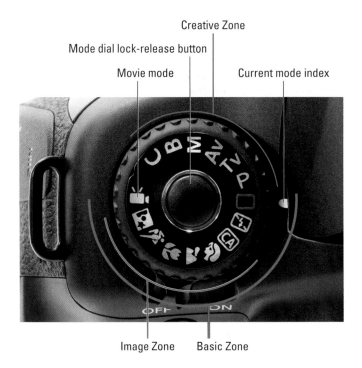

Figure 2-1: To change the exposure mode, press the Mode dial lock-release button while rotating the dial.

Canon categorizes the various modes as follows:

- **Basic Zone:** The Basic Zone category includes the following point-and-shoot modes:

 - *Full Auto*: This is the most basic of the camera's modes; the camera determines what type of scene you're trying to capture and handles everything but framing and focusing for you.

 - *Flash Off*: This one works just like Full Auto except that the flash is disabled.

 - *Creative Auto*: This mode is like Full Auto on steroids, giving you an easy way to tweak some picture qualities, such as how much the background blurs.

 - *Image Zone modes:* This subgroup includes five modes that are geared to capturing specific types of scenes: Portrait, Landscape, Close-up, Sports, and Night Portrait.

 Chapter 3 tells you how to get the most out of all these modes, but be forewarned: To remain easy to use, all these automatic modes prevent you from taking advantage of most of the camera's exposure, color, and focusing controls. You can still adjust the options discussed in this chapter, but the camera takes control of most everything else.

- **Creative Zone:** When you're ready to take full control over the camera, step up to one of the Creative Zone modes. This category includes the advanced exposure modes (P, Tv, Av, and M), which we detail in Chapter 7. In addition, this zone offers B mode, which stands for *bulb*. With a bulb exposure, the shutter stays open as long as you keep the shutter button pressed; this option is handy for shooting fireworks and other special subjects where you want to control exposure time "on the fly" rather than dialing in a specific shutter speed between shots (covered in Chapter 7). This zone also offers C mode, which is a custom mode you can create using your own favorite settings. Chapter 10 explains how to register the settings you want to use in C mode.

- **Movie:** Movie mode is outside the zoning limits, as it stands on its own, with no zone moniker.

Keeping track of all these *zones* (groupings of modes) is a little confusing, especially because the modes in the Image Zone category are often referred to generically in photography discussions as *creative scene modes* or *creative modes.* So, to keep things straight, we capitalize Canon's convention of grouping what we might call *advanced exposure modes* into something called the Creative Zone. By the same token, we will often refer to *automatic exposure modes* by Canon's term, Basic Zone modes. When necessary, we use the full name to identify the Creative Auto mode, which straddles the line between fully automatic and advanced.

One very important and often misunderstood aspect about the exposure modes: Although your access to exposure and color controls, as well as to some other advanced camera features, depends on the setting of the Mode dial, it has *no* bearing on your *focusing* choices. You can choose from manual focusing or autofocusing in any mode, assuming that your lens offers autofocusing. (Chapter 1 shows you how to set the lens to manual or autofocusing.)

All exposure modes are found on the Mode dial. Change modes by depressing and holding down the center of the Mode dial to unlock it while turning the knob to the mode of your choice. There is *no other way* to change exposure modes.

Changing the Drive Mode

In Drive mode, you tell the camera what to do when you press the shutter button: Record a single frame or a series of frames, or record one or more shots after a short delay.

Your camera offers the following Drive mode settings, which are represented by the symbols you see in the margin:

- ✔ **Single:** This setting, which is the default for Creative Auto and all fully automatic modes except Portrait and Sports, records a single image each time you press the shutter button. In other words, this is normal photography mode.

- ✔ **Continuous:** Sometimes known as *burst mode,* this mode records a continuous series of images as long as you hold down the shutter button. You can choose from two burst-mode settings:

 - *High-speed continuous:* At this setting, the camera can capture a maximum of about 5.3 frames per second (fps).

 - *Low-speed continuous:* This setting drops the maximum capture rate to about 3 fps.

Why would you want to capture fewer than the maximum number of shots? Well, frankly, unless you're shooting something that's moving at a really, really fast pace, not too much is going to change between frames when you shoot at 5-plus fps. So when you set the burst rate that high, you typically just wind up with lots of shots that show the exact same thing, wasting space on your memory card.

A couple of other continuous-mode pointers:

 - The actual number of frames you can record per second depends in part on your shutter speed. At a slow shutter speed, the camera may not be able to reach the maximum frame rate. (See Chapter 7 for an explanation of shutter speed.)

- Some other functions can slow down the continuous capture rate. For example, when you use flash or enable the High ISO Noise Reduction feature (explained in Chapter 6), you typically can't achieve the highest burst rate. The speed of your memory card also plays a role in how fast the camera can capture images. In other words, consider 5.3 shots per second a best-case scenario.

 ✓ **10-Second Self-Timer/Remote Control:** Want to put yourself in the picture? Select this mode, depress the shutter button, and run into the frame. You have about 10 seconds to get yourself in place and pose before the image is recorded.

 You can also use the self-timer function to avoid any possibility of camera shake. The mere motion of pressing the shutter button can cause slight camera movement, which can blur an image. Put the camera on a tripod and then activate the self-timer function. This enables "hands-free" — and therefore motion-free — picture taking. This is great for close-up or macro work in which camera shake is magnified. Anything that magnifies the subject also magnifies camera shake, including the use of telephoto lenses and shooting close-ups, where small subjects are rendered large on the sensor.

As another alternative, you can purchase one of the optional remote-control units sold by Canon. You can opt for either a wireless unit or one that plugs into the remote-control terminal on the left side of the camera. Either way, set the Drive mode to this option or the following one when you want to trigger the shutter release button with the remote control.

 ✓ **2-Second Self-Timer/Remote Control:** This mode works just like the regular Self-Timer/Remote Control mode, but the capture happens just two seconds after you fully press the shutter button. Unfortunately, this mode isn't available to you in the fully automatic exposure modes or Creative Auto mode; you can choose this option only in certain Creative Zone modes (P, Tv, Av, M, or C).

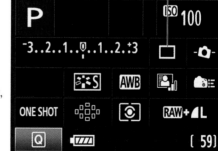

Figure 2-2: The Drive mode icon.

To check the current Drive mode, display the Shooting Settings screen. The Drive mode icon appears in the area labeled in Figure 2-2.

If you want to use a different mode, you have two options:

✐ **The Drive button:** The easiest way to change Drive mode is to press the Drive button on the top of the camera. The available modes are displayed on the LCD monitor on the back of the camera, as shown in Figure 2-3. Scroll through the options by using the Main dial, the Quick Control dial, or the multicontroller. Press the Drive button or Set to return the monitor to its previous state.

✐ **The Quick Control screen:** First, display the Shooting Settings screen; press the Info button a few times to scroll through the other displays and get to the Shooting Settings screen. Now press the Quick Control button to shift to Quick Control mode and use the multicontroller to highlight the Drive mode icon, as shown on the left in Figure 2-3. The name of the current setting appears at the bottom of the screen. Rotate the Main dial to cycle through the available Drive mode options.

Alternatively, highlight the Drive mode icon and then press the Set button. You then see a screen showing all the possible settings (the right side of Figure 2-3.) Press right or left on the multicontroller or rotate the Main dial to highlight your Drive mode of choice. Finally, press the Set button to lock in the setting.

Again, you can access all five Drive mode options *only* in the advanced exposure modes (P, Tv, Av, M, and C). In all other modes, your choices are more limited.

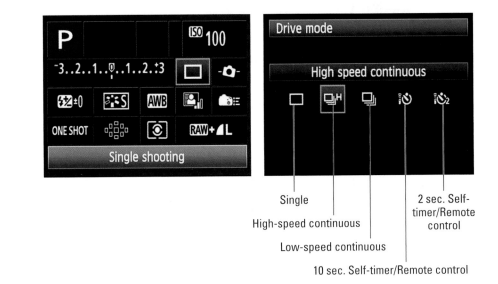

Figure 2-3: Access all these Drive options only in advanced exposure modes.

Your selected Drive mode remains in force until you change it or switch to an exposure mode for which the selected Drive mode isn't available.

Using the Flash

The built-in flash on your 60D offers an easy, convenient way to add light to a too-dark scene. For even more lighting power, you can attach an external flash head to the *hot shoe,* which is the bracket-like contact on top of the camera, shown in Figure 2-4.

Built-in flash Hot shoe

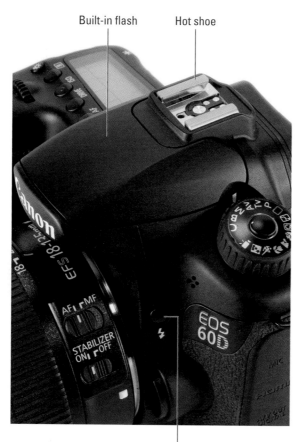

Flash button

Figure 2-4: In the P, S, A, and M exposure modes, press the Flash button to raise the built-in flash.

Because the features of external flash heads vary from model to model, this book concentrates on making the best use of the built-in flash. If you need help using an external flash, though, one of the best places to start is the Web

site www.strobist.com, which is loaded with flash photography tips and techniques. (*Strobe* is another word for *flash.*) Canon also offers many resources on the subject at its Web site, www.canon.com.

The next two sections provide the fundamentals of using the built-in flash; Chapter 7 discusses more advanced aspects of flash photography with the 60D.

Exploring basic flash modes

Your built-in flash has three basic modes of operation, which are represented by the icons shown in the margin:

- **Auto flash:** The camera decides when to fire the flash, basing its decision on the lighting conditions.

- **On:** The flash fires regardless of the lighting conditions. You may hear this flash mode referred to as *force* flash because the camera is forced to trigger the flash even if its exposure brain says there's plenty of ambient light. This flash mode is sometimes also called *fill* flash because it's designed to fill in shadows that can occur even in bright light.

- **Off:** The flash does not fire, no way, no how.

As with most everything else on your camera, which settings are available to you depends on the exposure mode you choose. Here's how things shake out:

- **Full Auto, Portrait, Close-Up, and Night Portrait:** Auto flash is used in these modes; you can't control whether the flash fires. However, you can set the flash to Red-Eye Reduction flash mode if you want. See the next section for the pros and cons of Red-Eye Reduction flash.

- **Landscape, Sports, and Flash Off modes:** Flash is disabled.

 Disabling flash in the Flash Off mode makes sense, of course. But why no flash in Sports and Landscape mode, you ask? Well, Sports mode is designed to enable you to capture moving subjects, and the flash can make that more difficult because it needs time to recycle between shots. On top of that, the maximum shutter speed that's possible with the built-in flash is 1/250 second, which often isn't fast enough to ensure a blur-free subject. Finally, action photos usually aren't taken at a range close enough for the flash to reach the subject, which is also the reason why flash is disabled for Landscape mode.

- **Creative Auto:** In this mode, you can choose from all three flash settings, and you can enable Red-Eye Reduction flash as well. See Chapter 3 for details on how to select the flash mode you want to use in Creative Auto mode.

✓ **P, Tv, Av, M, B (bulb), and C (custom):** In these modes, you don't actually choose a flash mode. Instead, you simply press the Flash button on the side of the camera to pop up the built-in flash when you want that extra burst of light and close the flash unit when you want to go flash free. You also have access to some advanced flash options, such as Flash Exposure Compensation, which enables you to vary the flash intensity. In C mode, flash settings depend on what you previously registered. See Chapter 7 for the complete story on using flash in these exposure modes. Chapter 10 shows you how to create a custom exposure mode.

The viewfinder displays the following symbols to alert you to the flash status:

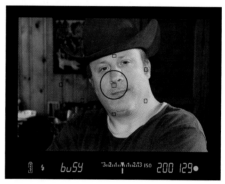

✓ **Flash On:** A little lightning bolt like the one you see in the lower-left corner of Figure 2-5 tells you that the flash is enabled.

✓ **Flash Recycling:** If you see the word "Busy" along with the lightning bolt, as shown in Figure 2-5, the flash needs a few moments to recharge. When the flash is ready to go, the "Busy"

Figure 2-5: A Busy signal means that the flash is recharging.

message disappears. Flash Recycling status also appears in the LCD panel.

Using Red-Eye Reduction flash

For any exposure mode that permits flash, you can enable a Red-Eye Reduction feature. When you turn on this feature, the Red-Eye Reduction lamp on the front of the camera lights up when you press the shutter button halfway. The purpose of this light is to attempt to shrink the subject's pupils, which helps reduce the chances of red-eye. The flash itself fires when you press the shutter button the rest of the way.

To enable Red-Eye Reduction, head to Shooting Menu 1. Select Red-Eye Reduc, as shown on the left in Figure 2-6, and press the Set button to display the second screen in the figure. Highlight Enable and press Set again. To turn off Red-Eye Reduction, just return to the menu and set the option to Disable.

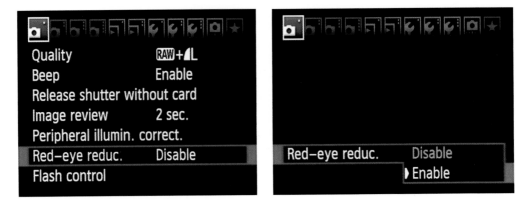

Figure 2-6: Turn Red-Eye Reduction flash mode on and off via Shooting Menu 1.

The viewfinder and Shooting Settings display don't offer any indication that Red-Eye Reduction is enabled. However, you can check the setting by pressing the Menu button and looking at the menu status or by pressing the Info button until the Camera Settings display appears; look for the little eyeball icon and the word *Enable* or *Disable,* shown in Figure 2-7.

After you press the shutter button halfway in Red-Eye Reduction flash mode, a row of vertical bars appears in the center of the viewfinder display, just to the left of the ISO value. A few moments later, the bars turn off one by one. For best results, wait until all the bars are off to take the picture. (The delay gives the subject's pupils time to constrict in response to the Red-Eye Reduction lamp.)

Figure 2-7: Check the Red-Eye Reduction status in the Camera Settings screen as well as in the menu.

Controlling Picture Quality

Almost every review of the 60D contains glowing reports about the camera's top-notch picture quality. As you've no doubt discovered for yourself, those claims are true, too: This baby can create large, beautiful images.

Getting the maximum output from your camera, however, depends on choosing the right capture settings. Chief among them, and the topic of this chapter, is the appropriately named Quality setting. This critical control

determines two important aspects of your pictures: *resolution,* or pixel count; and *file format,* which refers to the type of computer file the camera uses to store your picture data.

Resolution and file format both play a large role in the quality of your photos, so selecting from the Quality settings on your camera is an important decision. Why not just dial in the setting that produces the maximum quality level and be done with it? Well, that's the right choice for some photographers. But because choosing that maximum setting has some disadvantages, you may find that stepping down a notch or two on the quality scale is a better option, at least for some pictures.

To help you figure out which Quality setting meets your needs, the rest of this chapter explains exactly how resolution and file format affect your pictures. Just in case you're having quality problems related to other issues, though, the first section of the chapter provides a handy quality-defect diagnosis guide.

Diagnosing quality problems

When we use the term *picture quality,* we're not talking about the composition, exposure, or other traditional characteristics of a photograph. Instead, we're referring to how finely the image is rendered in the digital sense.

Figure 2-8 illustrates the concept: The first example is a high-quality image, with clear details and smooth color transitions. The other examples show five common digital-image defects. You may want to open photos in photo editing software and zoom in. Some defects have a similar appearance unless magnified.

Each defect is related to a different issue, and only two are affected by the Quality setting. So if you aren't happy with your image quality, first compare your photos with those in the figure to properly diagnose the problem. Then try these remedies:

- ✔ **Pixelation:** When an image doesn't have enough *pixels* (the colored tiles used to create digital images), details aren't clear, and curved and diagonal lines appear jagged. The fix is to increase image resolution, which you do via the Quality setting. See the upcoming section, "Considering Resolution: Large, Medium, or Small?" for details.

- ✔ **JPEG artifacts:** The "parquet tile" texture and random color defects that mar the third image in Figure 2-8 can occur in photos captured in the JPEG (*jay*-peg) file format, which is why these flaws are referred to as *JPEG artifacts.* This defect is also related to the Quality setting; see the "Understanding File Type (JPEG or Raw)" section, later in this chapter, to find out more.

- ✔ **Noise:** This defect gives your image a speckled look, as shown in the lower-left example in Figure 2-8. Noise is most often caused by a high ISO setting (an exposure control) or by long exposure times (shutter speeds

longer than one second). Chapter 7 explores these topics in detail. To adjust shutter speed or ISO, you must switch to one of the advanced exposure modes (P, Tv, Av, B, M, or C).

✓ **Color cast:** If your colors are seriously out of whack, as shown in the lower-middle example in Figure 2-8, try adjusting the camera's White Balance setting. Chapter 8 covers this control and other color issues. Note, though, that you also must use an advanced exposure mode to adjust white balance.

✓ **Lens/sensor dirt:** A dirty lens is the first possible cause of the kind of defects you see in the last example in Figure 2-8. If cleaning your lens doesn't solve the problem, dust or dirt may have made its way onto the camera's image sensor. See the sidebar "Maintaining a pristine view," elsewhere in this chapter, for information on safe lens and sensor cleaning.

High quality Pixelation JPEG artifacts

Noise Color cast Lens/sensor dirt

Figure 2-8: Refer to this symptom guide to determine the cause of poor image quality.

We took some mild image processing liberties to exaggerate the flaws in our example images to make the symptoms easier to see. With the exception of an unwanted color cast or a big blob of lens or sensor dirt, these defects may not even be noticeable unless you print or view your image at a very large size. And the subject matter of your image may camouflage some flaws; most people probably wouldn't detect a little JPEG artifacting in a photograph of a densely wooded forest, for example.

In other words, don't consider Figure 2-8 as an indication that your camera is suspect in the image quality department. First, *any* digital camera can produce these defects under the right circumstances. Second, by following the guidelines in this chapter and the others mentioned in the preceding list, you can resolve any quality issues that you may encounter.

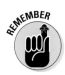

Decoding the Quality options

Your camera's Quality setting determines both the image resolution and file format of the pictures you shoot. To access the control, you can go two routes:

- ✓ **Quick Control screen:** After displaying the Shooting Settings screen, press the Quick Control button and use the multicontroller to highlight the Quality option, as shown on the left in Figure 2-9. You can then rotate the Main dial or Quick Control dial to cycle through the available Quality settings. Or, if you prefer, press the Set button to display the screen shown on the right in Figure 2-9, which contains all the possible Quality options. This time, use the Main dial to change Raw settings, and the Quick Control dial or the multicontroller to highlight the JPEG setting you want to use. Press Set to wrap up things.

- ✓ **Shooting Menu 1:** Press the Menu button and then display Shooting Menu 1, as shown on the left in Figure 2-10. Highlight Quality and press the Set button to display the screen you see on the right in the figure. Use the controls as just described to highlight the options you want to use and then press Set.

If you're new to digital photography, the Quality settings won't make much sense to you until you read the rest of this chapter, which explains format and resolution in detail. But even if you're schooled in those topics, you may need some help deciphering the way that the settings are represented on your camera. As you can see from Figures 2-9 and 2-10, the options are presented in rather cryptic fashion, so here's your decoder ring:

- ✓ The Quick Settings screen has three areas of information (separated by labels) that describe the currently selected Quality setting. The top area has the *resolution,* or total pixel count (measured in megapixels, MP), for the types of photos you have enabled (raw or JPEG); the horizontal and vertical pixel count; and the number of subsequent shots you can fit

on your current memory card if you select that Quality setting. We label these in Figure 2-9. The other two areas identify possible Raw and JPEG settings and highlight your choices. A dash indicates that you don't want to save those file types. (The Main dial and arrow icons to the right of the file types is a reminder to use those controls to change settings.) The next section explains pixels and megapixels, if you're new to the game.

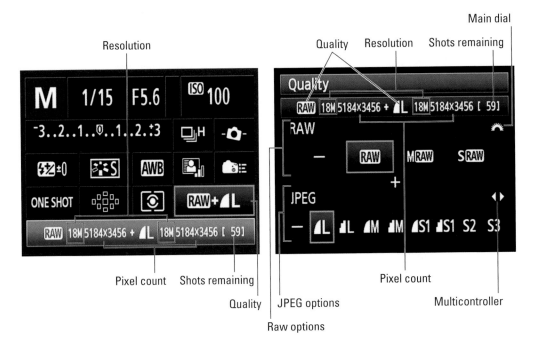

Figure 2-9: You can change the Quality setting in seconds by using the Quick Control screen.

Figure 2-10: You also can select the Quality option via Shooting Menu 1.

✔ This same informational bar (indeed, it's the same screen except for the color differences) appears at the top of the screen when you change the setting via Shooting Menu 1 or press Set after highlighting the Quality option on the Quick Settings screen. (See the right screens in Figures 2-9 and 2-10.) The next two rows of both screens show icons representing the eight Quality settings.

✔ Settings on the bottom row of these screens capture images in the JPEG file format. The little arc-like icons represent the level of JPEG *compression,* which affects picture quality and file size. You get two JPEG options: Fine and Normal. The smooth arcs represent the Fine setting; the jagged arcs represent the Normal setting. Check out the upcoming section "JPEG: The imaging (and Web) standard" for details.

✔ Within the JPEG category, you can choose from five resolution settings, represented by L, M, S1, S2, and S3 (large, medium, and three levels of small). See the next section for information that helps you select the right resolution.

✔ The Quality settings in the middle row enable you to capture images in the Raw file format. Raw files have three resolution settings: L (which is unlabeled, but has the maximum pixel count), M, and S. One of the two Raw settings also records a JPEG Fine version of the image, also at the maximum (Large) resolution. The upcoming section "Raw (CR2): The purist's choice" explains the benefits and downsides to using the Raw format.

Which Quality option is best depends on several factors, including how you plan to use your pictures and how much time you care to spend processing your images on your computer. The rest of this chapter explains these and other issues related to the Quality settings.

Considering Resolution: Large, Medium, or Small?

To decide upon a Quality setting, the first decision you need to make is how many pixels you want your image to contain. *Pixels* are the little square tiles from which all digital images are made; *pixel* is short for *pic*ture *el*ement. You can see some pixels close up in the right image in Figure 2-11, which shows a greatly magnified view of the eye area in the left image (which was converted to S3 size to prove the point).

The number of pixels in an image is referred to as its *resolution.* Your camera offers five resolution levels, which are assigned the generic labels Large, Medium, and Small (1–3) and are represented on the list of Quality settings

by the initials L, M, and S (1–3). Table 2-1 shows you the pixel count that results from each option. (If you select Raw as your Quality setting, images are always captured at the Large resolution value.)

Figure 2-11: Pixels are the building blocks of digital photos.

Table 2-1	The Resolution Side of the Quality Settings	
Symbol	**Setting**	**Pixel Count**
L	Large	5184 x 3456 (18MP)
M	Medium	3456 x 2304 (8MP)
S1	Small 1	2592 x 1728 (4.5MP)
S2	Small 2	1920 x 1280 (2.5MP)
S3	Small 3	720 x 480 (0.35MP)

In the table, the first pair of numbers shown for each setting in the Pixel Count column represents the image *pixel dimensions* — that is, the number of horizontal pixels and the number of vertical pixels. The values in parentheses indicate the total resolution, which you get by multiplying the horizontal and vertical pixel values. This number is usually stated in *megapixels,* or MP for short. The camera displays the resolution value using only one letter M, however (refer to Figures 2-9 and 2-10). Either way, 1MP equals 1 million pixels.

To choose the right setting, you need to understand the three ways that pixel count affects your pictures:

✓ **Print size:** Pixel count determines the size at which you can produce a high-quality print. If you don't have enough pixels, your prints may exhibit the defects you see in the pixelation example in Figure 2-8, or worse, you may be able to see the individual pixels, as in the right example in Figure 2-11. Depending on your photo printer, you typically need anywhere from 200 to 300 pixels per linear inch, or *ppi,* of the print. To produce an 8 x 10 print at 200 ppi, for example, you need a pixel count of 1600 x 2000, or just less than 2MP.

Even though many photo editing programs enable you to add pixels to an existing image, doing so isn't a good idea. For reasons we won't bore you with, adding pixels — known as *upsampling* — doesn't enable you to successfully enlarge your photo. In fact, resampling typically makes matters worse. The printing discussion in Chapter 6 includes some example images that illustrate this issue.

✓ **Screen display size:** Resolution doesn't affect the quality of images viewed on a monitor, television, or other screen device the way it does for printed photos. Instead, resolution determines the *size* at which the image appears. This issue is one of the most misunderstood aspects of digital photography, so I explain it thoroughly in Chapter 6. For now, just know that you need *way* fewer pixels for onscreen photos than you do for printed photos. In fact, the smallest resolution setting available on your camera, 720 x 480 pixels, is plenty for e-mail sharing. At larger sizes, the recipient usually can't view the entire picture without scrolling the display (or the photo is resized to fit the monitor, which defeats the purpose of having a large file in the first place).

✓ **File size:** Every additional pixel increases the amount of data required to create a digital picture file. So, a higher-resolution image has a larger file size than a low-resolution image.

Large files present several problems:

- You can store fewer images on your memory card, on your computer's hard drive, and on removable storage media (such as a CD-ROM).

- The camera needs more time to process and store the image data on the memory card after you press the shutter button. This extra time can hamper fast-action shooting.

- When you share photos online, larger files take longer to upload and download.

- When you edit your photos in your photo software, your computer needs more resources and time to process large files.

As you can see, resolution is a bit of a sticky wicket. What if you aren't sure how large you want to print your images? What if you want to print your photos *and* share them online?

We take the better-safe-than-sorry route, which leads to the following recommendations about which Image Size setting to use:

- **Always shoot at a resolution suitable for print.** You then can create a low-resolution copy of the image in your photo editor for use online. Chapter 6 shows you how.

 Again, you *can't* go in the opposite direction, adding pixels to a low-resolution original in your photo editor to create a good, large print. Even with the very best software, adding pixels doesn't improve the print quality of a low-resolution image.

- **For everyday images, Medium is a good choice.** The Large setting to be overkill for most casual shooting, which means that you're creating huge files for no good reason. Keep in mind that even at the Medium setting, your pixel count (3456 x 2304) is far more than you need to produce an 8 x 10" print at 200 ppi, and almost exactly what you need for an 8 x 10" print at 300 ppi.

 The 60D manual prefers 200 ppi when it suggests print sizes. It recommends using size L for 17 x 23" prints, M for 11 x 17" tabloid prints, and S1 for 8 x 10" letter prints.

- **Choose Large for an image that you plan to crop, print very large, or both.** The benefit of maxing out resolution is that you have the flexibility to crop your photo and still generate a decent-sized print of the remaining image. Figure 2-12 offers an example. When Robert was shooting this photo, he couldn't get any closer to the chipmunk than the first picture shows. But because the resolution cranked up to Large (even though he was shooting at 135mm, the chipmunk remains tiny in the frame), Robert was able to later crop the shot to the composition in the right image and still produce a reasonable print.

Figure 2-12: When you can't get close enough to fill the frame with the subject, capture the image at the Large resolution setting and crop later.

✔ **Reduce resolution if shooting speed is paramount.** If you're shooting
action and the shot-to-shot capture time is slower than you'd like — that
is, the camera takes too long after you take one shot before it lets you
take another — dialing down the resolution may help. Also see Chapter
9 for other tips on action photography.

Understanding File Type (JPEG or Raw)

In addition to establishing the resolution of your photos, the Quality set-
ting determines the *file format,* which simply refers to the type of image file
that the camera produces. Your 60D offers two file formats — JPEG and Raw
(sometimes seen as *raw* or *RAW*), with a couple variations of each. The next
sections explain the pros and cons of each setting.

Don't confuse *file format* with the Format option on Setup Menu 1. That
option erases all data on your memory card; see Chapter 1 for details.

JPEG: The imaging (and Web) standard

This format is the default setting on your camera, as it is for most digital cam-
eras. JPEG is popular for two main reasons:

✔ **Immediate usability:** JPEG is a longtime standard format for digital
photos. All Web browsers and e-mail programs can display JPEG files, so
you can share them online immediately after you shoot them. You also
can get JPEG photos printed at any retail outlet, whether it's an online
or a local printer. Additionally, any program that has photo capabilities,
from photo editing programs to word processing programs, can handle
your files.

✔ **Small files:** JPEG files are smaller than Raw files. And smaller files mean
that your pictures consume less room on your camera memory card and
on your computer's hard drive.

The downside — you knew there had to be one — is that JPEG creates
smaller files by applying *lossy compression.* This process actually throws
away some image data. Too much compression leads to the defects you see
in the JPEG artifacts example in Figure 2-8, near the start of this chapter.

On your camera, the amount of compression that's applied depends on
whether you choose a Quality setting that carries the label Fine or Normal.
The difference between the two breaks down as follows:

✔ **Fine:** At this setting, represented by the symbol you see in the margin,
very little compression is applied, so you shouldn't see many compres-
sion artifacts, if any.

✔ **Normal:** Switch to Normal, and the compression amount rises, as does the chance of seeing some artifacting. Notice the jaggedy-ness of the Normal icon, as shown in the margin? That's your reminder that all may not be "smooth" sailing when you choose a Normal setting.

Note, though, that even the Normal setting doesn't result in anywhere near the level of artifacting that you see in the example in Figure 2-8. Again, that example is exaggerated to help you recognize artifacting defects and understand how they differ from other image-quality issues. In fact, if you keep your image print or display size small, you aren't likely to notice a great deal of quality difference between the Fine and Normal compression levels. The differences become apparent only when you greatly enlarge a photo.

Given that the differences between Fine and Normal aren't all that easy to spot until you really enlarge the photo, is it okay to shift to Normal and enjoy the benefits of smaller files? Well, only you can decide what level of quality your pictures demand. For most photographers, the added file sizes produced by the Fine setting aren't a huge concern, given that the prices of memory cards fall all the time. Long-term storage is more of an issue; the larger your files, the faster you fill your computer's hard drive and the more DVDs or CDs you need for archiving purposes. But in the end, it's usually good practice to take the storage hit in exchange for the lower compression level of the Fine setting. You never know when a casual snapshot is going to be so great that you want to print or display it large enough that even minor quality loss becomes a concern. And of all the defects that you can correct in a photo editor, artifacting is one of the hardest to remove. So stick with Fine when shooting in the JPEG format.

How many pictures fit on my memory card?

That question is one of the first asked by new camera owners — and it's an important one because you don't want to run out of space on your memory card just as the perfect photographic subject presents itself.

As we explain in the discussions in this chapter, image resolution (pixel count) and file format (JPEG or Raw) together contribute to the size of the picture file which, in turn, determines how many photos fit in a given amount of camera memory.

The following table shows you the approximate size of the files, in megabytes (MB), that are generated at each of the possible resolution/format combinations on your 60D. (The actual file size of any image also depends on other factors, such as the subject, ISO setting, and Picture Style setting.) In the Image Capacity column, you see approximately how many pictures you can store at the setting on a 4GB (gigabyte) memory card.

Picture Capacity of a 4GB Memory Card

Symbol	Quality Setting	File Size	Image Capacity
◢ L	Large/Fine	6.4MB	490
◢ L	Large/Normal	3.2MB	990
◢ M	Medium/Fine	3.4MB	940
◢ M	Medium/Normal	1.7MB	1930
◢ S1	Small 1/Fine	2.2MB	1500
◢ S1	Small 1/Normal	1.1MB	3100
S2	Small 2	1.3MB	2580
S3	Small 3	0.3MB	10790
RAW	Raw	24.5MB	130
M RAW	Raw/Medium	16.7MB	190
S RAW	Raw/Small	11.1MB	300
RAW ◢ L	Raw+Large/Fine	41MB*	100
M RAW ◢ L	Raw/Med+Large/Fine	23.1MB*	140
S RAW ◢ L	Raw/Small+Large/Fine	17.5MB*	180

Combined size of the two files produced at this setting.

To make the best decision, do your own test shots, carefully inspect the results in your photo editor, and make your own judgment about what level of artifacting you can accept. Artifacting is often much easier to spot when you view images onscreen. It's difficult to reproduce artifacting here in print because the printing press obscures some of the tiny defects caused by compression. Your inkjet prints are more likely to reveal these defects.

If you don't want *any* risk of artifacting, bypass JPEG altogether and change the file type to Raw (CR2). Or consider your other option, which is to record two versions of each file, one Raw and one JPEG. The next section offers details.

Whichever format you select, be aware of one more important rule for preserving the original image quality: If you retouch pictures in your photo software, don't save the altered images in the JPEG format. Every time you alter and save an image in the JPEG format, you apply another round of lossy compression. And with enough editing, saving, and compressing, you *can* eventually get to the level of image degradation shown in the JPEG example in Figure 2-8, at the start of this chapter. (Simply opening and closing the file does no harm.)

Always save your edited photos in a nondestructive format. TIFF is a good choice and is a file-saving option available in most photo editing programs. Should you want to share the edited image online, create a JPEG copy of the TIFF file when you finish making all your changes. That way, you always retain one copy of the photo at the original quality captured by the camera.

Raw (CR2): The purist's choice

The other picture-file type that you can create on your 60D is *Camera Raw,* or just *Raw* (as in, uncooked) for short.

Each manufacturer has its own flavor of Raw files; Canon's are CR2 files (or, on some older cameras, CRW). You'll see that three-letter designation at the end of your picture filenames on your computer.

Raw is popular with advanced, very demanding photographers, for two reasons:

- ✔ **Greater creative control:** With JPEG, internal camera software tweaks your images, adjusting color, exposure, and sharpness as needed to produce the results that Canon believes its customers prefer (or according to settings you chose). With Raw, the camera simply records the original, unprocessed image data. The photographer then copies the image file to the computer and uses special software known as a *raw converter* to produce the actual image, making decisions about color, exposure, and so on at that point. The upshot is that "shooting Raw" enables you, not the camera, to have the final say on the visual characteristics of your image.

- ✔ **Higher bit depth:** *Bit depth* is a measure of how many distinct color values an image file can contain. JPEG files restrict you to 8 bits each for the red, blue, and green color components, or *channels,* that make up a

digital image, for a total of 24 bits. That translates to roughly 16.7 million possible colors. On the EOS 60D, a Raw file delivers a higher bit count, collecting 14 bits per channel.

Although jumping from 8 to 14 bits sounds like a huge difference, you may not really ever notice any difference in your photos — that 8-bit palette of 16.7 million values is more than enough for superb images. Where having the extra bits can come in handy is if you really need to adjust exposure, contrast, or color after the shot in your photo-editing program. In cases where you apply extreme adjustments, having the extra original bits sometimes helps avoid a problem known as *banding* or *posterization,* which creates abrupt color breaks where you should see smooth, seamless transitions. (A higher bit depth doesn't always prevent the problem, however, so don't expect miracles.)

✔ **Best picture quality:** Because Raw doesn't apply the destructive compression associated with JPEG, you don't run the risk of the artifacting that can occur with JPEG.

But of course, as with most things in life, Raw isn't without its disadvantages. To wit:

✔ **You can't do much with your pictures until you process them in a Raw converter.** You can't share them online, for example, or put them into a text document or multimedia presentation. You can print them immediately if you use the Canon-provided software, but most other photo programs require you to convert the Raw files to a standard format first. Ditto for retail photo printing. So when you shoot Raw, you add to the time you must spend in front of the computer instead of behind the camera lens. Chapter 6 gets you started processing your Raw files using your Canon software.

✔ **Raw files are larger than comparable JPEGs.** Unlike JPEGs, Raw doesn't apply lossy compression to shrink files. (A hallmark of the JPEG is its ability to shrink file size dramatically, but that comes at the expense of quality.) This means that Raw files are significantly larger than JPEGs, so they take up more room on your memory card and on your computer's hard drive or other picture-storage devices. Thankfully, the 60D has three sizes of Raw files for you to choose from. That enables you to shrink the file size down by reducing the photo's dimensions, but not at the expense of overall quality.

Whether the upside of Raw outweighs the down is a decision that you need to ponder based on your photographic needs, schedule, and computer-comfort level.

If you do decide to try Raw shooting, you can select from the following Quality options:

- ✔ **RAW:** This setting produces a single Raw file at the maximum resolution (18MP).

- ✔ **RAW M:** This setting produces a single Raw file at a medium resolution (10MP).

- ✔ **RAW S:** This setting produces a single Raw file at a low resolution (4.5MP).

- ✔ **RAW+Large/Fine:** This setting produces two files: the large-sized Raw file plus a JPEG file captured at the Large/Fine setting. At first glance, this option sounds great: You can share the JPEG online or get prints made and then process your Raw files when you have time. (To see the flip side of saving JPEGs with any Raw option, read the upcoming Warning.)

- ✔ **RAW M+Large/Fine:** This setting saves the medium-sized Raw file and a JPEG file captured at the Large/Fine setting.

- ✔ **RAW S+Large/Fine:** This setting saves the small-sized Raw file and a JPEG file captured at the Large/Fine setting.

The problem is that, the JPEG image is captured at the maximum pixel count — which is *too* large for onscreen viewing. That means that you have to edit the JPEG file anyway to trim down the pixel count before online sharing although you can produce great prints right away. In addition, creating two files for every image eats up substantially more memory card space. We'll leave it up to you to decide whether the pluses of saving two file types at the same time outweigh the minuses.

Our take: Choose Fine or Raw

At this point, you may be finding all this technical goop a bit much — that lizard-eyed look on your face is a giveaway — so allow us to simplify things for you. Until you have time or energy to completely digest all the ramifications of JPEG versus Raw, here's a quick summary:

- ✔ If you require the absolute best image quality and have the time and interest to do the Raw conversion process, shoot Raw. Choose a size that matches your output need: Small for onscreen, Medium for most printing needs, and Large for the largest size possible. See Chapter 6 for more information on the conversion process.

- ✔ If great photo quality is good enough for you, you don't have wads of spare time, or you aren't that comfortable with the computer, stick with one of the Fine JPEG settings (Large/Fine, Medium/Fine, or Small/Fine).

✔ If you want to enjoy the best of both worlds, consider Raw+Large/Fine (or Raw M+Large Fine, or Raw S+Large/Fine) — assuming, of course, that you have an abundance of space on your memory card and your hard drive. Otherwise, creating two files for every photo on a regular basis isn't really practical.

✔ Select JPEG Normal if you aren't shooting pictures that demand the highest quality level and you aren't printing or displaying the photos at large sizes. The smaller file size also makes JPEG Normal the way to go if you're running seriously low on memory card space during a shoot.

✔ Finally, remember that the format and resolution together determine the ultimate picture quality. So be sure that you select the Quality setting that offers both the appropriate number of pixels and format for how you plan to use your image. If you capture an image at the Small/Normal setting, for example, and then print the photo at a large size, the combination of a lower pixel count and a higher level of JPEG compression may produce a disappointing picture quality.

REMEMBER

Maintaining a pristine view

Often lost in discussions of digital photo defects — compression artifacts, pixelation, and the like — is the impact of plain ol' dust and dirt on picture quality. No matter which camera settings you use, you can't achieve great picture quality with a dirty lens. So make it a practice to clean your lens on a regular basis, using one of the specialized cloths and cleaning solutions made expressly for that purpose.

If you continue to notice random blobs, specks, or hair-like defects in your images (refer to the last example in Figure 2-8), you probably have a dirty *image sensor.* That's the part of your camera that does the actual image capture — the digital equivalent of a film negative, if you will. By default, your camera performs an internal sensor cleaning every time you turn it on and off; you can also run the cleaning process at any time you want by opening Setup Menu 2, choosing the Sensor Cleaning option, and then selecting Clean Now.

If you frequently change lenses in a dirty environment, this internal cleaning mechanism may not be able to fully remove all specks from the sensor. In that case, you need a more thorough cleaning, which is done by actually opening the camera and using special sensor-cleaning tools. You can do this job yourself, but it's not recommended. An image sensor is pretty delicate, and you can easily damage it or other parts of your camera if you aren't careful. Instead, find a local camera store that offers this service. You'll probably find sensor cleaning costs running about $30 to $50. If you bought your camera at a traditional camera store, the store may even provide free sensor cleaning as a way to keep your business.

One more cleaning tip: Never — and we mean *never* — try to clean any part of your camera using a can of compressed air. Doing so can harm your camera in multiple ways, from damaging your shutter to blowing dust into areas where it can't be removed. Many experienced travel photographers carry an ear-syringe type blower to gently remove dust from their cameras.

Taking Great Pictures, Automatically

*A*re you old enough to remember the Certs television commercials from the 1960s and '70s? "It's a candy mint!" declared one actor. "It's a breath mint!" argued another. Then a narrator declared the debate a tie and spoke the famous catchphrase: "It's two, two, two mints in one!"

Well, that pretty much describes the EOS 60D. On one hand, it provides a full range of powerful controls, offering just about every feature a serious photographer could want. On the other, it also offers fully automated exposure modes that enable people with absolutely no experience to capture beautiful images. "It's a sophisticated photographic tool!" "It's as simple as 'point and shoot'!" "It's two, two, two cameras in one!"

Of course, you probably bought this book for help with your camera's advanced side, so that's what other chapters cover. This chapter, however, is devoted to your camera's point-and-shoot side, explaining how to get the best results from the fully automatic exposure modes. You can also find details about the new Creative Auto mode in this chapter. Sort of like "fully automatic plus," this

mode handles most duties for you but enables you to control a few aspects of your pictures, such as whether flash is used and whether the background is softly focused or as sharp as your subject.

Getting Great Point-and-Shoot Results

 Your camera offers several automatic point-and-shoot exposure modes, all of which we explain later in this chapter. In any of those modes, though, the fundamental key to good photos is to follow a specific picture-taking technique.

Give it a whirl. Start by setting the Mode dial on top of the camera to Full Auto, as shown in the left image in Figure 3-1. Then set the focusing switch on the lens to the AF (autofocus) position, as shown in the right image in Figure 3-1. (The figure features the lens that is bundled with the 60D. If you own a different lens, the switch may look and operate differently; check your lens manual for details.)

Auto/Manual Focus switch

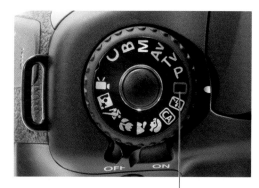 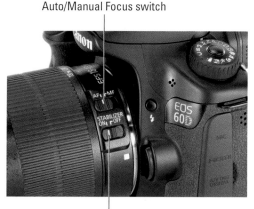

Full Auto mode Image Stabilizer switch

Figure 3-1: Choose these settings for fully automatic exposure and focus.

 Also set the Stabilizer switch to the On setting, as shown on the right in Figure 3-1. This setting turns on the Image Stabilizer feature, which is designed to produce sharper images by compensating for camera movement that can occur when you handhold the camera. Again, if you use a lens other than the kit lens, check your lens manual for details about using its stabilization feature, if provided.

The exception to this rule is when you have the camera mounted on a tripod or are stabilizing it some other way.

Your camera is now set up to work in the most automatic of automatic modes. Follow these steps to take the picture:

1. **Looking through the viewfinder, frame the image so that your subject appears under an autofocus point.**

 The *autofocus points* are those nine tiny rectangles clustered in the center of the viewfinder. The autofocus points are highlighted in red in Figures 3-2 and 3-3. When the camera autofocuses, the point(s) it uses change from black to red.

2. **Press and hold the shutter button halfway down.**

 The camera's autofocus and autoexposure meters begin to do their thing. In dim light, the flash will pop up if the camera thinks light is needed. Additionally, the flash may emit an *AF-assist beam,* a few rapid pulses of light designed to help the autofocusing mechanism find its target. (The *AF* stands for autofocus.)

Figure 3-2: The tiny rectangles in the viewfinder indicate autofocus points.

 At the same time, the autoexposure meter analyzes the light and selects initial aperture (f-stop) and shutter speed settings, which are two critical exposure controls. These two settings appear in the viewfinder; in Figure 3-2, the shutter speed is 1/60 second, and the f-stop is f/5.6. You also see the current ISO setting and the maximum burst rate (in this case, seven shots). (Chapter 7 details shutter speed, f-stops, and ISO; see Chapter 1 for information about the maximum burst rate.)

 When focus is established, the camera beeps at you.

 You can silence this beeping via Shooting Menu 1, as we discuss at the end of Chapter 1.

 Additionally, the focus indicator in the viewfinder lights, as shown in Figure 3-3, and the dot inside an autofocus point briefly turns red. That red dot indicates which autofocus point the camera used to establish focus. Sometimes multiple dots turn red, as in Figure 3-3, which simply tells you that all the objects within those autofocus areas are now in focus. The autoexposure meter continues monitoring the light up to the time you take the picture, so the f-stop and shutter speed values in the viewfinder may change if the light shifts.

WARNING!

3. **Press the shutter button the rest of the way down to record the image.**

While the camera sends the image data to the camera memory card, the memory card access lamp lights, as shown in Figure 3-4. Don't turn off the camera or remove the memory card while the lamp is lit, or you may damage both camera and card.

When the recording process is finished, the picture appears briefly on the camera monitor. By default, the review period is two seconds. See Chapter 5 to find out how to adjust or disable Instant Review as well as how to switch to Playback mode to take a longer look at your image.

We need to add a couple important notes about this process, especially related to Step 2:

✔ **Solving autofocus problems:** When you shoot in the fully automatic modes, as well as in Creative Auto mode, the camera typically focuses on the closest object. If the camera insists on selecting an autofocus point that isn't appropriate for your subject, the easiest solution is to switch to manual focusing. Chapter 1 shows you how. Or you can use the advanced exposure modes, which enable you to select a specific autofocus point. Chapter 8 explains that option plus a few other tips for getting good autofocus results.

Focus light

Figure 3-3: The green light indicates that the camera has locked focus.

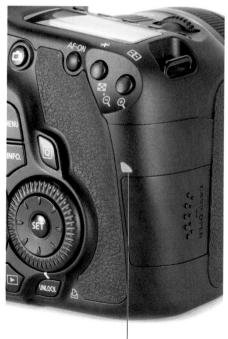

Memory card access light

Figure 3-4: The card access lamp lights while the camera sends the picture data to the card.

✔ **Shooting moving subjects:** If the focus indicator doesn't light but you hear a continuous series of beeps, the camera detected motion in the scene and shifted to the AI Servo autofocusing mode. (The AI stands for *artificial intelligence.*) In this mode, the camera focuses continually after you press the shutter button halfway to try to maintain focus on the subject. As long as you keep the subject within one of the autofocus points, focus should be correct. However, continuous autofocusing is possible only in the Full Auto, Flash Off, Creative Auto, and Sports modes. In the other fully automatic modes, focus locks when you press the shutter button halfway. See Chapter 8 for more tips about this and other autofocus modes.

✔ **Locking exposure:** By default, pressing the shutter button halfway doesn't lock exposure along with focus. Your camera instead continues metering and adjusting exposure until you fully press the shutter button. If you want to lock exposure, you must use an advanced exposure mode and rely on the AE (autoexposure) Lock button. You also can simply switch the camera's Mode dial to M, which shifts the camera to manual exposure mode, and then set your desired exposure settings (aperture, shutter speed, and ISO). Chapter 7 discusses these and other exposure issues.

✔ **Changing the Drive mode setting:** In most of the automatic exposure modes, your camera automatically sets the Drive mode to Single, which records a single image with each press of the shutter button. In Portrait and Sports modes, though, the camera instead selects Continuous mode, which records pictures as long as you hold down the shutter button. Creative Auto gives you the choice of both Drive modes. And you can also set the Drive mode to a Self-Timer or Remote Control setting for any exposure mode. See Chapter 2 for details.

More focus factors to consider

When you focus the lens, in either autofocus or manual focus mode, you determine only the point of sharpest focus. The distance to which the sharp-focus zone extends in front of and behind that point — *depth of field* — depends in part on the *aperture setting,* or *f-stop,* which is an exposure control. Some of your camera's fully automatic exposure modes are designed to choose aperture settings that produce a certain depth of field.

Depth of field also depends your distance to the subject and the focal length at which you have the lens. You're in total control of these factors, regardless of the shooting mode you're in. Distance works like this: The closer you are to your subject, the smaller the depth of field. Conversely, the further away you are, more appears to be in focus. Focal lengths operate differently; smaller focal lengths (think wide angle) increase the depth of field, and longer focal lengths (think telephoto) shrink it.

For more information on depth of field, refer to Chapter 8.

Shooting in the Fully Automatic Modes

You can choose from eight Basic zones (also known as fully automatic exposure) modes, highlighted in Figure 3-5. The next sections provide details on each mode.

As you explore these modes — or any exposure mode, for that matter — remember that you can use manual or autofocus as you see fit. If you opt for autofocus, the camera locks the autofocus point differently depending on the exposure mode, however.

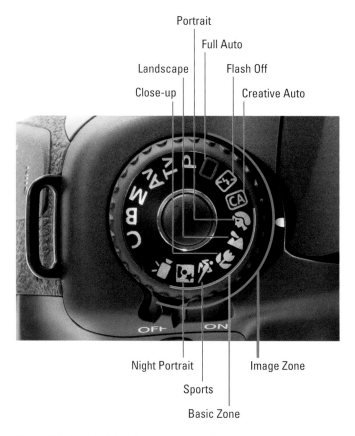

Figure 3-5: Set the dial to the exposure mode you want to use.

Full Auto mode

In Full Auto mode, represented on the Mode dial by the rectangle you see in the margin, the camera selects all settings based on the scene that it detects in front of the lens. Your only job is to lock in focus, using the two-stage autofocus technique we outline at the beginning of the chapter, or by setting the lens to manual focus mode and using the focus ring on the lens, as explained in Chapter 1.

Full Auto mode is great for casual, quick snapshooting. But keep these limitations in mind:

- **Picture Style:** Full Auto mode records your photo using the Standard Picture Style setting. The aim of this mode is to produce a crisp, vivid image. You can get more details about how Picture Styles affect your photos in Chapter 8.

- **Drive mode:** The camera selects the Single setting automatically, so you record one image for every press of the shutter button although you can change it to a 10-second self-timer or remote control.

- **Flash:** Auto flash is used. That is, the camera fires the flash automatically if the available light is too dim to otherwise expose the picture. You can enable Red-Eye Reduction mode; see Chapter 2.

- **Autofocusing:** In most cases, the camera focuses the closest object that falls under one of the autofocus points. To focus on a different area, the easiest option is to switch to manual focusing.

 If you stick with autofocus, note that the camera adjusts its autofocusing behavior depending on whether it thinks you're shooting a still or moving subject. For still subjects, the camera locks focus when you press the shutter halfway. If the camera senses motion, it continually adjusts focus from the time you press the shutter button halfway. You must reframe your shot as necessary to keep the subject within one of the nine autofocus points to ensure sharp focus.

 See Chapter 8 for additional information on getting good autofocus results.

- **Color:** Color decisions are also handled for you automatically. Normally, the camera's color brain does a good job of rendering the scene, but if you want to tweak color, you must switch to an advanced exposure mode. You can then manipulate color via the White Balance controls and Picture Style options, all covered in Chapter 8.

- **Exposure:** You also give up total control over exposure to the camera. Chapter 7 shows you what you're missing.

- **Quality:** You can choose any Quality setting. Chapter 2 discusses this setting, which determines both the image resolution (or pixel count) and the file format (JPEG or Raw).

The results that this setting creates vary widely depending on the available light and how well the camera detects whether you're trying to shoot a portrait, a landscape, an action shot, or whatever. The bottom line is that Full Auto is a one-size-fits-all approach that may not take best advantage of your camera's capabilities. If you want to more consistently take great pictures instead of good ones, explore the exposure, focus, and color information found in Part II so that you can abandon this exposure mode in favor of ones that put more photographic decisions in your hands.

Automatic scene modes (Image Zone modes)

In Full Auto mode, the camera tries to figure out what type of picture you want to take by assessing what it sees through the lens. If you don't want to rely on the camera to make those decisions, your camera offers five other fully automatic modes specifically designed for taking popular categories of pictures. For example, most people prefer portraits with softly focused backgrounds. So, in Portrait mode, the camera selects settings that can produce that type of background behind your subject.

These five automatic modes — the ones represented by the little pictographs highlighted in Figure 3-5 — are *Image Zone modes* in Canon lingo (and in your camera manual).

Whatever you call them, all six modes share a couple of limitations — or benefits, depending on how you look at things:

> ✓ **Flash:** You have no control whether the flash fires.

> ✓ **Exposure:** The camera makes all exposure decisions, too.

In each Image Zone mode (Portrait, Landscape, Close-up, Sports, and Night Portrait), you can change Shoot by Ambience, Shoot by Lighting or Scene Type, and Drive settings. (The exception is Night Portrait, where you can't change Shoot by Lighting or scene type.) For more information on Ambience and Lighting, take a look at the section at the end of this chapter. We cover Drive modes in Chapter 2.

In the next sections, you can read about the unique features of each of the scene modes.

Portrait mode

Portrait mode attempts to select an aperture (f-stop) setting that results in a short depth of field, which blurs the background and puts the visual emphasis on your subject. Figure 3-6 offers an example. Keep in mind, though, that the short depth of field produced by Portrait mode may result in softer focus on objects set in front of your subject, not just those behind it. Either way, the extent to which the depth of field is reduced depends on the current lighting conditions (which affect the range of f-stops the camera can use),

the distance between your subject and those foreground or background objects, and a couple of other factors discussed in Chapter 8.

Figure 3-6: Portrait setting produces a softly focused background.

Along with favoring an f-stop that produces a shorter depth of field, the camera selects these settings in Portrait mode:

- **Picture Style:** Logically enough, the camera automatically sets the Picture Style option to Portrait. As detailed in Chapter 8, this Picture Style results in a slightly less sharp image, the idea being to keep skin texture nice and soft. Colors are also adjusted subtly to enhance skin tones.

- **Drive mode:** Contrary to what you may expect, Drive mode is set to Continuous, which means that the camera records a series of images in rapid succession as long as you hold down the shutter button. This technique can come in especially handy if your portrait subject can't be counted on to remain still for very long — a toddler or pet, for example.

 Should you want to include yourself in the portrait, you can switch the Drive mode setting to a Self-Timer or Remote Control mode. See the end of Chapter 2 for details.

- **Flash:** Auto flash is used; the camera decides whether you need flash. For outdoor portraits, this can pose a problem: A flash generally improves outdoor portraits, and if the ambient light is very bright, the camera doesn't give you access to the flash. For an illustration of the difference a flash can make, see Chapter 7. That chapter also contains tips on using flash in nighttime and indoor portraits.

Although you can't control whether the flash fires, you can choose to enable or disable Red-Eye Reduction flash, which we explain in Chapter 2.

✔ **Autofocusing:** Portrait mode employs the One-Shot AF (autofocus) mode. This is one of three AF modes available on your camera, all detailed in Chapter 8. In One-Shot mode, the camera locks focus when you press the shutter button halfway. Typically, the camera locks focus on the closest object that falls under one of the nine autofocus points. If your subject moves out of the selected autofocus point, the camera doesn't adjust focus to compensate.

Landscape mode

 Landscape mode — designed for capturing scenic vistas, city skylines, and other large-scale subjects — produces a large depth of field and deliberately (but subtly) intensifies blues and greens. As a result, objects both close to the camera and at a distance appear sharply focused, as shown in Figure 3-7.

Like Portrait mode, Landscape mode achieves the greater depth of field by manipulating the exposure settings: specifically, aperture and f-stop settings. Consequently, the extent to which the camera can succeed in keeping everything in sharp focus depends on available light. To fully understand this issue, see Chapters 7 and 8. And in the meantime, know that you also can extend depth of field by zooming out (if you're using a zoom lens, that is) and by moving farther from your subject.

If you find that you can't get a sharp hand-held photo because the shutter speed is too slow (a result of having a smaller aperture), make sure to enable Image Stabilization. Or, you could use a tripod to stabilize the camera.

As for other camera settings, using Landscape mode results in the following options:

✔ **Picture Style:** The camera automatically sets the Picture Style option to Landscape, which produces a sharper image, with well-defined *edges* (the borders between areas of contrast or color change). The Picture Style setting also produces more vivid blues and greens, which is what most people prefer

Figure 3-7: Landscape mode produces a large zone of sharp focus.

from their landscape photos. You can read more about Picture Styles in Chapter 8.

✔ **Drive mode:** The camera selects the Single option, which records one image for each press of the shutter button. As with the other scene modes, you can switch to a Self-Timer or Remote Control setting by following the steps laid out in Chapter 2.

✔ **Flash:** The built-in flash is disabled, which is typically no big deal. Because of its limited range, a built-in flash is of little use when shooting most landscapes, anyway.

✔ **Autofocusing:** The AF (autofocus) mode is set to One-Shot, which means that focus locks when you press the shutter button halfway. (See Chapter 8 for details.) Focus usually is set on the nearest object that falls under one of the nine autofocus points. However, remember that because of the large depth of field that the Landscape mode produces, both far and near objects may appear equally sharp, depending on their distance from the lens.

Close-Up mode

Switching to Close-Up mode doesn't enable you to focus at a closer distance to your subject than normal as it does on some non-SLR cameras. The close-focusing capabilities of your camera depend entirely on the lens you use.

Choosing Close-Up mode does tell the camera to try to select an aperture (f-stop) setting that results in a short depth of field, which blurs background objects so that they don't compete for attention with your main subject. This mode was used to capture the orchid in Figure 3-8, for example. As with Portrait mode, though, how much the background blurs varies depending on the distance between your subject and the background as well as on the lighting conditions (which determine the range of f-stops that will produce a good exposure), your camera-to-subject distance, and the lens focal length. (Chapter 8 explains all these issues.)

Other settings selected for you in Close-Up mode are as follows:

✔ **Picture Style:** Close-Up mode uses the Standard Picture Style, just like Full Auto. The resulting image features crisp edges and vivid colors.

✔ **Drive mode:** The Drive mode is set to Single, so you record one photo each time you fully press the shutter button. However, you can select a Self-Timer or Remote Control mode if needed.

✔ **Flash:** Flash is set to Auto, so the camera decides whether the picture needs the extra pop of light from the built-in flash. For times when the camera enables the flash, you have the option of using Red-Eye Reduction mode.

Whether you enable Red-Eye Reduction, watch your subject-to-camera distance if you're shooting a living subject; a burst of flash light at close

range can be harmful to the subject's eyes. A better choice in this scenario is to switch to the Creative Auto mode, which lets you disable the flash as well as request a shallow depth of field.

✓ **Autofocusing:** The AF mode is set to One-Shot mode; again, that simply means that when you press the shutter button halfway, the camera locks focus, usually on the nearest object that falls under one of the nine autofocus points.

See Chapter 8 for more details about AF modes and other focusing issues. Chapter 9 offers additional tips on close-up photography.

Figure 3-8: Close-Up mode also produces short depth of field.

Sports mode

 Sports mode results in a number of settings that can help you photograph moving subjects, such as the running child in Figure 3-9. First, the camera selects a fast shutter speed, which is needed to "stop motion." *Shutter speed* is an exposure control that you can explore in Chapter 7.

Also, keep these Sports mode settings in mind:

✓ **Picture Style:** The camera automatically sets the Picture Style option to Standard, which is designed to produce sharp images with bold colors.

✔ **Drive mode:** To enable rapid-fire image capture, the Drive mode is set to Continuous. This mode enables you to record multiple frames with a single press of the shutter button. You also have the option of switching to a Self-Timer or Remote Control mode. Check out the end of this chapter for details on Drive mode settings.

✔ **Flash:** Flash is disabled, which can be a problem in low-light situations, but it also enables you to shoot successive images more quickly because the flash needs a brief period to recycle between shots. In addition, disabling the flash permits a faster shutter speed; when the flash is on, the maximum shutter speed is 1/250 second. (See Chapter 7 for details about flash and shutter speeds.)

Figure 3-9: To capture moving subjects and minimize blur, try Sports mode.

✔ **Autofocusing:** The AF mode is set to AI Servo. In this mode, the camera establishes focus initially when you press the shutter button halfway. But if the subject moves, the camera attempts to refocus.

For this feature to work correctly, you must adjust framing so that your subject remains within one of the autofocus points. You may find it easier to simply switch to manual focusing and twist the focusing ring as needed to track the subject's movement yourself.

The other critical thing to understand about Sports mode is that whether the camera can select a shutter speed fast enough to stop motion depends on the available light and the speed of the subject itself. In dim lighting, a subject that's moving at a rapid pace may appear blurry even when photographed in Sports mode.

To fully understand shutter speed, visit Chapter 7. And for more tips on action photography, check out Chapter 9.

Night Portrait mode

As its name implies, Night Portrait mode is designed to deliver a better-looking portrait at night (or in any dimly lit environment). Night Portrait does so by combining flash with a slow shutter speed. That slow shutter speed produces a longer exposure time, which enables the camera to rely more on ambient light and less on the flash to expose the picture. The result is a brighter background and softer, more even lighting.

Slow shutter speed issues are covered in detail in Chapter 7; Chapter 9 has some additional nighttime photography tips. For now, the important thing to know is that the slower shutter speed means that you probably need a tripod. If you try to handhold the camera, you run the risk of moving the camera during the long exposure, resulting in a blurry image. Enabling the Image Stabilizer (IS) feature of your lens (if available) can help, but for nighttime shooting, even using that may not permit successful handheld shooting. Your subjects also must stay perfectly still during the exposure, which can also be a challenge.

If you do try Night Portrait mode, be aware of these other settings that are selected automatically by the camera:

- **Picture Style:** The Standard setting, designed to deliver sharp, bold photos, is selected. See Chapter 8 for more about Picture Styles.

- **Drive mode:** The default setting is Single, but you also can choose a Self-Timer or Remote Control mode. Check out Chapter 2 for details.

- **Flash:** Flash is enabled when the camera thinks more light is needed — which, assuming that you're actually shooting at night, should be most of the time. You can set the flash to Red-Eye Reduction mode if you prefer. See the section "Using Red-Eye Reduction Flash," in Chapter 2, for details.

- **Autofocusing:** The AF mode is set to One-Shot, which locks focus when you depress the shutter button halfway.

Flash Off mode

The Flash Off mode delivers the same results as Full Auto mode but ensures that the flash doesn't fire, even in dim lighting. This mode provides an easy way to ensure that you don't break the rules when shooting in locations that don't permit flash: museums, churches, and so on. It can also come in handy any time you prefer not to use flash. See Chapters 7 and 9 for information about flash photography.

Gaining More Control with Creative Auto

Creative Auto mode might be better named "Full Auto Plus." This mode is set up initially to work the same way as Full Auto, explained earlier in this chapter. But if you don't like the results you get, you can make the following adjustments for your next shot:

- Enable or disable the flash.

- Adjust color and contrast through the Shoot by Ambience option.

- Soften or sharpen the apparent focus of the picture background.

- Select from four Picture Styles, which affect the color and sharpness of the image. One of the available options creates a black-and-white photo.

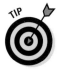

Although Creative Auto is great for beginners to have an easy way to have a little more input on their pictures, Creative Auto still doesn't give you anywhere near the level of creative control you get in the advanced exposure modes. For example, you can decide whether you want the flash to fire in Creative Auto mode, but you can't adjust flash power or change the way the camera calculates the flash exposure, as you can in the P, Tv, Av, M, B, and C modes. That said, if you're feeling overwhelmed by all the new stuff that comes with digital SLR photography and you're not ready to dive into the more advanced exposure modes covered in Chapters 7 and 8, by all means, Creative Auto is a better choice than the other modes covered in this chapter. Here's how to use it:

1. **Set the Mode dial on top of the camera to the CA setting.**

 The Creative Auto version of the Shooting Settings screen, as shown in Figure 3-10, appears on the monitor. (If you don't see the screen, press the Info button or press the shutter button halfway and then release it.) The six settings you can adjust in this mode are labeled in the figure.

Figure 3-10: In Creative Auto mode, the Shooting Settings screen displays these controls.

2. **Press the Quick Control button.**

 Pressing the Quick Control button shifts the screen into Quick Control mode. One of the six adjustable settings is highlighted, and a text label appears at the bottom of the screen to remind you what the highlighted setting does. In Figure 3-11, for example, the Flash setting is highlighted.

3. **Press the multicontroller to move the highlight over the setting you want to adjust.**

4. **Adjust the highlighted setting by rotating the Main dial.**

 See the upcoming list for some advice about each option.

 For Drive and Flash options, you must press the Set button to display a screen containing all possible settings. Then use the Main dial to change the top setting or the Quick Control dial to change the bottom setting. Then press Set to return to the Quick Control screen.

5. **To adjust another setting, press Set again and use the multicontroller to highlight it.**

6. **After you select all the settings you want to change, press the shutter button halfway and release it, or press the Quick Control button again.**

 The monitor returns to the normal Shooting Settings display, and you're ready to take your picture.

 The settings you choose remain in effect from shot to shot. If you turn the camera off or switch to a different exposure mode, though, the settings return to their defaults. (The default settings are shown earlier, in Figure 3-10.)

CA	Drive mode
Standard setting	Single shooting
	□ ⧉ ⏱
📷 _._!_._ 📷	Flash firing
□ ⚡A	Auto flash
Drive mode/Flash firing	⚡A ⚡ 🚫

Help text Selected option

Figure 3-11: Press the Quick Control button to enter Quick Control mode and adjust the Creative Auto options.

Now for the promised explanations of how the four Creative Auto options work:

✏ **Shoot by Ambience:** This setting enables you to alter how the camera processes the photo. See the next section for details.

✏ **Background (blur/sharpen):** The middle option on the Creative Auto screen gives you some control over depth of field.

Unfortunately, this feature doesn't play nice with the flash. If you set the flash mode to On, the bar becomes dimmed and out of your reach when the flash pops up. Ditto if you set the flash mode to Auto and the camera sees a need for flash.

Assuming that the flash doesn't get in your way, move the little indicator on the bar to the left to shorten depth of field, which makes distant objects appear blurrier. (Remember that after highlighting the bar, you just rotate the Main dial to move the indicator.) Shift the indicator to the right to make distant objects appear sharper.

The camera creates this shift in depth of field by adjusting the aperture setting (f-stop). A lower f-stop number produces a more shallow depth of field, for a blurrier background; a higher f-stop setting produces a greater depth of field, for a sharper background. However, because aperture also plays a critical role in exposure, the range of f-stops the camera can choose — and, therefore, the extent of focus shift you can achieve with this setting — depends on the available light. The camera gives priority to getting a good exposure, assuming that you'd prefer a well-exposed photo to one that has the background blur you want but is too dark or too light. Understand, too, that when the aperture changes, the camera also must change the shutter speed, ISO (light sensitivity setting), or both to maintain a good exposure.

At very slow shutter speeds, camera shake can blur the image. A blinking shutter speed value alerts you to the potential for this problem; put your camera on a tripod to avoid the risk of camera shake. Also remember that moving objects appear blurry at slow shutter speeds.

To find out more about depth of field, aperture, shutter speed, ISO, and exposure, see Chapters 7 and 8 for the complete story.

✏ **Drive mode:** You can choose from three of the Drive mode options: Single Shooting, Low Speed Continuous, and Self-timer: 10sec/Remote Control. (These options are explained in Chapter 2.)

✏ **Flash:** You can choose from three flash settings, which are represented on the Shooting Settings screen by the icons in the margin:

 • *Auto:* The camera fires the flash automatically if it thinks extra light is needed to expose the picture.

 • *On:* The flash fires regardless of the ambient light.

 • *Off:* The flash doesn't fire.

For the Auto and On settings, you can use the Red-Eye Reduction flash feature. See Chapter 2 for more information about flash photography.

Adding in Ambience and Lighting

Through the Shoot by Ambience and Shoot by Lighting or Scene Type options, you can customize Basic Zone modes to better match your artistic desires and the lighting at hand.

These two options have the following characteristics:

- ✔ **Shoot by Ambience:** When you select a setting in Shoot by Ambience, you're telling the camera how to process the photo. It has nothing to do with the ambience of the scene but everything to do with what you want the final photo to look like. By selecting Shoot by Ambience, you bypass the need to "develop" the photo on a computer. It should come off the card just the way you want it.

 Shoot by Ambience is available in Creative Auto, Portrait, Landscape, Close-up, Sports, and Night Portrait modes.

 Shoot by Ambience is similar to Picture Styles (see Chapter 8), only with more basic settings and controls.

- ✔ **Shoot by Lighting or Scene Type:** When you select a setting in Shoot by Lighting or Scene Type, you're telling the camera what the actual lighting conditions are. This, in turn, helps it take an accurate photo of the scene, where whites look white and don't take on a color cast from the lighting.

 Figure 3-12 shows how you can save a shot that has the wrong colors by choosing the correct lighting. Using the Daylight setting (left) — because the portraits of George and Martha were in direct sunlight — makes the photo too red. Opting for the Tungsten Light setting, though (right), corrects this problem.

 Shoot by Lighting or Scene Type is available in Portrait, Landscape, Close-up, and Sports modes. Two settings, though — Tungsten and Fluorescent — aren't available in Landscape shooting mode.

 Using Shoot by Lighting or Scene Type enables you to select a custom white balance when in a Basic Zone mode. (See Chapter 8 for more information on white balance.)

Both "Shoot By" tools extend beyond the pure basics of automatic shooting and rely on you to make decisions that add value to your photos. If you're a novice photographer, using them will help you make the adjustment to a more manual approach to shooting.

You enable Shoot by Ambience or Shoot by Lighting or Scene Type from the Quick Control screen. Although the 60D manual covers using them only in Live View, you can also select them (assuming that you're in a compatible exposure mode) when using the viewfinder. Here's how:

1. **Check whether the shooting mode you're in is compatible with Shoot by Ambience or Shoot by Lighting or Scene Type.**

 - *Ambience:* Creative Auto, Portrait, Landscape, Close-up, Sports, or Night Portrait

 - *Lighting or Scene Type:* Portrait, Landscape, Close-up, or Sports

 For example, say you're shooting in Portrait mode. Check out the Shooting Settings screen; you can adjust the Shoot by Ambience or Shoot by Lighting or Scene Type settings.

 Conversely, say you're in Creative Auto mode and want to change the Shoot by Lighting or Scene Type — and realize you can't. You have to switch to another mode if you want to control those settings.

 When you find a favorite combination, make sure to come back to it.

2. **The manual tells you to press Live View now, but you don't have to. You can also make these adjustments from the standard Quick Control screen.**

 Unless your monitor has gone dark to save power, you see the Shooting Settings screen, as shown on the left image of Figure 3-13. If the monitor is dark, just nudge the shutter button to wake the camera and display the screen.

Daylight Tungsten Light

Figure 3-12: Changing the lighting can have a significant impact on the overall photo.

3. Either way, press Q to activate the Quick Control screen, as shown in Figure 3-13.

4. Use the multicontroller to select Shoot by Ambience or Shoot by Lighting or Scene Type.

Note: The two options aren't labeled until you press Q (as shown in Figure 3-13), and even then, you have to pay attention to the label that appears at the bottom of the screen. Before that, you see the setting that's active, not the option name.

You can jump to Step 6 by using the Quick Control dial here. You can scroll through all the available options for the setting you're modifying. The advantage of using the Quick Control dial now is speed. You don't need to press a button, scroll to an option, and press the button again. On the other hand, you don't see all the options at once, and those could help you keep track of what you're doing.

5. Press Set.

This opens up the choices for each option, as shown in the left images of Figures 3-14 and 3-15.

6. Scroll down by using the Quick Control dial or the multicontroller and then highlight a setting.

You have a lot of choices. Remember that Ambience is how you want the photo to look, and Lighting reflects the conditions.

7. Ambience settings

- *Standard:* The default; produces a standard-looking photo. (Refer to Figure 3-13.) In Portrait or Landscape modes, the Standard Ambience setting isn't the same as for other shooting modes.

- *Vivid:* A photo with more contrast and saturation than the Standard setting.

- *Soft:* Softens focus.

- *Warm:* Warms (adds a reddish-orange color cast) as it softens.

- *Intense:* Boosts contrast and saturation, as shown in upcoming Figure 3-16. See the left image of Figure 3-14 to see changing the Ambience setting to Intense.

- *Cool:* Adds a cool (in other words, blue) color cast to the photo.

- *Brighter:* Lightens the photo.

- *Darker:* Darkens the photo.

- *Monochrome:* Creates a black-and-white photo, with an optional color tint.

If you want to know what happens behind the scenes, Shoot by Ambience settings change the current shooting mode's Picture Style (covered in Chapter 8) by increasing or decreasing Sharpness, Contrast, Saturation, and Color Tone. So, choosing Soft doesn't actually change the focus; it just doesn't sharpen the photo as much as the other settings. Each setting can also trigger an up or down change in Exposure Compensation (covered in Chapter 7). All Shoot by Lighting or Scene Type does is change the camera's white balance (which you can read about in Chapter 8).

Figure 3-13: Activate the Quick Control screen to change Ambience and Lighting.

Figure 3-14: Making a Shoot by Ambience setting change.

Shoot by lighting or scene type

Default setting
Daylight
Shade
Cloudy
Tungsten light
Fluorescent light
Sunset

Close-up

Intense

ISO AUTO Daylight

Q RAW+▲L [162]

Figure 3-15: Select the lighting that matches the scene.

For Ambience settings, you can use the multicontroller to highlight the Ambience strength (as shown in the right panel of Figure 3-14), and then use the Quick Control dial to dial in a new value. This allows for further customization.

8. **Lighting or Scene Type**

- *Default:* Determines the lighting conditions automatically.

- *Daylight:* For when subjects are in direct sunlight, as shown in Figures 3-16.

- *Shade:* For when subjects are outdoors on a sunny day but in the shade.

- *Cloudy:* Optimized for cloudy or overcast days.

- *Tungsten Light:* For when the primary light source is tungsten, filament-based lighting.

- *Fluorescent Light:* Correctly interprets fluorescent lighting.

Figure 3-16: An Intense, Daylight close-up of an interesting nut and bolt.

- *Sunset:* For when you're shooting into the sun at sunset.

9. **Press Set to lock in the setting.**

That's it. You return to the Shooting Settings screen, and you see your new setting displayed, as shown in the middle image of Figure 3-14 and the right image of 3-15. You're ready to shoot.

Exploring Live View Shooting and Movie Making

In This Chapter

▷ Getting acquainted with Live View mode

▷ Customizing the Live View display

▷ Exploring Live View and movie autofocusing options

▷ Recording movies

▷ Playing and trimming your movies

*A*t first glance, it may seem odd that we chose to cover two seemingly unrelated functions — Live View still photography and movie recording — in the same chapter. As you explore these features, however, you quickly discover that they involve many of the same buttons, tricks, and techniques, most of which are different from those you use for normal, through-the-viewfinder photography with the 60D.

With that organizational rationale out of the way, the first half of this chapter shows you the ins and outs of Live View photography, which you use to compose your images on the camera's LCD monitor rather than the viewfinder. The second half walks you through the steps of recording, viewing, and editing your digital movies.

Using Your Monitor as a Viewfinder

Live View is the now-standard name given to the camera feature with which you frame images via its LCD monitor rather than the viewfinder (as shown in Figure 4-1), just as you may have done when using a point-and-shoot digital camera. On the 60D, you can opt for Live View shooting for still photography; and for movie recording, it's your *only* option because you can't use the viewfinder when making movies.

Either way, be aware of the following monitor-related tips and warnings any time you take advantage of Live View:

- **Consider your focusing methods.** You have a choice of three autofocusing methods, described later in this chapter, in addition to manual focus. These autofocusing options are different from those available during regular still photography, which we cover in Chapter 8.

- **Using Live View for an extended period can reduce picture quality and harm your camera.** When you work in Live View mode, the camera's innards heat up more than usual, and that extra heat can create the right electronic conditions for *noise,* a defect that gives pictures a speckled look. (Chapter 7 offers more information.) Perhaps more critically, the increased temperatures can damage the camera.

 If the symbol shown in the margin appears on the monitor, the camera is warning you that it's getting too hot. If you continue shooting and the temperature continues to increase, the camera automatically shuts off to prevent further damage. Don't let things get to that point, though. Your pictures will probably be noisy, and you risk permanently harming the camera. So when you see this symbol, turn off the camera or at least exit Live View mode to give the monitor a brief rest. Keep in mind that in extremely warm environments, you may not be able to use Live View mode for long before the system shuts down.

- **Aiming the lens at the sun or other bright lights also can damage the camera.** Of course, you can cause problems doing this even during normal shooting, but the potential risk increases when you use Live View.

- **Any time you use the camera monitor, whether composing a shot or reviewing images, you put extra strain on the battery.** Keep an eye on the battery level icon to avoid running out of juice at a critical moment.

- **The monitor display can wash out in bright sunlight.** You may find it difficult to compose outdoor shots in Live View mode although the 60D has improved the appearance of the LCD in sunlight. And of course, with the movable monitor, you often can adjust it to provide better viewing.

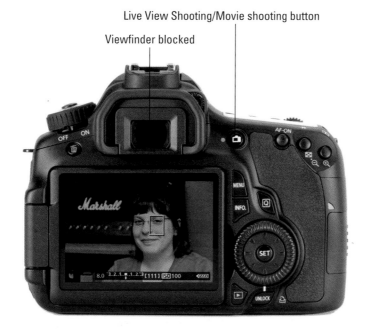

Live View Shooting/Movie shooting button

Viewfinder blocked

Figure 4-1: Using Live View on the 60D.

Taking Photos in Live View

Shooting still photos in Live View mode involves a few options that differ from those you encounter for regular photography with the 60D. In fact, there's even a separate Live View menu that contains options available only when the camera is in Live View mode.

The next several sections give you the background you need to know to fully exploit Live View on the 60D. Before you dig in, though, be aware of the following caveats about Live View photography:

✔ **Some photography features are disabled or limited in Live View mode.** Here's the list of affected features:

- *Flash:* Flash Exposure lock (covered in Chapter 7) is disabled. Additionally, non-Canon flash units don't work in Live View mode. And, here's one more quirk: When you take a flash shot in Live View mode, the camera's shutter sound leads you to believe that two shots have been recorded; in reality, though, only one photo is captured.

- *Continuous shooting:* You can use Continuous Drive mode (intro-duced in Chapter 2), but the camera uses the exposure settings chosen for the first frame for all images. And, as with flash shots, you hear two shutter sounds for the first frame in the continuous sequence.

- *Metering mode:* You cannot use center-weighted average, partial, or spot exposure metering; the camera always uses evaluative meter-ing in Live View mode. Chapter 7 explains metering modes.

- *Mirror Lock-Up and Set button functions:* You can't enable mirror lock-up (Custom Function III-5) in Live View mode. Also, none of the custom settings you apply to the Set button (Custom Function IV-2) work in Live View mode. Chapter 10 has more information on enabling Mirror lock-up.

✔ **You must be extra careful to keep the camera steady.** When you use the monitor to frame the image, you must hold the camera away from your body, a shooting posture that increases the likelihood of blurry images caused by camera shake. When you use the viewfinder, you can brace the camera against your face, creating a much steadier shooting stance. And, if you use a *long lens* (a telephoto or zoom lens that extends to a long focal length), the potential for camera shake is compounded. So, for best results, mount the camera on a tripod when you use Live View, or choose an ISO that enables you to use higher shutter speeds. (Chapter 7 gets into the topics of ISO and shutter speed.)

✔ **Cover the viewfinder to prevent light from seeping into the camera and affecting exposure.** The camera ships with a little cover designed just for this purpose.

This laundry list of warnings doesn't mean that we're advising you not to use Live View, however — just that you shouldn't envision it as a full-time alternative to using your viewfinder. Rather, think of Live View as a special-purpose tool that can help in shooting situations where framing with the viewfinder is cumbersome.

Live View is helpful when doing still life tabletop photography, for example, especially in cases that require a lot of careful arrangement of the scene. Often, you want to place your camera at a low or high position to compose the subject with the drama and perspective you desire. Scrunching down or climbing on tippy toes to get your eye to the viewfinder can be a real hassle. With Live View, you can alleviate much of that bothersome routine (and pain) because you can see how things look in the monitor no matter the camera position. Low-angle landscape shots or close-ups are also a lot easier to shoot with Live View, especially when you zoom in to critically check focus.

With that lengthy preamble out of the way, the next few sections show you how to enable Live View and explain the process of Live View shooting.

Customizing Live View

Live View is enabled in the menu system on the 60D by default. That is, it's ready to be turned on the moment you need it, which you do by pressing the Live View button. Shooting Menu 4 (shown in Figure 4-2) contains the Live View settings. They are

Figure 4-2: Shooting Menu 4 houses Live View settings.

✔ **Live View Shooting:** Enable or disable Live View. When disabled, pressing the Live View button does nothing.

✔ **AF Mode:** Choose a Live View AF mode from this menu. Options are

- *Live mode:* This is the standard AF mode in Live View. It's slower than standard autofocus and requires that you move a focus rectangle over the subject.

- *Face Detection Live mode:* This AF mode can detect faces, which is great when you're photographing people or animals and the camera can reliably see their faces. In fact, it's ideal when shooting standard portraits and casual shots of your friends and family. The camera may not always be able to make out faces, however, in low light or when the subject is moving about or not looking directly at you.

- *Quick mode:* This mode uses the AF sensor the camera uses when you are in viewfinder mode, which is faster. The downside to Quick Mode is that it blanks out the Live View monitor when focusing.

We have more info on each AF mode in the next section.

✔ **Grid Display:** When you're doing the kind of work for which Live View is best suited, such as taking product shots or capturing other still-life subjects, the exact placement of objects in the frame is often important. To assist careful composition, the camera can display a grid on the monitor. You access the grid from Shooting Menu 4, and you can choose from two types of grids:

- *Grid 1:* Loosely spaced gridlines, as shown in Figure 4-3

- *Grid 2:* A tighter grid

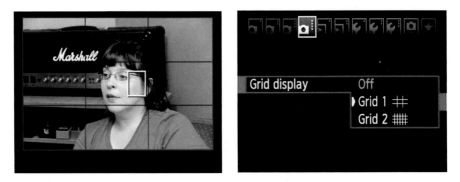

Figure 4-3: Enable the grid via the Grid display option on Shooting Menu 4.

✔ **Aspect Ratio:** The 60D takes photos with a traditional 3:2 *aspect ratio* (the relationship of a photo's width to its height) by default, but this isn't the only option. You can set the following aspect ratios from Shooting Menu 4 when shooting in Live View mode:

- *3:2:* The standard aspect ratio, derived from the aspect ratio of the sensor, which is the same as 35mm film. When photo quality is set to Large, photo dimensions are 5184 x 3456 pixels (18MP).

- *4:3:* The same aspect ratio as older televisions. When photo quality is set to Large, photo dimensions are 4608 x 3456 pixels (8MP).

- *16:9:* Creates photos with a widescreen appearance. When photo quality is set to Large, photo dimensions are 5184 x 2912 (15.1MP).

- *1:1:* Square photos. When photo quality is set to Large, photo dimensions are 3456 x 3456 pixels (11.9MP).

Aspect ratio isn't available when shooting in the Basic Zone and (for some reason) also when you're not using Live View. JPEGs are cropped, and the original data cannot be recovered. Raw photos, although they appear cropped, contain all the original data, which means you can change your mind about the aspect ratio later.

✔ **Exposure Simulation:** When enabled, the monitor displays the photo as it would look, given the current exposure settings. In other words, if you're underexposing the scene, the preview will be too dark. This is a great way to visualize exposure before you commit by taking the photo.

When disabled, you see a preview that is exposed so you can see it on the monitor better. It may bear little semblance to the actual photo.

✔ **Silent Shooting:** Choose from between two modes (plus disabling it) that sound and behave differently:

- *Mode 1:* This mode is quieter than normal but does not prohibit continuous or high-speed continuous shooting.

- *Mode 2:* Shooting noise is minimized at the expense of shooting speed. Taking a photo and holding down the shutter button prevents you from taking another photo. You have to release the shutter button halfway to be able to take another photo. Clearly, only single shots are possible in this mode.

 - *Disabled:* Turns off Silent Shooting; you hear more clunks and knocks (normal camera noise) as the mirror flips back and forth in the camera body.

- **Metering Timer:** Control how long the camera displays exposure information after you press the shutter button halfway and the camera meters the scene. The default is 16 seconds, but other values range from 4 seconds to 30 minutes.

Autofocusing in Live View mode

Live View mode offers three distinctly different autofocus modes, which we explain in the preceding section. This section shows you the basics of each mode. As you continue to read how to take photos in Live View mode later in the chapter, return here for detailed information on using autofocus modes.

Live mode

Live mode autofocus is best suited for shooting static subjects, such as landscapes, portraits, or still lifes. If you're shooting someone who is running all over the place, you're going to have an impossible time focusing and getting a good shot using Live mode.

To use Live mode, follow these steps:

1. **Set AF mode to Live mode:**

 a. *Press Menu, navigate to Shooting Menu 4, highlight AF Mode, (see the left image of Figure 4-4), and then press Set.*

 b. *Use the Quick Control dial or press up or down with the multicontroller to highlight an AF mode (see the right image of Figure 4-4), and then press Set again to lock in your choice.*

2. **Press the Live View button.**

 You see a white rectangle in the middle of the screen. This is the Live View AF point. This is the area the camera will "lock on" to when it focuses.

 That being said, the rectangle isn't always where you need it. That means you have to be ready to move it around, which, you will quickly realize, is a far cry from how fast autofocus works when you're using the viewfinder.

Figure 4-4: Selecting an AF mode for Live View shooting.

3. Move the AF point around the screen with the multicontroller.

This takes some skill with your fingers — and patience, while you wait for the box to move around.

If you want to reset the box to the center of the screen, press the Erase button, located on the back-left side of the camera.

4. Initiate autofocus by pressing the shutter button halfway or by pressing AF-ON.

The camera will attempt to achieve focus. When successful, it will beep at you, and the white box will turn green (see Figure 4-5). As long as you continue to hold the shutter button halfway down, autofocus is locked. If you release the button before taking the photo, autofocus is lost.

5. Take the photo.

If you're satisfied with the focus, composition, and exposure, go ahead and press the shutter button all the way down to take the photo.

Face Detection Live mode

Face Detection Live mode is best suited for taking portraits and casual shots of people and animals. The camera attempts to detect faces, automatically moves the AF point over faces, and then focuses. One big difference between this mode and the normal Live mode is that you don't have to move the focus box around the screen. The camera tries to automatically detect and frame faces with an

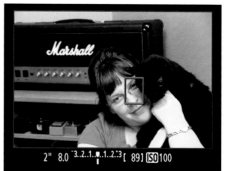

Figure 4-5: When the box turns green, you're in focus.

autofocus frame. That's right, *faces*. The 60D can detect multiple faces in the scene, which can cause confusion over which face to focus on. (You use the multicontroller to move the target over a different face.)

TIP

Face detection works best when people or animals are looking directly at the camera, and the most prominent features that make up their face (their eyes and mouth) aren't obscured by hair or other objects. Face detection becomes more problematic when your subject is in profile or turned mostly away from the camera.

This mode isn't foolproof, but it's faster than normal Live mode and may enable you to shoot Live View shots of casual get-togethers and parties without becoming so frustrated you blow a gasket.

To use Face Detection Live mode, follow these steps:

1. **Set AF mode to Face Detection Live mode:**

 a. Press Menu, navigate to Shooting Menu 4, highlight AF mode, and press Set.

 b. Use the Quick Control dial or press up or down with the multicontroller to highlight an AF mode, and then press Set again to lock in your choice.

2. **Press the Live View button.**

3. **Focus.**

REMEMBER

Detecting faces isn't the same thing as focusing. You still have to initiate autofocus by pressing the shutter button halfway or pressing AF-ON. When focus is achieved, the white focus box will turn green (see Figure 4-6), and you hear a beep.

If focus can't be achieved, the AF rectangle turns on. And if the camera can't detect a face in the scene, the normal AF rectangle is shown in the center.

4. **Take the photo.**

Press the shutter button all the way down to take the photo.

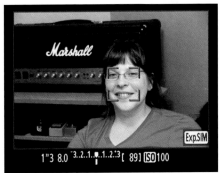

Figure 4-6: Face detection will follow a person around the screen.

Quick mode

Quick mode sounds great, and it certainly sounds quicker, but it has some quirks that you have to get used to:

- The monitor is blacked out when the camera is focusing. You can't see what's in the frame during this time. This can be disconcerting.

- Selecting an AF point (the same used by viewfinder AF modes) requires you to enter Quick Control mode. This takes more time than selecting AF points via the viewfinder. The good news is that it's not that different than selecting AF points in Quick Control mode normally.

Your mileage may vary, of course. We encourage you to find the situation where Live View autofocusing with Quick mode is the bee's knees for you.

To use Quick mode, follow these steps:

1. **Set the AF mode to Quick mode:**

 a. *Press Menu, navigate to Shooting Menu 4, highlight AF mode, and press Set.*

 b. *Use the Quick Control dial or press up or down with the multicontroller to highlight an AF mode, and then press Set again to lock in your choice.*

2. **Select a shooting mode.**

 This is a bit tricky. If you want to use the Quick mode in the simple no-frills way (described in Step 4), you can use any exposure mode the camera has, from Landscape to Portrait and up through M, P, Tv, and so forth.

 If you want to be able to control AF points, you must be in a Creative Zone mode (P, Tv, Av, M, B, or C). Right.

3. **Press the Live View button.**

 If the AF mode is set to Quick mode (as in Step 1), you see the familiar white AF box appear on the LCD monitor, only it's not an AF box anymore. It's a magnifying frame that you can move around later (there's not much point to it now) and check the focus with.

 When you want to confirm focus using whatever method you choose in Step 4, press the Magnify button once or twice to zoom in and use the multicontroller to move the frame around. It can take a bit of effort to work this into your routine unless you have the camera mounted firmly on a tripod.

Also present are the nine AF points, which are dark gray and seemingly don't do anything. At the moment, they don't.

4. **Focus by using one of two methods:**

 Automatic AF Point selection: This is the "Take what the camera gives you" method, which is (we think) where the term *Quick mode* comes from. It's pretty fast, but the camera doesn't always focus on what you want. This path requires nothing more from you other than this:

 a. *Press the shutter button halfway to initiate autofocus and meter.*

 The camera makes a lot more noise than normal as the mirror clunks in and out of the way as the camera autofocuses.

 As you press the shutter button halfway, the LCD screen will go black as the camera autofocuses. Try to stay motionless. When the picture comes back (see Figure 4-7), and not before, you're ready to take the picture.

 Don't be fooled. The camera sounds like you're taking a photo, but you're not. Don't stop after this step, thinking you've taken the photo. Wait until you see the photo being reviewed before moving on.

 b. *Check focus if desired, and proceed to Step 5.*

 Manual AF Point selection: The second path requires more work from you, but you get to control the focus points. Remember that you must be in a Creative Zone mode to be able to manually select AF points. Here's how:

 a. *Press Q (see Figure 4-1 if you need a refresher on the buttons on the back of the camera) to activate the Quick Control screen.*

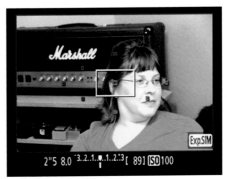

Figure 4-7: This is what you see after autofocus is achieved in Quick mode.

 By entering Quick Control, you have the ability to select the AF point just like you were using the viewfinder. It's a bit tricky until you get used to it.

 b. *Enter AF point selection mode by pressing and holding down the multicontroller until none of the options on the left side of the screen are highlighted in blue.*

 When this happens, one or more AF points become highlighted.

 c. Select an AF point by using the Quick Control or Main dial to scroll through the available AF points.

 d. Focus and then put the AF point over the subject and press the shutter button halfway.

 e. Check focus, if desired, and proceed to Step 5.

 5. Press the shutter button completely to take the photo.

Taking a shot in Live View mode

After you set up Live View the way you want it to work, follow these steps to take a picture:

1. Decide whether you want to use autofocusing or manual focusing, and set the lens to the appropriate position.

For manual focusing, set the lens switch to MF; for autofocusing, set it to AF. (You can see this in Chapter 1.) If you use a lens other than the kit lens sold with the 60D, the switch that shifts you to manual focus may sport a label other than MF. Consult the lens manual for specifics.

2. If the camera is mounted on a tripod, turn off the Image Stabilizer feature.

Image stabilization isn't necessary when you shoot with a tripod. And, because IS consumes extra battery power, turning it off is a good idea for Live View tripod shooting with most lenses. However, check your lens manual just to be sure: Some lens manufacturers vary in their recommendations on this issue.

3. Press the Live View button to switch from normal viewfinder operation to the Live View preview.

Your scene appears in the monitor, as shown in Figure 4-8. (If nothing happens when you press the button, return to the preceding section and follow the steps to enable Live View.)

Four display options are available during Live View shooting, so don't panic if your screen contains either more onscreen data than the one in the figure or no data. The next section explains the display options and how to interpret everything you see. For now, just press the Info button to cycle through the display modes.

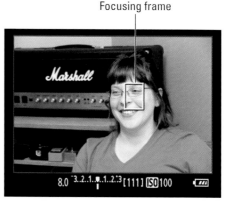

Focusing frame

Figure 4-8: Place the focusing frame over the point where you want to establish focus.

4. **Frame the shot.**

5. **Press the multicontroller to move the focusing frame over the spot where you want to focus.**

 The *focusing frame* is that rectangle in the center of the screen (refer to Figure 4-8).

 To put the focusing frame smack in the middle of the screen, press the Erase button (the one that sports the trash can symbol).

6. **If you're focusing manually, turn the lens focusing ring to set initial focus.**

 On the kit lens, the focusing ring is at the far end of the lens. (See Chapter 1, if you need help.)

 If you're using an autofocus method, press the shutter halfway to set initial focus.

7. **To magnify the view and verify focus, press the AF Point Selection button (optional).**

 This magnifies the area within the focusing frame. Your first press of the button magnifies the view by 5, as shown on the left in Figure 4-9. The second press zooms to 10X magnification, as shown on the right. Press again to return to the normal view.

 In the lower-right corner of the monitor is a label showing the current magnification level. Underneath that label, the box inside the small rectangle indicates the portion of the overall frame that's visible. If you need to, you can reposition the focusing frame to check another part of the image by using the multicontroller. Figure 4-9 shows the additional information that can be viewed when you press the Info button to change the display mode; again, we tell you more about that topic later in this chapter.

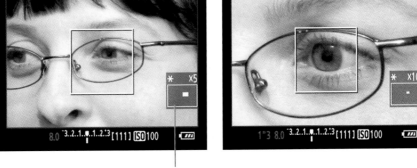

Magnified image area

Figure 4-9: Magnify the preview to double-check focus.

In this magnified view, you can fine-tune the focus manually (if you're using manual focus) or via auto focus by pressing the shutter button halfway. When the focus is sharp, move on to the next step.

8. **Press the shutter button fully to take the shot.**

 You see your just-captured image on the monitor for a few seconds before the Live View preview returns.

9. **To exit the Live View preview, press the Live View button.**

 You return to the standard Shooting Settings screen. You can then return to framing your images through the viewfinder.

Customizing Live View shooting data

When you first use Live View mode, you see your subject and the focusing frame. You can press Info to add basic shooting information (the exposure index, ISO, and battery indicator, to name a few) to the bottom of the display. A second press reveals an assortment of settings along the left side (white balance, AF mode, and so forth). A third press of the button adds a brightness histogram into the mix, and a fourth removes the histogram and adds the electronic level. Press Info again to cycle back to the default display.

Figure 4-10 serves as your road map to the maxed-out data display; the following list gives you the guided tour:

- ✒ **Data along the bottom of the screen is similar to data you normally see in the viewfinder display.** With the exception of the shots-remaining value and the battery level status, these settings relate to exposure issues you can explore in Chapter 7. Additional Flash Compensation and Highlight Tone Priority symbols (not shown in Figure 4-10) appear only if you enable those features from menus.

- ✒ **The Autofocus mode symbol appears regardless of whether you set your lens to manual or autofocus.** The symbol tells you which of the three possible Autofocus options is selected.

- ✒ **Some other symbols on the left side of the screen are the same as when you view shooting information in Playback mode.** We discuss this topic earlier in this chapter; here's a quick reminder:

 - • *Picture Style:* Chapter 8 details Picture Styles, which affect picture color, contrast, and sharpness. The symbol you see in Figure 4-10 represents the Standard style.

 - • *White balance:* The initials AWB, shown in the figure, represent Auto White Balance. To see what icons for other settings look

like and find out what white balance does in the first place, visit Chapter 8.

- *Drive mode:* The icon you see in the figure represents Single Drive mode, in which you capture one image for each press of the shutter button. See the end of Chapter 2 for information about other drive modes.

- *Quality:* This icon tells you the selected Quality setting, which Chapter 2 explains. The symbol shown in the figure represents the Large/Fine Quality setting.

- *AE (autoexposure) lock* and *flash status* are two more symbols you might see on your screen. Neither symbol appears if you don't use these features (they weren't used for Figure 4-10). Both are covered in Chapter 7.

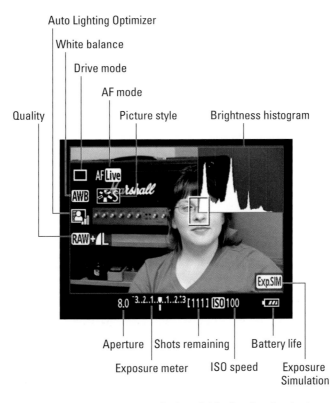

Auto Lighting Optimizer
White balance
Drive mode
AF mode
Quality
Picture style
Brightness histogram

Aperture Shots remaining Battery life
Exposure meter ISO speed Exposure Simulation

Figure 4-10: You can choose to display all this shooting data in the Live View frame.

✔ **Symbols you might see in the lower-right corner indicate the following:**

- *AEB:* This symbol appears when you enable automatic exposure bracketing (AEB), an exposure tool covered in Chapter 7. If you see an *FEB* indication (flash exposure bracketing), that function is possible only when you shoot with a compatible Canon Speedlite external flash. See the flash unit's manual for help with this option.

- *Exp.SIM:* This symbol, which stands for *Exposure Simulation,* indicates whether the image brightness you see on the monitor is simulating the actual exposure you will record. If the symbol blinks or is dimmed, the camera can't provide an accurate exposure preview, which can occur if the ambient light is either very bright or very dim. Exposure Simulation is also disabled when you use flash in Live View mode.

✔ **The brightness histogram is another tool you can use to gauge whether your current settings will produce a good exposure.** See the discussion on interpreting a brightness histogram in Chapter 5 to find out how to make sense of what you see. When you use flash, however, the histogram is dimmed; what you can see isn't accurate because it doesn't reflect the exposure as it will be when the flash is used.

Using the Quick Control screen in Live View mode

Chapter 1 explains how you can use the Quick Control screen to adjust certain camera settings. In Live View mode, you can use the Quick Control method to adjust the Picture Style, White Balance, Drive mode, and Quality settings. If you opt for Live View autofocusing, you also can adjust the autofocusing mode.

To use this feature, press the Quick Control button to activate the strip of icons on the left side of the screen. Then use the multicontroller to highlight the option you want to adjust. Text appears at the bottom of the screen to show you the current setting. For example, in Figure 4-11, the White Balance option is highlighted; the text label shows the Auto setting selected. (See Chapter 8 for the full story on White balance.)

After you highlight an icon on the left side of the screen, rotate the Main dial to cycle through the available settings. Press the Quick Control

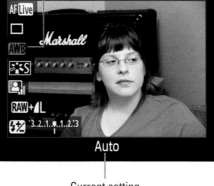

Figure 4-11: Press the Quick Control button to use the Live View version of the Quick Control screen.

button again (or half-press the shutter release) to return to the normal Live View display and take the picture.

 To adjust other picture-taking settings, you can use the standard menu or button/dial operations. For example, to adjust ISO, press the ISO button and rotate the Main dial.

Recording Movies

The 60D raises the bar again with its full high-definition (HD) movie recording. You don't have quite as many recording options as with a *real* (dedicated) video camera but — trust us — you can make outstanding movies with your camera.

Before delving into the specifics, here's a broad overview of moviemaking:

✔ **Movie quality:** You can record movies at five different quality levels. (See Table 4-1.) In this case, *quality* means two attributes: pixel dimensions and frame rate. The setting you choose determines the frame size and aspect ratio of the movie:

- *Full high definition:* 1920 x 1080

- *High definition:* 1280 x 720

- *Standard definition:* 640 x 480

The two higher-quality settings produce movies that have a 16:9 aspect ratio, which is used on many nwew TV sets and computer monitors. The 640 x 480 setting delivers a 4:3 format, like CRT monitors and TVs.

Table 4-1	Video Size and NTSC Frame Rates		
Quality Setting	*Pixel Size*	*Frames per Second (fps)*	*Minutes per 4GB Card*
Full High Definition	1920 x 1080	30	12
Full High Definition	1920 x 1080	24	12
High Definition	1280 x 720	60	12
Standard Definition	640 x 480	60	24
Movie Crop	640 x 480	60	24

These figures are for NTSC video systems used in the United States and Japan, among other countries. Frame rates are different for PAL systems. When shooting PAL video, 25 fps takes the place of 24 fps, and 50 fps is used instead of 60 fps. To sum, NTSC operates at 60 or 30 fps, and PAL operates at 50 or 25 fps. 24 fps is the worldwide default for film.

The higher the Quality setting, the larger the size of the file needed to store the movie. At the highest setting, you can fit about 12 minutes of movie on a 4GB memory card; drop the setting to 640 x 480 and you can double the length of the movie. The Quality setting also determines the frame rate, explained next.

✓ **Frame rate:** The *frame rate* determines the smoothness of the playback. Using the Full HD setting, you can choose either 24 or 30 frames per second (fps). At the other three settings, the frame rate is 60 fps, which not only makes for smooth playback but also gives you the option for some neat slow-motion effects. Most of us see no noticeable difference between 30 and 24 fps unless your movies include a lot of motion or if you *pan* (move the camera across the scene) during your recording.

✓ **Maximum file size:** The maximum file size for a movie is 4GB, regardless of the capacity of your memory card. When a movie reaches the 4GB limit — or 29 minutes and 59 seconds (29:59) — the camera automatically stops recording. You can always start a new recording, however, and you can join the segments in a movie-editing program later, if you want.

✓ **Use larger memory cards for longer movies:** Because a 4GB card doesn't hold a full 4GB of data, you can't record a 4GB movie on a 4GB card. If you want to get the full 29:59, recording time in a single video clip, you have to use a card larger than 4GB. Table 4-1 shows movie pixel dimensions, frame rates, and recording times.

✓ **Sound recording:** You can record sound or shoot a silent movie. If you enable sound, note the position of the microphone: It's the little four-hole area on the front of the camera, just above the EOS label, as shown in Figure 4-12. Don't inadvertently cover the microphone with your finger! And keep in mind that anything *you* say is picked up by the mic along with any other audio present in the scene. For better sound quality in your movies, use an optional microphone with the new External Microphone IN terminal (right above the remote control terminal on the camera's left side). This terminal lets you record in stereo (see Figure 4-13) if you attach a stereo microphone.

Microphone (mono)

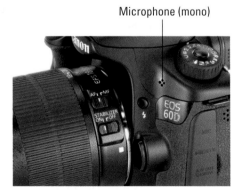

Figure 4-12: These tiny holes lead to the camera's internal microphone.

✔ **Video format:** Movies are created in MOV format, which means that you can play them on your computer with most movie-playback programs. If you want to view your movies on a TV, you can connect the camera to the TV, as explained in Chapter 10. Or, if you have the necessary computer software, you can convert the MOV file to a format that a standard DVD player can recognize and then burn the converted file to a DVD. You also can edit your movie in a program that can work with MOV files.

✔ **Still picture capture:** You can snap a still shot during a movie recording session. See the later section "Shooting your first movie" for details.

So far, so good. None of the aforementioned details is terribly unusual or complicated. Where things get a little tricky for the would-be filmmaker are in the areas of focus and exposure:

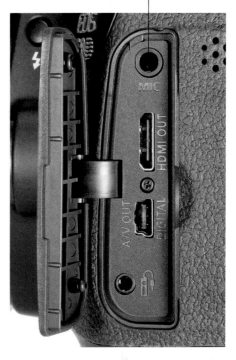

External microphone IN terminal (stereo)

Figure 4-13: Attach an external microphone for better sound quality.

✔ **Focus:** As with regular Live View photography, you can use autofocusing to establish initial focus on your subject before you begin recording. You can choose from the same three autofocusing options available for Live View shooting, which are explained in this chapter. By default, focus-while-recording is turned off; Figure 4-14 shows the menu selections to enable autofocus in movie mode. After these selections are turned on, you can initiate autofocusing again during the recording (by pressing the shutter release), but the focus mechanism tends to "hunt" for the focus point, going in and out of focus until it locks onto something. To boot, if you're using the internal microphone, you'll probably record the sound of the lens as it focuses, not an especially pleasant addition to your movies. So unless you're recording a static subject — say, a guitar player sitting on a stool or a speaker at a lectern — opt for manual focusing. You can then adjust focus manually any time during the recording.

Movie exposure Auto
AF mode ʼᴸʼ Live mode
AF w/ shutter button during '🎥
AF and metering butt. for '🎥
'🎥ISO speed setting increments
'🎥Highlight tone priority

AF w/ shutter button during '🎥
Disable
Enable

Figure 4-14: Turning on Autofocus during movie recording.

If you plan to zoom in and out, practice before the big event. It's a bit of a challenge to zoom and focus at the same time, especially while holding the camera in front of you so that you can see the monitor. (Using a tripod makes the maneuver slightly easier.)

✔ **Exposure:** The camera automatically sets exposure based on the light throughout the entire scene. However, you can apply Exposure Compensation, which gives you some control over the autoexposure result, and you can apply AE Lock (autoexposure lock) to force the camera to stick with a certain set of exposure settings even if the light in the scene changes. See the next section to find out how to use these two features during movie recording.

For the ultimate in exposure control, you can manually set the shutter speed and aperture by turning on manual exposure control from Movie Menu 2 (see Figure 4-15). Of course, if you choose manual exposure control for a movie, you're responsible for making sure it's properly exposed. In other words, unless you're trying for creative control or you can't help but experiment, Auto mode is safest for your movie recording needs. If you do use manual exposure for movie recording, you gain access to Highlight Tone Priority (shown in the figure) that helps preserve detail in bright areas of your subject.

Finally, all precautions related to Live View that we mention earlier in this chapter — including the information about the camera's internal temperature — apply to movie recording as well. (Flip to the earlier section "Taking Photos using Live View" for details.)

With those bits and pieces of information in mind, the rest of this chapter explains how to set up, record, and play movies.

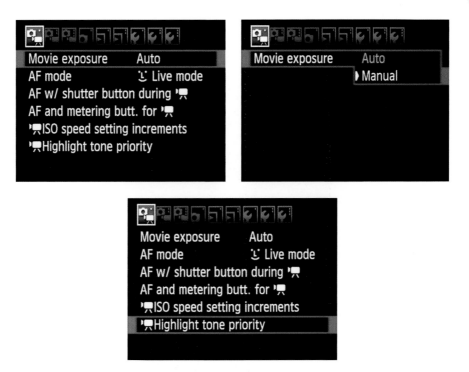

Figure 4-15: Movie recording exposure options.

Changing the information display

After you set the Mode dial to Movie mode, the viewfinder turns off, and you see your scene on the monitor. Initially, the screen looks like the one you see in Figure 4-16. The same focusing frame you get in Live View mode appears, and the bottom of the screen shows the exposure meter, battery status icon, and shots-remaining value. If you press the shutter button halfway to engage the autoexposure meter, you also see the camera's selected aperture (f-stop) and shutter speed, as shown in the figure.

As with Live View mode, you can press the Info button to change the display mode. This time, though, you have only four options: Display nothing but the focusing frame, show the exposure settings and battery level, see options (see Figure 4-17), and add the electronic level.

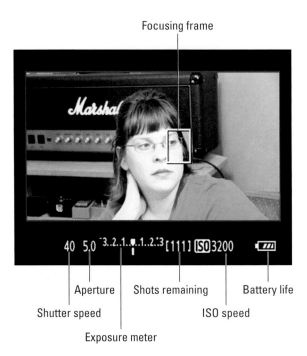

Figure 4-16: The default Movie display contains only a few pieces of shooting data plus the focusing frame.

A couple of items in these two figures warrant a little further explanation:

> ✔ **The shutter speed, ISO, and shots-remaining values relate only to any still shots you may capture during a recording session.** (See the later section "Shooting your first movie" for details on that trick.) For movie recording, the camera controls the aperture, shutter speed, and ISO settings for you to determine the exposure (unless you're manually controlling that aspect of the movie by enabling the Manual Exposure setting on Movie Menu 1).

> ✔ **The Picture Style and White Balance options work as they do for normal photography.** Picture Style affects color, contrast, and sharpness; White Balance enables you to deal with lighting conditions that may create an unwanted tint or color cast. Chapter 8 explains both features.

> ✔ **The exposure meter works as it does when you take still pictures in the Creative modes, which is to say that it indicates the amount of exposure compensation that's applied.** This feature enables you to request that the camera adjust the brightness of your next recording. It also affects any still shots you take. If the little white bar under the meter is at the center position, as shown in the figures, no compensation

has been applied. See the later section "Shooting your first movie" for help with this setting.

- The **Movie Size/Time Remaining** value shows you the recording size you selected along with the length of the movie that will fit on your memory card if you stick with that size.

- The **Still Quality** setting indicates the Quality option that will be used if you take a still photo. Chapter 2 explains the Quality option, which controls resolution and format (JPEG or Raw).

- The **Exposure Simulation icon works the same way as in Live View** mode although the little symbol is different. If it appears white, as in the figure, you can expect your movie to be about as bright as the live scene you see in the monitor. In very dim or very bright light, the monitor may not be able to provide an accurate representation of the movie brightness and lets you know by dimming the Exposure Simulation symbol. The movie still records at the best exposure settings the camera can select, however.

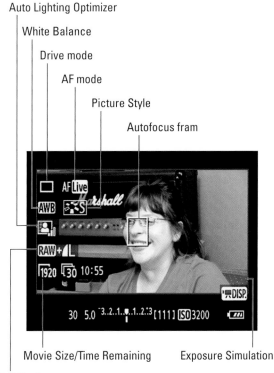

Auto Lighting Optimizer
White Balance
Drive mode
AF mode
Picture Style
Autofocus fram

Movie Size/Time Remaining Exposure Simulation
Still Quality

Figure 4-17: Press Info to reveal these additional shooting options.

Setting basic recording options

Before you begin shooting your first movie, review the basic recording settings. You adjust some settings from the Movie menus; for others, you can either visit menus or, for faster results, use the Quick Control method.

The next three sections provide some details on the recording settings; Table 4-2 offers a quick reminder of where you can find the various movie settings.

Table 4-2	Basic Movie Recording Options
To Adjust This Option	*Head for This Menu or Screen*
Movie size	Quick Control screen or Movie Menu 2
Sound recording	Movie Menu 2
Autofocus mode	Quick Control screen or Movie Menu 1
Picture style	Quick Control screen or Movie Menu 3
Still picture quality	Quick Control screen or Shooting Menu 1

Reviewing options on the Movie menus

The Movie menus contain several recording options, including the one that enables or disables sound. Before you can access the Movie menus, you must set the camera's Mode dial to the Movie setting. After your image appears on the monitor, press the Menu button and then find your way to the two Movie menus.

Here's a rundown of the menu options in Movie Menu 1 (shown earlier, in Figure 4-14):

- **Movie Exposure:** Normal recording is with autoexposure, but you can select Manual to have full control over your movie exposures.

- **AF Mode:** If you decide to try autofocusing, you can choose from three autofocus methods: Live mode, Face Detection, and Quick mode, which are covered earlier in this chapter. (Again, though, manual focusing is recommended.)

- **AF w/ Shutter Button During Movie:** Use this option to have the camera autofocus *during* movie recording when you press the shutter button. Remember that this setting can be distracting during playback — the image can drift in and out of focus — and the sound of the lens focusing mechanism might be recorded (and it ain't a pretty sound).

- **AD and Metering Button for Movies:** This setting works like a Custom Function. You can swap button functions for metering, AF start, AF stop, and AE lock between the shutter, AF-ON, and AE lock buttons.

- **ISO Speed Setting Increments:** Switch between 1/3 and full stop ISO increments when shooting movies.

- **Highlight Tone Priority:** Disables or enables Highlight Tone Priority, which works just like the still function; namely, the camera tries to protect highlights and keep them from blowing out.

Figure 4-18 shows the options under Movie Menu 2:

Figure 4-18: Turn sound recording on or off from the Movie menu.

✔ **Movie Recording Size:** Use this option to specify the movie quality setting. See the preceding section for details that will help you choose.

✔ **Sound Recording:**

- *Auto:* You want the camera to record sound with either the built-in microphone or an optional external stereo mic, and you don't want to mess with any settings.

- *Manual:* You want to set the recording level (microphone sensitivity) and wind filter option yourself. (This option tells the camera to try to minimize the effects of wind noise as if the microphone were protected by a wind barrier.)

- *Disable:* Turn off sound recording.

The bottom of the screen has an audio meter that shows you how strong the sound is as it is being monitored by the microphone. Audio levels are measured in decibels (dB), and the scale runs from –40 (very, very soft) to 0 (as much as can be measured digitally without running out of room).

Adjust the level of the source (tell someone to quiet down or speak up) or the Recording level yourself until the sound peaks consistently in the –12 range (as in Figure 4-19). The indicators on the meter turn yellow in this range, which is good. (The extra space, called *headroom,* gives you both a good signal and a comfortable margin of error.) If the sound is too loud, it will peak at 0, appear red, and cause distortion. You should avoid that if at all possible.

✔ **Silent Shooting:** These are the same options mentioned in the earlier Live View section.

✔ **Metering Timer:** This option works exactly as it does for regular Live View shooting. To recap: When you press the shutter button halfway, the exposure meter comes to life, and the camera then establishes the autoexposure settings needed to produce a good exposure. To save battery power, the meter goes to sleep after 16 seconds, but you can request a shorter or longer delay from the Metering Timer menu option.

(See Chapter 7 for a thorough explanation of the meter and exposure in general.)

✔ **Grid Display:** As with Live View shooting, you can display two different styles of grids to help keep your shots aligned properly. Choose Grid 1 for a loosely spaced grid (refer to Figure 4-2); choose Grid 2 for a more tightly spaced grid. For no grid, leave the option set to Off, the default.

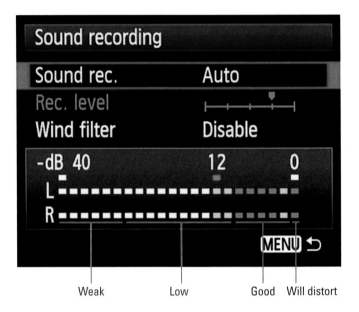

Figure 4-19: Monitor peak sounds levels to make sure they aren't too loud.

Movie Menu 3 has even more options:

✔ **Exposure Compensation:** You can apply exposure compensation for movies just like still photos although you have only three stops to work with instead of five. See Chapter 7 for more information on exposure.

✔ **Auto Lighting Optimizer:** This works just like still photos, as explained in Chapter 7.

✔ **Picture Style:** Likewise, you can assign a Picture Style (explained in Chapter 8) to movies.

✔ **White Balance:** Set the white balance for movies. Check out Chapter 7 for more info on white balance.

✔ **Custom White Balance:** As with stills, you can customize the white balance.

TIP

You also can adjust several of these settings from the Quick Control screen, which is faster than using the Movie menu. See the next section for details.

Adjusting settings from the Quick Control screen

As you can during Live View shooting, you can adjust some movie-recording settings by using the Quick Control technique. Follow these steps to use this method of adjusting recording settings:

1. Press the Quick Control button to enter Quick Control mode.

You see a column of control icons running down the left side of the screen. One of the icons is highlighted, as shown in Figure 4-20, and the bottom of the screen tells you the current setting for that option. In Figure 4-20, the White Balance setting is highlighted, for example, and Auto White Balance is in force.

2. Press up or down using the multicontroller to highlight the icon that represents the option you want to change.

As a reminder, from top to bottom, the icons enable you to adjust these settings:

- Autofocus Mode
- Still Photo Drive
- White Balance
- Picture Style
- Auto Lighting Optimizer
- Still Picture Quality
- Movie Size

The earlier section "Changing the information display" provides some insight on these settings.

Active option

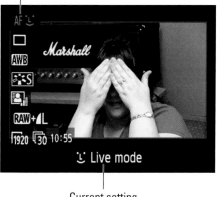

Current setting

Figure 4-20: Press the Quick Control button to shift to Quick Control mode and then use the Main dial to adjust the highlighted option.

3. Rotate the Main or Quick Control dial to change the setting.

Alternatively, press Set to see the full list of options on screen.

4. Press the Quick Control button again (or half-press the shutter release) to exit Quick Control mode and return to the normal display.

Shooting your first movie

When you're ready to try your hand at moviemaking, take these steps:

1. **Set the Mode dial to the Movie setting.**

 As soon as you select Movie mode, you can preview your shot on the monitor. You also see various bits of recording data on the screen; remember that you can press the Info button to cycle through the different data display modes if you want more or less screen clutter.

2. **Review and select the movie quality, sound recording, and other options as explained in the preceding sections.**

 If the Quality setting appears red, your memory card doesn't have sufficient free space to store your movie. You can try lowering the Quality setting; if that doesn't work, free some card space by deleting pictures. (Refer to Figure 4-17 for a look at the icon that represents the Quality setting; again, you may need to press the Info button to get to this display mode.)

3. **Compose your shot.**

4. **Set focus.**

 As in Live View mode, manual focusing is the best way to go, for all the reasons covered earlier in this chapter. So set the lens switch to MF and twist the focusing ring on the lens to bring your subject into focus.

 To double-check focus, you can use the same techniques as in Live View mode:

 - Use the multicontroller to move the focusing frame over the area you want to inspect. Then press the AF Point Selection button once to zoom to 5X magnification; press again to zoom to 10X magnification. Press the button once more to return to normal magnification.

 - To return the focusing frame to the dead center of the screen, press the Erase button.

5. **(Optional) Apply Exposure Compensation.**

 Exposure Compensation works much as you would expect in autoexposure Movie mode, except that you can shift it only through a range of –3 to +3 stops. (The camera will display up to five stops either way, but the extra two stops of exposure compensation will be applied only to still shots taken when you're in Movie mode.)

 To apply this exposure shift, rotate the Quick Control dial to display the exposure meter at the bottom of the screen. Move the bar under the meter to the right for a brighter picture; move the indicator left for a darker picture.

6. Press the Live View/Movie Shooting button to start recording.

A red "recording" symbol appears on the monitor, as shown in Figure 4-21.

In the full-data display mode — the one where all the setting icons appear on the left side of the screen — all icons except the movie recording Quality symbol disappear, as shown in the figure. Next to the icon, you no longer see the length of the recording that will fit on your memory card. Instead, the value represents the elapsed recording time.

7. To stop recording, press the Live View/Movie Shooting button.

That's all there is to the basic movie-shooting process. But we need to point out a few additional details: some minor, some not:

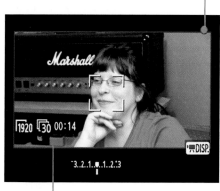

Recording light

Elasped time

Figure 4-21: The red dot indicates that you're recording.

 ✔ **Using AE Lock:** Normally, the camera adjusts exposure during the recording as needed. If you prefer to lock in the exposure settings, you can do so using AE (autoexposure) Lock. Just like shooting stills if you want to lock exposure during movie recording, press the AE Lock button. To cancel AE Lock, press the AF Point Selection button. Of course, you can *lock* exposure by using manual exposure mode when shooting movies too. It boils down to your preference as to which method you choose to lock exposure during movie recording.

 ✔ **Snapping a still photo during movie recording:** You can interrupt your recording to take a still photo without exiting Movie mode. Just press the shutter button as usual to take the shot. The camera records the still photo as a regular image file, using the same Picture Style and White Balance setting you set for your movie. The Still Quality setting determines the picture resolution and file format.

Here are a few drawbacks to capturing a still photo in Movie recording mode:

 • If you're shooting a movie at one of the two highest size settings, which capture a movie in the 16:9 aspect ratio, the area included in your still photo is different from what's in the movie shots. All still

photos have an aspect ratio of 3:2, so you gain some image area at the top and bottom and lose it from the sides. If the movie size is set to 640 x 480, your still photo still has a 3:2 aspect ratio.

- You can't use flash. Although your video might look okay, the light level may not be adequate for a good-looking still photo. You may be shooting in a situation where you want to use fill flash to light someone's face. You won't be able to if you take a still photo when shooting a movie.

- Perhaps most importantly, your movie will contain a still frame at the point you took the photo; the frame lasts about one second. Ouch. If you're savvy with a video editor, you can edit each still photo out of the video, but if you shoot 50 stills in 5 minutes of video, editing is going to take a while.

Data transfer alert

✔ **Using the right memory cards:** We mention this tip in Chapter 1, but it's important enough to repeat: For the best movie recording and playback performance, use memory cards that have a speed rating of 6 or higher. And, keep an eye out for the little data recording indicator shown here. The indicator shows you how much movie data the camera has in its *buffer* — a temporary data storage tank — awaiting transfer to the memory card. If the indicator level reaches the top, the camera stops recording new data so that it can finish sending existing data to the card. You can also try reducing the movie size setting to improve the transfer speed. If the recording progress indicator keeps hitting the limit, buy a faster memory card.

✔ **Turning off image stabilization:** If possible, turn off image stabilization to save battery power. On the kit lens, set the Image Stabilizer switch to the Off position.

✔ **Movie Crop mode:** The 60D includes a video mode that gives you, in effect, a 7X zoom lens for free when you're recording a movie. Available as a movie quality or size setting, Movie Crop captures the center 640 x 480 pixels to greatly magnify your movie image. Image noise may be more noticeable in this mode but, shucks, how can you *not* like a feature that gives you a big zoom like this!

✔ **Paying attention to camera temperature:** As in Live View mode, the camera's internal temperature may increase significantly during movie recording, especially if you're shooting in hot weather. The little thermometer symbol on the screen is your cue to stop recording and turn off the camera to allow it to cool. If you ignore the warning, the camera stops recording and prevents you from doing any more shooting until it cools.

Playing movies

Chapter 10 explains how to connect your camera to a television set for big-screen movie playback. To view movies on the camera monitor, follow these steps:

1. **Press the Playback button and then locate the movie file.**

 When reviewing pictures in full-frame view, you can spot a movie file by looking for the little movie camera icon in the upper-left corner of the screen, as shown in Figure 4-22.

 In Index playback, you see little "film sprocket" holes along the left edges of movie files. You can't play movies in Index mode, so use the Quick Control dial or multicontroller to highlight the file you want to view and then press the AF Point Selection button to open full-frame view.

2. **Press the Set button.**

 You see a strip of playback controls at the bottom of the screen, as shown in Figure 4-23.

Movie symbol

Figure 4-22: The little movie camera symbol indicates that you're looking at a movie file.

3. **Use the Quick Control dial or multicontroller to highlight the Play button and then press Set.**

 The control strip disappears, and your movie begins playing.

4. **To adjust the volume, rotate the Main dial.**

 Note the little white wheel in the volume display area of the screen. That icon reminds you to use the Main dial to adjust a setting. Rotating the dial controls only the camera speaker's volume; if you connect the camera to a TV, control the volume on the TV instead.

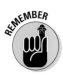

During playback, you can pause the movie and redisplay the control strip at any time by pressing Set. Here's a look at what the various controls do:

✓ **Play in slow motion:** Highlight the Slow Motion button and press Set. Press the multicontroller to the right to increase the slow-motion speed; press left to reduce it. (A little scale appears in the top-right corner of the screen to indicate where the current setting falls within the range of available slow motion speeds.) To exit slow-motion playback, press Set. The control strip reappears; highlight the Play button and press Set to view the movie at normal speed.

✔ **Display the first or last frame of the movie:** Highlight the respective frame button, labeled in the figure, and press Set.

✔ **Display the previous frame:** Highlight the Previous Frame button and press Set. Each press of the button takes you back a single frame.

✔ **Display the next frame:** Highlight the Next Frame button and press Set. Press repeatedly to continue advancing frame by frame.

✔ **Fast forward or rewind:** Highlight the Next Frame button and hold down the Set button to fast-forward (although "fast" is a relative term here). Highlight the Previous Frame button and hold down Set to rewind.

✔ **Edit:** Click this icon to open the Editing screen, where you can remove unwanted sections from the beginning or end of your movie.

✔ **Exit movie playback:** Highlight the Exit symbol and press Set.

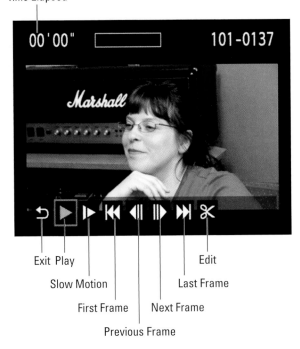

Time Elapsed

Exit Play

Slow Motion

First Frame

Previous Frame

Next Frame

Last Frame

Edit

Figure 4-23: To "press" a playback control button, highlight it and press Set.

Editing movies

Although never intended as a substitute for computer-based video editing software, the 60D Edit feature makes it delightfully easy to remove unwanted parts from the beginning or end of a movie — right on your camera. If you read that previous sentence carefully, you might be asking, "What if I want to cut that bad section in the middle of my movie, where I aimed the camera at my feet?" Well, that's why we have computers. This onboard editing is handy but basic, so don't expect miracles.

Here are the simple steps for trimming the start or finish of a movie:

1. **Click the Edit icon (it looks like a pair of scissors; see Figure 4-24) to enter the Editing screen.**

2. **Select the Cut Beginning icon or the Cut End icon to begin the editing process. (See Figure 4-25.)**

 In this example, we cut the last part of the movie. The bar at the top of the screen shows the playback position. In this example, you see that we're removing the first half of the movie; the blue area represents what remains of our edited creation.

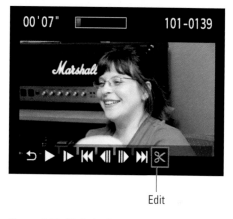

Edit

Figure 4-24: Click the Edit icon to open the Editing screen.

3. **Use the multicontroller or Quick Control dial to advance frame by frame.**

 If you hold down the multicontroller, you fast-forward (or fast-backward) in your movie. Do this until you find the last point at which you want to cut the movie. Press the Set button to remove that beginning or ending portion. The blue portion of the bar at the top of your screen (see the right side of Figure 4-25) shows what will be saved.

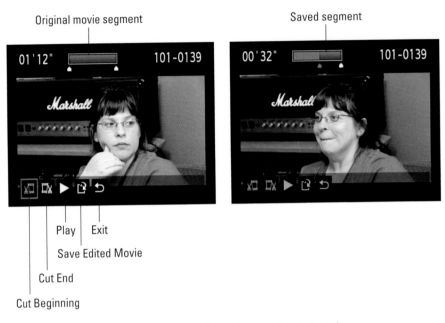

Figure 4-25: Camera editing controls to cut beginning or cut end of movies.

4. **Press the Save Edited Movie icon to commit your edit.**

 When you press Save (see the label in Figure 4-25), you're asked whether you want to save your edited movie as a new file or overwrite the original (see Figure 4-26). It's *much* safer to save the edited version as a new file. That way, if you ever decide that you did a lousy job (you edited out the cake cutting at your sister's wedding, for instance), you'll have your original movie on the memory card to save the day.

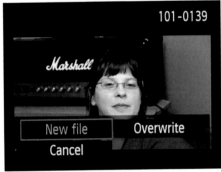

Figure 4-26: Saving the edited movie as a new file on the memory card.

Part II
Working with Picture Files

The 5th Wave By Rich Tennant

"Try putting a person in the photo with the product you're trying to sell. We generated a lot of interest in our eBay Listing once Leo started modeling my hats and scarves."

*Y*ou have a memory card full of pictures. Now what?

Turn to the first chapter in this part, which explains how to review, rate, sort, and delete picture from your memory card. You'll see how to adjust the amount of picture data that shows up on screen and what all the bits and pieces of information are.

After that, turn to the next chapter to find out how to get those pictures from your camera on to your computer — and, just as important, how to choose the right software to edit, process, and print them.

5

Picture Playback

*W*ithout question, one of the best things about digital photography is being able to view pictures right after you shoot them. No more guessing whether you got the shot you want or need to try again; no more wasting money on developing and printing pictures that stink. In fact, this feature alone was reason enough for many photographers to retire all their film-based hardware and chemistry. And as the LCD monitors on cameras have gotten sharper and have higher resolutions, reviewing in-camera photos has steadily become more reliable.

This chapter walks you through how to play back your pictures immediately. You'll see how to view one or more at a time, jump through photos, rotate, zoom, get more information about them, and more.

Additionally, this chapter explains how to delete pictures you don't like and protect the ones you love from accidental erasure. (Be sure also to visit Chapter 10, which covers some additional ways to view your images, including how to create in-camera slide shows and display photos and movies on a TV screen.)

Disabling and Adjusting Instant Review

After you take a picture, it automatically appears briefly on the camera monitor. By default, the instant-review period lasts just two seconds. You can customize this behavior via the Image Review option on Shooting Menu 1, as shown in Figure 5-1.

Figure 5-1: Extend or disable automatic picture review.

Highlight Image Review and then press Set. You can select

- ✔ **A specific review period:** Pick 2, 4, or 8 seconds.

- ✔ **Off:** Disable automatic instant review. Turning off the monitor saves battery power, so keep this option in mind if the battery is running low. You can still view pictures by pressing the Playback button. See the next section for details.

- ✔ **Hold:** Display the current image indefinitely, or at least until the camera automatically shuts off to save power. See the Chapter 1 section about Setup Menu 1 to find out about the auto shutdown feature.

Viewing Images in Playback Mode

To switch your camera to Playback mode and view the images on your memory card, take these steps:

1. **Press the Playback button, shown in Figure 5-2 and in the margin.**

 At the default settings, the camera displays a single picture at a time, with a row of picture data at the top of the frame, as shown in Figure 5-2. (The image information may be overlaid a bit differently on your LCD.) You can also display multiple images at a time; the next section tells all.

Info button

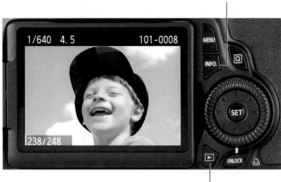

Playback button

Figure 5-2: The default Playback mode displays one picture at a time, with minimal picture data.

To find out how to interpret the picture data and specify which data you want to see, see the later section, "Viewing Picture Data."

2. **Press the multicontroller right or left to scroll through your pictures.**

 • *Right:* View images starting with the oldest one on the card.

 • *Left:* View images in reverse order, starting with the most recent picture.

 Just keep pressing right or left to browse through all your images.

3. **To return to picture-taking mode, press the Playback button or press the shutter button halfway.**

 You can also press AF-ON or change the exposure mode on the Mode dial to kick you out of Playback. The camera exits Playback mode and the Shooting Settings display appears on the monitor. Chapter 1 introduces you to that display.

Jumping through images

If your memory card contains scads of images, here's a trick you'll love: By using the Jump feature, you can rotate the Main dial to leapfrog through pictures rather than press the multicontroller right or left a bazillion times to get to the picture you want to see. You also can search for the first image shot on a specific date or tell the camera to display only movies or only still shots.

Set up the initial Jump mode by displaying Playback Menu 2 and highlighting Image Jump, as shown on the left in Figure 5-3. (The little symbol at the end of the option name represents the Main dial, in case you care.)

Highlight alert	Disable
AF point disp.	Disable
Histogram	Brightness
Image jump w/	
Slide show	
Rating	
Ctrl over HDMI	Disable

Image jump w/

Jump 10 images

Figure 5-3: You can specify a Jump mode from Playback Menu 2.

Press Set to display the right screen in Figure 5-3, where you can see all Jump mode settings:

- ✔ **1 Image:** This option, in effect, disables jumping, restricting you to browsing pictures one at a time. So what's the point? You can use this setting to scroll pictures by using the Main dial instead of the multicontroller, if you prefer.

- ✔ **10 Images:** Advance 10 images at a time.

- ✔ **100 Images:** Advance 100 images at a time.

- ✔ **Date:** If your card contains images shot on different dates, you can jump between dates with this option. For example, if you're looking at the first of 30 pictures taken on June 1, you can jump past all others from that day to the first image taken on, say, June 5.

- ✔ **Folder:** This option jumps you to the first photo in a different folder on the memory card. Pretty snazzy! (If you want to test this out, follow the steps provided in Chapter 10 to create a new folder. Then take at least one picture and save it to the new folder.)

- ✔ **Movies only:** Say your memory card contains still photos and movies. If you want to view only the movie files, select this option. Then you can rotate the Main dial to jump from one movie to the next without seeing any still photos.

- ✔ **Stills only:** This is the opposite of the Movies option: Your movie files are hidden from view when you use the Main dial to scroll photos. You scroll one picture at a time, just as when you use the 1 Image option.

- ✔ **Image rating:** If you've set ratings for one or more photos on the memory card, view only those, or only those photos with a specific rating. The upcoming section on rating photos explains how to assign a rating to pictures.

For any Jump mode except Image Rating, just highlight the mode you want to use and then press Set. If you select the Image Rating mode, use the Main dial to select a rating before you press Set. Then take the following steps to jump through your photos:

1. **Press the Playback button to put the camera into Playback mode.**

2. **Set the camera to display a single photo.**

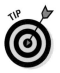

You can use jumping only when viewing a single photo at a time because the Main dial serves another function in Index playback. To leave Index mode, press the AF Point Selection button (the one marked with the blue magnifying glass with a plus symbol in it) until you see only one image on the monitor.

3. **Rotate the Main dial.**

The camera jumps to the next image. The number of images you advance, and whether you see movies as well as still photos, depends on the Jump mode you select.

If you select any Jump setting but 1 Image, a *jump bar* appears at the bottom of the monitor, as shown in Figure 5-4, indicating the current Jump setting.

You can change the Jump setting without having to return to Playback Menu 2. Press Q to enter Quick Control mode during Playback (that part is important), select the Image jump function at the bottom of the screen, and choose a new option.

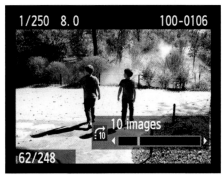

4. **To exit Jump mode, press another button or use the multicontroller or the Quick Control dial to switch to the next or previous photo.**

Figure 5-4: Press up on the multicontroller to cycle through the Jump mode options.

Now you're back to regular Playback mode, in which each right or left press of the multicontroller (or a turn on the Quick Control dial) advances to the next picture. You can return to your selected Jump mode by rotating the Main dial at any time while still in Playback mode.

Viewing multiple images at a time

To quickly review and compare several photos, set the camera to Index display mode and view thumbnails of either four or nine images at a time, as shown in Figure 5-5. Just press the AE Lock button, which is the center

button in the upper-right corner of the camera back (and shown in the margin). Press once to display four thumbnails at a time; press again to display nine thumbnails.

Selected photo Selected photo

Figure 5-5: View four or nine thumbnails at a time.

The little blue checkerboard and magnifying glass icons under the AE Lock button are reminders of the function the button serves in Playback mode. The checkerboard indicates the Index function, and the minus sign in the magnifying glass tells you that pressing the button reduces the size of the thumbnail image. (The white label above the button indicates a function related to picture taking.)

Remember these factoids about navigating and viewing your photo collection in Index display mode:

✔ **A highlight box surrounds the selected image.** For example, in the left screen in Figure 5-5, the upper-right photo is selected.

✔ **Use the multicontroller or Quick Control dial to select a different image.** As you can guess, press up to shift the selection box up, press right to move it right, and so on. Or, turn the dial clockwise to scroll through photos to the right and counterclockwise to go left.

✔ **Rotate the Main dial to scroll through screens of thumbnails.** Rotate right to shift to the next screen; rotate left to go back one screen.

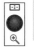

✔ **Press the AF Point Selection button to reduce the number of thumbnails.** This button lives right next door to the AE Lock button. It, too, has a blue magnifying glass icon, this time with a plus sign in the center to

indicate that pressing the button enlarges the thumbnail size. Press once to switch from nine thumbnails to four; press again to switch from four thumbnails to singe-image view, filling the screen with the selected image. To return to Index display mode, press the AE Lock button again.

Rotating vertical pictures

When you take a picture, the camera can record the image *orientation:* that is, whether you held the camera horizontally or on its side to shoot vertically. This bit of data is simply added into the picture file. Then when you view the picture, the camera reads the data and rotates the image so that it appears upright in the monitor, as shown on the left in Figure 5-6. The image is also rotated automatically when you view it in the photo software that shipped with your camera.

Figure 5-6: Display a vertically oriented picture upright (left) or sideways (right).

Don't confuse *portrait orientation* (taller than wide) with a portrait-type shot, or *landscape orientation* (wider than tall) with a landscape. (The terms *portrait* and *landscape* also apply to Picture Styles, a feature you can explore in Chapter 8.)

By default, automatic picture rotation is enabled. To turn it off, use the Auto Rotate option on Setup Menu 1, as shown in Figure 5-7. You also can specify that you want the picture to be rotated just on your computer monitor by choosing the second of the two On settings (the one that doesn't sport the little camera icon).

Figure 5-7: Go to Setup Menu 1 to disable or adjust automatic image rotation.

If you turn off automatic rotation, you can still rotate images during playback:

1. **Display Playback Menu 1 and highlight Rotate, as shown in Figure 5-8.**

2. **Press the Set button.**

 An image appears on the monitor (the right side of Figure 5-8).

3. **Navigate to the photo you want to rotate.**

 If you're viewing pictures one at a time, just press right or left using the multicontroller to scroll to the photo that needs rotating. In Index display mode, press right or left to put the highlight box around the photo. You can also scroll by using the Quick Control dial.

4. **Press the Set button to rotate the image.**

 Press once to rotate the image 90 degrees; press again to rotate 180 degrees from the first press (270 total degrees); press once more to return to 0 degrees, or back where you started.

5. **Press Menu to exit Rotate mode and return to Playback Menu 1.**

These steps apply only to still photos; you can't rotate movies during playback. See Chapter 4 for more about movie playback. You can also rotate photos during playback by entering Quick Control mode. Check out the upcoming section, "Entering Quick Control during playback."

Zooming in for a closer view

To more closely inspect a portion of a photo, press the AF Point Selection button (shown here in the margin). This feature is especially handy for checking small details, such as whether anyone's eyes are closed in a group portrait.

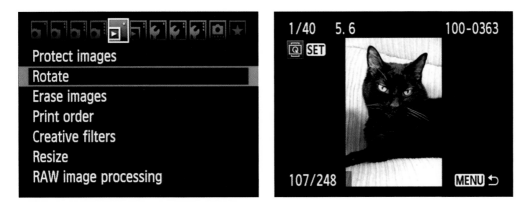

Figure 5-8: You also can rotate individual images from Playback Menu 1.

As with image rotating, zooming works only for still photos and only when you're displaying photos one at a time. So if you're viewing pictures in Index display mode, press the AF Point Selection button as many times as needed to display a single image on the monitor. Then use these techniques to adjust the image magnification:

✔ **Zoom in.** Press and hold the AF Point Selection button until you reach the magnification you want. You can enlarge the image up to ten times its normal display size.

✔ **View another part of the picture.** Whenever the image is magnified, a little thumbnail representing the entire image appears in the lower-right corner of the monitor, as shown in Figure 5-9. The white box indicates the area of the image that's visible. In the figure, for example, you see a magnified view of the left-center area of the chipmunk in Figure 5-9.

Use the multicontroller to scroll the display to view a different portion of the image.

✔ **View more images at the same magnification.** Here's an especially neat trick: While the display is zoomed, you can rotate the Quick Control dial to display the same area of the next photo at the same magnification. For example, if you shot a group portrait several times, you can easily check each one for shut-eye problems. If you rotate the Main dial, you skip ahead at the same magnification.

✔ **Zoom out.** To zoom out to a reduced magnification, press the AE Lock button. Continue holding down the button until you reach the magnification you want.

> ✔ **Return to full-frame view when zoomed in.** When you're ready to return the camera to the normal magnification level from being zoomed in (this doesn't work when viewing thumbnails), you don't need to keep pressing the AE Lock button until you zoom out all the way. Instead, press the Playback button, which quickly returns you to full-frame view.

Entering Quick Control during playback

As we mention earlier, you can enter Quick Control during playback and set several image properties. It's a snap.

1. **During playback, press Q.**

2. **Use the up and down arrows of the multicontroller to select a function from the left side of the screen (see Figure 5-10).**

 There's no need to press Set to activate the function. It happens automatically. You can tell what function you highlighted by the dialog title that appears at the bottom of the screen. The options appear under the function name. In this case, the Creative Filters are off. That needs to be rectified.

 You can choose from the following list of functions (starting with the icon in the upper-left corner):

 - *Protect Images:* Prevent photos from being accidentally deleted.

 Keep in mind that formatting the memory card does wipe out even protected photos.

 - *Rotate:* Rotate the current photo.

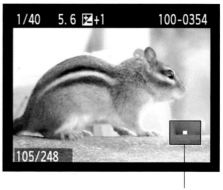

Figure 5-9: Press the multicontroller to scroll the display of the magnified image.

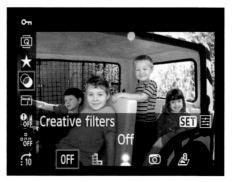

Figure 5-10: Scroll to select a function, and then options.

- *Rating:* Rate photos from zero to five stars.

- *Creative Filters:* Apply a filter to the selected photo. Options are Off, Grainy B/W, Soft Focus, Toy Camera Effect (applied in Figure 5-11), and Miniature Effect. (Find more about Creative Filters in Chapter 10.)

- *Resize:* Um, resize the current photo.

- *Highlight Alert:* If enabled, show areas of the photo that are too bright. These areas (quite often the sky or bright reflections) slowly blink. This alerts you that the exposure may be too bright, and you need to let less light into the camera. You'll see the "blink-ies" regardless of what display format you're in; more on that in the next section.

- *AF Point Display:* Shows or hides autofocus points when reviewing photos.

- *Image Jump:* Sets the jump behavior when using the Main dial during playback.

You can read more about rotating, rating, protecting, and jumping through images in other sections of this chapter. See Chapter 10 for a look at the Creative Filters, and visit Chapter 6 for information about photo size and resizing.

3. **Use the left and right arrows of the multicontroller to switch function settings.**

4. **Press Q again to exit Quick Control and return to Playback.**

 No need to press Set. The settings are locked in.

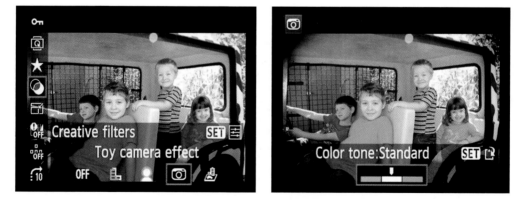

Figure 5-11: Apply a Creative Filter from the Quick Control in Playback screen.

Viewing Picture Data

When you review still photos, you can press the Info button to change the type and amount of shooting data that appear with the photo in the monitor. The next several sections offer a guide to the data-display options, starting with the most basic and advancing through the other playback display screens. See Chapter 4 to find out about the information displayed during movie playback.

Working display controls

Displaying photo information and changing the amount to display is a pretty simple matter. We cover the basic mechanics here and concentrate in subsequent sections on the type of information you see:

1. **Press the Playback button (shown in Figure 5-12) to enter photo Playback mode.**

 The amount and type of information displayed carries over. That is, if you chose to show no information last time you reviewed a photo, that's what you'll see this time.

2. **Press Info to change display formats.**

 The four types (each of which are covered fully in the following sections) are No Information, Basic Information, Detailed Information (which includes an overall brightness histogram), and Histogram.

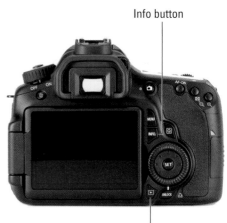

Info button

Playback

Figure 5-12: These two buttons control playback and how much info you see.

3. **Continue pressing Info to cycle through the different display formats.**

 When you find the one you want, leave the format there. When you return to Playback mode, you'll be in the same display format.

No Information (image only) display mode

In the first display mode, officially called No Information display, your LCD appears as shown in Figure 5-13.

As you might guess, No Information mode includes, well, no information. Well, almost. If the AF Point Display option is enabled in the Playback Menu 2 (or through the Quick Control screen), autofocus points show up as red rectangles corresponding to their location in the viewfinder.

If you shot the photo in Live View and used Live mode or Face Detection Live mode autofocusing methods (see Chapter 4 to decode all that), you see a focus rectangle instead of individual autofocus points. If you used Quick mode, which uses the camera's normal autofocus points, you will see them displayed.

Figure 5-13: The simplest Playback mode, No Information.

This information is present in all display modes if the option is enabled.

Regardless, you get to see a large, uncluttered view of your image. Pressing the Info button advances you to the next viewing mode.

Displaying basic information

Basic Information mode, shown in Figure 5-14, starts to spoon-feed you some details about your image.

Along the top of the screen are the following bits of information (labeled in Figure 5-14):

- ✔ **Shutter speed and f-stop (aperture):** Chapter 7 explains these two exposure settings.

- ✔ **Exposure compensation:** If you used exposure compensation for your shot, that value is noted at the top edge of the display (not shown in Figure 5-14). See Chapter 7 for info on exposure compensation.

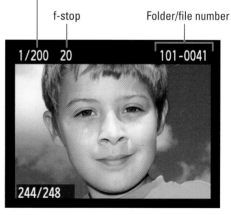

Shutter speed

f-stop

Folder/file number

Figure 5-14: Press Info twice for the Basic Information display.

✔ **Protection:** If you protected the image, a little key icon appears (not shown in Figure 5-14). You can find out how to protect your images later in this chapter; see "Protecting Photos."

✔ **Rating:** If you rated the photo, the rating is shown right by the folder and file number (not shown in Figure 5-14). See the section "Rating Photos" for details about image ratings.

✔ **Folder number and last four digits of file number:** See Chapter 1 for information about how the camera assigns folder and file numbers.

In the bottom-left corner of the LCD are two numbers separated by a slash (/): image number/total images. This pair of values shows you the current image number and the total number of images on the memory card. For example, in Figure 5-14, you see picture 244 of 248. (Don't confuse the image number with the file number; again, the last four digits of the file number appear in the top-right corner of the display, along with the folder number.)

All information presented in Basic Information mode is also included in the last two more comprehensive modes, too. It's a more-info-as-you-go approach, with a twist.

From Basic Information mode, press the Info button again to shift to Detailed Information display mode. There, you hit the mother lode of information, which we discuss next.

Detailed Information display mode

In Detailed Information display mode, the camera presents a thumbnail of your image along with scads of shooting data (see Figure 5-15). To open this screen, first display your photo in full-frame view. The Detailed Information display isn't available in Index display (when four or nine thumbnails are displayed at a time; see Figure 5-5). Then press the Info button as many times as needed to cycle through the four information display options until you see the one shown in the figure.

To sort out the maze of other data, it helps to break the display into five rows of information: the row along the top of the screen and the four rows that appear under the image thumbnail and histogram. One note

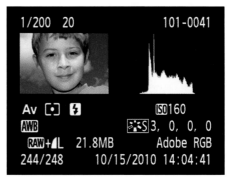

Figure 5-15: You can view more picture data in Detailed Information display mode.

about the next few figures, which detail what you see in each row: The figures include all possible symbols and values and other shooting data only for the purpose of illustration. If a data item doesn't appear on your monitor, it simply means that the feature wasn't enabled when you captured the photo.

The chart-like thingy on the top right side of the screen is an exposure-evaluation tool known as a *histogram*. You get schooled in the art of reading histograms in the next section.

Here is what appears in the five rows:

✔ **Row 1 data:** You see the same data that appears in the two basic display modes explained in the preceding section. This row doesn't change, regardless of whether you took the photo in a Creative Zone mode or in a Basic Zone mode.

✔ **Row 2 data:** Shift your attention to the row of symbols just underneath the thumbnail and histogram. These symbols are labeled in Figure 5-16:

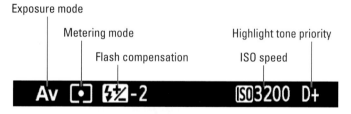

Exposure mode

Metering mode

Flash compensation

Highlight tone priority

ISO speed

Av 〔•〕 🔆2 -2 ISO3200 D+

Figure 5-16: This row contains additional exposure information.

- *Exposure mode:* This symbol indicates which of the camera's exposure modes you used: Full Auto, Av (aperture-priority autoexposure), or Portrait, for example. The symbols mirror what you see on the camera Mode dial. You can find details about all modes in Chapters 3 and 7.

- *Metering mode:* This symbol represents metering mode, which determines which part of the frame the camera uses when calculating exposure. Chapter 7 explains.

- *Flash/flash compensation amount:* See whether the flash fired — and if so, how much you adjusted the flash power using the Flash Compensation feature, detailed in Chapter 7, if any.

- *ISO speed:* Chapter 7 also explains this option, which controls the light sensitivity of the camera's image sensor.

- *Highlight Tone Priority:* If you enabled this exposure feature for the shot, you see the little D+ symbol. See Chapter 7 to find out how Highlight Tone Priority affects photos.

You see slightly less information on row 2 if you took the photo in a Basic Zone mode; compare Figure 5-15 with Figure 5-19 to see this in action with a Basic Zone mode photo showing both histograms. Settings not available in Basic Zone modes (Highlight Tone Priority and Flash Exposure Compensation, in this case) show up.

✔ **Row 3 data:** Information on this row of the display, labeled in Figure 5-17, relates mostly to color settings.

Here's the scoop:

Figure 5-17: Look to this row for details about advanced color settings.

- *White Balance setting:* Chapter 8 has details on this option, which helps ensure accurate photo colors. The setting shown in the figure, AWB, stands for Auto White Balance. When a custom color temperature is used, you see it displayed as a number. See the table in Chapter 8 for a look at the symbols representing other White Balance settings.

- *White Balance correction:* This collection of data tells you whether you applied an adjustment to the White Balance setting you used. Chapter 9 explains this advanced color option.

- *Picture Style:* The Picture Style symbol looks similar to the multi-controller on the camera back. Ignore the graphical aspect of the icon. The thing to key on is the letter, which tells you at a glance what picture style you used for the photo. The *S* in Figure 5-17 represents the Standard Picture Style, for example. The values to the right relate to four characteristics that you can adjust for each Picture Style. Chapter 8 explains how each Picture Style affects an image.

✔ **Row 4 data:** Shown at the top of Figure 5-18, this row tells you the following tidbits of information:

- *Quality and file size:* For details on the Quality setting and its effect on file size and picture quality, see Chapter 2. File size is shown in megabytes (MB). The Quality symbols shown during playback are the same ones used to indicate the Quality setting on the camera menus and Shooting Settings screen. Figure 5-15 (earlier in this chapter) shows the symbol that represents the Raw+Large/Fine setting. Chapter 2 has a chart to help you decode the other symbols.

- *Original decision data:* You can tag an image file with a hidden code indicating that the image hasn't been altered in a photo program or otherwise tampered with after it was captured. To check the code, you need a separate product, the Original Data Verification Kit, which retails for about $700, unfortunately. If you enable the feature on the camera, which we explain how to do in Chapter 10, a lock icon appears in this area of the playback screen.

- *Color space:* Your camera can capture images in two color spaces: sRGB and Adobe RGB. A *color space* is a definition of the spectrum of colors that an image can contain. You can change color spaces only in advanced exposure modes; Chapter 8 has details about how and why to do so.

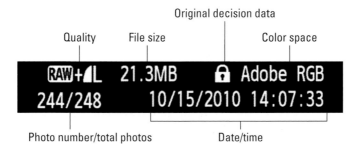

Figure 5-18: The bottom two rows of the display offer this data.

If the photo was shot in a Basic Zone mode, lighting or scene information (such as Daylight or Default setting) is displayed in place of original decision data and color space.

Row 5 data: Wrapping up the smorgasbord of shooting data, the bottom row of the playback screen holds three more pieces of information (refer to Figure 5-18):

- *Image number/total images recorded:* Again, this pair of numbers indicates the current image number with respect to the total number of images on the current memory card.

- *Eye-Fi card transmission status:* If you use these special memory cards, a small icon depicting a wireless connection appears on pictures that you downloaded to your computer wirelessly. This is not shown in Figure 5-18. (Visit www.eye.fi for details about Eye-Fi memory cards.).

- *Date and time:* These values show you the exact moment that the image was recorded. Of course, you must first set the camera date and time, as Chapter 1 explains.

TIP

If any area of the image thumbnail is blinking (in this or the previous display modes), you don't need a histogram to know that you may have an exposure problem. Blinking spots indicate pixels that are completely white. An abundance of blinking spots can indicate a problem known as *blown* or *clipped highlights,* where areas that should contain a range of light shades are so overexposed that they are instead a solid blob of white. Depending on where in the image those areas occur, you may or may not want to retake the photo. For example, if someone's face contains the blinking spots, you should take steps to correct the problem. But if the blinking occurs in, say, a bright window behind the subject and the subject looks fine, you may choose to simply ignore the alert. Just remember that blinkies indicate a lack of detail in those areas of an image.

Understanding Histogram display mode

A variation of the Shooting Information display, the Histogram display offers the data you see in Figure 5-19. Again, you see the thumbnail view of your image, but this time some of the extensive shooting data is replaced by additional histograms. And this is where the twist we mention earlier in this chapter comes into play. Just when you thought you were building a progressive crescendo of information as you moved from viewing mode to viewing mode, you actually see *less* printed info in the Histogram display mode. Detailed Information mode includes the most text about your image.

That's not to say that the histograms don't provide valuable information; the next two sections explain what knowledge you can glean from the histograms. See the preceding sections for a map to the other shooting data on the screen.

As with the Detailed Information display, this one is available only when you're viewing photos one at a time. If your monitor is showing four or nine thumbnails, press the AF Point Selection button to see full-frame view. Then press Info as needed to see the Histogram display.

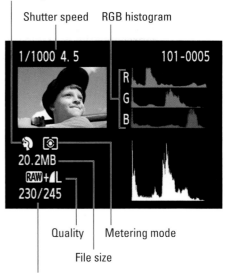

Figure 5-19: Histogram display mode replaces some shooting data with an RGB histogram.

Interpreting a brightness histogram

One of the most difficult photo problems to correct in a photo editing program is known as *blown highlights,* or *clipped highlights* in others. In plain English, both terms mean that *highlights* — the brightest areas of the image — are so overexposed that areas that should include a variety of light shades are instead totally white. For example, in a cloud image, pixels that should be light to very light gray become white because of overexposure, resulting in a loss of detail in those clouds.

In Shooting Information display mode, areas that fall into this category blink in the image thumbnail. This warning is a helpful feature because simply viewing the image on the camera monitor isn't always a reliable way to gauge exposure. The relative brightness of the monitor and the ambient light in which you view it affect the appearance of the image onscreen.

For a detailed analysis of the image exposure, check the *Brightness histogram,* which is a little graph that indicates the distribution of shadows, highlights, and *midtones* (areas of medium brightness) in an image, as shown in Figure 5-20. Photographers use the term *tonal range* to describe this aspect of their pictures. The Brightness histogram appears to the right of the image thumbnail in Shooting Information display mode and in the lower-right corner in Histogram display mode.

The horizontal axis of the graph represents the possible picture brightness values, from the darkest shadows on the left to the brightest highlights on the right. And, the vertical axis shows you how many pixels fall at a particular brightness value. A spike indicates a heavy concentration of pixels. For example, in Figure 5-20, which shows the histogram for the boy image in Figure 5-19, the histogram indicates a broad range of brightness values but with the majority of pixels falling between medium and dark brightness.

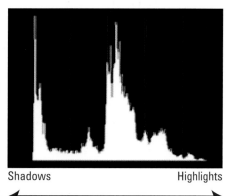

Shadows Highlights

Figure 5-20: The Brightness histogram indicates the tonal range of an image.

Keep in mind that there is no single "perfect" histogram that you should try to duplicate. Instead, you need to interpret the histogram with respect to the amount of shadows, highlights, and midtones that make up your subject. For example, the histogram in Figures 5-19 and 5-20 makes sense for this particular image because the subject has lots of midtones, with some dark tones

that shift the histogram to the left. Pay attention, however, if you see a very high concentration of pixels at the far right or left end of the histogram, which can indicate a seriously overexposed or underexposed image, respectively.

Reading an RGB histogram

When you view images in Histogram display mode, you see two histograms: the Brightness histogram (covered in the preceding section) and an RGB histogram, shown in Figure 5-21.

To make sense of an RGB histogram, you first need to know that digital images are known as *RGB images* because they're created from three primary colors of light: red, green, and blue. Whereas the Brightness histogram reflects the brightness of all three color channels rolled into one, RGB histograms let you view the values for each individual channel.

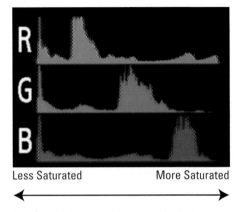

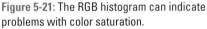
Less Saturated More Saturated

Figure 5-21: The RGB histogram can indicate problems with color saturation.

When you look at the brightness data for a single channel, though, you evaluate color *saturation*. We don't have space in this book to provide a full lesson in RGB color theory, but the short story is that when you mix red, green, and blue light, and each component is at maximum brightness, you create white. Zero brightness in all three channels creates black. If you have maximum red and no blue or green, though, you have fully saturated red. If you mix two channels at maximum brightness, you also create full saturation. For example, maximum red and blue produce fully saturated magenta. And, wherever colors are fully saturated, you can lose picture detail. For example, a rose petal that should have a range of tones from medium to dark red may instead be a flat blob of dark red.

The upshot is that if all the pixels for one or two channels are slammed to the right end of the histogram, you may be losing picture detail because of overly saturated colors. If all three channels show a heavy pixel population at the right end of the histograms, you may have blown highlights — again, because the maximum levels of red, green, and blue create white. Either way, you may want to adjust the exposure settings and try again.

A savvy RGB histogram reader can also spot color balance issues by look-ing at the pixel values. But frankly, color balance problems are fairly easy to notice just by looking at the image on the camera monitor.

If you're a fan of RGB histograms, however, you may be interested in another possibility: You can swap the standard Brightness histogram that appears in Shooting Information playback mode with the RGB histogram. Just visit Playback Menu 2, highlight the Histogram option, as shown on the left in Figure 5-22, and press the Set button to display the right screen in the figure. Select RGB instead of Brightness and press the Set button again.

For information about manipulating color, see Chapter 8.

Highlight alert	Disable
AF point disp.	Disable
Histogram	Brightness
Image jump w/	10
Slide show	
Rating	
Ctrl over HDMI	Disable

Histogram	▶ Brightness
	RGB

Figure 5-22: You can change the histogram type that appears in Shooting Information display mode.

Deleting Photos

When you spot a clunker during your picture review, you can erase it from your memory card in a few ways, as outlined in the next three sections.

Erasing single images

To delete photos one at a time, take these steps:

1. **Select the image you want to delete.**

 If you're viewing images in single-frame mode, just display the image on the monitor. In Index display mode, use the multicontroller to move the highlight box over the image thumbnail.

2. **Press the Erase button, shown in the margin.**

 The words *Cancel* and *Erase* appear at the bottom of the screen, as shown in Figure 5-23.

3. **Press the right side of the multicontroller to highlight Erase and then press the Set button.**

 Your picture is zapped into digital oblivion.

Figure 5-23: Highlight Erase and press Set to delete the current image.

If you accidentally erase a picture, don't panic. You *may* be able to restore it by using data-restoration software. Lexar (www.lexar.com) and SanDisk (www.sandisk.com) are two popular memory card companies that either sell or recommend recovery software to help you in case a card becomes corrupted or you accidentally delete images. To have a chance at recovering deleted data, you must *not* take any more pictures or perform any other operations on your camera while the current memory card is in it. If you do, you may overwrite the erased picture data for good and eliminate the possibility of recovering the image.

Erasing all images on your memory card

To dump all pictures on the memory card (make sure that you download them first!), take this approach:

1. **Display Playback Menu 1 and highlight Erase Images, as shown on the left in Figure 5-24.**

2. **Press the Set button to display the screen on the right in Figure 5-24.**

3. **Highlight All Images on Card and press the Set button.**

 After you press Set, a confirmation screen asks whether you really want to delete all your pictures.

 You can also choose to erase all the photos in a particular folder at this point. (See Chapter 10 for information on folders.) Highlight a folder and then press Set.

4. **Select OK and press Set to go ahead and dump the photos.**

 Note, though, that pictures you have protected, a step discussed two sections from now, are left intact.

5. **Press Menu to return to Playback Menu 1.**

 Or press the shutter button halfway to return to shooting pictures.

Protect images
Rotate
Erase images
Print order
Creative filters
Resize
RAW image processing

🗑 Erase images

Select and erase images
All images in folder
All images on card

MENU ↩

Figure 5-24: Use the Erase option on Playback Menu 1 to delete multiple images quickly.

Erasing selected images

If you want to erase selected, but not all, images on your memory card, you can save time by using this deleting option:

1. **On Playback Menu 1, highlight Erase Images (refer to the left image of Figure 5-24) and press Set.**

 You see the main Erase Images screen, shown in Figure 5-25.

2. **Highlight Select and Erase Images and press the Set button.**

 You see the current image in the monitor. At the top of the screen, a little check box appears, as shown on the left in Figure 5-26.

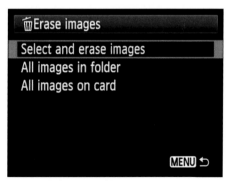

3. **Press up or down on the multi-controller to put a check mark in the box and tag the image for deletion.**

 If you change your mind, press the multicontroller up or down again to remove the check mark.

4. **Press the multicontroller left or right to view the next image.**

Figure 5-25: You can delete multiple selected images at once.

Marked for deletion

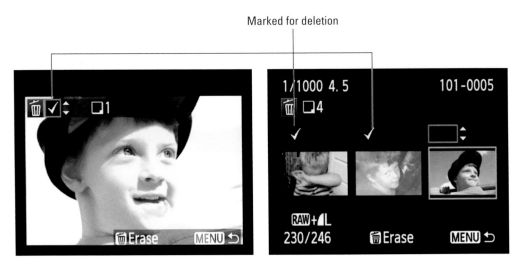

Figure 5-26: Use the multicontroller to select the boxes for images you want to delete.

5. Keep repeating Steps 3 and 4 until you mark all images you want to trash.

If you don't need to inspect each image closely, you can display up to three thumbnails per screen (refer to the image on the right in Figure 5-26). Just press the AE Lock button (zoom out), shown in the margin, to shift into this display. Again, just use up and down on the multicontroller to mark images for deletion, and use right and left to advance through images.

To return to full-frame view, press the AF Point Selection button (zoom in), shown in the margin. If you need an even closer look, keep pressing the button to switch from full-frame view to a magnified view. Use the techniques outlined earlier in this chapter, in the section "Zooming in for a closer view," to adjust the magnification power and scroll the display to view other areas of the image.

6. Press the Erase button.

You see a confirmation screen asking whether you really want to get rid of the selected images.

7. Highlight OK and press Set.

The selected images are deleted, and you return to the Erase Images menu.

8. Press Menu to return to Playback Menu 1.

Or, to continue shooting, press the shutter button halfway.

Deleting versus formatting: What's the diff?

Chapter 1 introduces you to the Format command, which lives on Setup Menu 1 and erases everything on your memory card. What's the difference between erasing photos by formatting and by using the Erase Images option on Playback Menu 1 to delete all pictures?

Well, in terms of pictures taken with your camera, none. But if you happen to have stored other data on the card, such as a music file or a picture taken on another type of camera, you need to format the card to erase everything on it. You can't view those files on the monitor, so you can't use the Erase Images feature to get rid of them.

Although using the Protect feature (explained next) prevents the Erase function from erasing a picture, formatting erases all pictures, protected or not. Formatting also ensures that the card is properly prepared to store any new images you may take.

Protecting Photos

You can protect pictures from accidental erasure by giving them protected status. After you take this step, the camera doesn't allow you to delete a picture from your memory card, whether you press the Erase button or use the Erase Images option on Playback Menu 1.

Formatting your memory card, however, *does* erase even protected pictures. For more about formatting, see the preceding discussion on deleting versus formatting.

The picture protection feature is especially handy if you share a camera with other people (unless they have a habit of formatting memory cards without asking). You can protect pictures so that those other people know that they shouldn't delete your outstanding images to make room on the memory card for their badly photographed ones. (This step isn't entirely foolproof, though, because anyone can remove the protected status from an image.)

Perhaps more importantly, when you protect a picture, it shows up as a read-only file when you transfer it to a computer, meaning that the photo can't be altered. Again, anyone with some computer savvy can remove the status, but this feature can keep casual users from messing around with your images after you've downloaded them to your system.

Of course, *you* have to know how to remove the read-only status if you plan to edit the photo in your photo software. *Hint:* In Canon ZoomBrowser EX, the free Windows-based software that ships with your camera, you can do this by clicking the image thumbnail and choosing File⇨Protect. This command toggles image protection on and off. In ImageBrowser, the Mac version of the Canon software, set the thumbnail display to List Mode and click the photo thumbnail. Then choose File⇨Get Info and click the Lock box to toggle file protection on and off. See Chapter 6 for help with using these programs.

Anyway, protecting a picture on the camera is easy. Just take these steps:

1. **Display Playback Menu 1 and highlight Protect Images, as shown on the left in Figure 5-27.**

Figure 5-27: Apply Protect Images status to prevent the accidental erasure of important images.

2. **Press Set.**

 From the Protect Images submenu (see the right image in Figure 5-27), you may choose

 • *Select Images:* Choose the photos you want to protect.

 • *All Images in Folder:* Protects all the photos in the current folder.

 • *Unprotect All Images in Folder:* This does the opposite, in case you downloaded those images and no longer need them protected.

 • *All Images on Card:* This is a handy option to protect all photos on the card. Note that it's not forward-looking; that is, it simply protects *existing* photos, and any photos you take after selecting this option are unprotected.

- *Unprotect All Images on Card:* The opposite of protecting all the photos on the card. Handy to clear everything, regardless of whether you know it's been protected or not.

3. To select photos to protect, highlight Select Images and then press Set.

An image appears on the monitor, along with a little key icon in the upper-left corner of the screen (indicating you are in Protect mode), but not above the photo (see the left side of Figure 5-28).

4. Navigate to the picture you want to protect.

Just press right or left on the multicontroller to scroll through your pictures.

5. Press Set to lock the picture.

Now a key icon appears with the data at the top of the screen, as shown in the right image of Figure 5-28.

6. Press the Menu button to exit the protection process.

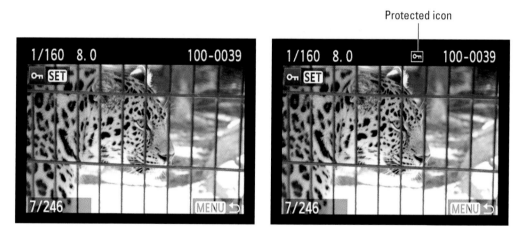

Figure 5-28: The key icon indicates that the picture is protected.

 To remove picture protection while the picture card is still in the camera, follow these same steps. When you display the locked picture, just press Set to turn off the protection. The little key icon disappears from the top of the screen to let you know that the picture is no longer protected.

Rating Photos

Many image browsers provide a tool that you can use to assign a rating to a picture: five stars for your best shots, one star for those you wish you could reshoot, and so on. But you don't have to wait because while shooting information is fresh in your mind, take care of this housekeeping task with your photos still on the memory card in your camera. This may help you remember particularly nice photos on location or over the course of time.

You can assign a rating to a photo in two ways. Here's the menu-based option:

1. **Press Menu and navigate to Playback Menu 2.**

2. **Choose Rating and then press Set.**

 This enters you in a form of Playback mode, with ratings appearing at the top of the screen, as shown in the image on right in Figure 5-29. The first icon is a star and the rating of the current photo. After this, you see a summary of the number of photos on the card with the given ratings.

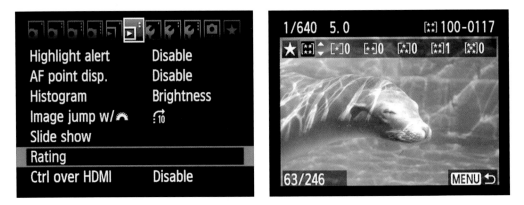

Figure 5-29: Rating photos is a great organizational tool.

3. **Press up or down on the multicontroller to change ratings for the given photo.**

 a. *Use left and right on the multicontroller to scroll through photos, one at a time.*

 The selected photo is highlighted.

 b. *Change the rating as before.*

Press the Reduce button to see three thumbnails at a time.

4. When finished, press Menu.

You can rate photos when in Quick Control mode during playback, as described earlier in the chapter; refer to Figure 5-11.

6

Downloading, Printing, and Sharing Your Photos

*F*or many novice digital photographers, the task of moving pictures from camera to computer — *downloading* — is one of the more confusing aspects of the art form. Unfortunately, providing you with detailed downloading instructions is impossible because the steps vary widely depending on which computer software you use to do the job.

To give you as much help as possible, however, this chapter starts with a quick review of photo software, in case you aren't happy with your current solution. Following that, you can find general information about downloading images, converting pictures that you shoot in the Raw (CR2; Canon Raw format) format to a standard format, and preparing your pictures for print and e-mail.

Choosing the Right Photo Software

Programs for downloading, archiving, and editing digital photos abound, ranging from entry-level software designed for beginners to high-end options geared to professionals. The good news is that if you don't need serious photo-editing capabilities, you can find free programs (including two from Canon) that should provide all the basic tools you require. We first take a

look at the Canon programs along with a few other freebies; following that, we offer some advice on a few popular programs to consider when the free options don't meet your needs.

Four free photo programs

If you don't plan on doing a lot of retouching or other manipulation of your photos and simply want a tool for downloading, organizing, printing, and sharing photos online, one of the following free programs may be a good solution:

- **Canon programs:** The CD that comes with your camera includes a number of Canon software tools, including Canon EOS Utility and ZoomBrowser EX MemoryCard Utility, both of which are small programs that simplify the process of downloading photos to your computer. (See the upcoming section "Sending Pictures to the Computer" for more information.) In addition, you get the following two photo viewing and editing programs:

 - *ZoomBrowser EX (Windows) and ImageBrowser (Mac):* This program (which goes by different names depending on whether you use a Windows-based or Macintosh computer), provides a simple photo organizer and viewer, as shown in Figure 6-1. It also offers a few basic photo editing features, including red-eye removal, a cropping tool, and exposure and color adjustment filters.

 - *Canon Digital Photo Professional:* Designed for more advanced users, this Canon product (see Figure 6-2) offers a higher level of control over certain photo functions. But its most important difference from ZoomBrowser/ImageBrowser is that it offers the tools you need to convert photos that you shoot in the Raw (CR2) format into a standard format (JPEG or TIFF). Chapter 2 explains formats; the upcoming section "Processing Raw (CR2) Files" shows you how to make the conversions using the program.

- **Apple iPhoto:** Most Mac users are very familiar with this photo browser, built in to the Mac operating system. Apple provides some great tutorials on using iPhoto at its Web site (www.apple.com) to help you get started if you're new to the program.

- **Windows Photo Gallery:** Some versions of Microsoft Windows also offer a free photo downloader and browser. In Windows 7 and Vista, the tool is Windows Photo Gallery.

- **Google Picasa:** Google offers a free, easy-to-use photo organizer (with limited editing capabilities) called Picasa. It's available for Mac and Windows computers. Check it out at www.google.com.

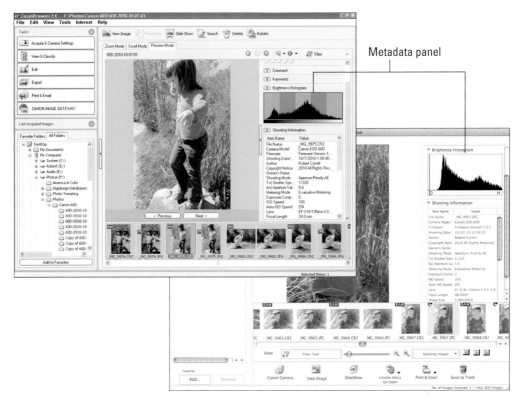

Metadata panel

Figure 6-1: Canon ZoomBrowser (left) and ImageBrowser (right) provide easy-to-use photo viewing and organizing tools.

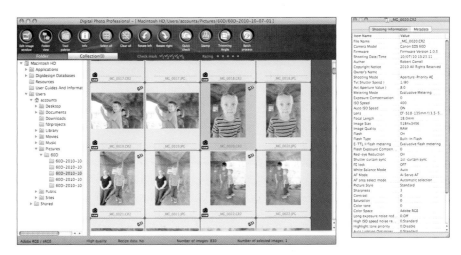

Figure 6-2: Canon Digital Photo Professional offers more advanced features, including a tool for converting Raw files to a standard picture format.

With most photo browsers, you must ask the software to search for and cata-log your photos or identify folders on your computer for the application to watch. If you use the program to handle the picture downloads, it typically catalogs pictures as part of the process. Check the program's Help system for details on taking the cataloging step and setting up the program as the default download tool.

After you download your photos, you can view camera *metadata* — the data that records the camera settings you used to take the picture — in the program, as follows:

 ✔ *ZoomBrowser EX/ImageBrowser:* Choose View➪Preview Mode to set the window to Preview mode, the mode used in Figure 6-1. The metadata panel then appears on the right side of the screen as a collection of expandable information groups.

 ✔ *Canon Digital Photo Professional:* Choose File➪Info to toggle the shooting information and metadata palette.

Many other photo programs also can display camera metadata but some-times can't display data that's very camera specific, such as the Picture Style. Every camera manufacturer records metadata differently, so it's a little diffi-cult for software companies to keep up with each new model.

Four advanced photo editing programs

Any of the programs mentioned in the preceding section can handle simple photo downloading and organizing tasks. But if you're interested in serious photo retouching or digital imaging artistry, you need to step up to a full-fledged photo editing program.

As with software in the free category, you have many choices; the following list describes a few that are most widely known:

 ✔ **Adobe Photoshop Elements (www.adobe.com, about $100):** Elements has been the best-selling consumer-level photo editing program for some time, and for good reason. With a full complement of retouching tools, onscreen guidance for beginners, and an assortment of templates for creating photo projects such as scrapbooks, Elements offers all the features that most consumers need. Figure 6-3 shows the Elements edit-ing window.

Figure 6-3: Adobe Photoshop Elements offers excellent photo editing tools.

- ✔ **Apple Aperture (www.apple.com, about $200):** Aperture is geared more to shooters who need to organize and process lots of images but typically do only light retouching work — wedding photographers and school portrait photographers, for example.

- ✔ **Adobe Photoshop Lightroom (www.adobe.com, about $300):** Lightroom is the Adobe counterpart to Aperture. In its latest version, it offers some fairly powerful retouching tools as well. Many pro photographers rely on this program or Aperture for all their photo organizing and Raw processing work.

- ✔ **Adobe Photoshop (www.adobe.com, about $700):** This program is for serious image editors only, not just because of its price but because it doesn't provide the type of onscreen help that you get with an entry-level editor, such as Elements. As you can see from Figure 6-4, which shows the Photoshop editing window, this isn't a program for the easily intimidated. Photoshop also doesn't include the creative templates and other photo crafting tools that you find in Elements. What you get instead are the industry's most powerful, sophisticated retouching tools, including tools for producing HDR (high dynamic range) and 3D images.

Not sure which tool you need, if any? Good news: You can download 30-day free trials of all these programs from the manufacturers' Web sites.

Figure 6-4: Adobe Photoshop is geared toward pros and heavy-duty photo editing enthusiasts.

Sending Pictures to the Computer

Whatever photo software you choose, you can take three approaches to downloading images to your computer: Use a memory card reader, connect the camera directly to the computer with the USB cable that came in your camera box, or go wireless with Eye-Fi. All transfer methods have their advantages, which we discuss in the next sections.

Connecting your camera and computer

You need to follow a specific set of steps when connecting the camera to your computer. Otherwise, you can damage the camera or the memory card.

Also note that for the process to work smoothly, Canon suggests that your computer run one of the following operating systems:

- Windows 7
- Windows Vista
- Windows XP with Service Pack 2 or 3 (SP2/SP3)
- Mac OS X 10.4 and higher

If you use another OS (operating system), check the support pages on the Canon Web site (www.canon.com) for the latest news about updates to system compatibility. You can always simply transfer images with a card reader, too.

With that preamble out of the way, these steps show you how to get your camera to talk to your computer:

1. **Assess the level of the camera battery and recharge it if it's low.**

 Running out of battery power during the transfer process can cause problems, including lost picture data.

 Alternatively, if you have an AC adapter, use it to power the camera during picture transfers.

2. **If your computer isn't already on, turn it on and give it time to finish its normal startup routine.**

3. **Make sure that the camera is turned off.**

4. **Insert the smaller of the two plugs on the USB cable into the A/V Out/ Digital port on the side of the camera.**

 This port is hidden under a little rubber door, just around the corner from the left side of the monitor, as shown in Figure 6-5. Gently pry open the little door and insert the cable end into the bottom mini-USB slot.

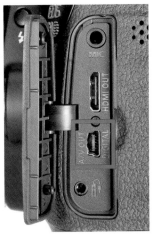

5. **Plug the other end of the cable into the computer's USB port.**

 Plug the cable into a port that's built in to the computer, as opposed to one that's on your keyboard or part of an external USB hub. Those accessory-type connections can sometimes foul up the transfer process.

6. **Turn on the camera.**

 Setting up the camera isn't necessary. Photo transfer with Canon EOS Utility works regardless of what mode the Mode dial is set to or whether the LCD monitor is turned toward you or into the camera.

Figure 6-5: Connect the smaller end of the USB cable here to download pictures.

What happens next depends on what software you choose to use to download photos. Aside from the card access lamp turning on briefly, there are no outward indications that the camera is in transfer mode. If you try to focus or take a photo, however, the viewfinder and LCD panel on top of the camera will display a "Busy" message.

For details about the next step in the downloading routine, move on to the next section.

Starting the transfer process

After you connect the camera to the computer (be sure to carefully follow the steps in the preceding section) or insert a memory card into the card reader, your next step depends, again, on the software installed on your computer and on the OS it runs.

Here are the most common possibilities and how to move forward:

- **On a Windows-based computer, a Windows dialog box (like the one shown in Figure 6-6) appears.** (The figure features the Windows XP version of the dialog box.) This dialog box suggests different programs you can use to download picture files. Which programs appear depends on what you have installed on your system; if you installed the Canon software, for example, one or more of those programs should appear in the list. To proceed, just click the transfer program you want to use.

Figure 6-6: Windows may display this initial boxful of transfer options.

Leaving the Always Do the Selected Action check box marked can have the unintended consequence of starting Canon software even if you use another non-Canon camera. De-conflicting cameras is a mess, frankly, if you want to use competing software download routines. If this is the case, clear the check box so you can choose the software to match the camera you're working with at the time.

- **An installed photo program automatically displays a photo download wizard.** For example, if you installed the Canon software, the EOS Utility window or MemoryCard Utility window may leap to the forefront. Or, if you installed another program, such as Photoshop Elements, its downloader may pop up instead. On a Mac, the built-in iPhoto software may display its auto downloader. (The Apple Web site, at www.apple.com, offers excellent video tutorials on using iPhoto, by the way.)

Usually, the downloader that appears is associated with the software you most recently installed. Each new program you add to your system tries to wrestle away control over your image downloads from the previous program.

If you don't want a program's auto downloader to launch whenever you insert a memory card or connect your camera, you should be able to turn off that feature. Check the software manual to find out how to disable the auto launch. Often, you can find this on/off switch in the software's Preferences area.

✓ **Nothing happens.** Don't panic; assuming that your card reader or camera is properly connected, all is probably well. Someone — maybe even you — simply may have disabled all automatic downloaders on your system. Just launch your photo software and then transfer your pictures using whichever command starts that process. You can find details on how to do it using the Canon software tools later in this chapter; for other programs, consult the software manual.

You could also use Windows Explorer or the Mac Finder to simply drag and drop files from your memory card to your computer's hard drive. The process is exactly the same as when you move any other file from a CD or DVD or another storage device onto your hard drive.

Again, it's impossible to give step-by-step instructions for using all the various photo downloaders that may be sprinkled over your hard drive. So we provide, in the next sections, details on using Canon software to download your files.

If you use other software, the concepts are the same, but check your program manual to uncover the small details. In most programs, you also can find lots of information by simply opening the Help menu.

Downloading images with Canon tools

The next two sections explain how to download pictures to your computer using two of the tools provided on the software CD that shipped with your 60D: Canon EOS Utility and MemoryCard Utility. Both actually are components of Canon ZoomBrower EX (Windows) and ImageBrowser (Mac).

Before you try the download steps, however, you may want to visit the Canon Web site and download the latest versions of the software in the suite. Even if you recently bought your camera, the shipping CD may be a little out of date. Just go to www.canon.com and follow the links to locate the software for your camera. (You can also download updated manuals.) In this book, the steps relate to the most current versions of the programs at time of publication: version 2.9 of the EOS Utility and version 6.6.0.23 for ZoomBrowser EX and ImageBrowser.

Using EOS Utility to transfer images from your camera

Follow these steps to transfer images directly from your camera to the computer using the Canon EOS Utility software:

1. **Connect your camera (turned off) to the computer.**

 See the first part of this chapter for specifics.

2. **Turn on the camera.**

 After a few moments, the EOS Utility window should appear automatically. If it doesn't, launch the program as you would any other on your system. Figure 6-7 shows the Mac version of the screen; the Windows version looks much the same.

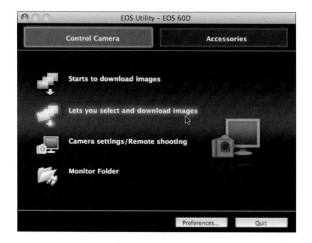

Figure 6-7: EOS Utility is designed for sending pictures from the camera to the computer.

3. **Click the Lets You Select and Download Images option, as shown in the figure.**

 Using this option, you can specify which pictures you want to download from the camera. After you click the option, you see a browser window that looks similar to the one in Figure 6-8, with thumbnails of the images now on your card. The figure shows the Mac version, but the Windows version contains the same components. Click the magnifying glass icons in the lower-right corner of the window to enlarge or reduce the thumbnail size.

4. **Select the images you want to copy to the computer.**

 In Windows, each thumbnail contains a check box in its lower-left corner. To select an image for downloading, click the box to put a check mark in it. Once again, the Mac version looks nearly identical.

 For a quick way to select all images, press Ctrl+A (Windows) or ⌘+A (Mac). Or choose Edit⇨Select Image⇨Select All. If you want to download all but a few images, an easy way is to first choose Select All and then deselect the unwanted images.

Figure 6-8: Select the thumbnails of the images you want to transfer.

5. Click the Download button at the bottom of the window.

A screen appears that tells you where the program wants to store your downloaded pictures. Figure 6-9 shows the Mac version of this notice; the Windows version contains the same options.

By default, pictures are stored in the Pictures or My Pictures folder in Windows (depending on the version of Windows you use) and in the Pictures folder on a Mac. You can put images anywhere you like; however, most photo editing programs look first for photos in those folders, so sticking with this universally accepted setup makes some sense.

Figure 6-9: You can specify where you want to store the photos.

6. Verify or change the storage location for your pictures.

If you want to put the pictures in a location different from the one the program suggests, click the Destination Folder button and specify the storage location and folder name you prefer. You also can choose to have the picture files renamed when they're copied; click the File Name button to access the renaming options.

7. Click OK to begin the download.

A progress window appears, showing you the status of the download.

8. When the download is complete, turn off the camera.

You can safely remove the cable connecting it to the computer.

That's the basic process, but you need to know a couple of fine points:

- ✔ **Setting download preferences:** While the camera is still connected and turned on, you can click the Preferences button at the bottom of the EOS Utility browser to open the Preferences dialog box, where you can specify many aspects of the transfer process.

- ✔ **Auto-launching the other Canon programs:** After the download is complete, the EOS Utility may automatically launch Canon Digital Photo Professional or ZoomBrowser EX (Windows) or ImageBrowser (Mac) so that you can immediately start working with your pictures. (You must have installed the programs for this to occur.)

 If you want to change the program that's launched, visit the Linked Software panel of the EOS Utility's Preferences dialog box. You then can select the program you want to use or choose None to disable auto-launch altogether.

- ✔ **Closing the EOS Utility:** The utility browser window doesn't close automatically after the download is complete. You must return to it and click the Quit button to shut it down.

Using MemoryCard Utility for card-to-computer transfers

With a card reader, you simply pop the memory card out of your camera and into the card reader instead of hooking the camera to the computer. Many computers and printers now have built-in card readers, and you can buy standalone readers for less than $30. *Note:* If you're using Secure Digital High Capacity (SDHC) or Secure Digital Extreme Capacity (SDXC) cards, the reader must specifically support that type.

Using a card reader offers two important advantages: First, you don't waste camera battery power. When you transfer directly from the camera, the camera must be powered up during the entire download process. Second, you don't have to precariously perch your camera on your computer desk, which likely has a keyboard, mouse, and other odds and ends on it. Dropping a $25 memory card reader is certainly less painful than dropping an expensive camera.

Transferring images from a memory card reader involves using the Canon MemoryCard Utility that comes with the Windows and Mac versions of ZoomBrowser EX and ImageBrowser. To try it out, take these steps:

1. Put your card in the card reader.

If all the planets are aligned — if the Canon software was the last photo software you installed and another program doesn't try to handle the job for you — the MemoryCard Utility window, shown in Figure 6-10,

appears automatically when you put your memory card into the card reader. The figure shows the Mac version of the window; the Windows version is identical except that the top of the window refers to ZoomBrowser EX, which is the Windows version of ImageBrowser.

If the window doesn't appear, you can access it this way:

Figure 6-10: Use MemoryCard Utility to transfer pictures via a card reader.

- *Windows:* Open the ZoomBrowser EX MemoryCard Utility program, using the steps you usually take to start a program.

- *Mac:* Start the program Canon Camera Window. The program should detect your memory card and display the MemoryCard Utility window.

2. **Click the Lets You Select and Download Images option.**

 You then see the browser window shown in Figure 6-11. The figure shows the Mac version; the Windows version contains the same basic components but follows conventional Windows design rules. Either way, thumbnails of the images on your memory card are displayed in the window.

Figure 6-11: Select images to download from the browser window.

3. **Select the images you want to download.**

 - *To select the first photo:* Click its thumbnail.

 - *To select additional pictures:* Ctrl+click (Windows) or ⌘+click (Mac) their thumbnails.

 - *To quickly select all images:* Press Ctrl+A in Windows or ⌘+A on a Mac. Or, depending on your operating system, do this:

 Windows: Choose Select All from the Select drop-down list, located on the toolbar near the top of the window.

 Mac: Choose Select All from the Select Image list, at the bottom of the window.

4. **Click the Image Download button.**

 In Windows, the button is near the upper-left corner of the browser window. On a Mac, it's in the lower-left corner (and for whatever reason, is named Download Images instead of Image Download).

 Either way, a new window opens to show you where the downloader wants to put your files and the name it plans to assign the storage folder, as shown in Figure 6-12.

 If you're not happy with the program's choices, click the Change Settings button to open a dialog box where you can select a different storage location. In the same dialog box, you can also choose to have the files renamed when they're copied. Click OK to close the Change Settings dialog box when you finish.

Figure 6-12: Set your files download destination.

 Most programs look first for photos stored in the location suggested initially by the downloader. In Windows, that folder is either Pictures or My Pictures, depending on which version of Windows you use. On a Mac, the folder is Pictures. Sticking with these default storage locations can simplify your life down the road, but of course you're free to set up whatever image-organization system works best for you.

5. **Click the Starts Download button.**

 Your files start making their way to your computer. When the download is finished, the MemoryCard Utility window closes and either ZoomBrowser EX (Windows) or ImageBrowser (Mac) appears, displaying the downloaded files.

Going Eye-Fi

The latest trend in photo downloading involves wireless transfer between the camera's memory card and your computer. At the moment, the leading brand of wireless memory card is Eye-Fi (www.eye.fi) although other card manufacturers (SanDisk, to name one) are also producing them.

You have to set up the wireless card on the camera and on your computer for the wireless transfer to work:

 ✓ **Camera setup:** The 60D has Eye-Fi compatibility built in and accessible through Setup Menu 1. Select Eye-Fi Settings to enable the transmission. *Note:* This menu is visible only if you have an Eye-Fi card in the camera.

 There is only one thing you need to set: Enable. You can also display connection information from the Eye-Fi menu to confirm the existence of the connection (it's better than guessing).

 ✓ **Computer setup:** You have to install software onto your computer for the Eye-Fi card to work. Refer to the card's manual for specifics. Eye-Fi cards are Mac/Win compatible.

Processing Raw (CR2) Files

Chapter 2 introduces you to the Raw file format, which enables you to capture images as raw data. One advantage of capturing Raw files, named *CR2* files on Canon cameras, is that *you* make the decisions about how to translate raw data into actual photographs. You can specify attributes such as color intensity, image sharpening, and contrast — which are all handled automatically by the camera if you use its other file format, JPEG.

The bad news: When you capture Raw files, you have to specify attributes, such as color intensity, image sharpening, and contrast before you can do anything with your pictures. Although you can print them immediately if you use the Canon software, you can't take them to a photo lab for printing, share them online, or edit them in your photo software until you process them using a raw converter tool. At the end of the process, you save the finished file in a standard file format, such as JPEG or TIFF.

If you decide to shoot in the Raw format, you can process your images in Digital Photo Professional, the Canon software that shipped with your camera. Or you can do the job right in the camera, using the Raw Image Processing option on Playback Menu 1. The next sections provide an overview of both processes.

Processing Raw images in the camera

For the quickest, most convenient Raw processing, you can do the job before you download images by using the Raw Image Processing feature on Playback Menu 1 — no computer or other software required. However, you need to understand one limitation: You can save processed files only in the JPEG format. As discussed in Chapter 2, that format results in some quality loss because of the file compression that JPEG applies. You can determine the level of JPEG compression applied to the processed file when you work through the in-camera conversion steps, but if you want to produce the absolute best quality from your Raw images, use a software solution and save your processed file in the TIFF format instead.

That said, in-camera Raw processing is a great option for times when you need JPEG copies of your Raw images for immediate online sharing. (JPEG is the standard format for online use.) Follow these steps to convert a photo:

1. **Select a mode in the Creative Zone (P, Tv, Av, M, B, or C).**

 If you're in another exposure mode, the menu in Step 3 won't be available.

2. **Press Menu and navigate to Playback Menu 1.**

3. **Select Raw Image Processing (as shown in Figure 6-13), and press Set.**

 This displays the Raw photos on your camera's memory card, as shown in Figure 6-13.

4. **Find the photo you want to work with.**

 There are a couple of ways to go about this:

 - *Multicontroller:* Press left and right on the multicontroller to review photos one at a time.

 - *Quick Control dial:* Spin the Quick Control dial to review photos one at a time.

 - *Main dial:* Use the Main dial to jump a number of photos.

 - *Index:* Press the AE Lock/FE Lock/Index/Reduce button once to display four thumbnails at a time (as seen on the left in Figure 6-14), or twice to display nine thumbnails (as seen on the right in Figure 6-14). Navigate through the photos, using the multicontroller (up, down, left, or right) or the Quick Control dial.

5. **Press Set.**

 The Raw processing options appear as an overlay on the screen with your photo, as shown in Figure 6-15.

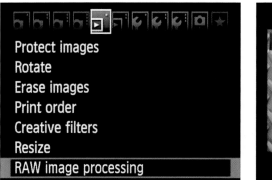

Figure 6-13: Processing Raw photos.

Figure 6-14: Displaying thumbnails to choose a photo.

6. Select image processing options with the multicontroller.

You have a number of options:

- *Brightness:* Make the photo brighter or dimmer in fractional stops of Exposure Value. Take care not to make highlights so bright they turn to white (known as *blowing out* highlights). For more information on brightness and exposure, have a look at Chapter 7.

- *White Balance:* Select the *white balance,* which accounts for the color temperature of the lighting in the scene to produce white whites. For more information on white balance, turn to Chapter 8.

- *Picture Style:* Select a picture style to process the photo with: Standard, Portrait, Landscape, Neutral, Faithful, Monochrome, or one of three user-defined settings (Picture Styles you created, using one of the other presets as a template). See Chapter 8 for more information on Picture Styles.

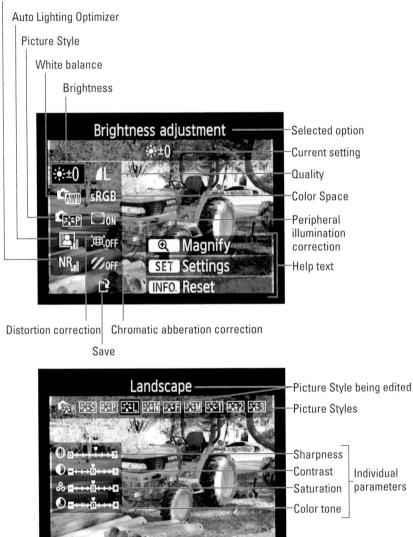

High ISO speed noise reduction

Auto Lighting Optimizer

Picture Style

White balance

Brightness

Brightness adjustment — Selected option

Current setting

Quality

Color Space

Peripheral illumination correction

Help text

Magnify

Settings

Reset

Distortion correction | Chromatic abberation correction

Save

Landscape — Picture Style being edited

Picture Styles

Sharpness

Contrast — Individual parameters

Saturation

Color tone

Figure 6-15: Selecting and editing photo properties.

- *Auto Lighting Optimizer:* Corrects brightness and contrast in the scene to make sure subjects are adequately visible. The settings are Off, Low, Standard, and Strong. Auto Lighting Optimizer is covered more fully in Chapter 7.

- *High ISO speed noise reduction:* Applies the noise reduction to high ISO photos according to the strength you select: Standard, Low, Strong, or Disable. Standard is a good overall setting, but if you need to maximize your overall shooting speed, disable in-camera noise reduction. Check out the "Dampening Noise" sidebar in Chapter 7 for more information on noise reduction.

- *Image-recording quality:* Sets the photo quality and pixel count to use when saving Raw photos as JPEGs. You can't save a Raw photo as a Raw photo; it must be saved as a JPEG. So, this setting shows what quality you want the edited photo saved as.

 We explain this and offer our general picture quality recommendations in Chapter 2. In this case, we recommend using Fine to preserve the photo's quality. Choose a photo size that meets or exceeds the capabilities of your intended output medium.

- *Color space:* Apply the sRGB or Adobe RGB color profile to the processed file. Chapter 8 has more information on the two color spaces and why you would want to choose one over the other. The short answer is that sRGB is fine if you don't plan on editing your photos very much. If you're doing a lot of brightness, color, or stylistic editing, choose Adobe RGB.

- *Peripheral illumination correction:* If enabled (there are only two choices: Enabled or Disabled), this setting brightens the corners of a photos to automatically correct vignetting.

- *Distortion correction:* When enabled, this setting automatically fixes distortion caused by the lens. You don't typically need to enable this unless you're using a lens that causes noticeable bulging or pinching. All lenses have some distortion, especially at wide angle focal lengths (24mm and shorter). To see whether your lens creates distortion, take a photo of a brick wall or something with horizontal and vertical lines and compare the results of enabling and disabling this setting. You can also compare the results of in-camera distortion correction with what you can achieve in programs like Canon's Digital Photo Professional.

Press Info to reset. Press AF Point Selection/Magnify button to zoom in for a better view.

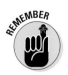

7. **Change settings with the Quick Control dial.**

You've highlighted a setting with the multicontroller or Main dial; you should see the setting name appear at the top of the screen.

Here are two ways to make changes:

- *Use the Quick Control dial.* Simply turn the Quick Control dial, and the setting will change. You see the current setting (displayed beneath the selected option) change, as shown on the left in Figure 6-15. Scroll through available options until you find one you like.

Some are very simple. For example, High ISO speed noise reduction is either enabled or disabled. Color space has only two options: sRGB or AdobeRGB. Others, such as Picture Style, have more options — and you can tweak further if you want. For the more complicated settings, we recommend using the next method.

- *Press Set:* This opens the settings screen, as shown on the bottom in Figure 6-15, and displays all the possible settings and options. In this case, you can choose an overall Picture Style and then navigate down and change detailed settings. Navigate up or down with the multicontoller and make changes with the Main or Quick Control dial.

 Press Set to lock in the changes and go back to the main screen.

8. **Select the Save option at the bottom of the screen and press Set to save the photo (left, Figure 6-16).**

9. **Confirm your decision by selecting OK (right, Figure 6-16).**

 The screen that appears tells you the filename of the photo as well as where (what folder) the photo is being saved.

10. **Press OK to finish.**

Figure 6-16: Saving the result.

Processing Raw files in Canon Digital Photo Professional

After downloading photos to your computer, follow these steps to process your Raw photos in Digital Photo Professional:

1. **Inside Digital Photo Professional, click the image thumbnail and then choose View⇨Edit in Edit Image Window.**

 Your photo appears inside an editing window, as shown in Figure 6-17. The exact appearance of the window may vary depending on your program settings. If you don't see the tool palette on the right side of the window, choose View⇨Tool Palette to display it. (Other View menu options enable you to customize the window display.)

Figure 6-17: You can convert Raw images using Digital Photo Professional.

The Tool palette offers three tabs full of controls for adjusting photos. You can find complete details in the program's Help system, but here are some tips for using a couple of the critical options:

- *Raw tab*: On this tab (as in Figure 6-17), you find controls for tweaking exposure, white balance, and color. For white balance, you can choose a specific setting, as shown in the figure (in this case, the current White Balance value is Shot Settings, which means the camera setting is preserved), or click the little eyedropper and then click an area of the image that should be white, black, or gray to remove any color cast. The rule for White Balance is this: If the photo doesn't have any obvious color-cast problems, don't mess with it.

 Using the Picture Style option, you can apply one of the camera's Picture Style options to the photo. Or, you can customize the style by dragging the Sharpness, Contrast, Color Saturation, and Color Tone sliders. (If you select Monochrome as the Picture Style, the Color Saturation and Color Tone sliders are replaced by Filter Effect and Toning Effect sliders.) Chapter 8 talks about Picture Styles.

• *RGB tab:* From this tab, you adjust exposure further by using Tone Curve adjustment, a tool that may be familiar to you if you've done any advanced photo editing. You can make additional color and sharpness adjustments here as well, but make those changes using the controls on the Raw tab instead. (The RGB tab options are provided primarily for manipulating JPEG and TIFF photos and not for Raw conversion.)

• *NR/Lens/ALO tab:* On this tab, shown in Figure 6-18, apply noise removal and correct certain lens distortion problems. You can even apply Peripheral Illumination Correction and the Auto Lighting Optimizer effects here instead of the in-camera correction. Click the Tune button to access the lens correction options.

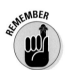

At any time, you can revert the image to the original settings by choosing Adjustment⇨Revert to Shot Settings.

2. **Choose File⇨Convert and Save.**

You see the standard file-saving dialog box with a few additional controls, as shown in Figure 6-19. The figure features the Windows Vista version of the dialog box, but the critical controls are the same no matter what type of computer you use.

3. **Set the save options.**

Here's the rundown of the critical options:

• *File Type:* Choose Exif-TIFF (8bit). This option saves your image in the TIFF file format, which preserves all image data. Don't choose

Figure 6-18: Apply Peripheral Illumination Correction from here as well as in the camera.

the JPEG format; doing so is destructive to the photo because of the lossy compression that's applied.

A *bit* is a unit of computer data; the more bits you have, the more colors your image can contain. Many photo editing programs can't open 16-bit files, or else they limit you to a few editing tools, so stick with the standard, 8-bit image option unless you know that your software can handle the higher bit depth. If you prefer 16-bit files, you can select TIFF 16bit as the file type.

Figure 6-19: Always save processed files to TIFF format.

- *Output Resolution:* This option *does not* adjust the pixel count of an image, as you might imagine. It only sets the default output resolution to be used if you send the photo to a printer. Most photo editing programs enable you to adjust this value before printing. The Canon software does not, however, so if you plan to print from the browser, set this value to 300.

- *Embed ICC Profile in Image:* On your 60D, you can shoot in either the sRGB or Adobe RGB color space; Chapter 8 has details on color space. Select this check box when saving your processed Raw file to include the color space data in the file. If you then open the photo in a program that supports color profiles, the colors are rendered more accurately. (*ICC* refers to the International Color Consortium, the group that created color-space standards.)

- *Resize:* Clear this check box so that your processed file contains all its original pixels.

4. **Enter a filename, select the folder and browse where you want to store the image, and then click Save.**

A progress box appears, letting you know that the conversion and file saving is going forward. Click the Exit button (Windows) or the Terminate button (Mac) to close the progress box when the process is complete.

5. **Close the Edit window to return to the browser.**

6. **Close Digital Photo Professional.**

 You see a dialog box that tells you that your Raw file was edited and asks whether you want to save the changes.

7. **Click Yes to store your raw-processing "recipe" with the Raw file.**

 The Raw settings you used are then kept with the original image so that you can create additional copies of the Raw file easily without having to make all your adjustments again.

Again, these steps give you only a basic overview of the process. If you regularly shoot in the Raw format, take the time to explore the Digital Photo Professional Help system so that you can take advantage of its other features.

Planning for Perfect Prints

Images from your 60D can produce dynamic prints, and getting those prints made is easy and economical, thanks to an abundance of digital printing services in stores and online. For home printing, today's printers are better and less expensive than ever, too.

That said, getting the best prints from your picture files requires a little bit of knowledge and prep work on your part, regardless of whether you decide to do the job yourself or use a retail lab. To that end, the next three sections offer tips to help you avoid the most common causes of printing problems.

Check the pixel count before you print

Resolution — the number of pixels in your digital image — plays a huge role in how large you can print your photos and still maintain good picture quality. You can get the complete story on resolution in Chapter 2, but here's a quick recap as it relates to printing:

✔ **Choose the right resolution before you shoot.** On your 60D, you set picture resolution via the Quality option, found on Shooting Menu 1, or via the Quick Control display.

 You must select the Quality option *before* you capture an image, which means that you need some idea of the ultimate print size before you shoot. When you do the resolution math, remember to consider any cropping you plan to do.

✔ **Aim for a minimum of 200 pixels per inch (ppi).** You'll get a wide range of recommendations on this issue, even among professionals. In general, if you aim for a resolution in the neighborhood of 200 ppi, you should be pleased with your results. If you want a 4 x 6–inch print, for example, you need at least 800 x 1200 pixels.

Depending on your printer, you may get even better results at a slightly lower resolution. On the other hand, some printers do their best work when fed 300 ppi, and a few request 360 ppi as the optimum resolution. However, using a resolution higher than that typically doesn't produce any better prints.

Unfortunately, because most printer manuals don't bother to tell you what image resolution produces the best results, finding the right pixel level is a matter of experimentation. Don't confuse *ppi* with the manual's statements related to the printer's dpi. *Dots per inch [dpi]* refers to the number of dots of color the printer can lay down per inch; many printers use multiple dots to reproduce one image pixel.

If you're printing photos at a retail kiosk or at an online site, the software you use to order prints should determine the resolution of your files and then suggest appropriate print sizes. If you're printing on a home printer, though, you need to be the resolution cop.

What do you do if you find that you don't have enough pixels for the print size you have in mind? Well, if you can't compromise on print size, you have the following two choices:

✔ **Keep the existing pixel count and accept lowered photo quality.** In this case, the pixels simply get bigger to fill the requested print size. When pixels grow too large, they produce a defect known as *pixelation:* The picture starts to appear jagged, or stair-stepped, along curved or oblique lines. Or, at worst, your eye can make out the individual pixels and your photo begins to look more like a mosaic than, well, like a photograph.

✔ **Add more pixels and accept lowered photo quality.** In some photo programs, you can use a process called *resampling* to add pixels to an existing image. Some other photo programs even resample the photo automatically for you, depending on the print settings you choose.

Although adding pixels might sound like a good option, it actually doesn't help in the long run. You're asking the software to make up photo information out of thin air, and the resulting image usually looks worse than the original. You don't see pixelation, but details turn muddy, giving the image a blurry, poorly rendered appearance.

Just to hammer home the point and show you the impact of resolution picture quality, Figures 6-20 and 6-21 show you the same image as it appears at 300 ppi (the resolution required by the publisher of this book), at 50 ppi, and then resampled from 50 ppi to 300 ppi. As you can see, there's just no way around the rule: If you want the best-quality prints, you need the right pixel count from the get-go.

300 ppi 50 ppi

Figure 6-20: A high-quality print depends on a high-resolution original.

Get print and monitor colors in sync

Ah, your photo colors look perfect on your computer monitor, but when you print the picture, the image is too red or too green or has another nasty color tint. This problem, which is probably the most prevalent printing issue, can occur because of any or all of the following factors:

- ✔ **Your monitor needs to be calibrated.** When print colors don't match the ones you see on your monitor, the most likely culprit is the monitor, not the printer. If the monitor isn't accurately calibrated, the colors it displays aren't a true reflection of your image colors. The same caveat applies to monitor brightness: You can't accurately gauge the exposure

of a photo if the brightness of the monitor is cranked way up or down. Many of today's new monitors are very bright, providing ideal conditions for Web browsing and watching movies — but not necessarily for photo editing. So you may need to turn the brightness way, way down to get to a true indication of image exposure.

To ensure that your monitor is displaying photos on a neutral canvas, you can start with a software-based *calibration utility,* which is just a small program that guides you through the process of adjusting your monitor. The program displays various color swatches and other graphics and then asks you to provide feedback about the colors you see onscreen.

50 ppi resampled to 300 ppi

Figure 6-21: Adding pixels in a photo editor doesn't rescue a low-resolution original.

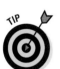

If you use a Mac, its operating system (OS) offers a built-in calibration utility, the Display Calibrator Assistant; Windows 7 offers a similar tool: Display Color Calibration. You also can find free calibration software for both Mac and Windows systems online; just enter the term *free monitor calibration software* into your favorite search engine.

Software-based tools, though, depend on your eyes to make decisions during the calibration process. For a more reliable calibration, you may want to invest in a hardware solution, such as the Pantone huey PRO ($99, www.pantone.com) or the Datacolor Spyder3Express ($89, www. datacolor.com). These products use a device known as a *colorimeter* to accurately measure display colors.

Whichever route you take, the calibration process produces a monitor *profile,* which is simply a data file that tells your computer how to adjust the display to compensate for any monitor color casts or brightness and contrast issues. Your Windows or Mac operating system loads this file automatically when you start your computer. Your only responsibility is to perform the calibration every month or so because monitor colors drift over time.

✔ **One of your printer cartridges is empty or clogged.** If your prints look great one day but are way off the next, the number-one suspect is an empty ink cartridge or a clogged print nozzle or head. Check your manual to find out how to perform the necessary maintenance to keep the nozzles or print heads in good shape.

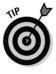

If black-and-white prints have a color tint, a logical assumption is that your black ink cartridge is to blame, if your printer has one. The truth is that images from a printer that doesn't use multiple black or gray cartridges always have a slight color tint because to create gray, the printer has to mix yellow, magenta, and cyan in perfectly equal amounts, which is difficult for a typical inkjet printer to pull off. If your black-and-white prints have a strong color tint, however, a color cartridge might be empty, and replacing it may help somewhat. Long story short: Unless your printer is marketed for producing good black-and-white prints, you'll probably save yourself some grief by simply having your black-and-whites printed at a retail lab.

When you buy replacement ink, by the way, keep in mind that third-party brands (although perhaps cheaper) may not deliver the same performance as cartridges from your printer manufacturer. A lot of science goes into getting ink formulas to mesh with the printer's ink-delivery system, and the printer manufacturer obviously knows most about that delivery system.

✔ **You chose the wrong paper setting in your printer software.** When you set up a print job, be sure to select the right setting from the paper type option: glossy or matte, for example. This setting affects the way the printer lays down ink on the paper.

✔ **Your photo paper is low quality.** Sad but true: Cheap, store-brand photo papers usually don't render colors as well as the higher-priced, name-brand papers. For best results, try papers from your printer manufacturer; again, those papers are engineered to provide top performance with the printer's specific inks and ink-delivery system.

Some paper manufacturers, especially those that sell fine-art papers, offer downloadable *printer profiles*, which are simply little bits of software that tell your printer how to manage color for the paper. Refer to the manufacturer's Web site for information on how to install and use the profiles. And note that a profile mismatch can also cause incorrect colors in your prints, including the color tint in black-and-white prints alluded to earlier.

✔ **Your printer and photo software are fighting over color management duties.** Some photo programs offer *color management* tools, which enable you to control how colors are handled as an image passes from camera to monitor to printer. Most printer software also offers color management features. The problem is, if you enable color management controls in both your photo software and printer software, you can create conflicts that lead to wacky colors. Check your photo software and printer manuals for color management options and ways to turn them on and off.

TECHNICAL STUFF

DPOF, PictBridge, and computerless printing

The 60D offers two features that enable you to print directly from your camera or a memory card assuming that your printer offers the required options.

One of the direct-printing features is Digital Print Order Format, or DPOF (*dee-poff*). With this option, you select pictures from your memory card to print and then specify how many copies you want of each image. Then, if your photo printer has a Secure Digital (SD) memory card slot (or SDHC/SDXC slots, if you use these new, high-capacity cards) and supports DPOF, you just pop the memory card into that slot. The printer reads your "print order" and outputs just the requested copies of your selected images. (You use the printer's own controls to set paper size, print orientation, and other print settings.)

A second direct-printing feature, PictBridge, works a little differently. If you have a PictBridge-enabled photo printer, you can connect the camera to the printer by using the USB cable

supplied with your camera. A PictBridge interface appears on the camera monitor, and you use the camera controls to select the pictures you want to print. With PictBridge, you specify additional print options from the camera, such as page size and whether to print a border around the photo.

Both DPOF and PictBridge are especially useful when you need fast printing. For example, if you shoot pictures at a party and want to deliver prints to guests before they go home, DPOF offers a quicker option than firing up your computer, downloading pictures, and so on. And, if you invest in one of the tiny portable photo printers on the market today, you can easily make prints away from your home or office. You can take both your portable printer and camera along to your regional sales meeting, for example.

If you're interested in exploring either printing feature, your camera manual provides complete details.

REMEMBER

Even if all the aforementioned issues are resolved, however, don't expect perfect color matching between printer and monitor. Printers simply can't reproduce the entire spectrum of colors that a monitor can display. In addition, monitor colors always appear brighter because they are, after all, generated with light.

Finally, be sure to evaluate print colors and monitor colors in the same ambient light — daylight, office light, whatever — because that light source has its own influence on the colors you see. Also allow your prints to dry for 15 minutes or so before you make any final judgments.

Preparing Pictures for E-Mail and Online Sharing

How many times have you received an e-mail message that looks like the one in Figure 6-22? Some well-meaning friend or relative sent you a digital photo that's so large you can't view the whole thing on your monitor.

The problem is that computer monitors can display only a limited number of pixels. The exact number depends on the monitor's resolution setting and the capabilities of the computer's video card, but suffice it to say that the average photo from one of today's digital cameras has a pixel count in excess of what the monitor can handle.

In general, a good rule is to limit a photo to no more than 640 pixels at its longest dimension. That ensures that people can view your entire picture without scrolling, as in Figure 6-23. This image measures 450 x 300 pixels.

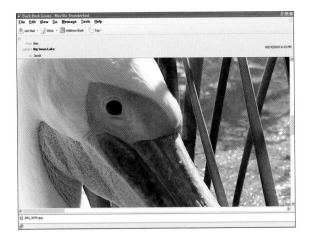

Figure 6-22: The attached image has too many pixels to be viewed without scrolling.

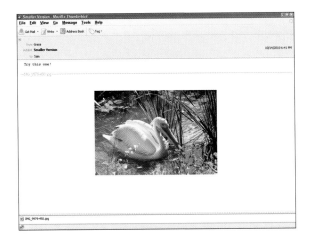

Figure 6-23: Keep e-mail pictures to no larger than 640 pixels wide or tall.

Sending photos via e-mail to mobile phones

Many people these days have *smartphones;* the most popular are iPhone, Android, and BlackBerry. With a smartphone, you can make calls, of course, but you can also search the Web, download and run apps, and send and receive text and e-mail messages. Very convenient, but you have to do it all on a really small screen. After all, the iPhone 4G size is 960 x 640 pixels, and the iPhone 3G/3GS is half that size.

Our advice is to always send photos via e-mail as small as reasonable. (The exception would be if the recipient wants a high-res photo.) Pixel dimensions aren't the issue so much as the amount of bandwidth needed to download the photo. We recommend that you make photos you want to send at least as small as what we specify for e-mails (and maybe smaller, depending on the recipient's device).

By using an Image Quality option explained in Chapter 2, you can capture images at 720 x 480 pixels (the smallest native file size the 60D can record to resample), but that's not a good idea unless you know that you never want to print the image because you won't have enough resolution to generate a good print. Instead, choose a resolution appropriate for print and then create a low-res copy of the picture for e-mail sharing. Some new e-mail programs have a photo-upload feature that creates a temporary low-res version for you, but if not, creating your own copy is easy. If you're posting to an online photo sharing site, you may be able to upload all your original pixels, but many sites have resolution limits.

In addition to resizing high-resolution images, check their file types; if the photos are in the Raw (.cr2) or TIFF format, you need to create a JPEG copy for online use. Web browsers and e-mail programs can't display Raw or TIFF files.

You have a couple ways to tackle both bits of photo prep. You can create a JPEG copy of a Raw image by using the camera's Raw conversion feature or the Raw-processing tools found in the free Canon software. The earlier section "Processing Raw (CR2) Files" has details on both options.

A second way is to create a low-resolution version of a JPEG image. You can create a low-resolution copy of a JPEG picture either in your photo software or right in the camera. Here's how to do the job in the camera:

1. **Press Menu and navigate to Playback Menu 1.**

2. **Select Resize and press Set.**

 You should see the first photo in the current folder, as shown in the right image in Figure 6-24.

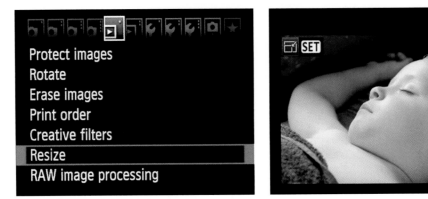

Figure 6-24: Preparing to resize a photo.

3. Choose a photo you want to resize.

Use the same navigation techniques as we mention earlier to find the photo you want to reduce.

You cannot resize Raw photos or S3 JPEGs (see Step 5), and you cannot increase a photo's size.

4. Press Set.

5. Select a new size from the available options.

If you're shooting at the largest size, all lower sizes are available. If you're working with a smaller photo, you will see only the sizes you can change to. The size you have selected is highlighted by a box with a blue border (as S3 is in the left image of Figure 6-25).

The sizes are

- *M:* 8MP; 3456 x 2304 pixels. Medium is about half the size of the largest photo that the 60D can shoot.

- *S1:* 4.5MP; 2592 x 1728 pixels. For comparison, this is larger than most computer monitor resolutions: in other words, good for printing, but overkill for desktop wallpapers and slide shows.

- *S2:* 2.5MP; 1920 x 1280 pixels. This size is probably optimal for use on your computer. Use it for wallpapers, screen savers, and slide shows.

- *S3:* 0.3MP; 720 x 480 pixels. This is a bit large for e-mail but not excessive. Because this is the smallest size you can resample in-camera, we suggest using it if you don't want to mess with resizing in an image editing program.

6. **Press Set and confirm that you want to save the file (as shown in the right image of Figure 6-25).**

Don't worry; you can't overwrite the original. You can only save a new file.

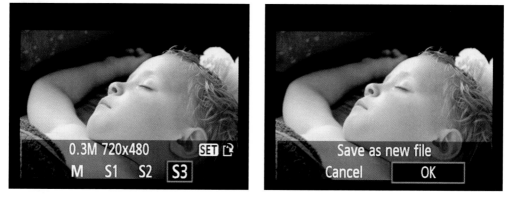

0.3M 720x480 SET

M S1 S2 S3

Save as new file

Cancel OK

Figure 6-25: Downsizing and saving.

7. **Note the filename and dismiss the final dialog by pressing Set.**

This step depends a lot on your preferences. We include it to warn you that it's easy to forget what photos you worked on and what you did when there are 200 of them on your memory card.

The new filename is assigned by the camera and is simply the next in sequence — as if you took a new photo.

Part III
Taking Creative Control

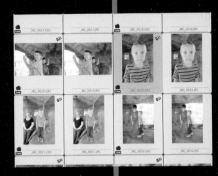

*A*s nice as it is to be able to set your camera to Automatic mode and let it handle most of your photographic decisions, we encourage you to also explore the advanced exposure modes (P, Tv, Av, M, B, and C). In these modes, you can make your own decisions about the exposure and focus and the color characteristics of your photo, which is key to capturing the photo as you see it in your mind's eye. And, don't think that you have to be a genius or spend years to be successful because adding just a few simple techniques to your photographic repertoire can make a huge difference in how happy you are with the pictures you take.

The first two chapters in this part explain everything you need to know to do just that, providing some necessary photography fundamentals and details about using the advanced exposure modes. Following that, Chapter 9 helps you draw together all the information presented earlier in this book, summarizing the best camera settings and other tactics to use when capturing portraits, action shots, landscapes, and close-ups.

7

Getting Creative with Exposure and Lighting

In This Chapter

▶ Exploring advanced exposure modes: P, Tv, Av, M, B, and C

▶ Understanding the basics of exposure

▶ Getting a grip on aperture, shutter speed, and ISO

▶ Choosing an exposure metering mode

▶ Tweaking autoexposure with exposure compensation

▶ Solving tough exposure problems

▶ Using flash in the advanced exposure modes

▶ Adjusting flash output

*B*y using the simple exposure modes we cover in Chapter 3, you can take great pictures with your EOS 60D. But to fully exploit your camera's capabilities — and, more importantly, to exploit *your* creative capabilities — you need to explore your camera's creative exposure modes, represented on the Mode dial by the letters P, Tv, Av, M, B, and C.

This chapter explains everything you need to know to start taking advantage of these modes. First, you get an introduction to three critical exposure controls: aperture, shutter speed, and ISO. Adjusting these settings enables you to not only fine-tune image exposure but also affect other aspects of your image, such as *depth of field* (the zone of sharp focus) and motion blur. In addition, this chapter explains other advanced exposure features (such as exposure compensation and metering modes) and also discusses the flash options available in the advanced exposure modes.

If you're worried that this stuff is too complicated for you, don't be. Even in these advanced exposure modes, the camera provides you with enough feedback that you're never truly flying without a parachute. Between the in-camera support and the information in this chapter, you can easily master the use of aperture and shutter speed and all the other exposure features — an important step in making the shift from picture-taker to photographer.

Before we get going, we have a couple housekeeping chores to take care of:

- ✐ Exposure modes P, Tv, Av, M, B, and C are called *Creative Zone modes* by Canon. Sometimes we use the term *advanced modes* to differentiate them from the Basic Zone modes.

- ✐ After a brief mention of the Camera User Settings mode (C on the Mode dial) in the first section, we dispense with mentioning it by name. The exposure characteristics of C mode depend on what shooting mode you're in when you register the settings (see Chapter 10 for info on that) and can be P, Tv, Av, M, or B.

Kicking Your Camera into Advanced Gear

With your camera in Creative Auto mode, covered in Chapter 3, you can affect picture brightness and depth of field to some extent by using the Exposure and Background sliders. However, you don't have full control over either aspect of your images, and you have no access to certain camera options that can help you solve tough exposure problems.

The moral of this story is that if you want to take full advantage of your camera's exposure tools, set the Mode dial to one of its six creative exposure modes, highlighted in Figure 7-1: P, Tv, Av, M, B, or C. To fully control exposure and other picture properties, choose one of these exposure modes.

Each mode offers a different level of control over two critical exposure settings: aperture and shutter speed. Later in this chapter, we explain these controls fully, but here's a quick introduction:

- ✐ **P (programmed autoexposure):** The camera selects both the aperture and shutter speed for you, but you can choose from different combinations of the two.

- ✐ **Tv (shutter priority autoexposure):** You select a shutter speed, and the camera chooses the aperture setting that produces a good exposure.

 Why *Tv?* Well, shutter speed controls exposure time; *Tv* stands for *time value.*

Bulb

Camera User Settings | Manual exposure

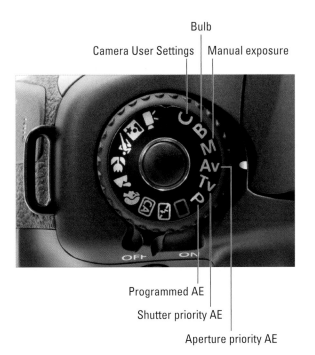

Programmed AE |
Shutter priority AE |
Aperture priority AE

Figure 7-1: The six creative exposure modes.

- **Av (aperture priority autoexposure):** The opposite of shutter-priority autoexposure, you select the aperture setting: thus *Av,* for *a*perture *v*alue. The camera then selects the appropriate shutter speed to properly expose the picture.

- **M (manual exposure):** Specify both shutter speed and aperture (and ISO, if you like). And even in M mode, the camera assists you by displaying a meter that tells you whether your exposure settings are on target.

- **B (Bulb):** Bulb mode is a special shutter speed mode, where you open the shutter normally to start taking the photo. The catch is that you keep the shutter open for as long as you hold down the shutter button. Bulb mode is great for night photography, catching lightning in action, and photographing thunderstorms or starry skies.

 Because the length of the exposure is entirely up to you, the camera provides no exposure information. You set the ISO and aperture based on other criteria and keep the shutter open as required.

 Because the Bulb mode treats exposure so differently than the other modes, we don't often lump it in with the others in this chapter.

✔ **C (Camera User Settings):** Camera User Settings is another special mode. You can *register* (save) most camera settings (including shooting mode, menu options, and so forth) and instantly recall them by selecting C from Mode Dial mode. (We explain how to set this in Chapter 10.)

In the context of exposure, this mode behaves exactly like the mode you selected when you registered the settings. In C mode, you see the actual exposure mode on the back of the camera in the Shooting Settings display.

Again, these modes won't make much sense to you if you aren't schooled in the basics of exposure. To that end, the next several sections provide a quick lesson in this critical photography subject.

Introducing the Exposure Trio: Aperture, Shutter Speed, and ISO

Any photograph, whether taken with a film or digital camera, is created by focusing light through a lens onto a light-sensitive recording medium. In a film camera, the film serves as the medium; in a digital camera, it's the image sensor, which comprises an array of light-responsive computer chips.

Between the lens and the sensor are two barriers — the aperture and shutter — which together control how much light makes its way to the sensor. The actual design and arrangement of the aperture, shutter, and sensor vary depending on the camera, but Figure 7-2 offers an illustration of the basic concept.

Along with the aperture and shutter, a third feature — ISO — determines *exposure* (what most of us would describe as the picture's overall brightness and contrast).

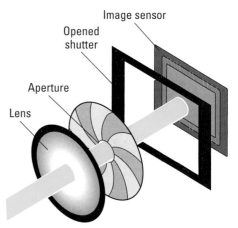

Figure 7-2: Aperture and shutter speed determine how much light strikes the image sensor.

"Stop" right here

Photographers throw around the term *stop* quite a bit. If you don't, you should try it. It's fun. More to the point, it distills many of the details of exposure into a single, easy-to-understand concept and makes it possible to talk about exposure without constantly having to convert between aperture, shutter speed, and ISO.

You see, a full stop (yes, there are such things as half and third stops) doubles or halves the amount of light that reaches your digital camera's sensor.

The really cool thing is that it doesn't matter how you change the stop. One stop of aperture has the same effect on exposure as one stop of shutter speed and one stop of ISO speed.

Therefore, when you "stop-up" by a full stop, you double the amount of light. You can increase the size of the aperture, use a longer shutter speed, or set a higher ISO to achieve this.

When you "stop-down" by a full stop, you halve the amount of light. You can reduce the size of the aperture, use a shorter shutter speed, or set a lower ISO.

This three-part exposure formula works as follows:

✔ **Aperture controls the amount of light.** The *aperture* is an adjustable hole in a diaphragm set inside the lens. By changing the size of the aperture, you control the size of the light beam that can enter the camera. Aperture settings are stated as *f-stop numbers,* or simply *f-stops,* and are expressed with the letter *f* followed by a number: f/2, f/5.6, f/16, and so on. The lower the f-stop number, the larger the aperture, as illustrated in Figure 7-3.

The range of possible f-stops depends on your lens and, if you use a zoom lens, on the zoom position (focal length) of the lens. For the kit lens sold with the 60D, you can select apertures from f/3.5 to f/22 when zoomed all the way out to the shortest focal length (18mm). When you zoom in to

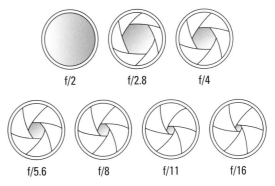

Figure 7-3: The smaller the f-stop number, the larger the aperture.

the maximum focal length (135mm), the aperture ranges from f/5.6 to f/36. (See Chapter 8 for a discussion of focal lengths.)

✔ **Shutter speed controls duration of light.** Set behind the aperture, the shutter works something like, er, the shutters on a window. Until you open the shutter, the camera's shutter stays closed, preventing light from striking the image sensor. When you press the shutter, the shutter opens briefly to allow light that passes through the aperture to hit the image sensor. The exception to this scenario is when you compose in Live View mode, the shutter remains open so that your image can form on the sensor and be displayed on the camera's LCD. In fact, when you press the shutter release in Live View mode, you hear a few clicks as the shutter first closes and then reopens for the actual exposure.

The length of time that the shutter is open — the *shutter speed* — is measured in seconds: 1/60 second, 1/250 second, 2 seconds, and so on. Available shutter speeds on the EOS 60D range from 30 seconds to 1/8000 second when you shoot without flash. If you want a shutter speed longer than 30 seconds, manual exposure mode also provides the *Bulb* (B) exposure feature. At this setting, the shutter stays open indefinitely as long as you press the shutter button — or until your battery dies.

If you use the built-in flash, the fastest available shutter speed is 1/250 second; the slowest shutter speeds range from 1/60 second to 30 seconds, depending on the exposure mode. See the section "Understanding your camera's approach to flash," later in this chapter, for details.

✔ **ISO controls light sensitivity.** ISO, which is a digital function (rather than a mechanical structure on the camera), enables you to adjust how responsive the image sensor is to light. Film or digital, a higher ISO rating means greater light sensitivity, which means that less light is needed to produce the image, enabling you to use a smaller aperture or a faster shutter speed or both.

The term *ISO* is a holdover from film days, when an international standards organization rated film stock according to its light sensitivity: ISO 100, ISO 200, ISO 400, ISO 800, and so on.

On your camera, you can select ISO settings ranging from 100 to a whopping 12800 when you shoot in the advanced exposure modes. (You're restricted to an ISO range of 200 to 6400, however, if you enable the Highlight Tone Priority function, which you can explore later in this chapter.) For the Basic Zone modes, you're limited to ISO speeds from 100 to 3200, and the camera chooses the setting for you automatically. (*Note:* Highlight Tone Priority isn't available in those modes.)

Distilled to its essence, the image-exposure process is this simple:

✔ Aperture and shutter speed together determine the quantity of light that strikes the image sensor.

✔ ISO determines how much the sensor reacts to that light.

The tricky part of the equation is that aperture, shutter speed, and ISO settings affect your pictures in ways that go *beyond* exposure. You need to be aware of these side effects, explained in the next section, to determine which combination of the three exposure settings will work best for your picture.

Understanding exposure-setting side effects

You can create the same exposure with different combinations of aperture, shutter speed, and ISO, which Figure 7-4 illustrates. Although the figure shows only two variations of settings, your choices are pretty much endless — you're limited only by the aperture range the lens allows and the shutter speeds and ISO settings the camera offers.

f/22, 1/30 second, ISO 100 f/4, 1/1000 second, ISO 100

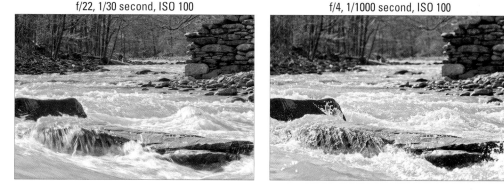

Figure 7-4: Aperture and shutter speed affect depth of field and motion blur.

The settings you select affect your image beyond exposure, though, as follows:

✔ **Aperture affects depth of field.** The aperture setting, or f-stop, affects *depth of field,* or the distance over which sharp focus is maintained. We introduce this concept in Chapter 3, but here's a quick recap: With a shallow depth of field, your subject appears more sharply focused than faraway objects; with a large depth of field, the sharp-focus zone spreads over a greater distance.

When you reduce the aperture size by choosing a higher f-stop number — "stop-down the aperture," in photo lingo — you increase depth of field. For example, notice that the background in the left image in Figure 7-4, taken at f/22, appears sharper than the right image, taken at f/4.

Aperture is just one contributor to depth of field, however. The camera-to-subject distance and the focal length of your lens also play a role in this characteristic of your photos. Depth of field is reduced as you move closer to the subject or increase the focal length of the lens (moving

from a wide angle lens to a telephoto lens, for example.) See Chapter 8 for the complete story on how these three factors combine to determine depth of field.

✔ **Shutter speed affects motion blur.** At a slow shutter speed, moving objects appear blurry, whereas a fast shutter speed captures motion cleanly. Compare the water motion in the photos in Figure 7-4, for example. At a shutter speed of 1/30 second (left photo), the water blurs, giving it a misty look. At 1/1000 second (right photo), the splashing water appears more sharply focused. The shutter speed you need to freeze action depends on the speed of your subject.

If your picture suffers from overall image blur, like you see in Figure 7-5, where even stationary objects appear out of focus, the camera moved during the exposure, and this is always a danger when you handhold the camera at slow shutter speeds. The longer the exposure time, the longer you have to hold the camera still to avoid the blur caused by camera shake.

f/32, 1/15 second, ISO 100

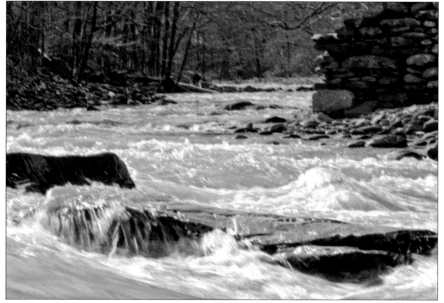

Figure 7-5: Slow shutter speeds increase the risk of allover blur caused by camera shake.

So how slow is too slow? That depends on your physical capabilities and your lens. For reasons that are too technical to get into, camera shake affects your picture more when you shoot with a lens that has a long

focal length. For example, you may be able to use a much slower shutter speed when you shoot with a lens that has a maximum focal length of 55mm, like the kit lens, than if you switch to a 200mm telephoto lens.

The best idea is to do your own tests to see where your handholding limit lies. Start with a slow shutter speed — say, in the neighborhood of 1/40 second — and then click off multiple shots, increasing the shutter speed for each picture. If you have a zoom lens, run the test first at the minimum focal length (widest angle) and then zoom to the maximum focal length for another series of shots. Then it's simply a matter of comparing the images in your photo editing program. (You may not be able to accurately judge the amount of blur on the camera monitor.) Check out Chapter 5 to find out how to see each picture's shutter speed when you view your images.

Overcoming camera shake by setting a moderate shutter speed does not guarantee that you will be able to freeze a fast-moving subject. In fact, 1/40 second is pitifully slow if you are shooting action shots. You will likely have to set the shutter speed to 1/250 second or more, depending on the speed and direction of the subject.

To avoid the issue altogether, the best answer is to use a tripod or otherwise steady the camera. If you need to handhold (and face it — no one can carry a tripod *all* the time), improve your odds of capturing a sharp photo by turning on image stabilization, if your lens offers it. (On the kit lens, flip the Image Stabilizer switch on the side of the lens to On to enable this feature.) See Chapter 8 for tips on solving other focus problems and Chapter 9 for more help with action photography.

✔ **ISO affects image noise.** When you select a higher ISO setting, making the image sensor more reactive to light, you risk creating *noise.* This defect looks like sprinkles of sand and is similar in appearance to film *grain,* a defect that often mars pictures taken with high ISO film.

Ideally, you should always use the lowest ISO setting on your camera — namely, ISO 100 — to ensure top image quality.

Sometimes, though, the lighting conditions simply don't permit you to do so and still use the aperture and shutter speeds you need. For example, consider the mossy close-ups in Figure 7-6. The goal for this image was to have the background blurry but the detail sharp in the spring moss in the foreground. The camera was positioned about one foot from the subject. At that close range, an f-stop of f/14 was needed to produce the desired depth of field. But because the moss was in shade (moss doesn't grow in the sun, after all), a shutter speed of 1/6 second was needed to expose the photo at ISO 100. Most of us can't handhold at a shutter speed that slow, and, sure enough, you see the blurry results in the photo on the left. Raising the ISO to 800 fixed the problem, enabling a shutter speed of 1/50 second, which was handholdable when bracing against the rocks on which the moss was growing.

ISO 100, f/14, 1/6 second ISO 800, f/14, 1/50 second

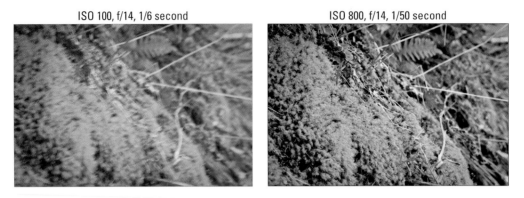

Figure 7-6: Raise the ISO to enable a higher shutter speed to ensure a blur-free shot while handholding the camera.

Fortunately, you usually don't encounter serious noise with the EOS 60D until you crank up the ISO. It's difficult to detect any noise in the ISO 800 image in Figure 7-6, for example. In fact, you may get away with using the next step up, ISO 1600, if you keep the print or display size of the picture small. As with other image defects, noise becomes more apparent when you enlarge the photo. Noise also is more problematic in areas of flat color.

To give you a better look at how ISO affects noise, Figure 7-7 offers views of trophies captured at several of the camera's ISO settings. Note that the highest setting is disabled by default; to access ISO 12800, you have to visit Custom Function IV-3, ISO Expansion.

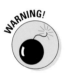

One more important note about noise: A long exposure time — say, 1 second or more — also can produce this defect. Your camera offers built-in noise-reduction filters that aim to compensate for both high ISO noise and long-exposure noise; see the later sidebar "Dampening noise" for details, including why these filters aren't necessarily the best solution to the problem. You may also be interested in pursuing noise reduction in software. For the record, the examples shown in Figure 7-7 were captured with the High ISO Noise Reduction option set to Standard, which applies the default amount of noise correction. Notice that detail in the trophy is degraded as the ISO increases. Were noise reduction turned off, the grittiness would be more apparent, whereas detail might not be as mushed as you see in the ISO 12800 example. Either way, you can easily see that ISO 12800 should be reserved for fleeting shots of Bigfoot or outer space aliens.

Long story short: Understanding how aperture, shutter speed, and ISO affect an image enables you to have much more creative input over the look of your photographs — and, in the case of ISO, to also control the quality of your images. (Chapter 2 discusses other factors that affect image quality.)

Original Photo

ISO 100 ISO 800

ISO 3200 H (ISO 12800)

Figure 7-7: Noise in images becomes more visible when you enlarge them.

Doing the exposure balancing act

When you change any of the three exposure settings — aperture, shutter speed, or ISO — one or both of the others must also shift to maintain the same image brightness.

Say you're shooting a soccer game, and you notice that although the overall exposure looks great, the players appear slightly blurry at the current shutter speed. If you raise the shutter speed, you have to compensate with either a larger aperture (to allow in more light during the shorter exposure) or a higher ISO setting (to make the camera more sensitive to the light). Which way should you go? Well, it depends on whether you prefer the shorter depth of field that comes with a larger aperture or the increased risk of noise that accompanies a higher ISO. Of course, you can also adjust both settings if you choose to get the exposure results you need.

All photographers have their own approaches to finding the right combination of aperture, shutter speed, and ISO, and you'll no doubt develop your own system when you become more practiced at using the advanced exposure modes. In the meantime, here are some handy recommendations:

✔ Use the lowest possible ISO setting unless the lighting conditions are so poor that you can't use the aperture and shutter speed you want without raising the ISO.

✔ If your subject is moving (or might move, like a squiggly toddler or an excited dog), give shutter speed the next highest priority in your exposure decision. Choose a fast shutter speed to ensure a blur-free photo or, on the flip side, select a slow shutter speed to intentionally blur that moving object, an effect that can create a heightened sense of motion. When shooting waterfalls, for example, consider using a slow shutter speed to give the water that blurry, romantic look.

✔ For images of nonmoving subjects, make aperture a priority over shutter speed, setting the aperture according to the depth of field you have in mind. For portraits, for example, try using a wide-open aperture (a low f-stop number) to create a short depth of field and a nice, soft background for your subject.

Keeping all this information straight is a little overwhelming at first, but the more you work with your camera, the more the whole exposure equation will make sense to you. You can find tips in Chapter 9 for choosing exposure settings for specific types of pictures; keep moving through this chapter for details on how to monitor and adjust aperture, shutter speed, and ISO settings.

Putting the f (stop) in focus

One way to remember the relationship between f-stop and depth of field is simply to think of the *f* as *focus:* The higher the *f*-stop number, the larger the zone of sharp *focus.*

Please *don't* share this tip with photography elites, who will roll their eyes and inform you

that the *f* in *f-stop* most certainly does *not* stand for focus but, rather, for the ratio between aperture size and lens focal length — as if *that's* helpful to know if you aren't an optical engineer. (Chapter 8 explains focal length, which *is* helpful to know.)

Monitoring Exposure Settings

When you press the shutter button halfway, the current f-stop, shutter speed, and ISO speed appear in the viewfinder display, as shown in Figure 7-8. Or, if you're looking at the Shooting Settings display, the settings appear as shown in Figure 7-9. In Live View mode, the exposure data appears at the bottom of the monitor and takes a form similar to what you see in the viewfinder. (The later sidebar "Exposure and Live View shooting" provides information about other exposure-related aspects of shooting in Live View mode, which we introduce in Chapter 4.)

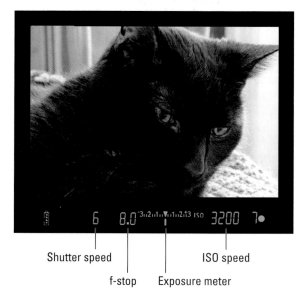

Shutter speed ISO speed

f-stop Exposure meter

Figure 7-8: The shutter speed, f-stop, and ISO speed appear in the viewfinder.

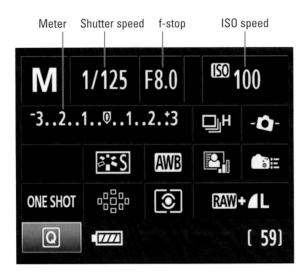

Meter Shutter speed f-stop ISO speed

Figure 7-9: You also can view the settings in the Shooting Settings display.

In the viewfinder and on the monitor in Live View mode, shutter speeds are presented as whole numbers, even if the shutter speed is set to a fraction of a second. For example, for a shutter speed of 1/6 second, you see just the number 6 in the display (refer to Figure 7-8). When the shutter speed slows to 1 second or more, you see quote marks after the number in both displays — 1" indicates a shutter speed of 1 second, 4" means 4 seconds, and so on.

The viewfinder, Shooting Settings display, and Live View display also offer an *exposure meter,* labeled in Figures 7-8 and 7-9. This little graphic serves two different purposes, depending on which of the advanced exposure modes you're using:

✔ **In manual exposure (M) mode, the meter acts in its traditional role, which is to indicate whether your settings will properly expose the image.** Figure 7-10 gives you three examples. When the *exposure indicator* (the bar under the meter) aligns with the center point of the meter, as shown in the middle example, the current settings will produce a proper exposure. If the indicator moves to the left of center (toward the minus side of the scale, as in the left example in the figure), the camera is alerting you that the image will be underexposed. If the indicator moves to the right of center (as in the right example), the image will be overexposed. The farther the indicator moves toward the plus or minus sign, the greater the potential exposure problem.

✔ **In the other modes (P, Tv, and Av), the meter displays the current Exposure Compensation setting.** You use the *Exposure Compensation* feature to tell the camera to produce a brighter or darker exposure than its autoexposure brain thinks is correct. When the exposure indicator is at 0, no compensation is being applied. See the later section, "Overriding autoexposure results with Exposure Compensation," for details.

Underexposed Correct exposure Overexposed

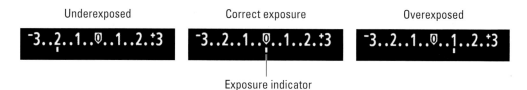

Exposure indicator

Figure 7-10: In manual exposure (M) mode, the meter indicates whether exposure settings are on target.

Because the meter is designated as an exposure compensation guide when you shoot in P, Tv, and Av modes, the camera uses different exposure-warning alerts in those modes. Here's what happens in each mode if the camera thinks you're headed for a lousy exposure:

✔ **Av mode (aperture priority autoexposure):** The shutter speed value blinks to let you know that the camera can't select a shutter speed that will produce a good exposure at the aperture you selected. Solution: Choose a different f-stop or adjust the ISO.

✔ **Tv mode (shutter priority autoexposure):** The aperture value blinks instead of the shutter speed. That's your notification that the camera can't open or stop down the aperture enough to expose the image at your selected shutter speed. Solution: Change the shutter speed or ISO.

✔ **P mode (programmed autoexposure):** In P mode, both the aperture and shutter speed values blink if the camera can't select a combination that will properly expose the image. Your only recourse is to either adjust the lighting or change the ISO setting.

The camera's take on proper exposure may not always be the one you want to follow, and here's why. First, the camera bases its exposure decisions on the current exposure metering mode. You can choose from four different metering modes (as covered next), and each calculates exposure on a different area of the frame. Second, you may want to purposely choose exposure settings that leave parts of the image very dark or very light for creative reasons. In other words, the meter and the blinking alerts are guides, not dictators.

Exposure and Live View shooting

In Live View mode, you use the LCD monitor instead of the viewfinder to compose your images. When you're using Live View mode, keep these exposure-related tips in mind:

✔ Your camera strap sports a little rubber viewfinder cover to place over the viewfinder when you're shooting in Live View mode.

✔ Several exposure functions described in this chapter are disabled in Live View mode.

✔ A non-Canon external flash won't fire in Live View mode.

✔ Image noise may increase if you engage Live View shooting for a long period.

✔ You can display certain exposure settings as well as a histogram along with your image in the monitor.

✔ In extreme lighting conditions, Exposure Simulation might not be able to simulate exposure properly. And, if you use flash, Exposure Simulation is automatically disabled.

Chapter 4 has details about Live View mode and using histograms; Chapter 11 has information about Custom Functions.

Choosing an Exposure Metering Mode

The *metering mode* determines which part of the frame the camera analyzes to calculate the proper exposure. The EOS 60D offers four metering modes, described in the following list and represented in the Shooting Settings display by the icons you see in the margin. However, you can access all four modes only in the Creative Zone and only during regular, through-the-viewfinder shooting. In Live View mode, as well as in the fully automatic exposure modes, you're restricted to the first of the four modes, Evaluative metering.

✔ **Evaluative metering:** The camera analyzes the entire frame and then selects exposure settings designed to produce a balanced exposure. The 60D evaluates the exposure of all the metering zones (factoid: there are 63 of them!), including the nine AF points during the process.

✔ **Partial metering:** The camera bases exposure only on the light that falls in the center 6.5 percent of the frame. The left image in Figure 7-11 provides a rough approximation of the area that factors into the exposure equation.

✔ **Spot metering:** This mode works like Partial metering but uses a smaller region of the frame to calculate exposure. For Spot metering, exposure is

based on just the center 2.8 percent of the frame, as indicated by the illustration on the right in Figure 7-11.

✓ **Center-Weighted Average metering:** The camera bases exposure on the entire frame but puts extra emphasis (weight) on the center.

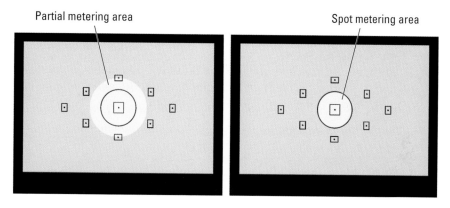

Figure 7-11: The spotlights indicate the metered area for Partial metering and Spot metering.

In most cases, Evaluative metering does a good job of calculating exposure, but it can get thrown off when a dark subject is set against a bright background or vice versa. For example, in the left image in Figure 7-12, the amount of bright background caused the camera to select exposure settings that underexposed the car's dashboard, which was the point of interest for the photo. Switching to Partial metering properly exposed the statue. (Spot metering would produce a similar result for this particular subject.)

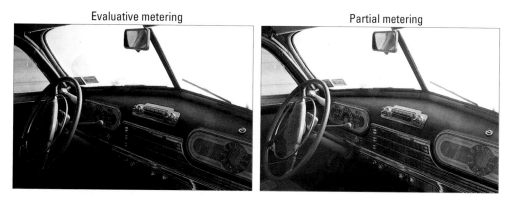

Figure 7-12: Using Evaluative metering underexposes the dashboard; Partial metering produces a better result.

Of course, if the background is very bright and the subject is very dark, the exposure that does the best job on the subject typically overexposes the background. You may be able to reclaim some lost highlights by turning on Highlight Tone Priority, a Custom Function explored later in this chapter.

Use either of these two options to change the metering mode:

- ✒ **Quick Control screen:** First, display the Shooting Settings screen by pressing the shutter button halfway and then releasing it. Then press the Quick Control button to shift into Quick Control mode and use the multicontroller to highlight the Metering mode icon, as shown on the left in Figure 7-13. The selected setting appears in the label at the bottom of the screen. Rotate the Main dial to cycle through the four modes or press Set to display a list of all four modes, as shown on the right in the figure. If you take the second route, use the multicontroller or the Main dial to highlight the icon for the mode you want to use and then press Set to lock in your decision.

- ✒ **Metering mode selection button:** Press the Metering mode selection button, as shown in Figure 7-14. You then see the screen shown on the right of Figure 7-13. Highlight your choice and press Set again to return to the menu.

Current setting Metering mode icon

Figure 7-13: Quickly adjust the Metering mode from the Quick Control screen.

In theory, the best practice is to check the metering mode before each shot and choose the mode that best matches your exposure goals. But in practice, that's a pain, not just in terms of having to adjust yet one more capture setting but also in terms of having to *remember* to adjust one more capture setting.

Here's some advice: Until you're truly comfortable with all the other controls on your camera, just stick with the default setting, which is Evaluative metering. That mode produces good results in most situations, and, after all, you can see in the monitor whether you disagree with how the camera metered or exposed the image and simply reshoot after adjusting the exposure settings to your liking. This option makes the whole metering mode issue a lot less critical than it is when you shoot with film.

The one scenario that might warrant an exception to this advice is if you want to capture a series of images of a subject that's significantly darker or brighter than its background. Then, switching to Partial, Spot, or Center-Weighted Average metering may save you the time of having to adjust the exposure for each image.

Metering mode button

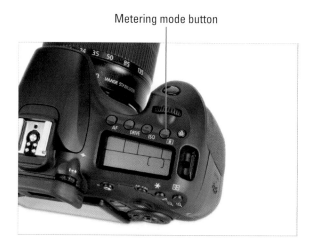

Figure 7-14: Or, access the Metering mode from the Metering mode selection button.

Setting ISO, f-stop, and Shutter Speed

If you want to control ISO, aperture (f-stop), or shutter speed, set the camera to one of the Creative Zone modes. Then check out the next several sections to find the exact steps to follow in each of these modes.

Controlling ISO

To recap the ISO information presented at the start of this chapter: Your camera's ISO setting controls how sensitive the image sensor is to light by basically turning up its "volume." At a camera's higher ISO values, you need less light to expose an image correctly.

Here's the downside to raising ISO: The higher the ISO, the greater the possibility of noisy images. Refer to Figure 7-7 for a reminder of what that defect looks like.

In the fully automatic exposure modes, the camera selects an ISO from 100 to 3200, depending on the available light and whether you use flash. You have no control over ISO in those exposure modes.

To access the ISO setting, press the ISO button on top of the camera. In the advanced exposure modes, you have the following ISO choices:

- **Select a specific ISO setting.** Normally, you can choose ISO 100, 200, 400, 800, 1600, 3200, or 6400. The Custom Function I-3 (called ISO Expansion) enables you to push the ISO to 12800. (Canon simply labels it H, probably for superduper High.) Figure 7-7 shows that the H setting is equivalent to a noisy photo, which is likely the reason why this highest ISO isn't available by default.

 To expand the ISO range, set Custom Function I-3 to On, as shown on the right in Figure 7-15. (The function number appears in the top-right corner of the screen.). For more information on how to set Custom Functions, please refer to Chapter 11.

C.Fn I :Exposure	C.Fn I :Exposure 3
C.Fn II :Image	ISO expansion
C.Fn III :Autofocus/Drive	0:Off
C.Fn IV :Operation/Others	1:On
Clear all Custom Func. (C.Fn)	1 2 3 4 5 6 7
	0 0 0 0 0 0 0

Figure 7-15: From Custom Function I-3, you can push the available ISO range to 12800.

One more complication to note: Another of the exposure-related Custom Functions — Highlight Tone Priority — affects the range of available ISO settings. If you enable this feature, you lose the option of using ISO 100 as well as the expanded ISO setting (12800 or H). Highlight Tone Priority is covered later in this chapter.

- **Let the camera choose (Auto ISO).** You can still rely on the camera to adjust ISO for you in the advanced exposure modes if you prefer.

And you get a related option not available in the fully automatic exposure modes: You can specify the highest ISO setting that you want the camera to use. Make the call through the ISO Auto setting on Shooting Menu 3, as shown in Figure 7-16. Out of the box, the 60D offers ISOs from 100 to 6400 (plus Auto ISO) in the advanced shooting modes. When ISO Expansion is turned on, an additional ISO, named H (ISO 12800), is enabled. ISO Expansion doesn't increase the range in Auto ISO mode; the top available Auto ISO is still 6400. The default maximum ISO Auto value is ISO 3200.

Figure 7-16: Specify the maximum ISO setting the camera can use in Auto ISO mode.

You can view the current ISO setting in the upper-right corner of the Shooting Settings screen, as shown in the left image of Figure 7-17. You can also monitor the ISO in the viewfinder display and in Live View display.

Figure 7-17: Accessing the ISO setting.

To adjust the setting, you have the following two options:

✔ **Press the ISO button.** It's located just behind the Main dial, on top of the camera. After you press the button, you see the screen shown on the right in Figure 7-17. Use the Quick Control dial, Main dial, or multicontroller to highlight your choice and then press Set.

✔ **Use the Quick Control screen.** After displaying the Shooting Settings screen, press the Quick Control button to shift to Quick Control mode and then highlight the ISO setting. Then either rotate the Quick Control or Main dial to cycle through the available ISO settings or press Set to display the same screen you see on the right in Figure 7-17. If you take the second approach, highlight your ISO setting and press Set again.

Dampening noise

Noise, the digital defect that gives your pictures a speckled look (refer to Figure 7-7), can occur for two reasons: a long exposure time and a high ISO setting.

The EOS 60D offers two noise-removal filters, one to address each cause of noise. Both filters are provided through Custom Functions, which means that you can control whether and how they're applied only in the advanced exposure modes. (Check out Chapter 11 for information on how to set Custom Functions.)

To control long-exposure noise reduction, visit Custom Function II-1, and select one of these three settings:

✔ *Off:* No noise reduction is applied. This setting is the default.

✔ *Auto:* Noise reduction is applied when you use a shutter speed of 1 second or longer, but only if the camera detects the type of noise that's caused by long exposures.

✔ *On:* Noise reduction is always applied at exposures of 1 second or longer. (*Note:* Canon suggests that this setting may result in more noise than either Off or Auto when the ISO setting is 1600 or higher.)

For high ISO noise removal, move to Custom Function II-2. This filter offers four settings, as shown in the right figure:

✔ *Standard:* The default setting

✔ *Low:* Applies a little noise removal

✔ *Strong:* Goes after noise in a more dramatic way

✔ *Disable:* Turns off the filter

Although noise reduction is a useful concept in theory, both filters have a few disadvantages. First, they're applied after you take the picture, when the camera processes the image data and records it to your memory card, which slows your shooting speed. In fact, using the Strong setting for High ISO noise removal reduces the maximum frame rate (shots per second) that you can click off.

Second, High ISO noise-reduction filters work primarily by applying a slight blur to the image. Don't expect this process to eliminate noise entirely, and expect some resulting image softness. You may be able to get better results by using the blur tools or noise-removal filters found in many photo editors because then you

can blur just the parts of the image where noise is most noticeable — usually in areas of flat color or little detail, such as skies.

Long Exposure Noise Reduction is a different beast and can usually do a better job of reducing noise than you can with extra software on your computer. The only downside to using Long Exposure Noise Reduction is that it doubles the processing time for each exposure — longer than 1 second — that you shoot. Say that you make a 30-second exposure at night. After the shutter closes at the end of the exposure, the camera takes a *second* 30-second exposure to measure the noise by itself, and then subtracts that noise from your *real* exposure. If the time delay isn't an issue, though, this filter can work wonders.

C.Fn Ⅱ :Image ◄ 1 ►
Long exp. noise reduction

0:Off
1:Auto
2:On

ⅰ 2 3
0 0 0

C.Fn Ⅱ :Image ◄ 2 ►
High ISO speed noise reduct'n

0:Standard
1:Low
2:Strong
3:Disable

ⅰ 2 3
0 0 0

In Auto ISO mode, the Shooting Settings display and Live View display initially show Auto as the ISO value, as you would expect. But when you press the shutter button halfway, which initiates exposure metering, the value changes to show you the ISO setting the camera has selected. You also see the selected value rather than Auto in the viewfinder. ***Note:*** When you view shooting data during playback, you may see a value reported that isn't on the list of "official" ISO settings: ISO 320, for example. This happens because in Auto mode, the camera can select values all along the available ISO range, whereas if you select a specific ISO setting, you're restricted to specific notches within the range.

We like to reserve the use of Auto ISO for those shooting times when the light is changing fast or we're moving from light to dark areas quickly. In these situations, Auto ISO can save the day, giving you properly exposed images without any ISO futzing on your part.

Adjusting aperture and shutter speed

You can adjust aperture and shutter speed only in Creative Zone modes; the exception is that you do not set a shutter speed in Bulb mode.

To see the current exposure settings, start by pressing the shutter button halfway. The following actions then take place:

1. The exposure meter comes to life. If autofocus is enabled, focus is also set at this point.

2. The aperture and shutter speed appear in the viewfinder or the Shooting Settings display, if you have it enabled. In Live View mode, the settings appear under the image preview on the monitor.

3. In manual exposure (M) mode, the exposure meter also lets you know whether the current settings will expose the image properly. In the other Creative Zone modes (P, Tv, and Av), the camera doesn't indicate an exposure problem by using the meter, but by flashing either the shutter speed or the f-stop value. (See the earlier section, "Monitoring Exposure Settings," for details.)

The technique you use to change the exposure settings depends on the exposure mode, as outlined in the following list:

- ✔ **P (programmed auto):** In this mode, the camera initially displays its recommended combination of aperture and shutter speed. To select a different combination, rotate the Main dial.

 - *To select a lower f-stop number (larger aperture) and faster shutter speed:* Rotate the dial to the right.

 - *To select a higher f-stop number (smaller aperture) and slower shutter speed:* Rotate the dial to the left.

- ✔ **Tv (shutter-priority autoexposure):** Rotate the Main dial to the right for a faster shutter speed; nudge it to the left for a slower speed. When you change the shutter speed, the camera automatically adjusts the aperture as needed to maintain the proper exposure.

 Changing the aperture also changes depth of field. So even though you're working in shutter-priority mode, keep an eye on the f-stop, too, if depth of field is important to your photo. *Note:* In extreme lighting conditions, the camera may not be able to adjust the aperture enough to produce a good exposure at the current shutter speed; again, possible aperture settings depend on your lens. So you may need to compromise on shutter speed — or, in dim lighting, raise the ISO.

- ✔ **Av (aperture-priority autoexposure):** Rotate the Main dial to the right to stop-down the aperture to a higher f-stop number. Rotate the dial to the left to open the aperture to a lower f-stop number. When you do, the camera automatically adjusts the shutter speed to maintain the exposure.

If you're handholding the camera, be careful that the shutter speed doesn't drop so low when you stop-down the aperture that you run the risk of camera shake. If your scene contains moving objects, make sure that when you dial in your preferred f-stop, the shutter speed that the camera selects is fast enough to stop action (or slow enough to blur it, if that's your creative goal).

✔ **M (manual exposure):** In this mode, you select both aperture and shutter speed, like so:

- *To adjust shutter speed:* Rotate the Main dial to the right for a faster shutter speed; rotate left for a slower shutter.

- *To adjust aperture:* Rotate the Quick Control dial, shown in Figure 7-18.

Rotate the dial to the right for a higher f-stop (smaller aperture); rotate left to select a lower f-stop. Don't let up on the button when you rotate the Main dial, or you will instead adjust the shutter speed.

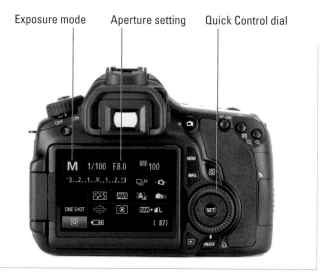

Exposure mode Aperture setting Quick Control dial

Figure 7-18: To set the aperture in M mode, rotate the Quick Control dial.

In M, Tv, and Av modes, the setting that's available for adjustment appears in the Shooting Settings display in purple, with little arrows at each side. Your camera manual refers to this display as the *Main dial pointer,* and it's provided as a reminder that you use the Main dial to change the setting.

For example, in M mode, the shutter speed appears purple until you hold down the Exposure Compensation button, at which point the marker shifts to the aperture (f-stop) value, as shown in Figure 7-19.

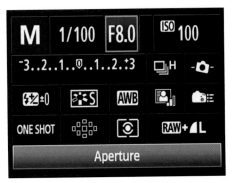

 You also can use the Quick Control method of adjusting the settings in the M, Tv, and Av modes. This trick is especially helpful for M mode because you can adjust the f-stop setting without having to remember what button to push to do the job. Try it out. After displaying the Shooting Settings screen, press the Quick Control button to shift to Quick Control mode and then use the multicontroller to highlight the setting you want to change. For example, in Figure 7-19, the aperture setting is highlighted, and a text label offers a helpful reminder with the name of the option at the bottom of the screen. Now, rotate the Main dial to adjust the setting, press the shutter button halfway, and release it to exit Quick Control mode.

Figure 7-19: Use the Quick Control screen to adjust aperture and shutter speed in M, Tv, and Av exposure modes.

Keep in mind that when you use P, Tv, and Av modes, the settings that the camera selects are based on what it thinks is the proper exposure. If you don't agree with the camera, you have two options. Switch to manual exposure (M) mode and simply dial in the aperture and shutter speed that deliver the exposure you want; or, if you want to stay in P, Tv, or Av mode, you can tweak the autoexposure settings by using Exposure Compensation, one of the exposure-correction tools described in the next section.

Sorting through Your Camera's Exposure-Correction Tools

In addition to the normal controls over aperture, shutter speed, and ISO, your EOS 60D offers a collection of tools that enable you to solve tricky exposure problems. The next four sections give you the lowdown on these features.

Overriding autoexposure results with Exposure Compensation

When you set your camera to the P, Tv, or Av exposure modes, you can enjoy the benefits of autoexposure support but retain some control over the final exposure. If you think that the image the camera produced is too

dark or too light, you can use a feature known as *Exposure Compensation,* which is sometimes also called *EV Compensation.* (The *EV* stands for *exposure value.*)

Whatever you call it, this feature enables you to tell the camera to produce a darker or lighter exposure than what its autoexposure mechanism thinks is appropriate. Best of all, this feature is probably one of the easiest on the camera to understand. Here's all there is to it:

- ✔ Exposure compensation is stated in EV values, as in +2.0 EV. Possible values range from +5.0 EV to –5.0 EV.

- ✔ A setting of EV 0.0 results in no exposure adjustment.

- ✔ For a brighter image, you raise the EV value. The higher you go, the brighter the image becomes.

- ✔ For a darker image, you lower the EV value. The picture becomes progressively darker with each step down the EV scale.

Each full number on the EV scale represents an exposure shift of one *full stop.* In plain English, it means that if you change the Exposure Compensation setting from EV 0.0 to EV –1.0, the camera adjusts either the aperture or the shutter speed to allow half as much light into the camera as it would get at the current setting. If you instead raise the value to EV +1.0, the settings are adjusted to double the light.

By default, the exposure is adjusted in 1/3 stop increments. In other words, you can shift from EV 0.0 to EV +0.3, +0.7, +1.0, and so on. But you can change the adjustment to 1/2-stop increments if you want to shift the exposure in larger jumps — from EV 0.0 to EV +0.5, +1.0, and so on. To do so, change Custom Function I-1, and select 1/2-Stop. If you make this change, the meter appears slightly different in the Shooting Settings display and Live View display than you see it in this book. (Only one intermediate notch appears between each number on the meter instead of the usual two.) The viewfinder meter doesn't change, but the exposure indicator bar appears as a double line if you set the Exposure Compensation value to a half-step value (+0.5, +1.5, and so on).

Exposure compensation is especially helpful when your subject is much lighter or darker than an average scene. For example, take a look at the first image in Figure 7-20. Because of the very dark shelves and metal objects, the camera chose an exposure that made the subject too light, especially for the baseball. Using –1 stop of exposure compensation resulted in a properly exposed image.

Sometimes you can cope with situations like this one by changing the Metering mode setting, as discussed earlier in this chapter. The images in Figure 7-21 were metered in Evaluative mode, for example, which meters

exposure over the entire frame. Switching to Partial or Spot metering probably wouldn't have helped in this case because the center of the frame was so dark. But using Exposure Compensation — dialing in a setting of EV –1.0 — produced the more appropriate exposure on the right.

EV 0.0　　　　　　　　　　　　　　　　　　　EV –1.0

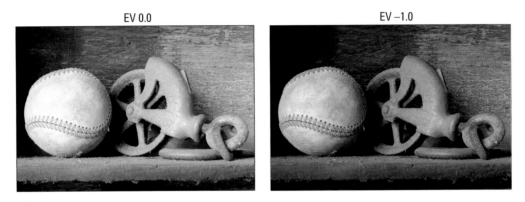

Figure 7-20: For a darker exposure than the autoexposure mechanism chooses, dial in a negative Exposure Compensation value.

In most cases, a 2-stop exposure compensation range is more than enough; a setting beyond that is typically useful only for creating HDR (high dynamic range) images, which you can explore in a later sidebar in this chapter. If you find yourself needing more than 2 stops of compensation, revisit the exposure settings and try to correct the problem there.

Figure 7-21: You can adjust exposure compensation from the Quick Control screen.

Here's how to dial in exposure compensation:

1. **When the Shooting Setting screen is displayed, press Q to activate the Quick Control mode.**

 The Q button is just above the Quick Control dial. You can see it in Figure 7-18.

2. **Use the multicontroller to highlight the exposure meter (refer to the left screen in Figure 7-21).**

3. **Rotate the Quick Control dial to move the exposure indicator left or right along the meter.**

 - Rotate the dial to the left to lower the Exposure Compensation value and produce a darker exposure.

 - Rotate the dial to the right to raise the value and produce a brighter exposure.

 - To return to no adjustment, rotate the dial until the exposure indicator is back at the center position on the meter.

 Alternatively, highlight the exposure meter and press Set. Rotate the Quick Control dial as above to change the amount of exposure compensation, and press Set to lock in the change.

 As an alternate to the alternate, you can set exposure compensation from Shooting Menu 2.

 Don't use the Main Dial in either case. It sets the Autoexposure Bracketing (AEB) distance.

4. **Press Q or the shutter button halfway to exit the Quick Control screen.**

Note that, unlike the LCD methods, which show the exact amount of exposure compensation up to +/–5 stops, the viewfinder displays only +/–2 stops. You *can* dial in more than those two stops, but you have to count *clicks* for any adjustment past +/–2 stops of exposure compensation because the viewfinder gives you no hints to how many more or fewer than 2 stops you selected.

In the viewfinder display, you see little triangles at both ends of the meter to remind you that you exceeded the normal 2-stop range of compensation.

How the camera arrives at the brighter or darker image you request depends on the exposure mode:

✓ **In Av (aperture priority) mode:** The camera adjusts the shutter speed but leaves your selected f-stop in force. Be sure to check the resulting shutter speed to make sure that it isn't so slow that camera shake or blur from moving objects is problematic.

✓ **In Tv (shutter priority) mode:** The opposite occurs: The camera opens or stops down the aperture, leaving your selected shutter speed alone.

✓ **In P (programmed autoexposure) mode:** The camera decides whether to adjust aperture, shutter speed, or both to accommodate the Exposure Compensation setting.

These explanations assume that you have a specific ISO setting selected rather than Auto ISO. If you do use Auto ISO, the camera may adjust that value instead.

Keep in mind, too, that the camera can adjust the aperture only so much, according to the aperture range of your lens. The range of shutter speeds is limited by the camera. So if you reach the end of those ranges, you have to compromise on either shutter speed or aperture or adjust ISO.

A final, and critical, point about exposure compensation: When you power-off the camera, it doesn't return you to a neutral setting (EV 0.0). The setting you last used remains in force for the Creative Zone exposure modes until you change it.

Improving high-contrast shots with Highlight Tone Priority

When a scene contains both very dark and very bright areas, achieving a good exposure can be difficult. If you choose exposure settings that render the shadows properly, the highlights are often overexposed, as in the left image in Figure 7-22. Although the dark lamppost in the foreground looks fine, the white building behind it has become so bright that all detail has been lost. The same thing occurred in the highlight areas of the green church steeple.

Your camera offers an option that can help produce a better image in this situation — Highlight Tone Priority — which was used to produce the second image in Figure 7-22. The difference is subtle, but if you look at that white building and steeple, you can see that the effect does make a difference. Now the windows in the building are at least visible, the steeple has regained some of its color, and the sky, too, has a bit more blue.

This feature is turned off by default, which may seem like an odd choice after looking at the improvement it made to the scene in Figure 7-22. What gives? The answer is that in order to do its thing, Highlight Tone Priority needs to limit your choice of ISO settings. Instead of the ISO 100–12800 range that's possible without Highlight Tone Priority, you're restricted to ISO 200–6400. This occurs because part of the way the camera favors highlights is to process the image at an ISO value one step below your selected setting by applying exposure compensation and other adjustments.

Highlight Tone Priority off Highlight Tone Priority on

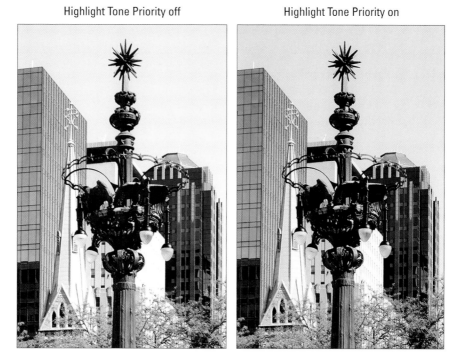

Figure 7-22: Use Highlight Tone Priority to help prevent overexposed highlights.

Losing the highest ISO is no big deal; the noise level at that high setting can make your photo unattractive, anyway. In bright light, though, you may miss the option of lowering the ISO to 100 because you may be forced to use a smaller aperture or a faster shutter speed than you like. Additionally, you can wind up with slightly more noise in the shadows of your photo when you use Highlight Tone Priority.

To enable Highlight Tone Priority, follow these steps:

1. **Set the camera Mode dial to one of the Creative Zone exposure modes.**

2. **Display the Custom Function menu.**

3. **Highlight C.Fn II: Image, as shown on the left in Figure 7-23, and press Set.**

4. **Rotate the Quick Control dial or press the multicontroller right or left to display Custom Function 3: Highlight Tone Priority.**

 Look for the Custom Function number in the upper-right corner of the screen.

Figure 7-23: Enable Highlight Tone Priority from Custom Function II-3.

5. **Press Set and then rotate the Quick Control dial or press the multicontroller up or down to highlight the Enable option, shown on the right in Figure 7-23.**

6. **Press Set.**

 Highlight Tone Priority is now enabled and remains on until you visit the Custom Functions playground again to turn it off.

As a reminder that Highlight Tone Priority is enabled, a D+ symbol appears near the ISO value in the Shooting Settings display, as shown in Figure 7-24. The same symbol appears with the ISO setting in the viewfinder and in the shooting data that appears onscreen in Live View mode and Playback mode. (See Chapters 4 and 5 to find out more about picture playback and Live View.)

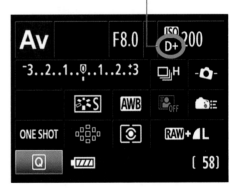

Highlight Tone Priority on

Figure 7-24: D+ indicates that Highlight Tone Priority is enabled.

Experimenting with Auto Lighting Optimizer

When you select a Quality setting that results in a JPEG image file — that is, any setting other than Raw — the camera tries to enhance your photo while it's processing the picture. Unlike Highlight Tone Priority, which concentrates on preserving highlight detail only, Auto Lighting Optimizer adjusts both shadows and highlights to improve the final image tonality. We find it especially beneficial when the subject has lots of dark tones that — without Auto Lighting Optimizer — would be rendered lifeless.

In the fully automatic exposure modes, as well as in Creative Auto, you have no control over how much adjustment is made. In the exposure modes of the Creative Zone, you can decide whether to enable Auto Lighting Optimizer. You also can request a stronger or lighter application of the effect than the default setting. Figure 7-25 offers an example of the type of impact that each Auto Lighting Optimizer setting can make on a scene with dark shadow areas.

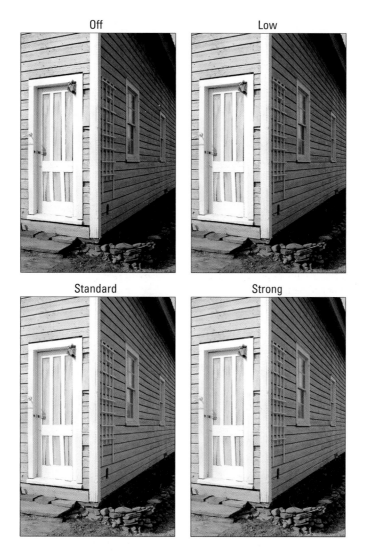

Figure 7-25: For this image, Auto Lighting Optimizer lightened the shadows to improve contrast.

Given the level of improvement that the Auto Lighting Optimizer correction made to this photo, you may be thinking that you'd be crazy to ever disable the feature, but it's important to note a few points:

- ✔ The level of shift that occurs between each Auto Lighting Optimizer setting varies dramatically depending on the subject. This particular example shows a fairly noticeable difference between the Strong and Off settings. You don't always see this much impact from the filter, though. Even in this example, it's difficult to detect much difference between Off and Low.

- ✔ Although the filter improved this particular scene, at times you may not find it beneficial. For example, maybe you're purposely trying to shoot a backlit subject in silhouette or produce a low-contrast image. Either way, you don't want the camera to insert its opinions on the exposure or contrast you're trying to achieve.

- ✔ Because the filter is applied after you capture the photo, while the camera is writing the data to the memory card, it can slow your shooting rate, just like using the Highlight Tone Priority feature.

- ✔ In some lighting conditions, the Auto Lighting Optimizer can produce an increase in image noise.

- ✔ The corrective action taken by Auto Lighting Optimizer can make some other exposure-adjustment features less effective. So turn it off if you don't see the results you expect when you're using the following features:

 - • Exposure compensation, discussed earlier in this chapter

 - • Flash compensation, discussed later in this chapter

 - • Automatic exposure bracketing, discussed later in this chapter

By default, the camera applies Auto Lighting Optimizer at the Standard level. If you want to experiment with other settings, visit Shooting Menu 2 and select Auto Lighting Optimizer (on the left in Figure 7-26). You have four choices, as shown on the right in Figure 7-26: Standard, which is the default level of correction, Strong, Low, and Disable (or Off). Highlight your preference and press Set again to lock the setting. The adjustment remains in force until you revisit the Shooting menu to change the setting. Again, you have this control only in the Creative Zone; in the fully automatic exposure modes, the filter is always applied at the Standard level.

If you're not sure what level of Auto Lighting Optimizer might work best or you're concerned about the other drawbacks of enabling the filter, consider shooting the picture in the Raw file format. For Raw pictures, the camera applies no permanent post-capture tweaking, regardless of whether this filter or any other one is enabled. Then, by using Canon Digital Photo Professional, the software provided free with the camera, you can apply the Auto Lighting Optimizer effect when you convert your Raw images to a standard file format. (See Chapter 6 for details about processing Raw files.)

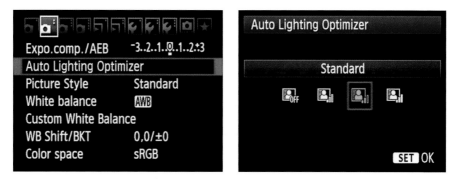

Figure 7-26: Set the level of Auto Lighting Optimizer from Shooting Menu 2.

Correcting lens vignetting with Peripheral Illumination Correction

Because of some optical science principles that are too boring and too deadly to explore, some lenses produce pictures that appear darker around the edges of the frame than in the center, even when the lighting is consistent throughout. This phenomenon goes by several names, but the two heard most often are *vignetting* and *light fall-off*. How much vignetting occurs depends on the lens, your aperture setting, and the lens focal length. (Chapter 8 explains focal length.)

The EOS 60D offers the Peripheral Illumination Correction feature, designed to compensate for vignetting by adjusting the light around the edges of the frame. Figure 7-27 shows an example. In the top image, light fall-off is noticeable at the corners. The bottom image shows the same scene with Peripheral Illumination Correction enabled. The Peripheral Illumination Correction setting is available from the camera, applied to JPEGs, but you can also apply (or unapply) it to raw photos in Digital Photo Professional.

This "before" example hardly exhibits serious vignetting; it's likely that most people wouldn't even notice if

Figure 7-27: Peripheral Illumination Correction tries to correct corner darkening.

it weren't shown next to the "after" example. Unless you turn off this option, you're not likely to notice significant vignetting with the 18–135mm kit lens bundled with the camera. But if your lens suffers from stronger vignetting, it's worth increasing the Peripheral Illumination Correction filter.

Peripheral Illumination Correction is available in all your camera's exposure modes, including all the fully automatic modes. But, a few factoids need spelling out:

- **The correction is available only for photos captured in the JPEG file format.** For Raw photos, you can choose to apply the correction and vary its strength if you use Canon Digital Photo Professional to process your Raw images. Chapter 6 talks more about Raw processing. Space limitations prevent us from covering this software fully, but you can find details in the software manual (provided in electronic form on the CD that ships with the camera).

- **For the camera to apply the proper correction, data about the specific lens has to be included in the camera's *firmware* (the internal software that runs the digital part of the show).** You can determine whether your lens is supported by opening Shooting Menu 1 and selecting the Peripheral Illumination Correction option, as shown on the left in Figure 7-28. Press Set to display the right screen in the figure. If the screen reports that correction data is available, as in the figure, the feature is enabled by default.

As you can see from the right image in Figure 7-28, the 18–135mm kit lens is supported.

If your lens isn't supported, you may be able to add its information to the camera; Canon calls this step *registering your lens*. You do this by cabling the camera to your computer and then using some tools included with the free EOS Utility software, also provided with your camera. (You use this same software when you choose to download photos by cabling the camera to the computer instead of using a memory-card reader.) Again, we must refer you to the manual for help on this bit of business because of the limited number of words that can fit in these pages.

- **If you're using a third-party (non-Canon) lens, Canon recommends that you *not* enable Peripheral Illumination Correction even if the camera reports that correction data is available.** You can still apply the correction in Digital Photo Professional when you shoot in the Raw format, though. To turn off the feature, select the Disable setting (refer to the screen shown on the right in Figure 7-28).

- **In some circumstances, you may see increased noise at the corners of the photo because of the correction.** The exposure adjustment can make noise more apparent. Also, at high ISO settings, the camera applies the filter at a lesser strength, presumably to avoid adding even more noise to the picture. (See the first part of this chapter for an understanding of noise and its relationship to ISO.)

Quality	RAW+**⌐L**
Beep	Enable
Release shutter without card	
Image review	2 sec.
Peripheral illumin. correct.	
Red–eye reduc.	Enable
Flash control	

Peripheral illumin. correct.
Attached lens
EF-S18-135mm f/3.5-5.6 IS
Correction data available
Correction
Enable
Disable

Figure 7-28: If the camera has information about your lens, you can enable the feature.

Locking Autoexposure Settings

To help ensure a proper exposure, your camera continually meters the light until the moment you press the shutter button fully to shoot the picture. In autoexposure modes — that is, any mode but B and M — it also keeps adjusting exposure settings as needed.

For most situations, this approach works great, resulting in the right settings for the light that's striking your subject when you capture the image. You may want to lock in a certain combination of exposure settings, though. Here's one such scenario: Suppose that you're shooting several images of a large landscape that you want to join into a panorama in your photo editor. Unless the lighting is even across the entire landscape, the camera's autoexposure brain will select different exposure settings for each shot, depending on which part of the scene is in the frame. That can lead to weird breaks in the brightness and contrast of the image when you stitch the image together. And, if it's the f-stop that's adjusted, which is what could happen in P or Tv exposure modes, you may notice shifts in depth of field as well because the aperture setting affects that aspect of your pictures.

The easiest way to lock in exposure settings is to switch to M (manual exposure) mode and use the same f-stop, shutter speed, and ISO settings for each shot. In manual exposure mode, the camera never overrides your exposure decisions; they're locked until you change them.

But if you prefer to stay in P, Tv, or Av mode, you can lock the current autoexposure settings. Here's how to do it for still photography; Chapter 4 details how to use the feature during Live View shooting:

1. **Press the shutter button halfway.**

 If you're using autofocusing, focus is locked at this point.

2. Press the AE Lock button, shown in Figure 7-29.

AE stands for *autoexposure*.

Exposure is now locked and remains locked for 4 seconds, even if you release the AE Lock button and the shutter button. To remind you that AE Lock is in force, the camera displays a little asterisk in the viewfinder. If you need to relock exposure, just press the AE Lock button again.

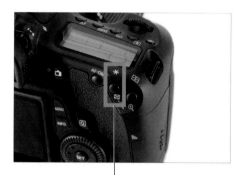

AE Lock button

Figure 7-29: You can lock autoexposure settings by pressing this button.

Note: If your goal is to use the same exposure settings for multiple shots, you must keep the AE Lock button pressed during the entire series of pictures. Every time you let up on the button and press it again, you lock exposure anew based on the light that's in the frame.

One other critical point to remember about using AE Lock: The camera establishes and locks exposure differently depending on the metering mode, the focusing mode (automatic or manual), and on an autofocusing the setting called AF Point Selection mode. (Chapter 8 explains this option thoroughly.) Here's the scoop:

- **Evaluative metering and automatic AF Point Selection:** Exposure is locked on the focusing point that achieved focus.

- **Evaluative metering and manual AF Point Selection:** Exposure is locked on the selected autofocus point.

- **All other metering modes:** Exposure is based on the center autofocus point, regardless of the AF Point Selection mode.

- **Manual focusing:** Exposure is based on the center autofocus point.

Again, if this focusing lingo sounded like gibberish, check out Chapter 8 to get a full explanation.

By combining autoexposure lock with Spot metering, you can ensure a good exposure for photographs in which you want your subject to be off-center, and that subject is significantly darker or lighter than the background. Imagine, for example, a dark statue set against a light blue sky. First, select Spot metering so that the camera considers only the object located in the

center of the frame. Frame the scene initially so that your statue is located in the center of the viewfinder. Press and hold the shutter button halfway to establish focus and then lock exposure by pressing the AE Lock button. Now reframe the shot to your desired composition and take the picture. (See Chapter 8 for details on selecting an autofocus point.)

These bits of advice assume that you haven't altered the function of the AE Lock button, which you can do via a Custom Function. You can swap the tasks of the shutter button and AE Lock button, for example, so that pressing the shutter button halfway locks exposure and pressing the AE Lock button locks focus. Chapter 11 offers details on the relevant Custom Function.

Bracketing Exposures Automatically

The EOS 60D offers *Automatic Exposure Bracketing,* or *AEB.* This feature makes it easy to *bracket exposures,* which simply means to take the same shot using several exposure settings to increase the odds that you come away with a per-fectly exposed image. One other popular use for bracketing is to create HDR images, which combine multiple exposures to create a picture that contains a broader tonal range than could be captured in one shot. The later section, "Putting AEB to work in HDR imaging," introduces this technique.

When you enable AEB, your first shot is recorded at the current exposure set-tings; the second, with settings that produce a darker image; and the third, with settings that produce a brighter image. You can specify how much change in exposure you want in the three images when you turn on the feature.

You can take advantage of AEB in any of the advanced exposure modes. However, the feature isn't available when you use flash. If you want to bracket exposures when using flash, you have to do it, either by using expo-sure compensation or, in manual exposure mode, by changing the aperture and shutter speed directly.

Speaking of exposure compensation, you can combine that feature with AEB, if you want. The camera simply applies the compensation amount when it calculates the exposure for the three bracketed images.

One feature you may want to disable when you use AEB, however, is the Auto Lighting Optimizer option. Because that feature is designed to automatically adjust images that are underexposed or lacking in contrast, it can render AEB ineffective. See the section "Experimenting with Auto Lighting Optimizer," ear-lier in this chapter, for information on where to find and turn off the feature.

Adjusting AEB

Setting up AEB is easy. If you've learned how to use exposure compensation, the steps are very similar. Instead of using the Quick Control dial or the multicontroller to adjust the exposure compensation value, use the Main dial to set the brackets the distance you want from the center point of the exposure index, as shown in Figure 7-30. Here are the specifics:

1. **Display Shooting Menu 2 and highlight Expo. Comp./AEB, as shown on the left in Figure 7-30.**

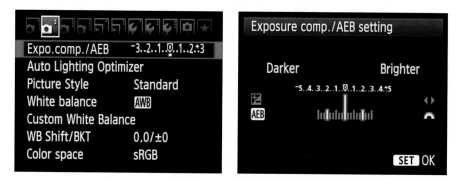

Figure 7-30: Auto exposure bracketing records your image at three exposure settings.

2. **Press Set.**

 You see a screen similar to the one shown on the right in Figure 7-30. This is the same dual-natured screen that appears when you apply exposure compensation from the menu, as explained earlier in this chapter. When the screen first appears, it's in Exposure Compensation mode, so the meter reflects the possible settings for that feature, –5 to +5.

3. **Rotate the Main dial to establish the amount of exposure change you want between images.**

As soon as you rotate the dial, the meter expands, giving you a broader range of adjustment than the Exposure Compensation feature, shown on the right in Figure 7-30. Here's what you need to know to understand the control:

 ✔ **Each whole number on the meter represents one stop.** The little lines under the meter show you the amount of exposure shift that will occur in the three shots the camera records. For example, if you use the setting shown in Figure 7-30, the camera shoots one image at the actual exposure settings (one on the middle), then takes the second image 2 stops down (one-quarter as much light), and then the third image is recorded 2 stops brighter as the base shot (four times as much light).

You can set the bracketing amount to a maximum of 2 stops between each photo.

✓ **Each bright line below the exposure meter represents a photo.** When you see three bright lines, you will shoot three photos. The distance that they're apart from each other corresponds to the exposure difference between each shot.

Keep rotating the dial until you get the exposure indicators to reflect the amount of adjustment you want between each bracketed shot.

Be careful not to try to use the Quick Control dial or the multicontroller instead of the Main dial to set the AEB amount. If you do, you enable the Exposure Compensation feature.

When AEB is enabled, the exposure meter in the Shooting Settings display shows the three exposure indicators to represent the exposure shift you established, as shown in Figure 7-31. You see the same markers in the viewfinder.

If you prefer, you can also enable AEB through the Quick Control screen. With the Shooting Settings screen displayed, press the Quick Control button and then use the cross keys to highlight the exposure meter. Press Set again to display a screen that works just like the one you get through the menus. Again,

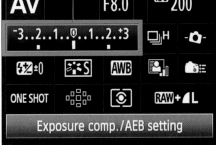

Auto Exposure Bracketing indicator

Figure 7-31: The three bars under the meter remind you that AEB is enabled.

rotate the Main dial to set the bracketing amount and then press Set to wrap things up.

How you record your trio of exposures depends on whether you set the Drive mode to Single or Continuous. Drive mode (described in Chapter 2) determines whether the camera records a single image or multiple images with each press of the shutter button.

✓ **AEB in Single mode:** You take each exposure separately, pressing the shutter button fully three times to record your trio of images.

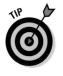

If you forget which exposure you're taking, look at the exposure meter. After you press the shutter button halfway to lock focus, the meter shows just a single indicator bar instead of three. If the bar is at 0, you're ready to take the first capture. If it's to the left of 0, you're on capture two, which creates the darker exposure. If it's to the right of 0, you're on capture three, which produces the brightest image. This assumes that

you haven't also applied exposure compensation, in which case the starting point is at a notch other than zero. (And yes, all these possible combinations can make your head spin.)

✔ **AEB in Continuous mode:** The camera records all three exposures with one press of the shutter button. To record another series, release and then press the shutter button again. In other words, when AEB is turned on, the camera doesn't keep recording images until you release the shutter button as it normally does in Continuous mode — you can take only three images with one press of the shutter button.

✔ **Self-Timer/Remote modes:** All three exposures are recorded with a single press of the shutter button, as with Continuous mode.

To turn off auto exposure bracketing, just revisit Shooting Menu 2 or the Quick Control screen and use the Main dial to change the AEB setting back to 0.

AEB is also turned off when you power-down the camera, enable the flash, replace the camera battery, or replace the memory card. You also can't use the feature in manual exposure (M) mode if you set the shutter speed to the Bulb option. (At that setting, the camera keeps the shutter open as long as you press the shutter button.)

Putting AEB to work in HDR imaging

After you get the hang of turning on and setting Auto Exposure Bracketing, look at how you can use that feature to work in one of photography's newest arenas: High Dynamic Range photography (HDR, as those in-the-know refer to it). (For an in-depth look at HDR photography, check out *High Dynamic Range Digital Photography For Dummies,* by Robert Correll.)

HDR imaging is used to tackle subjects with more *dynamic range* than can be captured in a single exposure. If that term is new to you, don't fret; it simply means that your subject has bright and dark areas that are, well, too light and too dark. In scenes with extreme dynamic range, digital cameras have trouble capturing detail in both those dark and light areas in a single exposure. The solution: Take multiple shots with different exposures and find a way to combine them. AEB is just what you need to easily generate three exposures: one with normal exposure (what the camera meters as the "best" exposure), one that's 2 stops underexposed, and one that's 2 stops overexposed.

The three shots of a backhoe in Figure 7-32 show a bracketed series of photos made with AEB. The normal exposure is first, and you can sure see why we call this a high dynamic range subject. In the normal exposure (again, what the meter determined was proper) the bright areas on the road, in the sky, and reflections off the window lack detail. The other two shots show the overexposed and underexposed images that AEB also generated. In this example, AEB was set to its maximum range of plus and minus 3 stops.

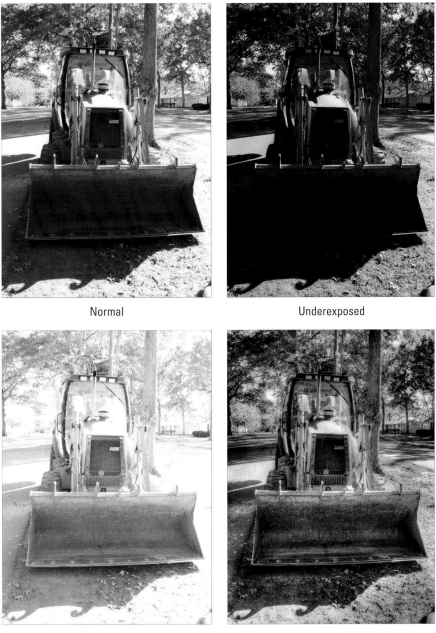

Normal Underexposed

Overexposed Combined

Figure 7-32: Use AEB to capture bracketed exposures, and then combine for the final HDR result.

These three images were combined with special image editing software (*tone-mapping* or HDR software) to build the final HDR image, where you can see the benefits of making those three exposures that provided the raw materials for both highlight detail and lush shadow detail. This is, in a nutshell, HDR imaging.

Here's a short list of guidelines you should follow for HDR photography:

- **Use a tripod.** Although some HDR software has settings to help align your handheld, bracketed series, it's much better to have your images all in alignment when you shoot them. A steady tripod (and remote release) are sound investments if HDR is your thing.

- **Use good software.** If you want to explore HDR photography, you should use software designed for just that task. A couple of excellent options are Photomatix Pro (www.hdrsoft.com) and FDRTools (www.fdrtools.com).

- **Sometimes three exposures aren't enough.** The three exposures (three stops apart) that AEB can produce should be enough for most of your landscape and interior photography. But what if you're working on a series done in the darkest of abandoned factories where bright windows clash with deep shadows? Those three exposures might not give you enough highlight and shadow detail to combine into a handsome final print. In this case, you have two options: Combine AEB with Exposure Compensation (shooting one AEB series of three images and then shifting Exposure Compensation to +4 and again to –4) or simply put your camera in Manual mode and shoot as many bracketed images as you need to ensure detail in both the bright and dark areas.

- **How much to bracket?** Don't bother with less than one stop between your exposures. And try not to have more than two stops difference between images in your bracketed series. As to how many images to shoot, just make sure you have good highlight detail on one end of your series and good shadow detail on the other.

Using Flash in Advanced Exposure Modes

Sometimes, no amount of fiddling with aperture, shutter speed, and ISO produces a bright enough exposure — in which case you simply have to add more light. The built-in flash on your camera offers the most convenient solution.

In the automatic exposure modes covered in Chapter 3, the camera decides when flash is needed. In Creative Auto mode, also discussed in Chapter 3, you can either let the camera retain flash control or set the flash to always fire or never fire. (You make that selection via the Quick Control screen.)

The Creative Zone modes leave the flash decisions entirely up to you; no Auto mode will hand the reins over to the camera. Instead, when you want to use flash, just press the Flash button on the side of the camera, highlighted in Figure 7-33. The flash pops up and fires on your next shot. To turn off the flash, just press down on the flash assembly to close it.

Flash button

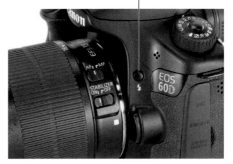

As you can in the fully automatic modes (also known as the Basic Zone), you also can set the flash to Red-Eye Reduction mode. Just display Shooting Menu 1 and turn the Red-Eye option on or off. When you take a picture with the feature enabled, the camera lights the Red-Eye Reduction lamp on the front of the camera for a brief time before the flash goes off in an effort to constrict the subject's pupils and thereby lessen the chances of red-eye.

Figure 7-33: Want flash? Just press the Flash button, and you're set to go.

The next section goes into a little background detail about how the camera calculates the flash power that's needed to expose the image. This stuff is a little technical, but it will help you to better understand how to get the results you want because the flash performance varies depending on the exposure mode.

Following that discussion, the rest of the chapter covers advanced flash features, including flash exposure compensation and flash exposure lock (FE Lock). You'll find some tips on getting better results in your flash pictures as well. For details on using Red-Eye Reduction flash, flip to Chapter 3, which spells everything out. Be sure also to visit Chapter 9, where you can find additional flash and lighting tips related to specific types of photographs.

Understanding your camera's approach to flash

When you use flash, your camera automatically calculates the flash power needed to illuminate the subject. This process is sometimes referred to as *flash metering*.

Your EOS 60D uses a flash-metering system that Canon calls E-TTL II. The *E* stands for *evaluative, TTL* stands for *through the lens,* and *II* refers to the fact that this system is an update to the first version of the system. It isn't important that you remember what the initials stand for or even the flash system's official name. What is helpful to keep in mind is how the system is designed to work.

First, you need to know that a flash can be used in two basic ways: as the primary light source or as a fill flash. When flash is the primary light source, both the subject and background are lit by the flash. In dim lighting, this typically results in a brightly lit subject and a dark background, as shown on the left in Figure 7-34.

Figure 7-34: Fill flash produces brighter backgrounds.

With fill flash, the background is exposed primarily by ambient light and the flash adds a little extra illumination to the subject. Fill flash typically produces brighter backgrounds and, often, softer lighting of the subject because not as much flash power is needed. The downside is that if the ambient light

is dim, as in this nighttime example, you need a slow shutter speed to properly expose the image, and both the camera and the subject must remain still to avoid blurring. The shutter speed for the fill flash image, shown on the right in Figure 7-34, was 1/30 second. Fortunately, the photographer had a tripod, and the deer didn't seem inclined to move.

Neither choice is necessarily right or wrong. Whether you want a dark background depends on the scene and your artistic interpretation. If you want to diminish the background, you may prefer the darker background you get when you use flash as your primary light source. But if the background is important to the context of the shot, allowing the camera to absorb more ambient light and adding just a small bit of fill flash may be more to your liking.

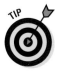

One more note on flash: Although most people think of flash as a tool for nighttime and low-light photography, most outdoor daytime pictures, especially portraits, also benefit from a little fill flash. Figure 7-35 shows you the same scene, shot at a farmer's market on a sunny morning, captured with and without fill flash, for example.

Without flash With flash

Figure 7-35: Flash often improves daytime pictures outdoors.

Using a flash in bright sunlight sometimes also produces a slight warming effect, as Figure 7-35 illustrates, giving colors a subtle reddish-yellowish tint. This color shift occurs because when you enable the flash, the camera's white balancing mechanism warms color slightly to compensate for the bluish light of a flash. But if your scene is lit primarily by sunlight, which is *not* as cool as flash light, the white balance adjustment takes the image colors a step warmer than neutral. If you don't want this warming effect, see Chapter 8 to find out how to make a manual white balance adjustment (as well as what to do if the color shift goes in the other direction, to the cool side of the spectrum).

How does this little flash lesson relate to your camera? Well, the exposure mode you use (P, Tv, Av, or M) determines whether the flash operates as a fill flash or as the primary light source. The exposure mode also controls the extent to which the camera adjusts the aperture and shutter speed in response to the ambient light in the scene.

In all modes, the camera analyzes the light both in the background and on the subject. Then it calculates the exposure and flash output as follows:

- **P:** In this mode, the shutter speed is automatically set between 1/60 and 1/250 second. If the ambient light is sufficient, the flash output is geared to providing fill flash lighting. Otherwise, the flash is determined to be the primary light source, and the output is adjusted accordingly. In the latter event, the image background may be dark, as in the left example in Figure 7-34.

- **Tv:** In this mode, the flash defaults to fill-flash behavior. After you select a shutter speed, the camera determines the proper aperture to expose the background with ambient light. Then it sets the flash power to provide fill-flash lighting to the subject.

 You can select a shutter speed between 30 seconds and 1/250 second. If the aperture (f-stop) setting blinks, the camera can't expose the background properly at the shutter speed you selected. You can adjust either the shutter speed or ISO to correct the problem.

- **Av:** Again, the flash is designed to serve as fill-flash lighting. After you set the f-stop, the camera selects the shutter speed needed to expose the background using only ambient light. The flash power is then geared to fill in shadows on the subject.

 Depending on the ambient light and your selected f-stop, the camera sets the shutter speed at anywhere from 30 seconds to 1/250 second. So be sure to note the shutter speed before you shoot; remember, at slow shutter speeds, you may need a tripod to avoid camera shake. Your subject also must remain still to avoid blurring.

If you want to avoid the possibility of a slow shutter altogether, you can set Custom Functions I-7 (shown in Figure 7-36) to another value. At the default setting, the camera operates as just described. If you instead select the second option, the camera sticks with a shutter-speed range of 1/60 to 1/250 second. And with the third option, the shutter speed is always set to 1/250 second when you use flash.

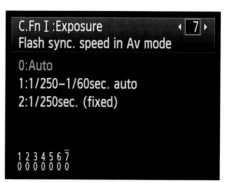

Figure 7-36: You can limit the camera to a fast shutter when using Av mode with flash.

The latter two options both ensure that you can handhold the camera without blur, but obviously, in dim lighting, it can result in a dark background because the camera doesn't have time to soak up much ambient light. At the 1/250 to 1/60 setting, the backgrounds are usually brighter than the 1/250 fixed setting, of course, because the camera at least has the latitude to slow the shutter to 1/60 second.

✔ **M:** In this mode, the shutter speed, aperture, and ISO setting you select determine how brightly the background will be exposed. The camera takes care of illuminating the subject with fill flash. The maximum shutter speed you can select is 1/250 second; the slowest normal shutter speed is 30 seconds.

You also can set the shutter speed to the Bulb setting, which keeps the shutter open as long as you keep the shutter button pressed, however. In Bulb mode, the flash fires at the beginning of the exposure if the Shutter Sync setting is set to the 1st Curtain setting; with the 2nd Curtain setting, the flash fires at the beginning of the exposure and again at the end. See the upcoming section "Exploring more flash options" for details about the Shutter Sync setting.

If the flash output in any mode isn't to your liking, you can adjust it by using flash exposure compensation, explained next. Also check out the upcoming section, "Locking the flash exposure," for another trick to manipulate flash results. In any autoexposure mode, you can also use exposure compensation, discussed earlier, to tweak the ambient exposure: that is, the brightness of your background. So you have multiple points of control: exposure compensation to manipulate the background brightness, and flash compensation and flash exposure lock to adjust the flash output.

One final point: These guidelines apply to the camera's built-in-flash. If you use certain Canon external flash units, you not only have more flash control, but you can also select a faster shutter speed than the built-in flash permits.

Adjusting flash power with Flash Exposure Compensation

TIP

When you shoot with your built-in flash, the camera attempts to adjust the flash output as needed to produce a good exposure in the current lighting conditions. On some occasions, you may find that you want a little more or less light than the camera thinks is appropriate.

You can adjust the flash output by using the feature called *Flash Exposure Compensation*. Similar to exposure compensation, discussed earlier in this chapter, flash exposure compensation affects the output level of the flash unit, whereas exposure compensation affects the brightness of the background in your flash photos. As with exposure compensation, flash exposure compensation is stated in terms of EV *(exposure value)* numbers. A setting of 0.0 indicates no flash adjustment; you can increase the flash power to +2.0 or decrease it to –2.0.

Figure 7-37 shows an example of the benefit of this feature — again, available only when you shoot in the advanced exposure modes. These tomatoes were photographed during bright daylight, but a tent awning shaded them. The first image shows you a flash-free shot. Clearly, a little more light was needed, but at normal flash power, the flash was too strong, blowing out the highlights in some areas, as shown in the middle image. Reducing the flash power to EV –1.3 resulted in a softer flash that straddled the line perfectly between no flash and too much flash.

No flash Flash EV 0.0 Flash EV –1.3

Figure 7-37: When normal flash output is too strong, lower the flash exposure compensation value.

As for boosting the flash output, well, you may find it necessary on some occasions, but don't expect the built-in flash to work miracles even at a flash exposure compensation of +2.0. Any built-in flash has a limited range, and you simply can't expect the flash light to reach faraway objects. In other words, don't even try taking flash pictures of a darkened recital hall from your seat in the balcony because all you'll wind up doing is annoying everyone.

Whichever direction you want to go with flash power, you have two ways to do so:

- ✔ **Quick Control screen:** This path is by far the easiest way to travel. After displaying the Shooting Settings screen, press the Quick Control button to shift to the Quick Control display. Then use the multicontroller to highlight the Flash Exposure Compensation value, as shown on the left in Figure 7-38. Rotate the Main dial to raise or lower the amount of flash adjustment. Or, if you need more help, press Set to display the second screen in the figure. You can use the Main dial or the multicontroller to adjust the flash power on this screen; press Set when you finish.

- ✔ **Shooting Menu 1:** The menu route to flash power is a little more tedious. Display Shooting Menu 1, select Flash Control, and press Set. You then see the left screen in Figure 7-39. Highlight Built-in Flash Func. Setting and press Set to display the right screen. Now highlight the third line, Flash Exp. Comp. (denoted by a pop-up flash symbol shown here) and press Set again. The little flash power meter becomes activated, and you can then use the Quick Control dial or the multicontroller to adjust the setting (just like exposure compensation). Press Set when you finish. In other words, learn the Quick Control method and save yourself a bunch of button presses!

You also have the option of customizing the Set button so that it displays the flash-power screen you see in Figure 7-39. (Chapter 11 shows you how to assign a new function to the Set button.)

Figure 7-38: The quickest way to adjust flash power is via the Quick Control screen.

Flash control		Built−in flash func. setting	
Flash firing	Enable	Flash mode	E−TTL II
Built−in flash func. setting		Shutter sync.	1st curtain
External flash func. setting		▲exp. comp.	⁻3..2..1..0..1..2.⁺3
External flash C.Fn setting		E−TTL II meter.	Evaluative
Clear ext. flash C.Fn set.		Wireless func.	Disable
	MENU ⤺	INFO. Clear flash settings	

Figure 7-39: You can also change flash power by using the menus, but it's a tedious task.

When flash compensation is in effect, the value appears in the Shooting Settings screen, as shown in Figure 7-40. You see the same plus/minus flash symbol in the viewfinder and Live View display although in both cases without the actual Flash Exposure Compensation value. If you change the Flash Exposure Compensation value to 0 (zero), the flash-power icon disappears from all the displays.

P	1/30	F3.5	*	ISO 100

⁻3..2..1..0..1..2.⁺3

Flash Compensation amount

Figure 7-40: The flash value appears only when flash compensation is in effect.

As with exposure compensation, any flash-power adjustment you make remains in force until you reset the control, even if you turn off the camera. So be sure to check the setting before using your flash. Additionally, the Auto Lighting Optimizer feature, covered earlier in this chapter, can interfere with the effect produced by flash exposure compensation, so you might want to disable it.

Locking the flash exposure

You might never notice it, but when you press the shutter button to take a picture with flash enabled, the camera emits a brief *preflash* before the actual flash. This preflash is used to determine the proper flash power needed to expose the image.

Occasionally, the information that the camera collects from the preflash can be off-target because of the assumptions the system makes about what area of the frame is likely to contain your subject. To address this problem, your

camera has a feature called *Flash Exposure Lock,* or FE Lock. This tool enables you to set the flash power based on only the center of the frame.

Unfortunately, FE Lock isn't available in Live View mode. If you want to use this feature, you must abandon Live View and use the viewfinder to frame your images.

Follow these steps to use FE Lock:

1. **With your pop-up flash up and ready, frame your photo so that your subject falls under the center autofocus point.**

 You want your subject smack in the middle of the frame. You can reframe the shot after locking the flash exposure, if you want.

2. **Focus manually or by using autofocus, in which case you press the shutter button halfway or use AF-ON to initiate autofocus.**

 Although you can release the shutter button if you like, we recommend you hold it down so you don't have to reestablish focus later.

3. **While the subject is still under the center autofocus point, press and release the AE Lock button.**

 The camera emits a preflash, and the letters FEL display for a second in the viewfinder. You also see the asterisk symbol — the one that appears above the AE Lock button on the camera body — next to the flash icon in the viewfinder.

4. **If needed, reestablish focus on your subject.**

5. **Reframe the image to the composition you want.**

 While you do, keep the shutter button pressed halfway (or hold AF-ON) to maintain focus if you're using autofocus.

6. **Press the shutter button the rest of the way to take the picture.**

 The image is captured using the flash output setting you established in Step 3.

FEL is also helpful when you're shooting portraits. The preflash sometimes causes people to blink, which means that with normal flash shooting, in which the actual flash and exposure occur immediately after the preflash, their eyes are closed at the exact moment of the exposure. With FEL, you can fire the preflash and then wait a second or two for the subject's eyes to recover before you take the actual picture.

Better yet, the flash exposure setting remains in force for about 16 seconds, meaning that you can shoot a series of images using the same flash setting without firing another preflash at all.

Exploring more flash options

When you set the Mode dial to a Creative Zone mode, Shooting Menu 1 offers a Flash Control option. Using this menu item, you can adjust flash power, as explained a couple of sections earlier (although using the Quick Control screen is easier). The Flash Control option also enables you to customize a few other aspects of the built-in flash as well as an external flash head.

To explore your options, highlight Flash Control, as shown on the left in Figure 7-41, and press Set. You then see the screen shown on the right in the figure. Here's the rundown of the available options:

Quality	RAW+⌿L
Beep	Enable
Release shutter without card	
Image review	2 sec.
Peripheral illumin. correct.	
Red–eye reduc.	Enable
Flash control	

Flash control

Flash firing	Enable
Built–in flash func. setting	
External flash func. setting	
External flash C.Fn setting	
Clear ext. flash C.Fn set.	

MENU ↩

Figure 7-41: You can customize additional flash options via Setup Menu 1.

- ✔ **Flash Firing:** Normally, this option is set to Enable. If you want to disable the flash, you can choose Disable instead. However, you don't have to take this step in most cases; just close the pop-up flash head on top of the camera if you don't want to use flash.

 What's the point of this option, then? Well, if you use autofocusing in dim lighting, the camera may need some help finding its target. To that end, it sometimes emits an *AF-assist beam* from the flash head, and that beam is a series of rapid pulses of light. If you want the benefit of the AF-assist beam but you don't want the flash to fire, you can disable flash firing. Remember that you have to pop up the flash unit to expose the lamp that emits the beam. You also can take advantage of this option when you attach an external flash head.

- ✔ **Built-In Flash Function Setting:** If you highlight this option and press Set, you display the screen shown in Figure 7-42.

 The first option is unavailable for the built-in flash. The other three affect the flash as follows:

- *Shutter Sync:* By default, the flash fires at the beginning of the exposure. This flash timing, known as *1st Curtain Sync,* is the best choice for most subjects. However, if you use a very slow shutter speed and you're photographing a moving object, 1st Curtain Sync causes the blur that results from the motion to appear in front of the object, which doesn't make much visual sense.

Built-in flash func. setting	
Flash mode	E–TTL II
Shutter sync.	1st curtain
▲exp. comp.	‾3..2..1..0̲..1..2.‡3
E–TTL II meter.	Evaluative
Wireless func.	Disable
INFO. Clear flash settings	

Figure 7-42: These advanced flash options affect only the built-in flash.

To solve this problem, you can change the Shutter Sync option to *2nd Curtain Sync,* also known as *rear-curtain sync.* In this flash mode, the motion trails appear behind the moving object. The flash fires twice in this mode: once when you press the shutter button and again at the end of the exposure.

- *Flash Exposure Compensation:* (denoted by the pop-up flash symbol) This setting adjusts the power of the built-in flash; again, see the earlier section, "Adjusting flash power with Flash Exposure Compensation," for details.

- *E-TTL II Metering:* This option enables you to switch from the default flash metering approach, called Evaluative. In this mode, the camera operates as described in the earlier section, "Understanding your camera's approach to flash." That is, it exposes the background using ambient light when possible and then sets the flash power to serve as fill light on the subject.

 If you instead select the Average option, the flash is used as the primary light source, meaning that the flash power is set to expose the entire scene without relying on ambient light. Typically, this results in a more powerful (and possibly harsh) flash lighting and dark backgrounds.

- *Wireless Function*: This option enables the built-in pop-up flash unit to act as a wireless control, or master unit. When it fires, it triggers off-camera Canon Speedlite flash units (although they have to be capable of serving as wireless slaves) to fire.

✔ **External Flash Function Settings:** The last three options on the Flash Control list (refer to the right screen in Figure 7-41) relate to external flash heads; they don't affect the performance of the built-in flash. However, they apply only to Canon EX-series Speedlites that enable you to control the flash through the camera. If you own such a flash, refer to the flash manual for details.

You can probably discern from these descriptions that most of these features are designed for photographers schooled in flash photography who want to mess around with advanced flash options. If that doesn't describe you, don't worry about it. The default settings selected by Canon will serve you well in most every situation. The exception is flash exposure compensation, which you can just as easily adjust via Shooting Menu 1.

Using an external flash unit

In addition to its built-in flash, your camera has a *hot shoe,* which is photo-geek terminology for a connection that enables you to add an external flash head like the one shown in Figure 7-43. The figure features the Canon Speedlite 430EX II, which is Canon's mid-range external flash and retails for around $330.

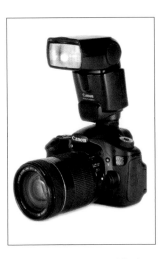

Although certainly not the cheapest of camera accessories, an external flash may be a worthwhile investment if you do a lot of flash photography, especially portraits. For one thing, an external flash offers greater power, enabling you to illuminate a larger area than you can with a built-in flash. And with flash units like the one shown in Figure 7-43, you can rotate the flash head so that the flash light bounces off a wall or ceiling instead of hitting your subject directly. This results in softer lighting and can eliminate the harsh shadows often caused by the strong, narrowly focused light of a built-in flash. (Chapter 9 offers an example of the difference this lighting technique can make in portraits.) Additionally, certain Canon flash units permit you to use a shutter speed faster than the 1/250-second limit imposed by the built-in flash.

Figure 7-43: An external flash with a rotating head offers greater lighting flexibility.

Whether the investment in an external flash will be worthwhile depends on the kind of photography you want to do. If you decide to purchase an external flash, we strongly recommend that you shop at a reputable camera store where the personnel can help you match the flash unit to your shooting needs. You don't have to buy a Canon flash, but be aware that non-Canon flash units don't operate in Live View mode.

You may also want to dig into some of the many books that concentrate solely on flash photography. There's a lot more to that game than you may imagine, and you'll no doubt discover some great ideas about lighting your pictures with flash. You can start with Chapter 9, which provides some specific examples of how to get better flash results when you shoot portraits, whether you go with the built-in flash, an external flash, or even no flash.

8

Manipulating Focus and Color

*T*o many people, the word *focus* has just one interpretation when applied to a photograph: Either the subject is in focus, or it's blurry. But an artful photographer knows that there's more to focus than simply getting a sharp image of a subject. You also need to consider *depth of field,* or the distance over which objects remain sharply focused. This chapter explains all the ways to control depth of field and also discusses how to use the EOS 60D advanced autofocus options.

In addition, this chapter dives into the topic of color, explaining such concepts as *white balance* (a feature that compensates for the varying color casts created by different light sources), and *color space* (an option that determines the spectrum of colors your camera can capture). We conclude with a discussion of Picture Styles.

Reviewing Focus Basics

We cover various focus issues in Chapters 1, 3, and 4. In case you're not reading this book from front to back, the following steps provide a recap of the basic process of focusing with your EOS 60D.

These steps relate only to regular, still photography. You can find details on autofocusing in Live View mode and Movie mode in Chapter 4:

1. **If you haven't already done so, adjust the viewfinder to your eyesight.**

 Chapter 1 explains how to take this critical step.

2. **Set the focusing switch on the lens to manual or automatic focusing.**

 To focus manually, set the switch to the MF position. For autofocusing, set the switch to the AF position, as in Figure 8-1. (These directions are specific to the kit lens sold with the EOS 60D, as shown in the figure. If you use another lens, the switch may look or operate differently, so check the product manual.)

3. **For handheld shooting, turn on Image Stabilization.**

 Auto/Manual Focus switch

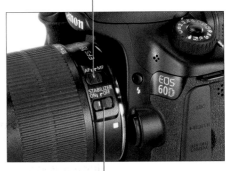

 For sharper handheld shots, set the Image Stabilizer switch on the kit lens to On (refer to Figure 8-1). If you use another lens that offers image stabilization (it may go by a different name, depending on the manufacturer), check the lens manual to find out how to turn on the feature.

 Image Stabilizer switch

 For tripod-mounted shooting with a non-Canon lens, the manufacturer may suggest turning off stabilization, so again, check the lens manual. You don't need to turn off the feature for most Canon IS lenses, but you can save battery power by doing so.

 Figure 8-1: Select AF for autofocus or MF for manual focus.

4. **Set your focus:**

 • *For autofocusing:* Frame your subject so that it appears under one of the nine autofocus points. Then press and hold the shutter button halfway. (See the "Using the AF-ON Button" section, a little later in this chapter, where we provide a safety net in case you're worried that you'll accidentally take a picture when you press the shutter button halfway.)

 In the Basic Zone modes — Full Auto, Creative Auto, and scenes in the Image Zone (like Portrait and Landscape although not Sports) — the focus lamp in the viewfinder lights, and one or

more of the autofocus points turns red, as shown in Figure 8-2. A red dot indicates an *active autofocus point* and tells you that the area under the dot is in focus. Focus is maintained as long as you continue to hold down the shutter button halfway.

AF (autofocus) points

Figure 8-2: The viewfinder offers these focusing aids.

If you shoot in Sports mode, the focus indicators don't appear. Instead, focus is continuously adjusted as needed to track a moving subject until you snap the picture. The same thing occurs in Full Auto, Flash Off, and Creative Auto modes if the camera senses motion in front of the lens; otherwise, focus is locked, and you see the indicator lights.

In the Creative Zone modes (P, Tv, Av, M, B, and C modes), you can choose which autofocusing behavior you prefer and also select which of the nine autofocus points you want to use when establishing autofocus. See the next section for the complete scoop on autofocusing options.

- *For manual focus:* Twist the focusing ring on the lens.

Even in manual mode, you can confirm focus by pressing the shutter button halfway. The autofocus point or points that achieved focus flash for a second or two, and the viewfinder's focus lamp becomes lit.

Shutter speed and blurry photos

A poorly focused photo isn't always related to the issues discussed in this chapter. Any movement of the camera or subject can also cause blur. Both problems are related to shutter speed, an exposure control we cover in Chapter 7. Be sure to also visit Chapter 9, which provides additional tips for capturing moving objects without blur.

Never twist the lens focusing ring on the kit lens without first setting the lens switch to the MF position. You can damage the lens by doing so! If you use another lens, check the lens manual for advice. Some lenses enable you to set focus initially using autofocus and then fine-tune focus by twisting the focusing ring without officially setting the lens to manual focus mode.

Using the AF-ON Button

If you're nervous about pressing the shutter halfway for fear that you'll accidentally take a photo (or several if you're in high-speed continuous drive mode), let us introduce you to the AF-ON button.

This button is located on the back of the camera, within easy reach of your right thumb when you're holding the camera and preparing to take photos. When you're in a Creative Zone mode, simply press AF-ON to activate autofocus and have the camera automatically calculate how much light is in the scene in order to (given the proper mode) automatically set exposure.

This is a handy button, especially if you're using the Main dial to change exposure settings and you can't keep your index finger perfectly calibrated to press the shutter button only halfway. Go ahead and press the AF-ON button for all you're worth, but your camera will never accidentally take a photo when you have the shutter button pressed halfway.

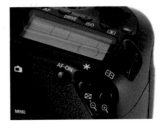

Adjusting Autofocus Performance

You can adjust two aspects of your 60D's autofocusing system:

- ✔ Which autofocus points you want the camera to use to establish focus
- ✔ Whether focus locks when you press the shutter button halfway or is continually adjusted until the time you take the shot

The next two sections explain these features.

Selecting an autofocus point

When you shoot in any of the fully automatic exposure modes (Full Auto, Portrait, Landscape, and so on) as well as in Creative Auto, the camera's autofocusing system looks at all nine autofocus points when trying to establish

focus. Typically, the camera sets focus on the point that falls over the object closest to the lens. If that focusing decision doesn't suit your needs, you have two options:

- ✔ Focus manually.
- ✔ Set the camera to a Creative Zone mode (P, Tv, Av, M, B, or C exposure mode. In these modes, you can tell the camera to base focus on a specific autofocus point.

Chapter 1 explains how to adjust focus manually. If you want to use autofocusing and specify an autofocus point, the following steps spell out the process.

Again, these steps assume that you aren't shooting in Live View mode or recording a movie. The intricacies of Live View and Movie mode autofocusing are covered in Chapter 4. However, some autofocusing concepts involved in normal shooting also come into play for Live View and movie autofocusing, so familiarize yourself with these steps before you jump to that discussion.

1. **Set the Mode dial to P, Tv, Av, M, B, or C.**

 You can specify an autofocus point only in these exposure modes.

AF Point Selection button

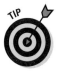

2. **Press and release the AF Point Selection button, highlighted in Figure 8-3.**

 You see the AF Point Selection screen on the monitor if you're on the Quick Control screen; if not, the autofocus points are illuminated in the viewfinder. From this screen, you can choose one of two modes:

Figure 8-3: Press and release the AF Point Selection button to select an autofocus point.

 - *Automatic AF Point Selection:* All focus points are considered. All autofocus points on the screen appear in color, as shown in Figure 8-4.

 - *Manual AF Point Selection:* Choose a single focus point. Only one point is selected, and it appears in color, as shown in Figure 8-5. In the figure, the AF point at 11 o'clock is selected.

 You can check the current mode by looking through the viewfinder, too. When you press and release the AF Point Selection button, all nine autofocus points turn red if you're in Automatic AF Point Selection

mode. A single point turns red if you're in Manual AF Point Selection mode.

3. **To choose a single autofocus point, set the camera to Manual AF Point Selection mode.**

 You can do this in two ways:

 - *Rotate the Main dial.* This option is easiest when you're looking in the viewfinder.

 - *Press the Set button.* Pressing the button toggles the camera between Automatic AF Point Selection and Manual AF Point Selection with the center point activated.

4. **Specify which AF point you want to use.**

 You can either rotate the Main dial or press the multicontroller to select a point. When all autofocus points again turn red, you've cycled back to automatic AF Point Selection mode. Rotate the dial or press the multicontroller to switch back to single-point selection.

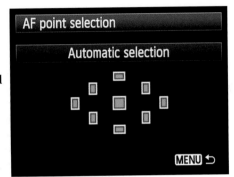

Figure 8-4: In Automatic mode, all nine autofocus points are active.

Figure 8-5: You also can base autofocus on a single point.

That's all there is to it. After you select the autofocus point, just frame your shot so that your subject falls under that point and then press the shutter button halfway to focus.

Changing the AF (autofocus) mode

Your camera offers three different autofocusing schemes, which you select through the AF mode control (not to be confused with Live View AF Mode). The three choices work like so:

- **One-Shot:** In this mode, which is geared to shooting stationary subjects, the camera locks focus when you press the shutter button halfway. Focus remains locked as long as you hold the shutter button at that halfway position.

✔ **AI Servo:** In this mode, the camera adjusts focus continually as needed from when you press the shutter button halfway to the time you take the picture. This mode is designed to make focusing on moving objects easier.

For AI Servo to work properly, you must reframe as needed to keep your subject under the active autofocus point if you're working in Manual AF Point Selection mode. If the camera is set to Automatic AF Point Selection, the camera initially bases focus on the center focus point. If the subject moves away from the point, focus should still be okay as long as you keep the subject within the area covered by one of the other nine autofocus points. (The preceding section explains these two modes.)

In either case, the green focus dot in the viewfinder blinks rapidly if the camera isn't tracking focus successfully. If all is going well, the focus dot doesn't light up, nor do you hear the beep that normally sounds when focus is achieved. (You can hear the autofocus motor whirring a little when the camera adjusts focus.)

✔ **AI Focus:** This mode automatically switches the camera from One-Shot to AI Servo as needed. When you first press the shutter button halfway, focus is locked on the active autofocus point (or points), as usual in One-Shot mode. If the subject moves, the camera shifts into AI Servo mode and adjusts focus as it thinks is warranted.

Which of these three autofocus modes is available to you, however, depends on the exposure mode:

✔ **P, Tv, Av, M, B, and C modes:** You can select any of the three AF mode options.

✔ **Portrait, Landscape, Night Portrait, and Close-Up modes:** The camera restricts you to One-Shot mode.

✔ **Sports mode:** The camera always uses AI Servo autofocus.

✔ **Full Auto, Creative Auto, and No Flash modes:** These modes always use AI Focus.

AI stands for *artificial intelligence,* if that helps.

So, assuming that you're using an exposure mode that enables you to choose from all three AF modes, which one is best? Here's our take: One-Shot mode works best for shooting still subjects, and AI Servo is the right choice for moving subjects. If you're just getting used to your camera and feeling overwhelmed with all its features, you may want to stick with AI Focus until you're ready to take more control. AI Focus does a good job in most cases of making that shift for you and saves you the trouble of having to think about adjusting one more setting between shots.

Whatever your decision, you can set the AF mode in two ways:

- **Quick Control screen:** Display the Shooting Settings screen (just press the shutter button halfway and release it). Then press the Quick Control button and use the multicontroller to highlight the icon shown in Figure 8-6. The selected AF mode setting appears at the bottom of the screen. Rotate the Quick Control or Main dial to cycle through the three mode options.

 If you prefer, you can press Set after highlighting the AF mode icon to display the screen shown on the right in Figure 8-6, where all the mode choices appear. Then use the multicontroller or the Quick Control or Main dial to highlight your choice and press Set again.

 Pressing Set to show all the choices for each setting is a great way to become familiar with all the settings. This method is also the most cumbersome and time-consuming of the three ways to change settings using the Quick Control screen.

- **AF button:** Don't forget about this button. It's on top of the camera, in front of the LCD panel, right beside the Drive button. Press it to go directly to the screen shown on the right in Figure 8-6. Select your choice and press Set.

Figure 8-6: Adjust the AF mode by using the Quick Control screen or pressing the AF button.

Manipulating Depth of Field

Getting familiar with the concept of depth of field is one of the biggest steps you can take to becoming a more artful photographer. *Depth of field* simply refers to the distance in which objects in a photograph are sharply in focus.

Chapters 3 and 7 provide an introduction to depth of field, but here's a quick summary just to hammer home the lesson:

- **With a shallow (small) depth of field:** Only your subject and objects very close to it are sharp. Objects at a distance from the subject are blurry.

- **With a large depth of field:** The zone of sharp focus extends to include distant objects.

Which arrangement works best depends entirely on your creative vision and your subject. In portraits, for example, a classic technique is to use a shallow depth of field, as in Figure 8-7. This approach increases emphasis on the subject while diminishing the impact of the background. For the photo shown in Figure 8-8, though, the goal was to give the historical marker, the lighthouse, and the cottage equal weight in the scene, so settings that produced a large depth of field were used to keep them all in focus.

Shallow depth of field

TIP

With a wide aperture, backgrounds (even messy ones) become much less distracting.

Note, though, that with a shallow depth of field, which part of the scene appears blurry depends on the spot at which you establish focus. In the lighthouse scene, for example, had settings that produced a short depth of field been used and focus set on the lighthouse, both the historical marker in the foreground and the cottage in the background might be outside the zone of sharp focus.

Figure 8-7: A shallow depth of field blurs the background and draws added attention to the subject.

So how do you adjust depth of field? You have these three points of control:

- **Aperture setting (f-stop):** The aperture is one of three exposure settings, all explained fully in Chapter 7. Depth of field increases as you stop down the aperture (by choosing a higher f-stop number). For shallow depth of field, open the aperture (by choosing a lower f-stop number).

Figure 8-9 offers an example. Notice that the trees in the background are much more softly focused in the f/5.6 example than in the f/11 version. Of course, changing the aperture requires adjusting the shutter speed or ISO to maintain the equivalent exposure; for these images, shutter speed was adjusted.

✓ **Lens focal length:** In lay terms, *focal length,* which is measured in millimeters, determines what the lens "sees." As you increase focal length (use a "longer" lens, in photography-speak) the angle of view narrows, objects appear larger in the frame, and — the important point in this discussion — depth of field decreases. Additionally, the spatial relationship of objects changes as you adjust focal length.

For example, Figure 8-10 compares the same scene shot at focal lengths of 138mm and 255mm. An f/22 aperture was used for both examples.

Large depth of field

Figure 8-8: A large depth of field keeps both near and far subjects in sharp focus.

f/5.6, 1/1000 second f/11, 1/200 second

Figure 8-9: Raising the f-stop value increases depth of field.

138mm, f/22 255mm, f/22

Figure 8-10: Using a longer focal length also reduces depth of field.

Whether you have any focal-length flexibility depends on your lens: If you have a zoom lens, you can adjust the focal length by zooming in or out. (The EOS 60D kit lens, which offers a focal length range of 18mm–135mm, is handy when zooming like this.) If your lens offers only a single focal length — a *prime* lens in photo-speak — scratch this means of manipulating depth of field (unless you want to change to a different prime lens, of course).

For more technical details about focal length and your camera, see the later sidebar, "Fun facts about focal length."

✔ **Camera-to-subject distance:** When you move the lens closer to your subject, depth of field decreases. This statement assumes that you don't zoom in or out to reframe the picture, thereby changing the focal length. If you do, depth of field is affected by both the camera position and focal length.

The extent to which background focus shifts as you adjust depth of field also is affected by the distance between the subject and the background. For increased background blurring, move the subject farther away from the background.

Together, these three factors determine the maximum and minimum depth of field you can achieve, as illustrated by the clever artwork shown in Figure 8-11 and summed up in the following list:

- **To produce the shallowest depth of field:** Open the aperture as wide as possible (select the lowest f-stop number), zoom in to the maximum focal length of your lens, and move as close as possible to your subject.

- **To produce maximum depth of field:** Stop down the aperture to the highest possible f-stop setting, zoom out to the shortest focal length your lens offers, and move farther from your subject.

Greater depth of field:
Select higher f-stop
Decrease focal length (zoom out)
Move farther from subject

Shorter depth of field:
Select lower f-stop
Increase focal length (zoom in)
Move closer to subject

Figure 8-11: Aperture, focal length, and your shooting distance determine depth of field.

Here are a few additional tips and tricks related to depth of field:

- **Aperture priority autoexposure (Av) mode:** When depth of field is a primary concern, try using aperture priority autoexposure (Av). In this mode (detailed fully in Chapter 7), you set the f-stop, and then the camera selects the appropriate shutter speed to produce a good exposure. The range of aperture settings you can access depends on your lens.

- **Creative Auto mode:** Creative Auto mode also gives you some control over depth of field. In that mode, you can use the Background slider to request a greater or smaller depth of field, as outlined in Chapter 3.

- **Fully automatic scene modes:** Some of the fully automatic scene modes are also designed with depth of field in mind. Portrait and Close-Up modes produce shortened depth of field; Landscape mode

produces a greater depth of field. You can't adjust aperture in these modes, however, so you're limited to the setting the camera chooses. And, in certain lighting conditions, the camera may not be able to choose an aperture that produces the depth of field you expect from the selected mode.

✔ **Depth of field preview:** Not sure which aperture setting you need to produce the depth of field you want? Good news: Your camera offers *depth of field preview,* which enables you to see in advance how the aperture affects the focus zone. See the later section "Checking depth of field" for details on how to use this feature.

✔ **Shutter speed:** If you adjust aperture to affect depth of field, be sure to always keep an eye on shutter speed as well. To maintain the same exposure, shutter speed must change in tandem with aperture, and you may encounter a situation where the shutter speed is too slow to permit handholding a camera. Lenses that offer optical image stabilization enable most people to handhold the camera at slower shutter speeds than nonstabilized lenses, but double-check your results. You can also consider raising the ISO setting to make the image sensor more reactive to light, but remember that higher ISO settings can produce noise. (Chapter 7 has details.)

Checking depth of field

When you look through your viewfinder and press the shutter button halfway, you can see only a partial indication of the depth of field that your current camera settings will produce. You can see the effect of focal length and the camera-to-subject distance, but because the aperture doesn't actually stop-down to your selected f-stop until you take the picture, the viewfinder doesn't show you how that setting will affect depth of field.

By using the Depth-of-Field Preview button on your camera, however, you can do just that when you shoot in the advanced exposure modes. Almost hidden away on the front of your camera, the button is labeled in Figure 8-12.

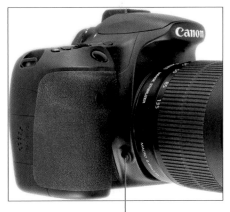

Depth-of-Field Preview button

Figure 8-12: See how the aperture setting will affect depth of field.

Fun facts about focal length

Every lens can be characterized by its *focal length,* or in the case of a zoom lens, the range of focal lengths it offers. Measured in millimeters, focal length determines the camera's angle of view, the apparent size and distance of objects in the scene, and depth of field. According to photography tradition, a focal length of about 50mm is a "normal" lens. Most point-and-shoot cameras feature this focal length, which is a medium-range lens that works well for the type of snapshots that users of those kinds of cameras are likely to shoot.

A lens with a focal length less than 35mm is typically known as a *wide angle* lens because at that focal length, the camera has a wide angle of view and produces a long depth of field, making it good for landscape photography. A short focal length also has the effect of making objects seem smaller and farther away. At the other end of the spectrum, a lens with a focal length longer than about 80mm is considered a *telephoto* lens (often referred to as a *long lens*). With a long lens, angle of view narrows, depth of field decreases, and faraway subjects appear closer and larger, which is ideal for wildlife and sports photographers.

Note, however, that the focal lengths stated here and elsewhere in the book are so-called "35mm equivalent" focal lengths. Here's the deal: For reasons that aren't really important, when you put a standard lens on most digital cameras, including your EOS 60D, the available frame area is reduced, as if you took a picture on a camera that uses 35mm film (the kind you've probably been using for years) and then cropped it.

This so-called *crop factor* (sometimes called the *magnification factor*) varies depending on the digital camera, which is why the photo industry adopted the 35mm-equivalent measuring stick as a standard. With your camera, the cropping factor is roughly 1.6. So the 18–135mm kit lens sold with the EOS 60D, for example, captures the approximate area you would get from a 29–270mm lens on a 35mm film camera. In the following figure, for example, the red outline indicates the image area that results from the 1.6 crop factor.

Note that although the area the lens can capture changes when you move a lens from a 35mm film camera to a digital body, depth of field isn't affected, nor are the spatial relationships between objects in the frame. So when lens shopping, you gauge those two characteristics of the lens by looking at the stated focal length — no digital-to-film conversion math is required.

Chuck Pace

To use this feature, just press and release the shutter button halfway or press AF-ON to acquire a good focus (optional, but a good idea), and then press and hold the Depth-of-Field Preview button. Which hand and what finger you use is up to you. It's a pesky little button to find and hold. Although it's closer to your right hand, if your left hand is under the lens, supporting the weight of the camera or ready to turn the zoom ring on the lens, your left index finger is close to the button. Depending on the selected f-stop, the scene in the viewfinder may then get darker. Or in Live View mode, the same thing happens in the monitor preview. Either way, this effect doesn't mean that your picture will be darker; it's just a function of how the preview works.

Note that the preview doesn't engage in P, Tv, or Av mode if the aperture and shutter speed aren't adequate to expose the image properly. You have to solve the exposure issue before you can use the preview.

Controlling Color

Compared with understanding some aspects of digital photography — resolution, aperture, shutter speed, and depth of field, for example — making sense of your camera's color options is easy-breezy. First, color problems aren't all that common, and when you encounter them, they're usually simple to fix with a quick shift of your camera's White Balance control. Second, getting a grip on color requires learning only a couple of new terms, an unusual state of affairs for an endeavor that often seems more like high-tech science than art.

The rest of this chapter explains the White Balance control, plus a couple of other options that enable you to fine-tune the way your camera renders colors. For information on software you can use to alter colors of existing pictures on your computer, see Chapter 6.

Correcting colors with white balance

Every light source emits a particular color cast. The old-fashioned fluorescent lights found in most public restrooms, for example, put out a bluish-green light, which is why our reflections in the mirrors in those restrooms always look so sickly. And, if you think that your beloved looks especially attractive by candlelight, you aren't imagining things: Candlelight casts a warm, yellow-red glow that's flattering to the skin.

Science-y types measure the color of light, officially known as *color temperature,* on the Kelvin scale, which is named after its creator. You can see an illustration of the Kelvin scale in Figure 8-13.

When photographers talk about "warm light" and "cool light," though, they aren't referring to the position on the Kelvin scale — or at least not in the way we usually think of temperatures, with a higher number meaning hotter. Instead, the terms describe the visual appearance of the light. Warm light, produced by candles and incandescent lights, falls in the red-yellow spectrum you see at the bottom of the Kelvin scale in Figure 8-13; cool light, in the blue-green spectrum, appears at the top of the scale.

At any rate, most of us don't notice these fluctuating colors of light because our eyes automatically compensate for them. Except in extreme lighting conditions, a white tablecloth appears white to us no matter whether we view it by candlelight, fluorescent light, or regular house lights.

8000 Snow, water, shade
 Overcast skies
 Flash
5000 Bright sunshine
 Fluorescent bulbs
 Tungsten lights
3000 Incandescent bulbs

2000 Candlelight

Figure 8-13: Each light source emits a specific color.

Similarly, a digital camera compensates for different colors of light through a feature known as *white balancing.* Simply put, white balancing neutralizes light so that whites are always white, which in turn ensures that other colors are rendered accurately. If the camera senses warm light, it shifts colors slightly to the cool side of the color spectrum; in cool light, the camera shifts colors in the opposite direction.

The good news is that your camera's Automatic White Balance setting, which carries the label AWB, tackles this process remarkably well in most situations. In some lighting conditions, though, the AWB adjustment doesn't quite do the trick, resulting in an unwanted color cast like the one you see in the left image in Figure 8-14.

Figure 8-14: Multiple light sources can result in a color cast in Auto White Balance mode (left); try switching to manual White Balance control to solve the problem (right).

Serious AWB problems most often occur when your subject is lit by a variety of light sources. For example, the cat in Figure 8-14 (his name is Fiddlesticks) was shot under a mix of tungsten photo lights along with strong window light. The paneling in the room collected all the yellow light and reflected it, resulting in a very warm (yellowish) photo. In Automatic White Balance mode (on the left), the camera didn't correctly compensate for the warm color in the room, giving the original image a yellow tint. No problem: Switching the white balance mode from AWB to something that looked better (Tungsten Light) did the trick. The right image in Figure 8-14 shows the corrected colors.

Unfortunately, you can't make this kind of manual white balance selection if you shoot in the fully automatic exposure modes. So, if you spy color problems in your camera monitor, switch to P, Tv, Av, M, B, or C mode. (Chapter 7 details all these exposure modes.) You also can select the White Balance setting in Movie mode.

The next section explains precisely how to make a simple white balance correction; following that, you can explore some advanced white balance features.

Changing the White Balance setting

You can select a specific white balance setting only in the Creative Zone modes (P, Tv, Av, M, B, and C). To adjust the setting, you can use either of the following two methods:

- ✔ **Quick Control screen:** From the Shooting Settings screen, press the Quick Control button to bring up the Quick Control screen. Then highlight the White Balance icon, found at the spot shown in Figure 8-15. The selected setting appears at the bottom of the screen, and you can then rotate the Main dial to cycle through the various options.

White Balance

Figure 8-15: You can adjust the White Balance setting from the Quick Control screen or from Shooting Menu 2.

If you want to see all settings at one time, press Set again instead of rotating the Main dial. Then you see the screen shown on the right in Figure 8-15, and you can use the Quick Control dial or multicontroller to make your choice.

On this screen, as in the Shooting Settings and Quick Control displays, the various White Balance settings are represented by the icons listed in Table 8-1. You don't need to memorize them, however, because as you scroll through the list of options, the name of the selected setting appears on the screen. For most settings, the camera also displays the approximate Kelvin temperature (K) of the selected light source, as shown in the figure. (Refer to Figure 8-13 for a look at the Kelvin scale.) Press Set once more after you select the option you want to use.

If the scene is lit by several sources, choose the setting that corresponds to the strongest one. The Tungsten Light setting is usually best for shooting scenes lit by regular incandescent household bulbs, by the way. Use the White Fluorescent setting when the scene is lit by fluorescent bulbs, provided the bulbs are "Cool White" and in the range of 4000 degrees Kelvin. However, you can't always use the White Fluorescent setting, even in rooms with fluorescent lights. If you have trouble, your best bet is to create a custom White Balance setting that's precisely tuned to the light. See the next section for details.

✔ **Shooting Menu 2:** Press Menu, go to Shooting Menu 2, and select White balance. Press Set and then choose settings, which are identical to those on the Quick Control screen. Highlight the setting you want to use and press Set.

Your selected White Balance setting remains in force for the P, Tv, Av, M, B, and C exposure modes until you change it again. To avoid accidentally using an incorrect setting later, you may want to get in the habit of resetting the option to the automatic setting (AWB) after you finish shooting whatever subject it was that caused you to switch to manual white balance mode.

Table 8-1	White Balance Settings
Symbol	*Setting*
AWB	Auto
☀	Daylight
🏠	Shade
☁	Cloudy

Symbol	Setting
![tungsten icon]	Tungsten
![white fluorescent icon]	White Fluorescent
![flash icon]	Flash
![custom icon]	Custom
K	Color Temp (in degrees Kelvin)

Setting the white balance temperature

Although the 60D has a number of good white balance presets, you also have the capability to set the white balance to a specific color temperature. Access the White Balance settings as in the previous section, and then select Color Temp. With it highlighted (see Figure 8-16), scroll through temperatures, using the Main dial. Each click changes the color temperature by 100° Kelvin. The overall range runs from 2500–7000°.

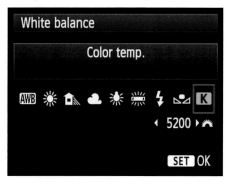

Figure 8-16: Set the temperature directly.

Creating a custom White Balance setting

If none of the preset white balance options produces the right amount of color correction, you can create your own, custom setting. To use this technique, you need a piece of card stock that's either neutral gray or absolute white — not eggshell white, sand white, or any other close-but-not-perfect white. (You can buy reference cards made just for this purpose in many camera stores for less than $20.)

Position the reference card so that it receives the same lighting you'll use for your photo. Then follow these steps.

1. **Set the camera to the P, Tv, Av, M, B, or C exposure mode.**

 You can't create a custom setting in any of the fully automatic modes. You can, however, select the custom setting you create when you record movies.

2. **Set the White Balance setting to Auto, as shown in the earlier section, "Changing the white balance setting."**

3. **Set the camera to manual focusing and then focus on your reference card.**

 Chapter 1 has details on manual focusing, if you need help.

4. **Frame the shot so that your reference card fills the center area of the viewfinder.**

 In other words, make sure that at least the center autofocus point and the surrounding circle — the *spot metering circle* — cover the reference card. (Feel free to shoot for overkill.)

5. **Make sure that the exposure settings are correct.**

 Press the shutter button halfway or check exposure. In M mode, make sure that the exposure indicator is at the midway point of the exposure meter. In other modes, a blinking aperture or shutter speed value indicates an exposure problem. If necessary, adjust ISO, aperture, or shutter speed to fix the problem; Chapter 7 explains how.

6. **Take the picture of your reference card.**

 You'll tell the camera to use this picture to establish a custom White Balance setting in the following steps.

7. **Display Shooting Menu 2 and highlight Custom White Balance, as shown on the left in Figure 8-17.**

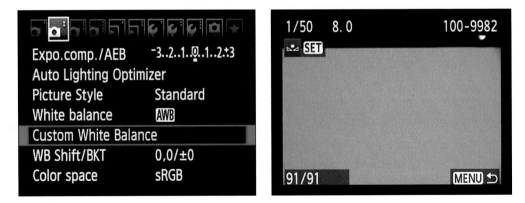

Figure 8-17: Create a custom white balance setting from Shooting Menu 2.

8. **Press Set.**

 You see the screen shown on the right in Figure 8-17. The image you just captured should appear in the display. If not, turn the Quick Control dial to scroll to the image.

9. **Press Set to select the displayed image as the basis for your custom white balance reference.**

 You see the message shown on the left in Figure 8-18, asking you to confirm that you want the camera to use the image to create the custom White Balance setting.

10. **Press right or left on the multicontroller to highlight OK and then press Set.**

 You see the screen shown on the right in Figure 8-18. This message tells you that the White Balance setting is now stored. The little icon in the message area represents the custom setting.

11. **Press Set one more time to finalize the custom setting.**

Your custom White Balance setting remains stored until the next time you work your way through these steps. Anytime you're shooting in the same lighting conditions and want to apply the same white balance correction, just press the WB button or use the Quick Control screen to access the White Balance settings and then select the Custom option.

Figure 8-18: The message on left indicates that your White Balance setting is stored.

Fine-tuning White Balance settings

As an alternative for manipulating colors, your 60D enables you to tweak white balancing in a way that shifts all colors toward a particular part of the color spectrum. The result is similar to applying a traditional color filter to your lens.

To access this option, White Balance Correction, follow these steps:

1. **Set the Mode dial to P, Tv, Av, M, B, or C exposure mode.**

 You can take advantage of White Balance Correction only in these modes.

2. **Display Shooting Menu 2 and highlight WB Shift/Bkt, as shown on the left in Figure 8-19.**

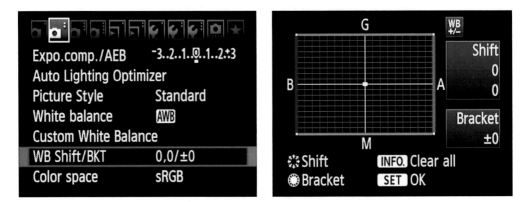

Figure 8-19: White Balance Correction offers one more way to control colors.

3. **Press Set to display the screen you see on the right in Figure 8-19.**

 The screen contains a grid that's oriented around two main color pairs: green and magenta (represented by the G and M labels) and blue and amber (represented by B and A). The little white square indicates the amount of white balance correction, or *shift*. When the square is dead center in the grid, as in the figure, no shift is applied.

4. **Use the multicontroller to move the square marker in the direction of the shift you want to achieve.**

 As you do, the Shift area of the display tells the amount of color bias you selected. For example, in Figure 8-20, the shift is four levels toward amber and two toward magenta.

 If you're familiar with traditional lens filters, you may know that the density of a filter, which determines the degree of color

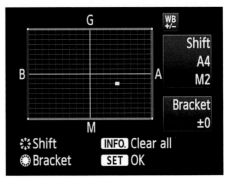

Figure 8-20: Press the multicontroller to move the marker and shift white balance.

correction it provides, is measured in *mireds* (pronounced "*my*-reds"). The white balance grid is designed around this system: Moving the marker one level is the equivalent of adding a filter with a density of 5 mireds.

5. Press Set to apply the change and return to the menu.

After you apply white balance correction, a +/– sign appears next to the White Balance symbol in the Shooting Settings display, as shown on the left in Figure 8-21. It's your reminder that white balance shift is being applied. The same symbol appears in the viewfinder, right next to the ISO value, and in the front left corner of the LCD screen on top of the camera.

You can see the exact shift values in Shooting Menu 2, as shown on the right in Figure 8-21, and also in the Camera Settings display. (To activate that display, remember to first display any menu and then press the Info button. Chapter 1 provides more details.)

Your adjustment remains in force for all advanced exposure modes until you change it. And the correction is applied no matter which White Balance setting you choose. Check the monitor or viewfinder before your next shoot; otherwise, you may forget to adjust the white balance for the current light.

6. To cancel White Balance Correction, repeat Steps 1–3, set the marker back to the center of the grid, and then press Set.

Use the multicontroller to move the marker back to the center of the grid. Be sure that both values in the Shift area of the display are set to 0.

As an alternative, you can press the Info button after you get to the grid display to clear all shifts. However, doing so also cancels white balance bracketing, which we explain in the next section. After you press Info, be sure to press Set to lock in your decision.

White Balance Shift indicator (blinking)

Figure 8-21: The +/– symbol lets you know that White Balance Shift is being applied.

Many film photography enthusiasts place colored filters on their lenses to either warm or cool their images. Portrait photographers, for example, often add a warming filter to give skin tones a healthy, golden glow. You can mimic the effects of these filters by simply fine-tuning your camera's White Balance settings as just described. Experiment with shifting the white balance a tad toward amber and magenta for a warming effect or toward blue and green for a cooling effect.

Bracketing shots with white balance

Chapter 7 introduces you to your camera's automatic exposure bracketing, which enables you to easily record the same image at three different exposure settings. Similarly, you can take advantage of automatic White Balance Bracketing. With this feature, the camera records the same image three times, using a slightly different white balance adjustment for each one.

This feature is especially helpful when you're shooting in varying light sources: for example, a mix of fluorescent light, daylight, and flash. Bracketing the shots increases the odds that the color renditions of at least one of the shots will be to your liking.

Note a couple of things about this feature:

- Because the camera records three images each time you press the shutter button, using white balance bracketing reduces the maximum capture speed that's possible when you use the Continuous shooting mode. See Chapter 2 for more about Continuous mode. Of course, recording three images instead of one also eats up more space on your memory card.

- The White Balance Bracketing feature is designed around the same grid used for White Balance Correction, explained in the preceding section. As a reminder, the grid is based on two color pairs: green/magenta and blue/amber.

- When White Balance Bracketing is enabled, the camera always records the first of the three bracketed shots using a neutral white balance setting — or, at least, what it considers to be neutral, given its own measurement of the light. The second and third shots are then recorded using the specified shift along either the green/magenta or blue/amber axis of the color grid.

If all that is as clear as mud, just take a look at Figure 8-22 for an example. These images were shot using a single tungsten studio light and the candlelight. White Balance Bracketing was set to work along the blue/amber color axis. The camera recorded the first image at neutral, the second with a slightly blue color bias, and the third with an amber bias.

Neutral +3 Blue bias +3 Amber bias

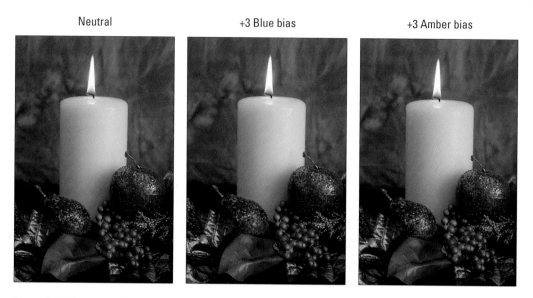

Figure 8-22: One neutral image was captured: one with a blue bias and one with an amber bias.

To enable White Balance Bracketing, follow these steps:

1. **Set the Mode dial to a mode in the Creative Zone (P, Tv, Av, M, B, or C).**

2. **Display Shooting Menu 2 and highlight WB/Shift Bkt.**

3. **Press Set to display the grid shown in Figure 8-23.**

 The screen is the same one you see when you use the White Balance Correction feature, explained in the preceding section.

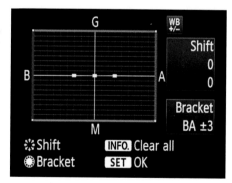

Figure 8-23: These settings were used to capture the bracketed candle images.

4. **Rotate the Quick Control dial to set the amount and direction of the bracketing shift.**

 Rotate the dial as follows to specify whether you want the bracketing to be applied across the horizontal axis (blue to amber) or the vertical axis (green to magenta).

 - *Blue to amber bracketing:* Rotate the dial right.

 - *Green to magenta bracketing:* Rotate the dial left.

As you rotate the dial, three markers appear on the grid, indicating the amount of shift that will be applied to your trio of bracketed images. You can apply a maximum shift of plus or minus three levels of adjustment.

The Bracket area of the screen also indicates the shift; for example, in Figure 8-23, the display shows a bracketing amount of plus and minus three levels on the blue/amber axis. The settings shown in Figure 8-23 were used to record the sample images in Figure 8-22. As you can see, even at the maximum shift (+/– 3), the difference to the colors is subtle.

If you want to get truly fancy, you can combine White Balance Bracketing with White Balance Shift. To set the amount of White Balance Shift, press the cross keys to move the square markers around the grid. Then use the Main dial to adjust the bracketing setting.

5. **Press Set to apply your changes and return to the menu.**

The bracketing symbol shown in Figure 8-24 appears in the Shooting Settings display. The Camera Settings display, which you bring up by pressing Info when any menu is visible, also reports the bracketing setting.

The bracketing setting remains in effect until you turn off the camera. You can also cancel bracketing by revisiting the grid screen shown earlier, in Figure 8-23, and either rotating the Main dial until you see only a single grid marker or pressing the Info button. Either way, press Set to officially turn off bracketing.

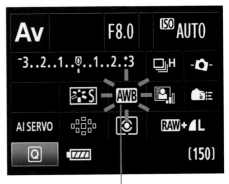

Blinking white balance symbol

Figure 8-24: This symbol indicates that White Balance Bracketing is turned on.

Choosing a Color Space: sRGB versus Adobe RGB

Normally, your camera captures images using the *sRGB color mode,* which simply refers to an industry-standard spectrum of colors. (The *s* is for *standard,* and RGB is for *red, green, blue,* which are the primary colors in the digital imaging color world.) This color mode was created to help ensure color consistency as an image moves from camera (or scanner) to monitor and printer; the idea was to create a spectrum of colors that all these devices can capture or reproduce.

However, the sRGB color spectrum leaves out some colors that *can* be reproduced in print and onscreen, at least by some devices. As an alternative,

your camera also enables you to shoot in the Adobe RGB color mode, which includes a larger *gamut* (spectrum) of colors. Figure 8-25 offers an illustration of the two spectrums.

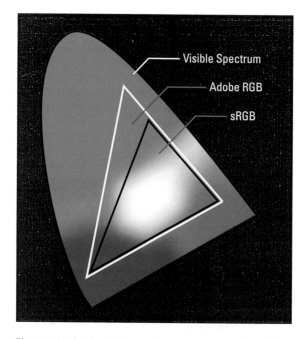

Visible Spectrum

Adobe RGB

sRGB

Figure 8-25: Adobe RGB includes some colors not found in the sRGB spectrum.

Which option is right for you depends on what you plan to do with your photos. If you're going to print your pictures without editing them, sRGB is probably the best choice because it typically results in the "punchy" colors that most people like. Some Internet printing services also request sRGB images.

On the other hand, if you're a color purist or will be editing your photos or making your own prints, or all three, experiment with Adobe RGB. For the record, this route is the one that we take because we see no reason to limit ourselves to a smaller spectrum from the get-go. However, note that some colors in Adobe RGB can't be reproduced in print; the printer substitutes the closest available color when necessary. Additionally, you need photo software that offers support for Adobe RGB as well as some basic *color management controls,* which ensure that your image colors are properly handled when you open, print, edit, and save your files. You should plan to spend a little time educating yourself about color management, too, because you can

muck up the works if you don't set all the color-management options correctly. Long story short: If you're brand-new to digital imaging, this option may be one to explore after you get more comfortable with the whole topic.

If you want to capture images in Adobe RGB instead of sRGB, visit Shooting Menu 2 and highlight the Color Space option, as shown on the left in Figure 8-26. Press Set to display the screen shown on the right in the figure. Press up or down using the multicontroller to highlight Adobe RGB and press Set again.

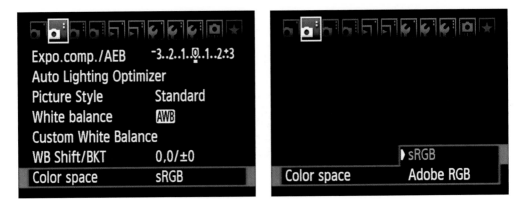

Figure 8-26: Choose Adobe RGB for a broader color spectrum.

 This color mode choice applies only when you shoot in the Creative Zone: P, Tv, Av, M, B, and C. In all other modes, the camera automatically selects sRGB as the color space. And, your Color Space selection is applied to only your JPEG images; with Raw captures, decisions on Color Space happen in your image editing software, not in the camera.

 After you transfer pictures to your computer, you can tell whether you captured an image in the Adobe RGB color space by looking at its filename: Adobe RGB images start with an underscore, as in _MG_0627.jpg. Pictures captured in the sRGB color space start with the letter *I*, as in IMG_0627.jpg.

Exploring Picture Styles

In addition to all the aforementioned focus and color features, your EOS 60D offers *Picture Styles,* which you can use to further tweak color as well as saturation, contrast, and image sharpening.

Sharpening is a software process that adjusts contrast in a way that creates the illusion of slightly sharper focus. The important thing to note in this context is that sharpening cannot remedy poor focus, but instead produces a subtle tweak to this aspect of your pictures.

The camera offers the following six basic Picture Styles:

- **Standard:** The default setting, this option captures the image by using the characteristics that Canon offers as suitable for the majority of subjects.

- **Portrait:** This mode reduces sharpening slightly from the amount that's applied in Standard mode, with the goal of keeping skin texture soft. Color saturation, on the other hand, is slightly increased. If you shoot in the Portrait autoexposure mode, the camera automatically applies this Picture Style for you.

- **Landscape:** In a nod to traditions of landscape photography, this Picture Style emphasizes greens and blues and amps up color saturation and sharpness, resulting in bolder images. The camera automatically applies this Picture Style if you set the Mode dial to the Landscape autoexposure mode.

- **Neutral:** This setting reduces saturation and contrast slightly compared with how the camera renders images when the Standard option is selected.

- **Faithful:** The Faithful style is designed to render colors as closely as possible to how your eye perceives them.

- **Monochrome:** This setting produces black-and-white photos: to be more precise, grayscale images. Technically speaking, a true black-and-white image contains only black and white, with no shades of gray.

- **User Defined:** You have three spaces to save your own styles. After you create them (shown later), select them here.

If you set the Quality option on Shooting Menu 1 to Raw (or Raw+Large/Fine), the camera displays your image on the monitor in black and white during playback. During the Raw converter process, you can either choose to go with your grayscale version or view and save a full-color version. Or, even better, you can process and save the image once as a grayscale photo and again as a color image.

If you *don't* capture the image in the Raw format, you can't access the original image colors later. In other words, you're stuck with *only* a black-and-white image.

The extent to which Picture Controls affect your image depends on the subject as well as on the exposure settings you choose and the lighting conditions. Figure 8-27 offers a test subject shot at each setting to give you a general idea of what to expect. As you can see, the differences are subtle, with the exception of the Monochrome option, of course. Key on the girl's pink shirt. It shows the differences the best, followed by her blue jeans.

Standard

Portrait

Landscape

Neutral

Faithful

Monochrome

Figure 8-27: Each Picture Control produces a slightly different take on the scene.

The level of control you have over Picture Styles, like most other settings in this chapter, depends on your camera's exposure mode:

- ✔ **In Full Auto and all other Basic Zone modes (Portrait and Landscape, for example):** You can't directly set a Picture Style. You may, however, choose a Lighting type or Ambience. (Read more about these in Chapter 3.)

- ✔ **In the Creative Zone (P, Tv, Av, M, B, and C):** You can not only select any of the six preset Picture Styles but also tweak each style to your liking and create up to three of your own, customized styles.

- ✔ **Movie mode:** You can select any Picture Style, including any custom styles you create. (To shoot a black-and-white movie, set the Picture Style to Monochrome before you start recording.)

For still photography, you can select a Picture Style in three ways:

- ✔ **Quick Control screen:** Press the Quick Control button to shift from the regular Shooting Settings display to the Quick Control screen and then highlight the Picture Style icon, as shown on the left in Figure 8-28. Rotate either the Main or Quick Control dial to cycle through the available styles.

The numbers you see along with the style name at the bottom of the screen represent the four characteristics applied by the style: Sharpness, Contrast, Saturation, and Color Tone. Sharpness values range from 0 to 7; the higher the value, the more sharpening is applied. At 0, no sharpening is applied. The other values, however, are all set to 0, which represents the default setting for the selected Picture Style. (Using certain advanced options, you can adjust all four settings; more on that momentarily.)

Figure 8-28: You can quickly select a Picture Style by using the Quick Control screen.

If you want to see all available styles, just press Set to display the screen you see on the right in Figure 8-28. Highlight the style you want to use, and the four style values appear along with the style name, as shown in the figure. Press Set to finish.

✔ **Shooting Menu 2:** Select the Picture Style option and press Set to display a menu full of all the styles. Highlight your choice and press Set again.

For movie recording, you can select a Picture Style either from Shooting Menu 2 or by using the Quick Control method. See Chapter 4 for help with the second option; it works a little differently than when you're shooting still photos.

This discussion of Picture Styles touches on just the basics. Your camera also enables you to modify each style, varying the amount of sharpness, contrast, saturation, and color tone adjustment that results from each style. And, you can create three of your own Picture Style presets, if you like.

Unless you're just tickled pink by the prospect of experimenting with Picture Styles, you're well advised to stick with the default Picture Style — Standard — and be done with it. First, you have way more important camera settings to worry about: aperture, shutter speed, autofocus, and all the rest. Why add one more setting to your list, especially when the impact of changing it is minimal?

Second, if you want to mess with the characteristics that the Picture Style options affect, you're much better off shooting in the Raw (CR2) format and then making those adjustments on a picture-by-picture basis in your Raw converter. In Canon Digital Photo Professional, which comes free with the camera, you can even assign any of the existing Picture Styles to your Raw files and then compare how each one affects the image. The camera tags your Raw file with whichever Picture Style is active at the time you take the shot, but the image adjustments are in no way set in stone or even in sand: You can tweak your photo at will. (The selected Picture Style does affect the JPEG preview that's used to display the Raw image thumbnails in Digital Photo Professional and other photo software.)

For these reasons, we opt in this book to present you with just this brief introduction to Picture Styles so that we can go into more detail about functions that are more useful (such as the white balance customization options presented earlier). If you're intrigued, the camera manual walks you step by step through all the various Picture Style options.

And, for übergeeks (you know who you are), the CD accompanying your 60D includes a software package named — are you ready? —Picture Style Editor, where you can create and save Picture Style files to your heart's content.

9

Putting It All Together

In This Chapter

▷ Reviewing the best all-around picture-taking settings

▷ Adjusting the camera for portrait photography

▷ Discovering the keys to super action shots

▷ Dialing in the right settings to capture landscapes and other scenic vistas

▷ Capturing close-up views of your subject

*E*arlier chapters of this book break down each and every picture-taking feature on the EOS 60D, describing in detail how the various controls affect exposure, picture quality, focus, color, and the like. This chapter pulls together all that information to help you set up your camera for specific types of photography (it's like a fun, post-graduation party).

The first few pages offer a quick summary of critical picture-taking settings that should serve you well no matter what your subject. Following that, you get our advice on which settings to use for portraits, action shots, land-scapes, and close-ups.

Although we offer specific recommendations in this chapter, we also want to stress that there really is no one "right way" to shoot a portrait, a landscape, or whatever. After all, the ultimate test is if the photo is good. Don't be afraid to wander off on your own, tweaking this exposure setting or adjusting that focus control, to discover your own creative vision. Experimentation is part of the fun of photography, after all — and thanks to your camera monitor and the Erase button, it's an easy, completely free proposition.

Recapping Basic Picture Settings

Your subject and lighting conditions and your creative goals determine which settings, such as aperture and shutter speed, you should use for your picture-taking options. We give you our take on those options throughout this chapter. For many basic options, however, we recommend the same settings for almost every shooting scenario. Table 9-1 shows you those recommendations and lists the chapter where you can find details about each setting.

Table 9-1	All-Purpose Picture-Taking Settings	
Option	*Recommended Setting*	*See This Chapter*
Image Quality	Large/Fine (JPEG) Medium/Fine (JPEG) Raw (CR2)	2
Drive mode	Action photos: Continuous All others: Single	2
ISO	100 or 200*	7
Metering mode	Evaluative	7
AF mode	AI Focus	8
AF Point Selection mode	Auto	8
White Balance	Auto	8
Picture Style	Standard	8
Live View	Disabled	4

**You start by setting your ISO to 100 and immediately raise it to 1600 to take indoor pictures at f/8 without a flash. If you put the ISO on Auto, the camera raises ISO without letting you know. Every time you raise ISO, you essentially raise the noise level although the noise increase often isn't noticeable. When you need noise level to be low, you have to be firm about it.*

Whether you have any say-so over these settings depends on the exposure mode. You must use a Creative Zone mode (P, Tv, Av, M, B, or C) to change the White Balance setting, for example. You can find details about which modes let you do what in the chapters that explain each function.

Many of the options listed in Table 9-1 have a corresponding button on the camera. Figure 9-1 shows the top of the camera, where the AF mode, Drive mode, ISO, and Metering mode buttons are located. (You use these when

you're monitoring parameters from the top LCD panel.) On the back of the camera are the Live View and AF Point Selection buttons. The only options listed in Table 9-1 without a dedicated button are Image Quality, White Balance, and Picture Style, which can all be easily accessed through the Quick Control screen.

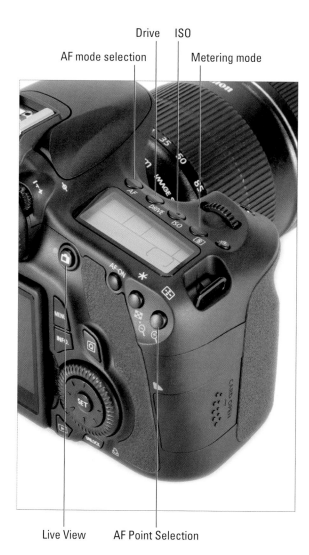

Figure 9-1: Despite advances in software, buttons are incredible things.

Setting Up for Specific Scenes

For the most part, the settings detailed in the preceding section fall into the "set 'em and forget 'em" category. That leaves you free to concentrate on a handful of other camera settings that you can manipulate to achieve a specific photographic goal, such as adjusting aperture to affect depth of field. The next four sections explain which of these additional options typically produce the best results when you're shooting portraits, action shots, landscapes, and close-ups. We offer a few compositional and creative tips along the way — but, again, remember that beauty is in the eye of the beholder, and for every so-called rule, plenty of great images prove the exception. As Ansel Adams so wisely said, "There are no rules for good photographs; there are only good photographs."

Shooting still portraits

A *still portrait* is a photograph of a subject who isn't moving. For subjects not keen on sitting still long enough to have their pictures taken — say, children or pets or even some teenagers we know — skip ahead to the next section and use the techniques we give for action photography instead.

Assuming that a subject is willing to pose (or you catch her in a moment of relative calm), the classic portraiture approach is to keep the subject sharply focused while throwing the background into soft focus, as shown in the examples in this section. This artistic choice emphasizes the subject and helps diminish the impact of any distracting background objects in cases where you can't control the setting. The following steps show you how to achieve this look:

1. **Set the Mode dial to Av (aperture priority autoexposure) and then select the lowest possible f-stop value.**

 As Chapter 7 explains, a low f-stop number opens the aperture, which shortens depth of field, or the range of sharp focus. So, dialing in a low f-stop value is the first step in softening your portrait background. (And, yes, the f-stop range available to you depends on your lens.) Keep in mind that the farther your subject is from the background, the more background blurring you can achieve at any one f-stop.

 Aperture priority autoexposure is preferred when depth of field is a primary concern because you can control the f-stop while relying on the camera to select the shutter speed that will properly expose the image. Just rotate the Main dial to select an f-stop. If you aren't comfortable using this advanced exposure mode, give Creative Auto a whirl and follow the steps in Chapter 3 to request a blurred background. (Press Q to enter Quick Control mode and highlight the Background blur slider in the middle of the Shooting Settings display in Creative Auto mode.) Portrait mode also results in a more open aperture although the exact f-stop setting is out of your control, and lighting conditions dictate the width of the aperture the camera will use. Chapter 3 details using Portrait mode.

If you choose a mode in the Creative Zone, you can monitor the current aperture and shutter speed in the Shooting Settings display (the left in Figure 9-2), in the viewfinder display (middle), and on the top LCD display (right).

2. **To further soften the background, zoom in or get closer (or both).**

 As covered in Chapter 8, zooming in to a longer focal length also reduces depth of field, as does moving physically closer to your subject.

 Avoid using a lens with a short focal length (a *wide angle* lens) for portraits. A short focal length can cause features to appear distorted, similar to the way people look when you view them through a security peephole in a door.

3. **For indoor portraits, shoot flash-free, if possible.**

 Shooting by available light rather than by flash produces softer illumination and avoids the problem of red-eye. To get enough light to go flash-free, turn on room lights or, during daylight, pose your subject next to a bright window.

 In the Av exposure mode, simply keeping the built-in flash unit closed disables the flash. In Creative Auto mode, choose the Flash Off setting. (Chapter 3 shows you how.) In Portrait mode, unfortunately, you can't disable the flash if the camera thinks more light is needed. Your only option is to change the exposure mode to No Flash, in which case the camera may or may not choose an aperture setting that throws the background into soft focus.

 If flash is unavoidable, see the list of flash tips at the end of this step list to get better results.

Shutter speed Aperture

| Av 1/1250 F5.6 | ISO 1000 |

Shutter speed

Aperture

Shutter speed Aperture

Figure 9-2: You can view exposure settings in the Shooting Settings display, viewfinder, or on the top LCD.

4. For outdoor portraits, use a flash.

Even in bright daylight, a flash adds a beneficial splash of light to a subject's face, as discussed in Chapter 7 and illustrated in Figure 9-3 (image on right).

Unfortunately, the camera doesn't let you use flash in Portrait mode if the light is very bright. In the Av exposure mode, just press the Flash button on the side of the camera to enable the flash; adjust flash strength in Quick Control mode by adjusting the Flash exposure compensation. In Creative Auto mode, set the flash to the Flash On (fill flash) setting; , see Chapter 3 for instructions.

In dim lighting, the camera may select a slow shutter speed when you enable the built-in flash in Av mode, so keep an eye on that value and use a tripod if necessary to avoid blurring from camera shake. On the flip side of the coin, the fastest shutter speed you can use with the built-in flash is 1/250 second, and in extremely bright conditions, that speed may be too slow to avoid overexposing the image. If necessary, move your subject into the shade. (On some external Canon flashes, you can select a faster shutter speed than 1/250 second; see your flash manual for details.)

No flash · With flash

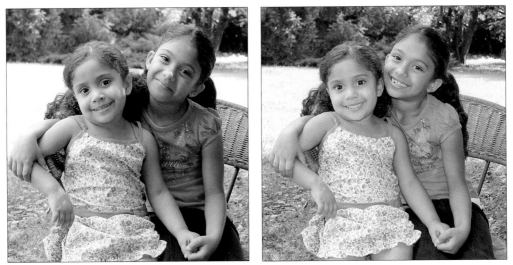

Figure 9-3: To properly illuminate the face in outdoor portraits, use fill flash.

5. **Press and hold the shutter button halfway to engage exposure metering and, in Autofocus mode, to lock in focus.**

 Make sure that an active autofocus point falls over your subject. (In the viewfinder, active autofocus points turn red.) For the best results, try to set focus on your subject's eyes; manually selecting a focus point can help in portrait shooting, too.

 Chapter 8 explains more about using autofocus, but if you have trouble, simply set your lens to manual focus mode and then twist the focusing ring to set focus.

 Alternatively, you can lock in a meter reading by pressing the AE Lock button and activating the autofocus by pressing AF-ON.

6. **Press the shutter button the rest of the way to capture the image.**

Again, these steps are but a starting point for taking better portraits. A few other tips can also improve your people pics:

�7 **Before pressing the shutter button, do a quick background check.** Scan the entire frame for intrusive objects that may distract the eye from the subject (utility poles and phone wires seem to be everywhere). If necessary (and possible), reposition the subject against a more flattering backdrop. Inside, a softly textured wall works well; outdoors, trees and shrubs can provide attractive backdrops as long as they aren't so ornate or colorful that they diminish the subject (for example, a magnolia tree laden with blooms).

▷ **Frame the subject loosely to allow for later cropping to a variety of frame sizes.** Because your camera produces images that have an aspect ratio of 3:2, your portrait perfectly fits a 4 x 6–inch print size, but requires cropping to print at any other proportions, such as 5 x 7 or 8 x 10. The printing section of Chapter 6 talks more about this issue.

▷ **Pay attention to white balance if your subject is lit by both flash and ambient light.** If you use the automatic White Balance setting (AWB), which we recommend, photo colors may be slightly warmer or cooler than neutral because the camera can become confused by mixed light sources. A warming effect typically looks nice in portraits, giving the skin a subtle glow. Cooler tones, though, usually aren't as flattering. Either way, if you aren't happy with the image colors, see Chapter 8 to find out how to fine-tune white balance. Again, you can make this adjustment only in P, Tv, Av, M, B, or C exposure modes.

Shooting Raw photos (as opposed to JPEGs of any quality) gives you a quality edge when correcting white balance problems after the shoot. With Raw, you're not changing the pixels (as with JPEGs); you're changing how they are interpreted as they are converted.

✔ **When flash is unavoidable, try these tricks to produce better results.**
The following techniques can help solve flash-related issues:

- *Indoors, turn on as many room lights as possible and let in natural light, too.* Try drawing back window curtains and opening shades. Open doors let in more light than closed ones.

 By using more ambient light, you reduce the flash power needed to expose the picture. This step also causes the pupils to constrict, further reducing the possibility of red-eye. (Pay heed to our white balance warning, however.)

- *Try setting the flash to Red-Eye Reduction mode when shooting night-time and indoor portraits.* Warn your subject to expect both a light coming from the Red-Eye Reduction lamp, which constricts pupils, and the actual flash. See Chapter 3 for details about using this flash mode, which you can find in Shooting Menu 1.

- *For night pictures, try Night Portrait mode.* In this autoexposure mode, the camera automatically selects a slower shutter speed than normal. The longer exposure time enables the camera to soak up more ambient light, producing a brighter background and reducing the flash power needed to light the subject. A slow shutter, however, means that you need to use a tripod to avoid camera shake, which can blur the photo. You also need to warn subjects to remain still during the exposure.

- *For professional results, use an external flash with a rotating flash head.* Then aim the flash head upward so that the flash light bounces off the ceiling and falls softly down on the subject. An external flash isn't cheap, but the results make the purchase worthwhile if you shoot lots of portraits. Compare the two portraits in Figure 9-4 for an illustration. In the first example, the built-in flash resulted in harsh, concentrated light on the subject's face and produces a distractingly visible reflection in the glass of the artwork behind her. To produce the better result on the right, a Canon Speedlite 430EX II was bounced off the ceiling. The scene looks much more natural, with no bright glass reflection.

 You can also set up your Canon Speedlite as an external flash and configure your camera for wireless flash operation, which can prove pretty handy. Showing you how is, unfortunately, outside the scope of this book; refer to your manual for details. In Chapter 1, we cover the 60D's remote control sensor.

 Buy a small box-like flash diffuser that slips on the flash head of your Speedlight. Sto-fen (www.stofen.com) makes them for virtually every make and model of flash. These nifty little helpers soften the flash, just like how a lamp shade softens a strong light.

- *To reduce shadowing from the flash, move your subject farther from the background.* Moving the subject away from the wall helps eliminate background shadows.

Positioning subjects far enough from the background that they can't touch it is a good general rule. If that isn't possible, though, try going in the other direction: If the person's head is smack against the background, any shadow will be smaller and less noticeable. For example, less shadowing is created when a subject's head is resting against a sofa cushion than if he sits upright with his head a foot or so away from the cushion.

- *Study the flash information in Chapter 7 and practice before you need to take important portraits.* How the camera calculates the aperture, shutter speed, and flash power needed to expose your subject and background varies depending on the exposure mode you use. To fully understand how to create the flash results you want, you have to experiment with every advanced exposure mode, all covered in Chapter 7.

For maximum control over aperture, shutter speed, and flash power, try working in Manual exposure mode and make friends with the Flash Compensation and FE Lock (flash exposure lock) features.

Capturing action

Using a fast shutter speed is the key to capturing a blur-free shot of any moving subject, whether it's a spinning Ferris wheel, a butterfly flitting from flower to flower, or, in the case of Figures 9-5 and 9-6, a playful young girl. In the first image, a shutter speed of 1/100 second was too slow to catch the subject without blur. For this subject, who was moving at a fairly rapid speed, a high shutter speed (all the way up to 1/8000 second) was required to freeze the action cleanly (and, frankly, to show off the maximum shutter speed of the 60D), as shown in Figure 9-6.

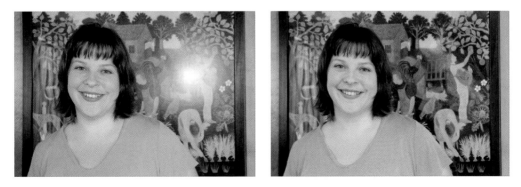

Figure 9-4: To eliminate harsh lighting and bright reflections (left), use bounce flash (right).

Try the techniques in the following steps to photograph a subject in motion:

1. **Set the Mode dial to Tv (shutter-priority autoexposure).**

 In this mode, you control the shutter speed, and the camera takes care of choosing an aperture setting that will produce a good exposure.

 If you aren't ready to step up to this advanced autoexposure mode, explained in Chapter 7, try using Sports mode, detailed in Chapter 3. Just be aware, though, that you have no control over any other aspects of your picture (such as white balance and flash) in that mode.

2. **Rotate the Main dial to select the shutter speed.**

 In the Shooting Settings display, the option that appears highlighted, with the little arrow pointers at each side, is the one

that you can adjust with the Main dial. In Tv mode, the shutter speed is the active option. After you select the shutter speed, the camera selects the aperture (f-stop) necessary to produce a good exposure.

Figure 9-5: A too-slow shutter speed (1/100 second) causes her to appear blurry.

The shutter speed you need depends on how fast your subject is moving, so you have to experiment. Another factor that affects your ability to stop action is the *direction* of subject motion. A car moving *toward* you can be stopped with a lower shutter speed than one moving *across* your field of view. Generally speaking, 1/500 second should be plenty for all but the fastest subjects: speeding hockey players, race cars, or boats, for example. For slower subjects, you can even go as low as 1/250 or 1/125 second.

If the aperture value blinks after you set the shutter speed, the camera can't select an f-stop that will properly expose the photo at that shutter speed. See Chapter 7 for more details about how the camera notifies you of potential exposure problems.

3. Raise the ISO setting or add flash to produce a brighter exposure, if needed.

In dim lighting, you may not be able to create a good exposure at your chosen shutter speed without taking this step. Raising the ISO increases the possibility of noise, but a noisy shot is better than a blurry shot. The current ISO setting appears in the upper-right corner of the Shooting Settings display, as shown in Figure 9-7; press the ISO button or use the Quick Control screen to adjust the setting.

Figure 9-6: Raising the shutter speed to 1/8000 second "freezes" the action.

You can't take the ISO reins in Sports mode; you can control that setting only in an advanced exposure mode.

If you stick with Tv mode and raise the ISO above 800 or so, you may want to enable High ISO Speed Noise Reduction to help alleviate noise. However, doing so can slow down the speed at which you can capture images, so it's a bit of a trade-off. For more on all these ISO issues, see Chapter 7.

Adding flash is a bit tricky for action shots, unfortunately. First, the flash needs time to recycle between shots, so try to go without if you want to capture images at a fast pace. Second, the built-in flash has limited range, so don't waste your time if your subject isn't nearby. Third, remember that the fastest possible shutter speed when you enable the built-in flash is 1/250 second, which may not be fast enough to capture a quickly moving subject without blur. (You can use a faster shutter speed with certain Canon external flash units, but this technique is best used to keep from overexposing photos you use fill flash on outdoors rather than freezing action shots.) For more on this issue, check out Chapter 7.

If you decide to use flash, you must bail out of Sports mode; it doesn't permit you to use flash.

4. **For rapid-fire shooting, set the Drive mode to High-speed Continuous.**

In this mode, you can take more than five pictures per second. The camera continues to record images as long as the shutter button is pressed. You can switch the Drive mode by pressing the Drive button or using the Quick Control screen. The icon representing the current mode appears in the Shooting Settings display (refer to the labeling in Figure 9-7).

5. **For fastest shooting, switch to manual focusing.**

You then eliminate the time the camera needs to lock focus in Autofocus mode. Chapter 1 shows you how to focus manually, if you need help.

If you use autofocus, try these two Autofocus settings for best performance:

- Set the AF Point Selection mode to Automatic. Press the button shown in the margin to adjust this setting.

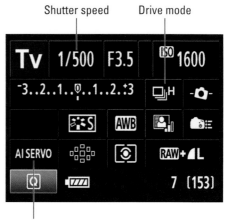

Shutter speed Drive mode

AF mode

Figure 9-7: Raising the ISO produces a brighter exposure.

- Set the AF (autofocus) mode to AI Servo (continuous-servo autofocus). Press the multicontroller to the right or use the Quick Control screen to access this setting. The name of the current setting appears in the Shooting Settings screen (refer to Figure 9-7).

Chapter 8 details these autofocus options.

6. **Turn off automatic image review to speed up the camera even more.**

You do this via the Image Review option in Shooting Menu 1. Turning off this option can help speed up the time your camera needs to recover between shots.

7. **Compose the subject to allow for movement across the frame.**

You can always crop the photo later to a tighter composition.

8. **Lock in autofocus (if used) in advance.**

Press the shutter button halfway or press and hold the AF-ON button to do so. Now when the action occurs, just press the shutter button the rest (or all) of the way. The image-capture time is faster because the camera has already done the work of establishing focus. Remember that in AI Servo mode, you must keep the subject under the active autofocus point (or points) for the camera to maintain focus. Again, Chapter 8 details this feature.

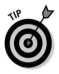

Using these techniques should give you a better chance of capturing any fast-moving subject, but action-shooting strategies also are helpful for shooting candid portraits of kids and pets. Even if they aren't running, leaping, or otherwise cavorting when you pick up your camera, snapping a shot before they move or change positions is often tough. So, if an interaction or scene catches your eye, set your camera into action mode and then just fire off a series of shots as fast as you can.

Capturing scenic vistas

Providing specific capture settings for scenic outdoor photography is tricky because there's no single best approach to capturing a beautiful stretch of countryside, a city skyline, or another vast subject. Depth of field is an example: One person's idea of a super cityscape might be to keep all buildings in the scene sharply focused. Another photographer might prefer to shoot the same scene so that a foreground building is sharply focused while the others are less so, thus drawing the eye to that first building.

That said, here are a few tips to help you photograph a scenic vista the way *you* see it:

- **Shoot in aperture priority autoexposure mode (Av) so that you can control depth of field.** If you want extreme depth of field so that both near and distant objects are sharply focused, as shown in Figure 9-8, select a high f-stop value. An aperture of f/13 worked for this shot.

 As an alternative to using Av mode, try Creative Auto mode and then use the slider on the Quick Control screen to request an aperture that will produce a sharper background. Landscape mode also tries to produce a large depth of field by selecting a high f-stop number, but you have no control over the exact value (or any other picture-taking settings).

 Of course, if the light is dim, the camera may be forced to open the aperture in either Creative Auto or Landscape mode, reducing depth of field, to properly expose the image. (Don't confuse Landscape autoexposure mode with the Landscape Picture Style, by the way; the Landscape exposure mode you want is the one you select from the Mode dial on top of the camera. See Chapter 8 for more details about Picture Styles.)

- **If the exposure requires a slow shutter speed, use a tripod to avoid blurring.** The downside to a high f-stop is that you need a slower shutter speed to produce a good exposure. If the shutter speed is slower than you can comfortably handhold, use a tripod to avoid picture-blurring camera shake. No tripod handy? Look for any solid surface on which to steady the camera. You can always increase the ISO setting to increase light sensitivity, which in turn allows a faster shutter speed, too, but that option brings with it the chance of increased image noise. See Chapter 7 for details. Also see Chapter 1 for details about image stabilization, which can help you take sharper handheld shots at slow shutter speeds.

Figure 9-8: Use a high f-stop value (or Landscape mode) to keep foreground and background sharply focused.

- ✔ **For dramatic waterfall and fountain shots, consider using a slow shutter to create that "misty" look.** Using a slow shutter speeds blurs the water, giving it a soft, romantic appearance. Figure 9-9 shows a close-up of this effect. Again, use a tripod to ensure that camera shake doesn't blur the rest of the scene.

- ✔ **At sunrise or sunset, base exposure on the sky.** The foreground will be dark, but you can usually brighten it in a photo editor, if needed. If you base exposure on the foreground, on the other hand, the sky will become so bright that all the color will be washed out — a problem you usually can't easily fix after the fact. You may also want to try some High Dynamic Range imaging techniques to produce an image that includes a greater range of shadows to highlights. Chapter 7 also explains this creative option. (Check out *High Dynamic Range Digital Photography For Dummies* if you want to learn more about HDR photography.)

This tip doesn't apply, of course, if the sunrise or sunset is merely serving as a gorgeous backdrop for a portrait. In that case, enable the flash and expose for the subject.

In the advanced exposure modes, you also can experiment with enabling the Highlight Tone Priority option, using Custom Function II-3. This feature can help you avoid blowing out highlights while still holding onto shadow detail. Chapter 7 offers more information.

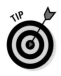

✔ **For cool, nighttime city pics, experiment with a slow shutter speed.** Assuming that cars or other vehicles are moving through the scene, the result is neon trails of light, like those you see in Figure 9-10. Shutter speed for this image was 10 seconds. The longer your shutter speed, the blurrier the motion trails.

Instead of changing the shutter speed manually between each shot, try setting the speed to Bulb. Available only in M (manual) exposure mode, this option records an image for as long as you hold down the shutter button. Just take a series of images, holding down the button for different lengths of time for each shot. In Bulb mode, you also can exceed the minimum (slowest) shutter speed of 30 seconds. Note that in Bulb mode, the camera displays the elapsed capture time on the monitor. (The viewfinder is dark while the shutter is open.)

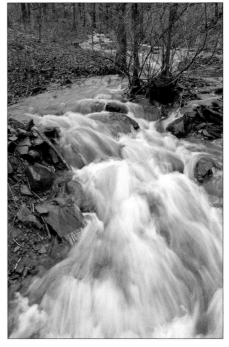

Figure 9-9: For misty water movement, use a slow shutter speed (and a tripod).

Because long exposures can produce image noise, you also may want to enable the Long Exposure Noise Reduction feature. You access this option via the Custom Function II-1. (See Chapter 11 for more information on setting Custom Function options.)

✔ **For the best lighting, shoot during the "magic hours."** That's the term photographers use for early morning and late afternoon, when the light cast by the sun is soft and warm, giving everything that beautiful, gently warmed look. This time of day, in the morning and evening, is often called the *golden hour.*

Can't wait for the perfect light? Tweak your camera's White Balance setting, using the instructions laid out in Chapter 8, to simulate magic-hour light. Try setting the White Balance to Daylight to capture warm tones, but shoot Raw photos to give you the flexibility to change your mind when you process the shots.

✔ **In tricky light, bracket shots.** *Bracketing* simply means to take the same picture at several different exposures to increase the odds that at least one captures the scene the way you envision. Bracketing is especially a good idea in difficult lighting situations such as sunrise and sunset.

Your camera offers Automatic Exposure Bracketing (AEB) when you shoot in the advanced exposure modes. See Chapter 7 to find out how to take advantage of this feature.

Also experiment with the Auto Lighting Optimizer and Highlight Tone Priority options; capture some images with the features enabled and then take the same shots with the features turned off. You control Auto Lighting Optimizer on Shooting Menu 2; Highlight Tone Priority is found under Custom Function II-3.

Figure 9-10: A slow shutter also creates neon light trails in street scenes.

Remember, too, that you can't use both these tonality-enhancing features concurrently; turning on Highlight Tone Priority (on the left in Figure 9-11) results in the appearance of a message like the one on the right in Figure 9-11 if you try to *also* turn on Auto Lighting Optimizer. A similar message appears if you try to turn on Auto Lighting Optimizer via the Quick Control screen. Likewise, if you're working with Auto Lighting Optimizer turned on and *then* you turn on Highlight Tone Priority, the 60D — without so much as a polite warning — turns *off* the Auto Lighting Optimizer option. The good news? When you subsequently turn off Highlight Tone Priority, any Auto Lighting Optimizer setting you had previously selected (before it was turned off by the camera when you turned on Highlight Tone Priority) returns from the dead. Whew!

Capturing dynamic close-ups

For great close-up shots, start with the basic capture settings outlined earlier, in Table 9-1. Then try the following additional settings and techniques:

✔ **Check your owner's manual to find out the minimum close-focusing distance of your lens.** How "up close and personal" you can be to your subject depends on your lens, not on the camera body. The 18–135mm kit lens can be as close as 1.48' from the subject (subject to camera sensor) when zoomed to 135mm.

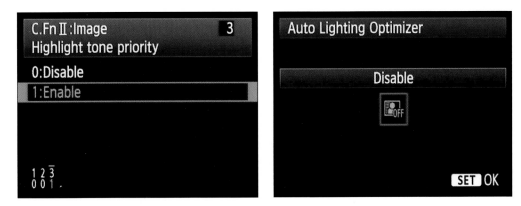

Figure 9-11: If you turn on Highlight Tone Priority (on the left) and then attempt to activate Auto Lighting Optimizer, you realize you can't enable it.

✔ **Take control over depth of field by setting the camera mode to Av (aperture-priority autoexposure) mode.** Whether you want a shallow or a medium or an extreme depth of field depends on the point of your photo. For the romantic scene shown in Figure 9-12, for example, setting the aperture to f/4.5 blurred the background, helping the subject stand out more. But if you want the viewer to clearly see all details throughout the frame — for example, if you're shooting a product shot for a sales catalog — go in the other direction, stopping down the aperture as far as possible.

Not ready for the advanced exposure modes? Try Creative Auto mode and follow the directions in Chapter 3 to set the Background slider to the "blurred" end of the scale. You also can try the Close-Up scene mode instead. (It's the one marked with the little flower on the Mode dial.) In this mode, the camera automatically opens the aperture to achieve a short depth of field and bases focus on the center of the frame. Creative Auto, however, enables you to control a few aspects of photos that you can't adjust in Close-Up mode, the most important of which is whether the flash fires.

Figure 9-12: Shallow depth of field helps set the subject apart from the background.

✔ **Remember that both zooming in and getting close to your subject decreases depth of field.** Back to that product shot: If you need depth of field beyond what you can achieve with the aperture setting, you may need to back away or zoom out, or both. (You can always crop your image to show just the parts of the subject that you want to feature.)

✔ **When shooting flowers and other nature scenes outdoors, pay attention to shutter speed, too.** Even a slight breeze may cause your subject to move, causing blurring at slow shutter speeds.

✔ **Use fill flash for better outdoor lighting.** Just as with portraits, a tiny bit of flash typically improves close-ups when the sun is your primary light source. You may need to reduce the flash output slightly, via the camera's Flash Exposure Compensation control. Chapter 7 offers details about using flash. A word of caution: When working close to your subject and using the built-in flash, remove any lens hood you might be using that could cast a shadow on the subject.

Keep in mind that the maximum shutter speed possible when you use the built-in flash is 1/250 second. So, in extremely bright light, you may need to use a high f-stop setting to avoid overexposing the picture. You also can lower the ISO speed setting, if it's not already all the way down to ISO 100.

You can't control whether the flash fires in Close-Up mode, so if flash is an issue, use either Av mode or Creative Auto mode.

✔ **When shooting indoors, try not to use flash as your primary light source.** Because you're shooting at close range, the light from your flash may be too harsh even at a low Flash Exposure Compensation setting. If flash is inevitable, turn on as many room lights as possible to reduce the flash power that's needed; even a hardware store shop light can work in a pinch as a lighting source. (Remember that if you have multiple light sources, though, you may need to tweak the White Balance setting.)

Again, if you don't want to use one of the advanced exposure modes, Creative Auto lets you determine whether the flash fires. See Chapter 3 for the lowdown.

✔ **To get *very* close to your subject, invest in a macro lens or a set of diopters (also called close-up filters).** A true macro lens is an expensive proposition; expect to pay around $200 or more. If you enjoy capturing the tiny details in life, a macro lens is worth the investment. For a less expensive way to go, though, you can spend about $40 for a set of *diopters,* which are sort of like reading glasses filters that you screw onto existing lens. (Check the filter size of the lens in the documentation; it's 67mm for the 18–135mm kit lens.)

Diopters come in several strengths: +1, +2, +4, and so on, with a higher number indicating a greater magnifying power. In fact, a diopter was used to capture the rose in Figure 9-13. The left image shows you the closest shot possible with the regular lens; to produce the right image, a +6 diopter was attached. The downfall of diopters, sadly, is that they typically produce images that are very soft around the edges, as in Figure 9-13, a problem that doesn't occur with a good macro lens.

No diopter +6 diopter

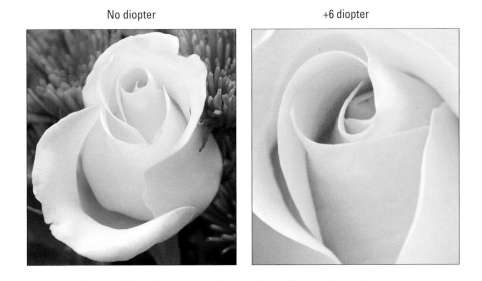

Figure 9-13: To extend the close-focus ability of a lens, add magnifying diopters.

Part IV
The Part of Tens

The 5th Wave — By Rich Tennant

"My God! I've gained 9 pixels!"

*I*n time-honored *For Dummies* tradition, this part of the book contains additional tidbits of information presented in the always popular Top Ten list format.

Chapter 10 shows you creative and practical features of the EOS 60D, such as applying creative filters, registering your own exposure mode, creating a slide show, and adding copyright information. Following that, Chapter 11 introduces you to ten ways to customize your camera — bonus options that although not at the top of the list of the features we suggest you study, are nonetheless interesting to explore when you have a free moment or two.

10

Ten Creative (and Practical) Features

In This Chapter

▶ Applying creative filters

▶ Creating a custom menu

▶ Creating your own exposure mode

▶ Plugging into a television

▶ Creating a slide show

▶ Locking up the mirror

▶ Registering dust for automatic cleaning

▶ Adding copyright information

▶ Using the electronic level

▶ Using cool custom folders

*T*his chapter is about expanding your knowledge of the 60D beyond things like setting the exposure or popping the flash. Here, we show you some of the camera's other cool features that add a lot of practicality (while remaining cool).

You'll see how to use Creative Filters to process your photos without using a computer, create your own preset exposure mode, organize your favorite menu settings into one convenient place, and more.

By the way, the rest of the book has lots of great information that will help you "decode" some of the material here. For example, Chapter 1 helps you get into and navigate around the menu system and camera settings. Chapters 7 and 8 are loaded with facts on exposure, lighting, focus, and color.

Using the Creative Filters

Creative filters — distinctive software effects designed to change how a photo looks — provide a fun and easy way to process photos in your camera. You can apply these filters to photos you've taken in the large Raw and any-sized JPEG file format. You don't need a computer, and you don't need to run sophisticated photo editing software.

To use these built-in creative filters, follow these steps:

1. **Press the Menu button and select Playback Menu 1.**

2. **Scroll down and select Creative Filters, as shown in Figure 10-1.**

3. **Press Set.**

 This starts the fun. You see the first photo on your camera's memory card (see Figure 10-2). Don't panic — you can change the photo if you want to. In fact, that's the next step.

4. **Select the photo you want to apply the filter to.**

 Use the multicontroller to move back and forth between photos, or use the Index button to show thumbnails, as shown in Figure 10-2.

5. **Press Set.**

6. **Select one of the following filters with the Quick Control dial or multicontroller:**

 - *Grainy B/W:* This miniature "way-back" machine turns your photos into old-fashioned, grainy, black-and-white photos.

Figure 10-1: Preparing to use Creative Filters.

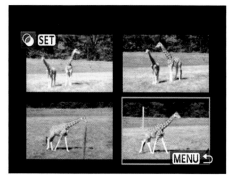

Figure 10-2: Choose a photo to apply a filter to.

 - *Soft Focus:* This filter softens the photo's focus (in other words, it blurs it) so it looks all soft and cuddly. It's great to use on photos of brides, babies, kittens, and teddy bears.

 - *Toy Camera Effect:* Creates an image with dark corners — *vignetting* — as shown in the right image in Figure 10-3. Vignetting is caused by poor-quality lenses not letting enough light in to expose the entire frame of film (like in toy cameras).

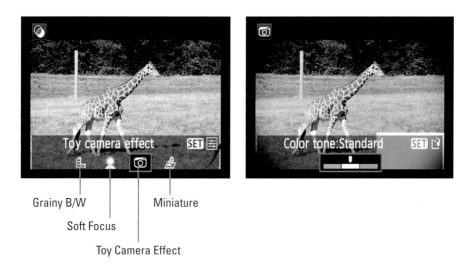

Grainy B/W Miniature

Soft Focus

Toy Camera Effect

Figure 10-3: Selecting and tweaking the filter.

- *Miniature Effect:* This is a depth of field effect, designed to simulate a macro photo taken with a very shallow area that is in focus. Contrast is also enhanced. To create the effect, identify a vertical or horizontal band that will remain sharp after processing. All other areas will be blurred.

7. **Vary the strength or effect of the filter with the Quick Control dial or multicontroller, as in Figure 10-3.**

 Each filter has a unique property that you can alter:

 - *Grainy B/W:* Increase or reduce contrast.
 - *Soft Focus:* Increase or reduce to adjust the focus.
 - *Toy Camera Effect:* Choose from three color tones: Cool, Standard, or Warm. Cool makes the photo look bluer, and Warm makes it look redder. I opt for Standard (which adds a blue-green color cast as part of the overall "toy camera and lens" effect) in Figure 10-3.
 - *Miniature Effect:* Move a sharpness rectangle up or down, or press Info to change its orientation from horizontal to vertical.

8. **Select Set to lock in changes and then OK to save the photo.**

 You don't have to worry about overwriting your original. The camera saves your photo and gives it the next open number in sequence.

If you're saving a combination of Raw and JPEG photos, the camera will apply the filter to the Raw photo only if the largest Raw is selected. (Check out Chapter 2 for more information on selecting different quality options.) Any other combination of smaller Raw or JPEG-only, and the camera uses the JPEG photo as the source image.

Creating Your Very Own Camera Menu

Canon does a good job of making it easy for you to change the most commonly used camera settings in their menu system (see Chapter 1 for more details). The menus are organized logically, so it's pretty easy to find what you need.

To make finding your favorite options even simpler, the EOS 60D enables you to create your own custom menu containing up to six items from the camera's other menus. Figure 10-4 shows a typical custom list of menu items that can be stored in My Menu. The last item, My Menu Settings, is always on the menu because you use this option to set up (and later change) your custom menu. Logically enough, the custom menu goes by the name My Menu and is represented by the star icon in the upper-right corner of the screen.

To create your menu, take these steps:

1. Set the camera Mode dial to a mode in the Creative Zone.

You can add menu items and order them from the custom menu only in P, Tv, Av, M, B, or C exposure modes. (For more information on the Creative Zone modes, see Chapters 1 and 7.)

2. Press the Menu button and display the My Menu screen.

Figure 10-4: Group your favorite menu items.

Initially, the screen shows only a single item — the My Menu Settings option, which always appears in this menu — as shown on the left in Figure 10-5.

3. Highlight My Menu Settings and press Set.

You see the screen on the right in Figure 10-5.

4. Highlight Register to My Menu and then press Set.

You see a scrolling list that contains every item on the camera's other menus, as shown on the left in Figure 10-6.

5. Highlight an item you want to include on your custom menu.

To add a specific Custom Function to your menu, scroll *past* the four Custom Function categories to find and highlight the individual function. The items named C.Fn I through IV simply put that Custom Functions menu item on your menu, and you still have to wade through multiple levels of steps to reach your function.

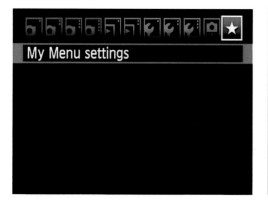

Figure 10-5: Add items to your menu.

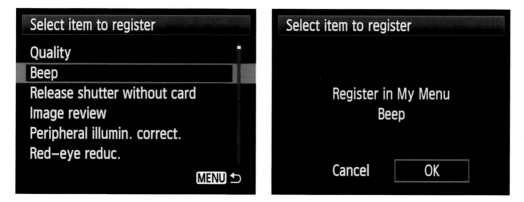

Figure 10-6: Highlight an item to put on your menu and press Set.

6. **Press Set.**

 You see a confirmation screen (the right side of Figure 10-6).

7. **Highlight OK and press Set.**

 You return to the list of menu options. The option you just added to your menu is dimmed in the list.

8. **Repeat Steps 5–7 to add up to five additional items to your menu.**

9. **Press the Menu button.**

 You see the My Menu screen, where the items you added to the menu should appear.

After creating your menu, you can further customize and manage it by following these suggestions:

- ✔ **Give your menu priority.** You can tell the camera that you want it to automatically display your menu any time you press the Menu button. To do so, select My Menu Settings on the main My Menu screen and then press Set. You then see the screen shown on the right side of Figure 10-5. Highlight Display from My Menu and press Set. Highlight Enable and press Set again.

- ✔ **Change the order of the list of menu items.** Once again, highlight My Menu Settings and press Set. Then highlight the Sort option (refer to the screen on the right in Figure 10-5) and press Set. Highlight a menu item, press Set, and then use the multicontroller to move the item up or down in the list. Press Set to glue the menu item in its new position. Press Menu to return to the My Menu Settings screen; press Menu again to return to your custom menu.

- ✔ **Delete menu items.** Display your menu, highlight My Menu Settings, and press Set. Then, to delete a single item, highlight Delete and press Set. Highlight the menu item you want to remove and press Set again. Highlight OK and press Set again to confirm your decision. To remove all items from your custom menu, choose Delete All Items (refer to the right side of Figure 10-5), press Set, highlight OK, and press Set again.

Creating Your Own Exposure Mode

One special setting on the Mode dial that's easy to overlook (but which is cool *and* practical) is the Camera User Settings (C), shown in Figure 10-7. With it, you set the shooting mode, shutter speed, metering mode, and so forth, and then save — *register*, in Canon lingo — those settings. Later, when you're out shooting, recall those settings in an instant from the Mode dial, which is faster and less annoying than having to reset all those things again.

To register your settings in the Camera User Settings mode (C), follow these steps:

1. **Set up your camera.**

 C mode is very powerful. You can (although not mandatory — you can put as little effort into this step as you want) set up your camera from top to bottom, to include as many shooting, exposure, metering, flash, and menu options as possible.

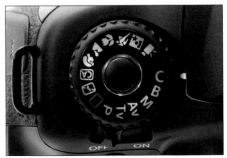

Figure 10-7: Your custom mode setting on the Mode dial.

And although you can save options from virtually every menu in the camera, there are a few limitations. Menu options that you can and cannot save in the Camera User Settings mode are

- *Shooting Menu 1:* All options
- *Shooting Menu 2:* All options
- *Shooting Menu 3:* ISO Auto
- *Shooting Menu 4:* All options
- *Playback Menu 1:* None
- *Playback Menu 2:* All except Rating and Ctrl over HDMI
- *Setup Menu 1:* All except Format and Select folder
- *Setup Menu 2:* All except Date/Time, Language, and Video system
- *Setup Menu 3:* Info button display options
- *My Menu:* None
- *Custom Functions:* All Custom Functions

2. **Press the Menu button and navigate to Setup Menu 3.**

3. **Select Camera User Settings (see upper-left image in Figure 10-8) and press Set.**

4. **From the next screen that appears (the upper-right image in Figure 10-8), register (save) the settings; then press Set.**

 If you want to clear the current settings and return C to the default setting, select Clear Settings instead.

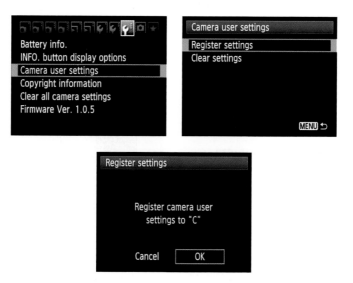

Figure 10-8: Register the settings you chose.

5. **Highlight OK on the confirmation screen (bottom image of Figure 10-8) and press Set.**

 That's it. When you want to use your custom settings, select C from the Mode dial (see Chapter 1 for more information on the Mode dial) and start taking pictures. Couldn't be easier!

Connecting Your Camera to a TV

Your camera is equipped with a playback feature with which you play pictures and movies on a television screen. In fact, you have three playback options:

- ✔ **Regular video playback:** Haven't made the leap yet to HDTV? No worries: You can use the camera to send a regular standard-definition (SD) audio and video signal to the TV. For this option, no added cable investment is needed because the cable you need is included with the camera. It's the one that has three plugs (one yellow, one red, and one white) at one end (the Stereo AV Cable, part number AVC-DC400ST).

- ✔ **HDTV playback:** If you have a high-definition (HD) television, use the camera to high-def playback. And you don't need to purchase an HDMI cable to connect the camera and television; the Interface Cable (what Canon calls it) is included in the box. The part number, should you need another one, is HTC-100.

- ✔ **For HDMI CEC TV sets:** If your television is compatible with HDMI CEC, your 60D enables you to use a TV's remote control to rule your playback operations. Just put the camera on the coffee table and sit back with your normal remote in hand to entertain family and friends with your genius. To make this operation work, you must enable Ctrl over HDMI via Playback Menu 2, as shown in Figure 10-9.

Figure 10-9: For HDMI output to an HDTV, you must enable the settings on Playback Menu 2.

With the right cable in hand and the camera turned off, follow these steps:

1. **Confirm camera video settings.**

 Access Setup Menu 2 and make sure the Video System option is set to match the technical specifications of your locale. Users in North America, Japan, Korea, and Mexico should select NTCS. If you're in Europe, Russia, China, or Australia, select PAL. For other locations, consult your television manual to confirm the video specifications.

2. **Open the little rubber door on the left side of the camera.**

 There, you find two *ports* (connection slots): a USB port for the AV cable, and one for the HDMI signal. The A/V port is the same one you use to connect the camera via USB for picture download, as explained in Chapter 6. Figure 10-10 shows the two ports. (The two round terminals under this same door are for a microphone and remote control; you don't use them for TV playback.)

3. **Attach the smaller plug on the A/V cable to the camera.**

 Make sure that the camera is off.

4. **For A/V playback, your cable has three plugs at the other end: Put the yellow one into your TV's Video In jack and the red and white ones into your TV's stereo Audio In jacks.**

 For HDMI playback, a single plug goes to the TV. The HDMI port of your television is probably on the back of the set although it could be on the side or in front. If you can't find it, consult your television manual.

 Consult your TV manual to find out which jacks to use to connect your camera and to find out which channel to select for playback of signals from auxiliary input devices.

5. **Turn on your camera to send the signal to the TV set.**

Figure 10-10: Connect your camera to a television, VCR, or DVD player.

If you don't have the latest and greatest HDMI CEC capability (or you lost your remote), control playback by using the same camera controls you normally use to view pictures on your camera monitor. (See Chapter 5 for help.) You can also run a slide show by following the steps outlined in the next section.

Enjoy! Watching playback or a slide show on a wide-screen HDTV sure beats crowding around a computer monitor.

You may need to adjust one camera setting, Video System, which is found on Setup Menu 2. The only two options are NTSC and PAL. Select the video mode used by your part of the world. (In the United States, Canada, and Mexico, NTSC is the standard.)

As with all electronic gear, here are a couple important caveats related to watching still pictures and videos on your television:

- Don't use your camera's A/V port and HDMI terminal at the same time.

- Do *not* use the HDMI port with anything other than the HDMI HTC-100 cable or a quality equivalent.

Presenting a Slide Show

Many photo editing and cataloging programs offer a tool for creating digital slide shows that can be viewed on a computer or (if copied to DVD) on a DVD player.

If you want a simple slide show — that is, one that just displays all the photos and movies on the camera memory card one by one — you don't need a computer or any photo software. You can create and run the slide show right on your camera.

The term *slide show* might make you think of a presentation that displays still photos (not movies) with optional music in the background. Canon defines the term to include still photo and movie playback from your camera. Unfortunately, there is no provision for adding background music to the show.

To create and run the slide show on your camera, follow these steps:

1. **Display Playback Menu 2 and highlight Slide Show, as shown on the left in Figure 10-11.**

2. **Press Set.**

 You see the screen shown on the right in Figure 10-11. The thumbnail shows the first image to appear in the slide show.

 Also on this screen, you see the total number of images slated for inclusion in the show. On your first trip to this menu screen, all images on the card are selected for the show.

Figure 10-11: Choose Slide Show and then use the options to customize a few aspects of the playback.

3. **Select which files you want to include in the slide show by highlighting All Images and then pressing Set.**

 This activates an option box, that lists the selection criteria (explained in the next step).

4. **Press the multicontroller up and down to scroll through the six playback options, and then make your choice:**

 - *All Images:* Choose this setting and then press Set to include all files, regardless of whether they're still photos or movies.

 - *Date:* With this option, play only pictures or movies taken on a single date. As soon as you select the option, the screen changes to show you the thumbnail of the first photo you took on the most recent shooting day, along with the number of pictures taken on the same day (see the figure on the left in Figure 10-12). To select a different date, press the Menu button to see a screen similar to the one shown on the right in Figure 10-12. The list shows you the shooting dates of all files on the memory card. Press the multicontroller up and down to scroll to the date you want to use and then press Set.

 - *Folder:* This option includes still photos and movies in the selected folder in the slide show. To change folders, press Info, select a new folder, and press Set to return.

 - *Movies:* Select this option and press Set to include only movies in your show.

 - *Stills:* Select this option and press Set to include only still photos in the show.

 - *Rating:* This option enables you to select the photos and movies you want to see based on their rating. Press Info to specify the rating.

5. **Highlight Set Up, as shown on the left in Figure 10-13, and then press Set.**

 You cruise to the screen where you can set the still photo display time (see the image on right in Figure 10-13). By default, all still photos appear for one second, but you can designate a longer display time.

6. **Highlight Display Time, press Set, highlight a choice from the menu (which offers six timing options, ranging from 1 to 20 seconds), and press Set again.**

 Movies are played in their entirety, regardless of the option you choose here.

Figure 10-12: With the Date option, you can limit the show to photos or movies shot on a specific day.

Figure 10-13: Specify how long to display each still photo.

7. Specify whether you want the slide show to "loop" continuously.

That is, set whether the camera stops when it reaches the last photo or movie, or starts the show over again. Here's how to make the call:

a. Highlight the Repeat option on the Slide Show screen (the left image in Figure 10-14).

b. Press Set to activate the option.

c. Highlight Enable for continuous looping or highlight Disable for a one-time playback (the right image in Figure 10-14).

d. Press Set again.

8. Specify transitions.

From the screen you reach after selecting Set Up, select Transition Effect, press Set, and choose a transition to play between slides. The options are

- *Off:* Don't use any transitions.
- *Slide In:* Photos slide in from the left.
- *Fade 1:* Photos fade in as if placed atop the previous slide.
- *Fade 2:* This transition quickly fades to black and then reveals the next slide.

9. Press Menu to return to the main Slide Show screen.

Refer to the screen on the left in Figure 10-13.

10. Highlight Start and press Set.

Your slide show begins playing.

Figure 10-14: Have your slide show loop or end.

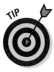

To present your slide show to a roomful of people, connect your camera to a television, as outlined in the previous section.

During the show, control the display by

- ✒ **Pausing/restarting playback:** Press the Set button. While the show is paused, press the right or left cross key to view the next or previous photo. Press Set again to restart playback.

- ✒ **Changing the information display style:** Press the Info button.

- ✒ **Adjusting sound volume for movies:** Rotate the Main dial.

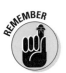

This applies to the volume level for movies that you have shot on your 60D and are including in the slide show. You cannot create a multimedia presentation that includes background music while still photos are being displayed.

Enabling Mirror Lockup

In any SLR camera, whether digital or film, light travels through the lens and is sent to the viewfinder by way of a mirror. When you press the shutter button all the way, the mirror flips up so that the light goes directly onto the image sensor, rather than being diverted to the viewfinder. You can see this illustrated in Chapter 7.

The problem with this system is that when the mirror flips, it causes a small amount of vibration. This vibration may introduce slight blurring in the photo, depending on the shutter speed you select. In general, slower shutter speeds (1/60 second and slower) are most susceptible to mirror-induced blurring, but many landscape and studio still-life photographers use their mirror lock-up feature religiously, no matter what their shutter speeds are, to capture the clearest, sharpest photo.

To reduce the effect of mirror slap–induced vibration, the 60D camera offers *mirror lockup.* When you enable this feature, the mirror movement is completed well before the shot is recorded, preventing camera shake.

To enable mirror lockup, take these steps:

1. **Set the Mode dial to a mode in the Creative Zone.**

 Mirror lockup isn't available in the fully automatic exposure modes.

2. **Press Menu and navigate to the Custom Functions menu.**

3. **Scroll down to C.Fn III: Autofocus/Drive and press Set.**

4. **Press left or right on the multicontroller until you see C.Fn III-5, Mirror Lockup; then press Set.**

5. **Press up or down to highlight the Enable option, as shown in Figure 10-15.**

6. **Press the Set button.**

After you enable mirror lockup, you take a slightly different approach to picture taking. Use this technique:

1. **Frame your shot.**

2. **If you're using autofocus, press and hold the shutter button halfway to focus.**

 Or, if you prefer manual focusing, twist the focusing ring as needed to focus the image.

```
C.FnⅢ:Autofocus/Drive          5
Mirror lockup

0:Disable
1:Enable

1 2 3 4 5
0 0 0 0 0
```

Figure 10-15: Enable mirror lockup to prevent camera shake.

3. **Press the shutter button all the way down to lock up the mirror. Then release the button.**

At this point, you can no longer see anything through the viewfinder. Don't panic; that's normal. The mirror's function is to enable you to see in the viewfinder the scene that the lens will capture, and mirror lockup prevents it from serving that purpose.

4. **Press the shutter button all the way again.**

 The camera takes the picture.

 Remember to disable the feature when you're finished unless you plan on using it the next time you pick up your camera.

Using a tripod or another type of support is critical to getting shake-free shots when using slow shutter speeds (fireworks, night photography, and even shots in dimly lit interiors all require slow shutter speeds if you don't boost ISO through the roof), whether you are using mirror lockup. For even more protection, set your camera to the 2-second self-timer mode, introduced in Chapter 2, and take your hands completely off the camera after you press the shutter button in Step 3. The picture is taken two seconds after the mirror lockup occurs. If you purchased the remote control unit for your camera, you instead can trigger the shutter button using it.

Adding Cleaning Instructions to Images

You've no doubt noticed that your camera displays a "Sensor Cleaning" message every time you turn off the camera. When you turn on the camera, a little "cleaning" icon flickers in the lower-right corner of the Shooting Settings

display. These alerts tell you that the camera is automatically performing a maintenance step designed to remove any dust particles from the sensor that have made their way into the camera interior.

If you don't see these alerts, open Setup Menu 2, choose the Sensor cleaning option, and then press Set. Next, set the Auto Cleaning option to Enable. (We don't see any good reason to disable this feature although Canon gives you the choice to do so.)

The automated sensor cleaning normally is all that's necessary to keep the sensor dust-free. If you notice that small spots are appearing consistently on your images, though, you may need to step in and take action on your own.

The best solution, of course, is to take your camera to a good repair shop and have the sensor professionally cleaned. We don't recommend taking on this job yourself; it's a delicate procedure, and you can easily ruin your camera.

Until you have the camera cleaned, however, you can use a feature on Shooting Menu 3 to create a custom dust-removal filter that you can apply in Digital Photo Professional, which is one of the free programs that ships with your camera.

The first step in creating the filter is to record a data file that maps the location of the dust spots on the sensor. To do this, you need a white piece of paper or another white surface and a lens that can achieve a focal length of 50mm or greater. (The kit lens sold with your camera qualifies.) Then take these steps:

1. **Set the lens focal length at 50mm or longer.**

 It doesn't really matter what focal length you use, as long as you're at 50mm or longer. At higher focal lengths (up to 135mm, or the maximum the kit lens can reach), you can use a smaller piece of paper because the lens will be zoomed in quite a bit.

2. **Switch the camera to manual focusing.**

 On the kit lens, move the focus switch from AF to MF.

3. **Set focus at infinity.**

 Some lenses have a marking that indicates the infinity position (the symbol that looks like a number 8 lying on its side). If your lens doesn't have the marking, hold the camera so that the lens is facing you and then turn the lens focusing ring clockwise until it stops.

4. **Set the camera to one of the Creative Zone modes (P, Tv, Av, M, or C).**

 You can create the dust data file only in these modes.

5. **Display Shooting Menu 3 and highlight Dust Delete Data, as shown on the left in Figure 10-16.**

6. **Press the Set button.**

 You see the Dust Delete Data message (the right side of Figure 10-16).

7. **Press the right multicontroller key to highlight OK and then press Set.**

 The camera performs its normal automatic sensor-cleaning ritual, which takes a second or two. You'll hear a clunk at the end of the process. Then you see the instruction screen shown on the left in Figure 10-17.

8. **Position the camera so that it's about 8 to 12 inches from your white card or piece of paper.**

 The card or paper needs to be large enough to completely fill the view-finder at this distance.

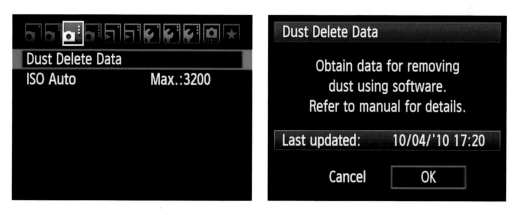

Figure 10-16: You can record dust-removal data that can be read by Digital Photo Professional.

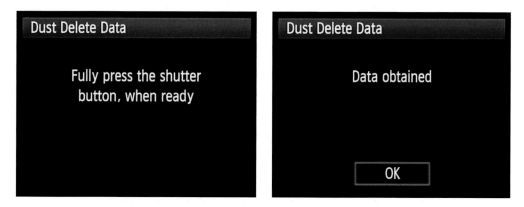

Figure 10-17: The Dust Delete Data is recorded when you press the shutter button all the way.

9. Press the shutter button all the way to record the Dust Delete Data.

No picture is taken; the camera just records the Dust Delete Data in its internal memory. If the process was successful, you see the message shown on the right in Figure 10-17.

If the camera tells you that it couldn't record the data, the lighting conditions are likely to blame. Make sure that the lighting is even across the entire surface of your white card or paper and that the paper is sufficiently illuminated; then try again.

10. Press the Set button.

The current date appears on the initial Dust Delete Data screen (refer to the right side of Figure 10-16).

After you create your Dust Delete Data file, the camera attaches the data to every subsequent image, regardless of whether you shoot in the fully automatic or advanced exposure modes.

To clean a photo, open it in Digital Photo Professional and choose Tools⇨Start Stamp Tool. Your photo then appears in an editing window; click the Apply Dust Delete Data button to start the automated dust-busting feature. The program's manual and Help system offer details about this process; look for the Help entry related to using the Copy Stamp tool.

Adding Copyright Data to Your Image Metadata

Including a copyright notice is a reasonable first step to take if you want to prevent anyone from using your pictures without your permission. Anyone who views your picture in a program that can display metadata will see your copyright notice and know who owns the rights to the picture. Obviously, that won't be enough to completely prevent unauthorized use of your images. And, technically speaking, you hold the copyright to your photo whether you take any steps to mark it with your name. But if you ever come to the point of pressing legal action against the perpetrator, you can at least show that you exercised due diligence in letting people know that you were the creator and hold the copyright.

Your EOS 60D can store your personal copyright information as part of a picture file's *metadata* — the extra data that contains your picture-taking settings and the date and time, for example. View metadata for pictures you've downloaded in Canon ZoomBrowser (Windows) and ImageBrowser (Mac).

To turn on the copyright function, take these steps:

1. **Set the camera Mode dial to a Creative Zone mode.**

 You can create or modify copyright information only in P, Tv, Av, M, B, or C exposure mode. Rest assured, however, that your copyright information — after it's created — is stored in all images you shoot in either the creative or automatic exposure modes.

2. **Press the Menu button and display Setup Menu 3.**

 Use the multicontroller to highlight Copyright Information, as shown on the left in Figure 10-18.

3. **Press Set.**

 You see the screen shown on the right in Figure 10-18. Decide what information you want added to your image metadata. A good place to start is to record your name because you *are* the photographer, after all.

4. **Use the multicontroller to highlight the Enter Author's Name option.**

 Your screen should look like the right side of Figure 10-18.

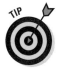

 Disable tagging later, if desired (maybe the camera is changing photographers), by using the Delete Copyright Information option shown on the right in Figure 10-18.

5. **Press Set.**

 This step opens the data entry screen, as shown on the left of Figure 10-19.

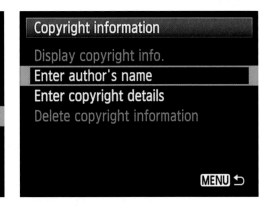

Figure 10-18: Tag files with your copyright notice.

Figure 10-19: Enter your name and other copyright information that you want tagged to your images.

6. **Enter your name.**

The upper-left box (shown on the left in Figure 10-19) is where you enter your name. The icons to the right of that box are navigational aids; use the Quick Control button to alternate between the text box to the character-selection area below.

If you want to go fast, use either the Main dial or Quick Control dial to quickly scroll from character to character in the list. If you want more tedium, use the multicontroller (to be fair, it's easy to move down lines with the multicontroller). Just move to the character you want and press Set to enter that character in the text box. If you make a mistake, press the Erase button (labeled with a trash can in the lower-right corner of your camera's back) to delete a character. You can selectively delete characters by switching focus to the text box and moving the cursor back or forward (you can use either dials or the multicontroller for this). When you press Erase, the character to the left of the cursor gets erased.

You can also go back and insert characters by switching focus to the text box, moving the cursor, switching focus down to the characters, and then entering new characters.

7. **Press Menu to accept your data.**

Press Info to cancel. You then return to the Copyright Information screen shown on the right in Figure 10-19.

8. **Highlight Copyright Information and then press Set to add additional copyright data, this time using the Enter Copyright Details menu item.**

We recommend adding the word *Copyright* and the year, for example, or your company name. Just repeat the same text entry process you used to enter your name.

9. **Press Menu to return to the Copyright Information screen.**

10. **To check the accuracy of your data, select Display Copyright Info and press Set.**

 You should see a screen similar to the right half of Figure 10-19.

11. **To wrap things up, press Menu one more time.**

You can also create copyright info with the EOS Utility software included with your 60D. Creating it isn't complicated, but it involves more steps than we have room to cover here.

Using the Electronic Level

Not every photograph has to be level with the horizon. However, many types of photos — landscapes, cityscapes, and architectural photography, for example — suffer greatly when the camera is tilted. The old-fashioned solution to leveling your camera is to use a bubble or spirit level (found at photography stores) to check the camera's alignment with the Earth. The 60D simplifies leveling your camera greatly by displaying an electronic level on the back LCD monitor that you can use to correct camera tilt.

You'll need to make sure the level is turned on and accessible through the Info button. Press Menu and navigate to Setup Menu 3. Select Info Button Display Options, press Set, and make sure Electronic Level is selected, as shown in Figure 10-20. If not, scroll down to the option and press Set to toggle it on. Scroll down to highlight OK and then press Set.

To display the electronic level, press the Info button until you see the level appear on the camera's back LCD panel. The level appears, as shown in Figure 10-21, whether you're using the viewfinder or shooting in Live View mode.

The electronic level acts like the attitude indicator in an aircraft. If you're tilting one way or another, a red line that represents the horizon moves one way or another. The gray line is your camera. To level the camera, tilt the camera back so the red line aligns with the gray and turns green, as shown in Figure 10-22.

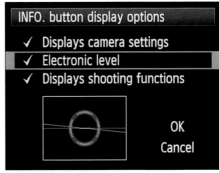

Figure 10-20: Making sure the electronic level is enabled.

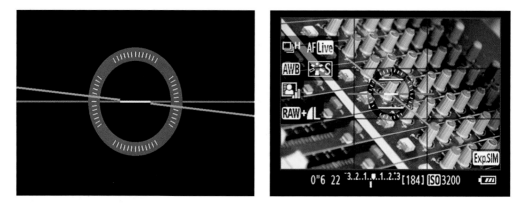

Figure 10-21: The level is visible in Live View or the viewfinder.

You can also activate the electronic level in the viewfinder by changing the behavior of the Set button. Check out Chapter 11 for more information.

Using Custom Folders

Custom folders are a feature you might find helpful when you want to separate and organize shots while you shoot. That's the good news. The bad news is that when you create a custom folder, the name is a pretty unimaginative number, and you can't change it.

Figure 10-22: When the camera is level, the line turns green.

Be that as it may, creating custom folders is pretty straightforward. Here's how:

1. **Press the Menu button and navigate to Setup Menu 1.**

2. **Scroll down to Select Folder (see Figure 10-23) and press the Set button.**

3. **Highlight Create Folder, as shown in Figure 10-24, and then press Set.**

 If you have a number of folders on your memory card, you may not be able to see Create Folder on the first screen. Keep scrolling!

The camera tells you the number of the new folder; in Figure 10-24, it's 101. Because you don't have the benefit of naming your new folder something obvious, like Kitchen or Party, you might want to keep a list of all folders you create, why you created them, and their assigned numbers.

4. **To confirm that you want to create the new folder, high-light OK, and then press Set.**

Auto power off	1 min.
Auto rotate	On📷💻
Format	
File numbering	Continuous
Select folder	

Figure 10-23: Select the Select Folder option.

Now here's how to use that custom folder. By the way, the camera will store photos in the new folder until you change it again or reach 9999 images, in which case the camera will create a new folder automatically.

Go back and repeat Steps 1 and 2 in the previous list. In Step 3, select the folder you want to use (see Figure 10-23) instead of choosing Create Folder (the left screen shown in Figure 10-24). The next picture you take goes in that folder. *Capiche?*

Select folder

100CANON 38
Create folder

Select folder

Create folder 101

Cancel OK

Figure 10-24: Creating the new folder.

11

Ten More Ways to Customize Your Camera

In This Chapter

▶ Reversing dial directions

▶ Setting Set

▶ Deciding how to select AF points

▶ Tweaking the exposure and focus lock buttons

▶ Turning off those red AF focus points

▶ Turning off AF-assist

▶ Swapping lenses

▶ Telling AF when to quit

▶ Swapping out focus screens

▶ Creating custom Picture Styles

Consider this chapter the literary equivalent of the end of one of those late-night infomercial offers: the part where the host exclaims, "But wait! There's more!"

The ten features covered in these pages fit the category of "interesting bonus items." They aren't the sort of features that drive people to choose one camera over another, and they may come in handy only for certain users, on certain occasions. Still, they're included at no extra charge with your camera, so check 'em out when you have a few spare moments. Who knows?

You may discover that a bonus feature is a hidden gem that provides just the solution you need for one of your photography problems.

Custom Function, What's Your Function?

Many features discussed here involve *Custom Functions,* which is a group of 20 advanced options accessible via the Custom Functions menu. Custom Functions don't work in Movie mode, and a few don't work when you're using Live View (namely, AF Point Selection method, Superimposed Display, Mirror Lockup, and Focusing Screen). On the D60, Canon groups Custom Functions into four categories, as shown in Table 11-1.

Table 11-1	**Custom Function Categories on the Canon EOS D60**	
Custom Function	*What It Does*	*Discussed Further in This Chapter*
C.Fn I: Exposure	Exposure level increments ISO speed setting increments ISO expansion Bracketing auto cancel Bracketing sequence Safety shift Flash sync speed in Av mode	7, 6
C.Fn II: Image	Long exposure noise reduction High ISO noise reduction Highlight tone priority	7
C.Fn III: Autofocus/Drive	Lens drive when using AF is impossible AF point selection method Superimposed display AF-assist beam firing Mirror lockup	8
C.Fn IV: Operation/Others	AF and metering buttons Assign Set button Dial direction during Tv/Av Focusing screen Add image verification data	7

Don't worry; there's no need to memorize this table. The functions are organized logically, and their names are prominently displayed onscreen. If you're not familiar with how to navigate the Custom Functions, the "Changing the Function of the Set Button" section spells things out.

Changing the Direction of the Dials

We start with an easy example that illustrates how to change Custom Functions: changing what direction you move the control dials to increase or decrease shutter speed and aperture values. This custom function is straightforward and displays a list of options as a text list, not graphically, as a few of the other Custom Functions do.

Start by accessing your EOS 60D Custom Functions, navigating to the function of your choice, and amending the settings to change the control dial direction to your liking:

1. **Set the Mode dial to one of the exposure modes in the Creative Zone (P, Tv, Av, M, B, or C).**

 You can't adjust the performance of the Set button in the Basic Zone (Full Auto, Flash Off, Creative Auto, and Image Zone, covered in Chapters 1 and 3). Typically, you use the Set button to lock in menu selections.

 Custom Functions won't work in Movie mode either, and a few (listed earlier in this chapter) don't work when you're using Live View.

2. **Press Menu to bring up the menu system, and then navigate to the Custom Function group (turn the Main dial or press the multicontroller left or right).**

 Although you can use either controller to move from menu group to menu group, rotating the Main dial is easy and intuitive.

3. **Using the Quick Control dial (rotate) or the multicontroller (press up or down), highlight the custom function you want to explore.**

 In this case, go for C.Fn. IV: Operation/Others, as shown on the left in Figure 11-1.

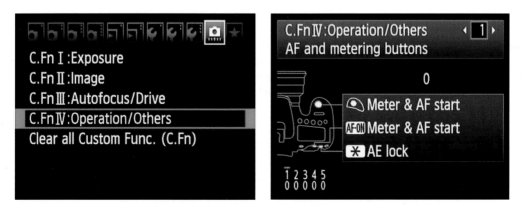

Figure 11-1: The Custom Function menu provides access to settings.

4. Press Set.

The screen should look something like the one on the right in Figure 11-1, at least along the bottom of the screen. What appears in the rest of the screen depends on which Custom Function is selected.

You might not see your Custom Function yet. Don't worry; you'll take care of that in the next step.

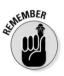

Custom Functions are grouped into four categories. The category number and name appear in the upper-left corner of the screen; the number of the selected function appears in the upper-right corner and is marked with a bar at the bottom of the screen. The blue text indicates the current setting of the selected Custom Function. You also can see the number of the option that's selected at the bottom of the screen, underneath the Custom Function number. A zero represents the default setting.

5. If necessary, turn the Quick Control dial or press the multicontroller left or right to scroll through the group's custom functions until you reach the function you want.

In this case, you're looking for Custom Function 3, Dial Direction During Tv/Av, as shown in Figure 11-2.

6. Press the Set button.

This activates the options and changes the focus from the function number at the top of the screen to the options. A highlight box appears around the selected option or option number, as shown on the left image of Figure 11-2. If that option appears in blue (as this one), it is also the active setting.

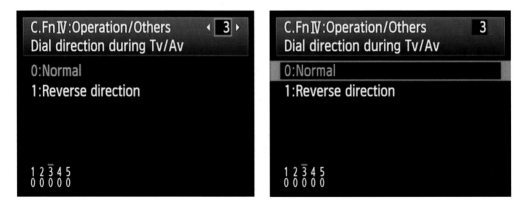

Figure 11-2: Pressing Set activates the options and enables you to change them.

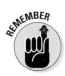

It's easy to forget this step and wonder why you can't change any of the settings. If you don't press Set, you can't change anything. It's Canon's way of protecting you from yourself.

7. **Rotate the Quick Control dial or press the multicontroller left or right to highlight the option you want.**

 In this case, there are only two options: 0: Normal (which is selected; see the right image of Figure 11-2) and 1: Reverse Direction.

8. **Press the Set button to lock in changes.**

Now whenever you're in a Creative Zone mode, the dial directions that increase or decrease shutter speed or aperture are reversed. Normally, turning the dials clockwise or to the right increases their values (faster shutter speeds and larger apertures).

To revert to default settings for all Custom Functions, select the Clear All Custom Functions menu choice in Step 3.

Changing the Function of the Set Button

Typically, the Set button serves a single function on the 60D: When a menu is displayed, you press the button to lock in menu selections. This setup keeps things simple, but you have the option to use the Set button for one additional task — displaying the Quality settings, the Flash Exposure Compensation setting, or several other handy items. The Set button retains its original purpose, regardless of the additional function you add to it.

To customize the button, take these steps:

1. **Set the camera Mode dial to one of the exposure modes in the Creative Zone.**

 You can't adjust the performance of the Set button in the Basic Zone (Full Auto, Flash Off, Creative Auto, and Image Zone). Nor does the button perform its new function when the camera is set to those modes. Yes, we think that stinks.

2. **Press Menu to bring up the menu system and then navigate to the Custom Function group (using the Main dial or the multicontroller).**

3. **Using the Quick Control dial or the multicontroller (up or down), highlight C.Fn. IV: Operation/Others, as shown on the left in Figure 11-3.**

4. **Press Set.**

 You see one of the functions displayed onscreen. Remember that the first Custom Function you reach might not be the one you're after. If not, see the next step.

Figure 11-3: Select a group, then a function.

5. **Scroll through the group's custom functions (Quick Control dial; or multicontroller, left or right) until you reach Assign SET Button, which is Custom Function 2.**

In this case, you don't see a complete list of options. You see the enabled option and an illustration of part of the camera back, as shown in Figure 11-3.

6. **Press the Set button.**

You have to press Set to access the options.

7. **Highlight your choice, using the Quick Control dial or multicontroller (left or right).**

- *0:* Pressing Set does nothing extra.

- *1:* Pressing the Set button when no menu is displayed whisks you to the screen where you can change the Image Quality setting.

- *2:* Pressing Set accesses the Picture Style screen.

- *3:* Pressing Set opens White Balance.

- *4:* Pressing Set opens Flash exposure compensation.

- *5:* Pressing Set (as shown in Figure 11-4) turns on the electronic level in the viewfinder — but again, only for the Creative Exposure modes.

8. **Press the Set button to lock in changes.**

Figure 11-4: Configure the Set button to turn the viewfinder level on or off.

Now whenever you shoot in the Creative Exposure modes and press Set while no menus are displayed, the button takes on the function you just assigned to it. To go back to the default setting, repeat these steps and select option 0 in Step 6. The button then reverts to its original single-minded purpose, which is to lock in menu selections.

Specifying the AF Point Selection Method

Typically, you specify the AF point by pressing the AF Point Selection/Magnify button to activate AF selection, and then accepting the AF point or selecting an AF point manually with the multicontroller.

Another way turns the multicontroller into a manual AF Point Selection tool without having to press another button. This speeds up the process if you need to select an AF point manually.

To set it up, follow these steps:

1. **Set the Mode dial to a mode in the Creative Zone.**

2. **Display the Custom Function group, highlight C.Fn. III: Autofocus/Drive, and then press Set.**

3. **Scroll to Custom Function III-2: AF Point Selection Method.**

4. **Press Set to activate the list of settings, as shown in Figure 11-5.**

5. **Scroll down (or use the Main dial) to highlight the option you want to enable:**

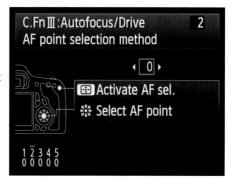

Figure 11-5: Some options are graphical, such as this one.

 - *0: Activate AF Selection/ Select AF Point:* The default behavior. When you press the AF Point Selection/ Magnify button, it activates AF point selection with the multicontroller.

 The AF point selection screen shows up on the Quick Control screen, as shown in the left image in Figure 11-6.

 - *1: Auto Selection/Manual Selection:* The new behavior. When you set it, pressing the AF Point Selection/Magnify button initiates automatic AF point selection. To set the points manually, go directly to the multicontroller.

After you meter the scene, you can press the multicontroller to set AF points. You see this represented on the Quick Control screen or through the viewfinder, as shown on the right in Figure 11-6.

6. Press the Set button to lock in changes.

Figure 11-6: Settings make quite a bit of difference in how things look.

Customizing Exposure and Focus Lock Options

By default, you initiate metering and autofocusing by pressing the shutter button halfway, and then lock autoexposure by pressing the AE (autoexposure) Lock button, labeled in Figure 11-7. The AF-ON button duplicates the behavior of the shutter button.

You can customize the locking behaviors of these three buttons via Custom Function IV-1. Here's how:

1. Set the Mode dial to a mode in the Creative Zone.

As with all Custom Functions, you can take advantage of this option only in P, Tv, Av, M, B, or C exposure modes. Additionally, the locking setup you specify applies to only those modes.

2. Display Setup Menu 3, highlight Custom Function IV: Operation/Others, and then press Set.

3. Select Custom Function 1.

Press the multicontroller right or left to scroll through the custom functions. Stop when you get to C.Fn. IV-1, as shown in Figure 11-8.

In this case (similar to adding functionality to the Set button), you see an illustration of the camera back and help text describing the function of each button in question.

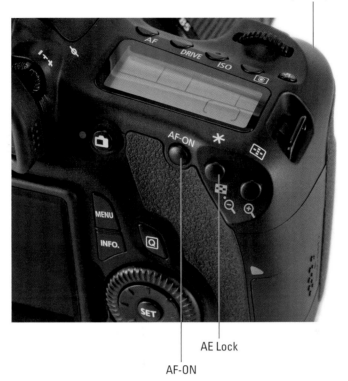

Shutter (hidden)

AE Lock

AF-ON

Figure 11-7: By default, pressing the AE Lock button locks the autoexposure setting.

4. **Press Set to activate the list of settings.**

 A highlight box appears around the setting number (not the illustration).

5. **Press the multicontroller left or right or turn the Quick Control dial to activate the option you want.**

 You have ten (yup, ten) possible presets that divide five potential functions (in the following list) between three buttons. You can't change the buttons individually; you have to choose an option that has the combination you want. This is too much to realistically show here (it's a lot easier to look at the camera and scroll through the list), but the possible behaviors are

 - *Metering:* Meters the scene. When this happens, you see exposure information displayed on the Quick Control screen, in the viewfinder, and on the top LCD screen.

- *AF start:* Initiates autofocus as long as the button is depressed (or pressed halfway in the case of the shutter button).

- *AF stop:* Stops autofocusing.

- *AE lock:* Meters and locks the exposure into the camera as long as you hold the button down.

- *No function:* This one is easy to explain!

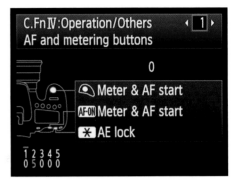

Figure 11-8: Adjust autoexposure and autofocus lock behavior via Custom Function IV-1.

It's just a matter of finding what mixture of functions and buttons that suits you best from among the ten choices. This might take some time to figure out what you like and don't like about the setting you're using.

6. **Press the Set button to finalize your choice.**

Now when you shoot in an advanced exposure mode, the camera locks focus and exposure according to the option you selected. In the fully automatic modes, the settings have no effect; you still press the shutter button halfway to focus, and you can't lock autoexposure.

Disabling the Red Focus Points

Although it might not seem like a big deal, the red autofocus lights (see Chapter 8 for more information) in the viewfinder can sometimes be distracting, especially if four or five light up as you initiate autofocus (even though this happens only when the AF mode is One Shot or the initial autofocus when in AI Focus mode).

To put the kibosh on the red autofocus lights, follow these steps:

1. **Set the Mode dial to a mode in the Creative Zone.**

2. **Display the Custom Function group, highlight C.Fn. III: Autofocus/ Drive, and then press Set.**

3. **Scroll to Custom Function III-3, Superimposed Display.**

4. Press Set to activate the list of settings, as shown in Figure 11-9.

5. Scroll down (or use the Main dial) to highlight the option you want to set:

- *0:* On

- *1:* Off

If you choose Off, you still see the red AF points light up when selecting them manually (otherwise you wouldn't know what AF point you were selecting), but they won't show up if you have the camera choosing them automatically. In other words, when you need to see them, they're on; see the left image of Figure 11-10. When you don't (the camera is taking care of them), you don't see them; see the right image of Figure 11-10.

| C.Fn Ⅲ :Autofocus/Drive | 3 |
| Superimposed display | |

0:On
1:Off

1 2 3 4 5
0 0 0 0 0

Figure 11-9: Some options are text based.

6. Press the Set button to lock in changes.

You've probably gotten the hang of selecting Custom Functions and changing the options around by now. If not, keep practicing and it will come.

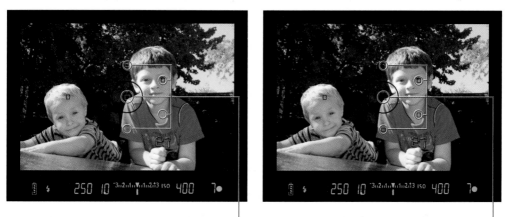

Active AF points Inactive AF points

Figure 11-10: The left photo has red autofocus points, and the right photo doesn't.

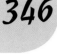

Disabling the AF-Assist Beam

In dim lighting, your camera emits an AF (autofocus)-assist beam from the built-in flash when you press the shutter button halfway — assuming that the flash unit is open, of course. This pulse of light helps the camera "see" its target better, improving the performance of the autofocusing system. For more information on autofocus, see Chapter 8.

If you're shooting in a situation where the AF-assist beam might be distracting to your subject or to others in the room, however, you can disable it. Take these steps to control this aspect of your camera:

1. **Set the Mode dial to a mode in the Creative Zone.**

 As with the other customization options discussed in preceding sections, this one is available only in P, Tv, Av, M, B, or C mode.

2. **Press menu and navigate to the Custom Functions menu.**

3. **Scroll down to C.Fn III: Autofocus/Drive and then press Set.**

4. **Scroll to Custom Function 4, AF-Assist Beam Firing.**

5. **Press the Set button.**

 The options shown in Figure 11-11 become accessible.

6. **Press the multicontroller up or down to highlight a setting.**

 You have four settings to choose from:

 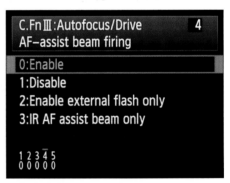

 Figure 11-11: You can disable the AF-assist beam.

 - *0:* The default; lets the AF-assist beam fire when needed.

 - *1:* Disables the AF-assist beam of both the built-in flash and compatible Canon EX-series Speedlite external flash units.

 - *2:* Disables the beam of the built-in flash while allowing the beam of a compatible EX-series Speedlite to function normally.

 - *3:* Allows the external Canon EOS-dedicated Speedlite with infrared (IR) AF-assist to use only the IR beam, which prevents the external flash from pulsing a series of small flashes (like the built-in flash) from firing.

An external Canon Speedlite has its own provision to disable the AF-assist beam: If you disable the AF-assist on the external flash, it

doesn't emit the AF-assist beam even if the Custom Function III-4 is set to Option 3. In other words, the external flash's own setting overrides the camera's Custom Function setting.

7. **Press the Set button.**

Your new setting affects all Creative Exposure modes. In automatic modes, the autofocus assist beam continues to light from the built-in flash when the camera deems it necessary.

Without the aid of the assist beam, the camera might have trouble autofocusing in dim lighting. The easiest solution is to simply focus manually; Chapter 1 shows you how.

Specialized Lenses

Notwithstanding the Introduction (where we talk about the freebies included with your camera that you can use to customize it), one "customization" that has the potential to improve your photos and make you a happier (albeit somewhat poorer) photographer is finding the right specialty lens.

The 60D comes with a good all-round kit lens, the EF-S 18–135mm f/3.5–5.6 IS standard zoom. This lens is certainly functional; its shortest length of 18mm provides adequate wide angle capability, and the extended 135mm zoom is long enough for most everyday distance shooting purposes. With a maximum aperture of f/3.5, it offers moderate low-light capability. Like Canon's other standard zooms, it also offers Image Stabilization (IS), and by itself, is reasonably priced. Photo quality isn't necessarily what you would expect from a Canon L series lens (Canon's best and most expensive lenses), but then again, this lens isn't meant to compete with those.

All that said, the kit lens is a start — but when you're ready to explore more creative options, consider adding specialty lenses like these:

- **Prime:** A *prime* lens has a set focal length: that is, not a range, like a zoom. Prime lenses are generally built better and have better optics than budget zoom lenses like the kit 18–135mm. The higher quality is partly because the lens can be engineered to perform optimally at just one focal length. The bottom line is that prime lenses offer good quality without excessive cost.

- **Telephoto:** A lens with a focal length greater than about 80mm is typically considered *telephoto,* meaning that you can zoom in on distant subjects. Of course, the kit lens does go to 135mm, so think about getting a telephoto lens longer than that. High-end (typically, professional-level) telephoto lenses have focal lengths of 200mm and up, resulting in a very specialized lens with less broad appeal than more general-purpose lenses. ***Note:*** Telephotos can be quite pricey.

✔ **Macro:** Use this type of lens to photograph close-ups: flowers, bugs, small objects, and even people. Their claim to fame is bring able to get the lens to focus while very close to the subject and having a greater *reproduction ratio* (how large something appears in the camera as opposed to its size in real life) than other lenses.

✔ **Wide angle:** Using a wide angle lens is the perfect solution when shooting landscapes or interiors of all sizes. Although the 18–135mm kit lens has good wide angle capability, you can get wider (down to 10mm) if you go for a dedicated wide angle lens, not to mention better photo quality. All wide angle lenses distort, regardless of focal length. This is viewed as a necessary trade-off to achieve traditional wide and ultra–wide angle focal lengths. Fisheye lenses comprise a unique wide angle category that have a massive field of view but at the expense of characteristic fisheye distortion.

So, experiment. Take a look at what type of lens or lenses suit your photography and see what your options are. Look at higher quality lenses as well as lenses that expand your capabilities. We don't think you'll regret it.

Controlling the Lens Focus Drive

It's pretty annoying when you try to autofocus and the camera doesn't get a good lock, but the lens motor keeps churning away like it's trying to swim the English Channel. This happens most often when shooting low-contrast subjects in low light. If that keeps happening to you, consider changing the lens focus drive behavior. Here's how:

1. **Set the Mode dial to a mode in the Creative Zone.**

 That includes the P, Tv, Av, M, B, or C modes.

2. **Display the Custom Function group, highlight C.Fn. III: Autofocus/Drive, and press Set.**

3. **Scroll to Custom Function 1, Lens Drive When AF Impossible.**

4. **Press Set to activate the list of settings, as shown in Figure 11-12.**

5. **Scroll down (or use the Main dial) to highlight the option you want to enable.**

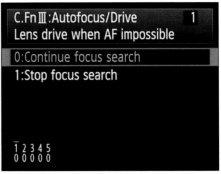

Figure 11-12: The bottom of the screen gives you a readout of all options in the group.

- *0:* Continue focus search; the default.
- *1:* Stop focus search; camera won't keep trying to focus when AF fails.

6. Press the Set button to lock in changes.

Of course, you have another option when the autofocus motor can't hone in on its target: Just set the lens to manual focusing and do the job yourself. Often, that's the easiest solution to a focus problem.

Replacing the Focusing Screen

For manual focus-only cameras, a *focusing screen* (a small piece of glass under the viewfinder) was a critical piece of engineering. Large viewfinders, combined with well-designed focusing screens with different optical characteristics, micro-prisms, and other etchings, made it possible to manually focus on small or far-away objects. If manual focus is all you had, it had to work.

Modern digital SLRs, of course, have sophisticated autofocusing systems, which reduce the importance of having a focusing screen optimized for manual focusing. The result is that the focusing screen that comes with your EOS 60D is good for autofocus but has no manual focus or alignment aids.

If you rarely or never use manual focus and are happy with focus aids and no grid lines, you can stop reading. If you want to try something more sophisticated, read on.

You can replace the focusing screen that comes with the 60D in favor of one of two specialized screens: Precision Matte with Grid and Super Precision Matte (these are explained in Step 5 in the list). It's a two-part process:

1. You have to physically change the focusing screen in the camera.

 We don't cover this process in detail because switching out hardware in your camera is outside the scope of this book. Essentially the process has four steps: Take the lens off the camera, use a special tool to unlock the installed screen, carefully take the installed screen out of the camera, and replace it with the new one.

 Your new focusing screen will come with directions for making the switch. If you're in doubt about completing this task yourself, we recommend taking your camera to an authorized Canon dealer and have someone knowledgeable there install the new focusing screen. If you want to perform the operation yourself, find a clean, well-lit, dust-free place and make sure to follow the instructions carefully and precisely.

2. Change C.Fn. IV-4 to match the type of screen you have.

 We show you how to do this in the following steps.

After you install a new focusing screen, you have to let the camera know; do so by taking these steps:

1. **Set the Mode dial to a mode in the Creative Zone.**

2. **Display the Custom Function group, highlight C.Fn. IV: Operation/ Others, and then press Set.**

3. **Scroll to Custom Function 4, Focusing Screen.**

4. **Press Set to activate the list of settings, as shown in Figure 11-13.**

5. **Scroll down (or use the Main dial) to highlight the option you want to enable.**

 - *0: Ef-A:* The default screen (Standard Precision Matte). It does very little, actually, except allow light to pass through into the viewfinder.

 - *1: Ef-D:* Precision Matte with Grid. Think of it as Ef-A with grid lines. No focusing aids here, but you see a permanent align-ment grid every time you look through the viewfinder.

 Figure 11-13: The default focusing screen is Ef-A.

 - *2: Ef-S:* Super Precision Matte. Like the Ef-A, it has no marks on it. However, it's optically different — designed to shrink the depth of field, which is supposed to make it more obvious when something is in focus and when it's not.

 Canon recommends using the Ef-S screen only when using lenses that are f/2.8 or faster. You can still use it with slow lenses, but the view-finder will look darker.

6. **Press the Set button to lock in changes.**

Creating Custom Picture Styles

New dSLRs continue to provide viable in-camera photo processing options. That's right; you don't always need to download the photo to your com-puter and slave over a photo editing application for hours trying to perfect a look. The 60D is no exception, with, among other things, robust support for Canon's Picture Style solution.

The 60D comes with six base Picture Styles to work with (Standard, Portrait, Landscape, Neutral, Faithful, and Monochrome), and you have three "slots" where you can save your own variations (User Def. 1, 2, and 3). Using these Picture Styles is covered in Chapter 8. In this section, we show you how to create your own custom Picture Style.

The two steps of creating custom Picture Styles are customizing Picture Styles and *registering* (saving) the result to User Def. 1, 2, or 3.

To adjust an existing style, follow these steps:

1. **Set the Mode dial to a mode in the Creative Zone.**

 Yes, you must set the Mode Dial to P, Tv, Av, M, B, or C to work with Picture Styles.

2. **Press Menu and navigate to Shooting Menu 2.**

3. **Scroll down to Picture Style (see Figure 11-14) and press Set.**

4. **Use the Quick Control dial or the multicontroller to scroll down and select a base Picture Style (see Figure 11-15).**

 This is the style you will work from and modify.

 The Landscape Picture Style is selected in this figure but it hasn't been activated yet (by pressing Set). That means the current style — in this case, Standard — is blue.

5. **Press Info.**

 You see all the options listed, as shown on the right in Figure 11-15: Sharpness, Contrast, Saturation, and Color Tone.

6. **Select an option from the list and then press Set.**

7. **Use the Quick Control dial or multicontroller to adjust the option (see Figure 11-16), and press Set.**

 Despite what you see onscreen, press Set, or the settings won't be saved.

 To quickly return all the settings to their default values, select Default Set and then press Set.

> Expo.comp./AEB ⁻3..2..1..0.1..2.⁺3
> Auto Lighting Optimizer
> Picture Style Standard
> White balance AWB
> Custom White Balance
> WB Shift/BKT 0,0/±0
> Color space Adobe RGB

Figure 11-14: Preparing to edit Picture Styles.

8. **Press Menu to return to the Picture Style screen.**

 Changes are shown in blue (in the Landscape row), as you can see from the right image in Figure 11-16.

Remember that you always base your style on an existing style, and then make changes. To then register (save) a new style to User Def. 1, 2, or 3, follow these steps:

1. **Set the Mode dial to a mode in the Creative Zone.**

2. **Press Menu and navigate to Shooting Menu 2.**

3. **Scroll down to Picture Style and press Set.**

Figure 11-15: Editing a Picture Style.

Figure 11-16: Changed values are displayed in blue.

4. **Use the Quick Control dial or the multicontroller to scroll down and select one of the three User Def. presets (see Figure 11-17). Then press Info.**

 That's right: Press Info. We know you've been trained to press Set a lot to navigate the menus and select options, but Picture Styles often use Info.

5. **If you want to base your setting on an existing style (other than the one visible), highlight Picture Style (left image of Figure 11-18) and then press Set.**

Figure 11-17: Edit and save your own styles.

6. **Select a new style by scrolling through the options with the Quick Control dial or the multicontroller.**

7. **Scroll to the options you want to modify and change them, as in Steps 7 and 8 in the preceding list.**

8. **Press Menu to register the Picture Style.**

 The name of the amended style that the user style was based on appears in the Picture Style menu and is shown in blue if it has been changed from the original setting.

Figure 11-18: Selecting a base Picture Style and editing a option.

Index